Photography
The Origins 1839–1890

The book has been published
thanks to the collaboration
and the contribution of

 UniCredit

Composition of the Work

Volume 1 The Origins
 1839–1890

Volume 2 A New Vision of the World
 1891–1940

Volume 3 From the Press to the Museum
 1941–1980

Volume 4 The Contemporary Era
 1981–2010

Photography
The Origins
1839–1890

edited by
Walter Guadagnini

Texts by
Quentin Bajac
Elizabeth Siegel
Francesco Zanot

Editorial Realization

Graphic Project
Marcello Francone

Editorial Coordination
Emma Cavazzini

Copy Editor
Andrew Ellis

Layout
Serena Parini

Translation
Paul Metcalfe, Susan Ann White and
Felicity Lutz for *Scriptum*, Rome

Iconographic Research
Federica Borrelli

Research
Luisa Grigoletto

*We are grateful to the following
for their precious collaboration*
Valerie Fougeirol, Paris
Viviana Bucarelli, New York

First published in Italy in 2010 by
Skira Editore S.p.A.
Palazzo Casati Stampa
via Torino 61
20123 Milano
Italy
www.skira.net

Printed and bound in Italy.
First edition

ISBN: 978-88-572-0718-6

Distributed in North America by
Rizzoli International Publications, Inc.,
300 Park Avenue South, New York,
NY 10010, USA.
Distributed elsewhere in the world by
Thames and Hudson Ltd., 181A High
Holborn, London WC1V 7QX, United
Kingdom.

Photography
The Origins 1839–1890

Reader's Guide

This history of photography is divided into four volumes, and is characterised by an innovative approach aimed at enabling the reader to follow different paths within a clearly defined structure.

Monographs

The work of a single author, Francesco Zanot, the monographs constitute the backbone of the individual volumes, tracing the historical evolution of photography through the books and exhibitions that marked its key stages. These short essays focus on the author of each of the books dealt with, or the photographers featured in the exhibitions, and place them in their historical context. The works and events discussed are therefore not considered in isolation, but become the starting points of a systematic analysis of the cultural climate within which they were born and presented. Identified and selected on the basis of their historical importance, and their capacity to exemplify particular uses of photography, the books and exhibitions included are linked to specific subjects of artistic, scientific, historical, and ethnographic character, thus pinpointing and illustrating the different aspects of the photographic medium. Fundamental importance attaches in these monographs to iconography, which makes the nature of the themes or event discussed immediately clear, while independently providing an image-based reading of the history narrated in the written text, and also making possible an essentially visual approach to the evolution of the photographic language. Each essay ends with a select bibliography for the author or authors discussed, aimed at readers interested in developing the subjects addressed in greater depth.

Essays

The essays constitute the second level of reading, with in-depth discussion of some of the primary themes of the historical period examined. Written by international specialists, they address subjects briefly discussed in the monographs, or concentrate on aspects of photographic practices that find no outlet in the official channels of exhibitions and published works. By their very nature, they cover a broad span of time, so as to constitute a history within a history, and above all to offer opportunities for reflection on some of the concepts and practices that have marked the history of photography, its functions, and its interpretations. Iconography plays a key role here too, and responds to the criterion of visual narration already noted in connection with the monographs. Attention is focused in both cases on striking a balance between the most renowned images, the icons of photography, and others that are less known but no less important for the purposes of providing the most complete overview possible.

Glossary

The history of the photography is inseparably bound up with the history of technology, the evolution of equipment for capturing and printing images all the way from the daguerreotype to digital cameras. For this reason, photography makes use of highly specific terminology regarding the succession of different processes, above all during its infancy, which is sometimes crucial to any understanding of the nature of the images before us. A basic glossary is therefore provided to help readers find their way in a world where primary importance attaches to the technical dimension.

Synoptic tables

In every history, synoptic tables supply the reader with crucial support as regards the reconstruction of the socio-cultural context within which the events recounted in the text developed. These aids become even more important in the case of photography, precisely because of its inherent propensity to engage in constant dialogue with all the manifestations of knowledge, history, and everyday life. Ever since the birth of photography, there has been no event devoid of photographic documentation, no personage not captured on film. At the same time, scientific progress has often been reflected in advances in photographic equipment, sometimes with a radical impact on the language of photography. Finally, as the relationship of photography with the so-called major arts has been one of the fundamental questions addressed ever since 1839, direct links are often to be found between artistic developments and the evolution of the photographic vocabulary.

Bibliography

Each volume has two separate types of bibliography, one accompanying each of the short monographs and essays, offering references for further exploration of the subjects and the authors addressed; and the other at the end of the volume, providing a concise but comprehensive overview of the vast literature for the entire period considered. The latter is thematically arranged to enable readers to refer to their own particular areas of interest. Specific studies regarding individual figures are not included in this general bibliography, but can be found in those accompanying the monographic texts, or those of the numerous volumes cited.

- Louis-Jacques-Mandé Daguerre
- William Henry Fox Talbot
- Anna Atkins
- "Exhibition of Recent Specimens of Photography"
- Maxime Du Camp
- Giacomo Caneva
- Roger Fenton
- Levi L. Hill
- Charles Piazzi Smyth
- Francis Frith

Monographs

William Henry Fox Talbot *The Pencil of Nature*
London: Longman, Brown, Green, and Longmans, 1844–46

Elizabeth Siegel

An Age of Albums

Essays

Contents

Walter Guadagnini

Introduction

It is reasonable to assume that whoever opens this book will have taken a photograph at least once in his or her lifetime, and will therefore have experienced at least some of the actions and decisions that led to the genesis of the images reproduced in this book and in the numerous other histories of photography published since its beginnings in the nineteenth century. This consideration raises a question. Which of the millions of photographs taken every day since 1839 are worthy of a place in a history of photography, and why? Over the years, this has in turn evolved into a further question. Given the nature of the instrument and its peculiarities, is it legitimate to reconstruct a history of photography that will naturally take only a tiny percentage of the images produced by this means into consideration? When the answer is affirmative (albeit vital to state that such a history should be declined in the plural, as histories of photography), as it is in this case, attention should therefore be focused immediately on clarifying the methodology underlying the identification of particular images, the narration of a specific history, and the viewpoint from which it is related.

First and foremost, these histories of photographs are the histories of their uses, their functions, and the intentions of those who took them. Be it public or private, a photograph can come into being for a whole variety of purposes. Scientists, artists, reporters, policemen, doctors, explorers and sociologists all perform the same action but with different aims, which affect not only the technical quality of the photograph, but also its destiny. Encompassing these differences within a unified narrative capable of accepting the varied nature of these uses and the associated results, is the challenge facing historians of photographs.

And it is a tough challenge, in that it presupposes the need to adapt our tools of interpretation to the different contexts, case by case. The consequences of reading an artistically conceived photographic portrait with the same analytical tools as one would read a mug-shot are easy to imagine. For this reason, past histories of photography were often characterized by a marked similarity in approach to the more traditional histories of art, and thus all too frequently transformed into histories of photographic *art*. For the same reason, greater awareness among scholars of the importance of widening their perspective has gradually led on the one hand to specialised studies, and on the other to the established practice of employing groups of authors, each focusing on their specific area of expertise, to write a joint history of photography. While this approach has unquestionably made it possible to provide readers with more information, and a more extensive and structured overview of the photographic sphere

in the broadest sense, it also has the limitation of producing a fragmentary discourse, in which the fundamental narrative thread is often lost, especially by non-specialist readers struggling to get their bearings, while beset by sometimes dissonant voices, and risk losing themselves in the resulting labyrinth.

Created to address this problem, the four volumes of this work in turn put forward a method that takes into account the questions raised both by photography as an instrument and by its previous histories. The first decision was to entrust the writing of the texts to a comparatively small group of authors. Each volume is in fact made up of three or four essays by specialists called upon to examine specific points in depth; plus a series of short monographic essays dedicated to individual photographers written by a single author, Francesco Zanot, which constitute the backbone of the work, its load-bearing structure, providing a narrative voice that ensures continuity throughout the various subjects and discussions, and which ensures a historical framework by adopting a strictly chronological approach.

The second element characterising these volumes is the identification of the subject matter of both the long and the short essays. This is based on the need to show how the various histories that can be recounted through photography are interwoven, and in turn how various narrative threads were themselves originated by photography. The short monographs thus focus on what might be described as the "public" destiny of photography, being entirely devoted to books, exhibitions, and events that have deeply and unavoidably affected the crucial and essential stages of the photographic discourse in its various incarnations. For all the social importance of the millions of anonymous photographs taken over a span of 170 years, the fact nevertheless remains that images exist which constitute milestones along a path than in turn interweaves with and challenges those of the other fields of knowledge encountered along the way.

The longer texts complete this reading, shifting the focus from the individual works and events to a broader vision, sometimes directly connected with them and sometimes unrelated. In this first volume, for example, Elizabeth Siegel discusses the history of the photographic album, thus entering an unquestionably private and apparently "ahistorical" sphere of photography to open up new horizons. Quentin Bajac instead addresses the perception of photography at its genesis, moving the focus of the discourse from the object to its definition in a transition crucial to any understanding of the nature of the instrument. Finally, the author of this present Introduction examines one of the practices most often connected with photography from a historical viewpoint, namely travel and the meeting with the

Other, in a space where public purpose and private history have almost equal weight.

While this approach can clearly make no claim to be exhaustive, it does provide readers with the historical background and also some of the basic tools for exploring such a vast world. Often this can be done from particular and unexpected angles, fully reflecting the importance of the photographic medium in the social history of the last two centuries, and at the same time pinpointing the salient moments of its own history: the images that have often been transformed into icons, symbols, and elements of our collective imagination, not least in virtue of the varying talents of their individual authors.

Quentin Bajac

The Machine-Made Art Photography between Science, Art and Industry, 1839–60

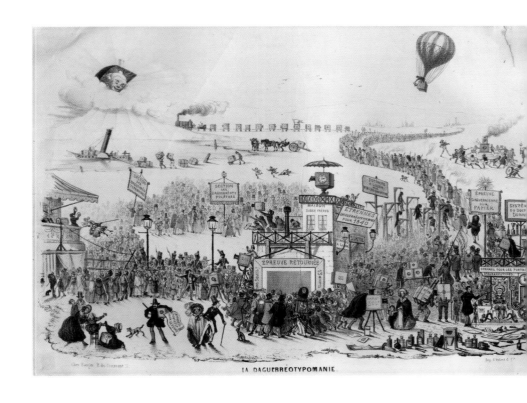

"A new art in an old civilisation", this was the phrase used by the physician and deputy Gay-Lussac in the House of Peers in 1839 (and here evidently "art" has the old meaning of *ars*, namely "technique", "process"), and its tersely expressed obvious juxtaposition makes it one that best describes the sudden breakthrough represented by the photographic image – in this case the Daguerre process. The shock waves of this invention (Fig. 1) were felt throughout the first twenty years of the medium. It was during this period that the most numerous and sometimes the most virulent debates on the status of the new image took place. A careful examination of them reveals the perplexity that the contemporaries of Daguerre and Fox Talbot felt when confronted with these new images: What status should they be given? What authority should they have? These debates reveal the confusion and uncertainty as regards the place photography should occupy in the order of representations: Was it art or industry? Reproduction or imitation? The issue was particularly delicate when it touched on the fine arts; because of its precision, the photographic image seemed to be a natural ally of the sciences, but what did it become when the aim was to produce art? In an age which, first with Romanticism and then nascent Realism, appeared to call into question a certain classical idealism, photography seemed to have come just at the right moment to reinforce these questions and shake some of the fundamental values of the fine arts system: namely the pre-eminence of the artist's work, the originality of his vision, the primacy of the idea, the importance of the imagination.

We have to go back to the origins to note that, when the first daguerreotypes appeared, photography was not automatically seen as a *natural* image. The first people, most of whom had a scientific background – the Frenchman Jean-Baptiste Biot, the German Alexander von Humboldt, and the American Samuel Morse – who found themselves confronted with the early daguerreotype plates (mostly views of Paris and still-lifes) in 1838–39, seem to have been just as struck by the wonderful and singular aspect of these representations. Mentioned in their accounts or in their correspondence all their experiences of seeing the first plates give the impression of an image that is so precise it is almost supernatural. What strikes one immediately on reading these is the difficulty the writers have in assigning a place and status to the object described, which is obviously both an image and an object (and these accounts explain in detail and often very precisely the new physical features of the plates), a strange combination of hyper-precision (insistence on the very numerous details of the image) and areas that are almost illegible, due to the reflections on the plates that makes viewing them sometimes difficult. These images, because of their originality, outdid everything that seemed to have been envisaged before, and they no longer fitted into the history of classical representations. Reference to the mirror, comparison with line engraving, the use of viewing modes linked to science (the magnifying glass), were used to explain the

1. Théodore Maurisset
Daguerreotypomania, December 1839
Lithograph with colour highlights,
25.4 x 35.1 cm
Rochester, George Eastman House

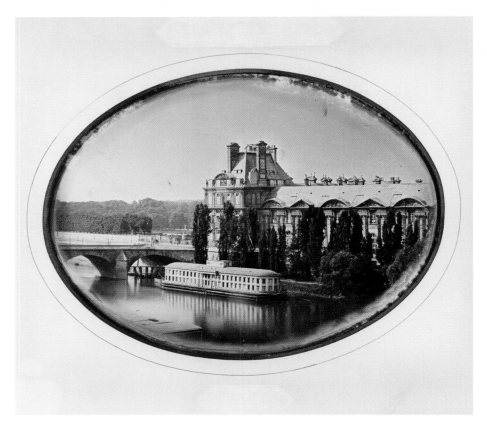

polymorphous nature of a new form of imagery that was a cross between art and science.

Rather than the experience of a natural reassuring image, the early daguerreotypes seemed to offer a kind of hyper-visibility never known before. In order to explain the exceptional nature of the Daguerre image, commentators almost systematically resorted to an optical instrument, the mirror. (Fig. 2) The analogy between Daguerre's plates and the surfaces of mirrors is evident, given the evident physical similarity between the two supports. Reflecting and monochrome, when those who described them wished to give their audience a point of reference, the plates called to mind a comparison with mirrors. This return of the unknown to the known was, however, merely apparent, since the Daguerre mirror goes beyond the usual experience of those surfaces by retaining "all impressions", to use the words of the critic Jules Janin, in 1839. One of the best illustrations of the astonishment this sight caused is to be found in an article that appeared in an American journal at the end of 1839. In an attempt to explain to his readers the unusual quality of the Daguerre image the author evokes the experience of a pedestrian in the middle of Broadway, "Let him suppose himself standing in the middle of Broadway with a looking glass held perpendicularly in his hand, in which is reflected the street, with all that herein is, for two or three miles, taking in the haziest distance. Then let him take the glass into the house, and find the impression of the entire view, in the softest light and shade, vividly retained upon its surface. This is the DAGUERREOTYPE."[1] The experience thus related, with the disruption of traditional visual experiences that it implied, shifted

the description into the domain of the strange, by giving the idea of a reflection that could be separated from its referent, so dear to Romantic fantastical literature. This account also evokes the words in which the writer Tiphaine de La Roche in his book *Giphantie*, 1760, anticipates a process that instantaneously fixes objects by using light, namely the photographic process before it was invented, "The first effect of this canvas is that of a mirror, but because of its viscous layer, the canvas retains images, which a mirror is not able to do. The latter faithfully reflects objects but does not retain them. Our canvases copy them just as faithfully, yet retain them all. This impression only takes an instant."[2] Popular literature extensively took over this analogy.

In fact a *Harper's Monthly* columnist, in 1855, tells a story in a realistic vein, in which the protagonist uses a daguerreotype like a mirror to perform the banal gesture of adjusting his tie. That same year, but in quite another far more fantastical context, the short story "The Magnetic Daguerreotype" appeared in *The Photography and Fine Art Journal*, in which the operator uses light to fix a portrait onto a mirror, but a portrait that constantly changes as though animated.[3]

Lastly, Rodolphe Töpffer from Switzerland, in one of the best-argued critical texts devoted to the daguerreotype that came out in 1840, stretches this parallel even further, but here for the first time to throw discredit on the new invention. If there was no real possibility for the images produced by the Daguerre method to enter the domain of art, it was because they were, after all, simply a kind of mirror, "For the mirror is basically nothing but an anticipation of the greater marvels one can expect from the Daguerre plate, the only difference being that the image, which is fleeting in the mirror and dependant on the presence of the subject, is fixed on the plate and consequently can be carried away from the subject."[4] Pushing his argument further, Töpffer even goes so far as to insinuate that painters and engravers have nothing to fear for the future. The likely future advances made in the process in terms of verisimilitude – capturing colour and movement – will remove it even further from art and bring its products a little closer to the experience of the mirror.

These references to the mirror can only be fully appreciated when placed in the context of declining Romanticism and nascent Realism, for which these reflecting surfaces constituted another possible aesthetic model. It is worth remembering here that in the 1820s Stendhal gave importance to the paradigm of the mirror in his definition of an empirical aesthetic anchored in reality, and in which one of the key sentences is "The novel is a mirror being carried along a road". This image, which evokes the experience of the pedestrian on Broadway quoted above, also directly refers to an essentially Romantic practice, which for certain travellers, particularly the English at the beginning of the nineteenth century, consisted in looking at nature in a slightly tinted mirror with one's back to the subject viewed.[5]

The mere action of framing a vast natural space and transforming the polychrome spectacle of nature into an almost monochrome one, like a print, marked a shift from nature to art. The experience of

the landscape was coupled with an artistic emotion through which the landscape became image. This also introduced the idea of a meaningful fragmentation, dear to the Romantics, as the scholar close to the German Romantic movement, Carl Gustav Carus, had already pointed out to Caspar David Friedrich some decades earlier, "Just do this experiment: look at a natural landscape in a mirror! You will see it reproduced with all its charms, all its colours and its forms and yet if you fix this reflection and compare it with the impression a work of art depicting a landscape has made on you, what do you note? It is evident that the work of art falls infinitely short of the truth."[6] It is symptomatic that in a letter addressed to Carus in 1839, the scholar Alexander von Humboldt, one of the experts designated along with Arago and Biot to give his opinion on the value of the Daguerre process, compares Daguerre's views to engravings on steel, "One can see at Daguerre's nothing but framed images generally on metal under glass, some less good views on paper and on glass plates, very similar to steel engraving, in a bistre, greyish ochre tone, the atmosphere is always somewhat sad and hazy."[7] It is evident that the reception of Daguerreian plates was influenced by declining Romanticism and nascent Realism.

The "somewhat sad and hazy" atmosphere of Daguerre's plates (Fig. 3), which were small, gleaming monochromes that could only be viewed by tilting them in a certain way or by using a dark cover to shade them, meant that the first viewers were rather disappointed and this was expressed more or less strongly, here and there. In fact, in order to be fully aware of the truly extraordinary nature of these images one had to resort to another optical instrument, generally associated with the field of science rather than that of art, the magnifying glass. The use of a magnifying glass[8] to view them is constantly mentioned in the early accounts and descriptions. Here is what von Humboldt writes, "The general tone is soft, fine, but as though burnished, grey, somewhat sad. I was able to see an interior view of the courtyard of the Louvre with countless bas-reliefs. Some straw must have just been taken along the quay. Can you see it in the picture? No. He handed me a magnifying glass and I saw bits of straw on all the windows. In one drawing, said Arago, a five-storey building occupied a space of about three-quarters of an inch; one could see in the image that in a skylight – and what a minute detail! – one pane had been broken and mended with paper."[9] Samuel Morse, the American inventor who was then in Paris, relates a similar experience in a letter to his brothers, he writes that by using a powerful lens that made everything fifty times bigger, each letter could be clearly and distinctly read, just like the tiniest fissures and lines on the walls of the buildings and the cobblestones of the streets.[10] Soon afterwards Jules Janin made a statement that was virtually identical, "Take the magnifying glass; can you see something that is a little darker than the rest on this uniform sand? It is a bird flying in the sky."[11]

There are many such examples. After these early accounts, and when the disappointment sometimes experienced on the first viewing had

passed, the magnifying glass became firmly established as the instrument capable of showing the exceptional nature of these images. The following year Töpffer noted how this mode of viewing revealed the extraordinary singularity of the process and its images to the eyes of the public, "One sees the middle classes going into raptures over a plate, which afforded them infinite pleasure when they recognised Pont Neuf, and all the stones of Pont Neuf, and all the street lamps of Pont Neuf, and all the cobblestones of Pont Neuf, and among the cobblestones of Pont Neuf, each blackened, stained or cracked cobble."[12]

While, as we have seen, the reference to the mirror, though at variance with classical artistic references, can nonetheless be compared to certain Romantic and emerging Realist aesthetics, the experience of the magnifying glass shifts the Daguerre plate still further towards the sciences or a scientific interpretation of the image through enlargement as brought about by the microscope or the telescope. In fact, Samuel Morse underlines how the effect of the lens on the picture was to a large extent similar to that of a telescope on reality.[13] The writer Edgar Allan Poe, who was interested in the daguerreotype, echoed him soon afterwards, by saying that if one examined a painting with a powerful microscope, any resemblance to nature disappeared, but the precise examination of a photograph only led to establishing a greater truth, a greater likeness to the thing represented.[14]

This argument soon became a cliché in the literature and criticism of photography. Far from proposing the equivalent of a natural image, the photographic image or, to be more exact, certain photographic processes (the Daguerre plate and then the collodion plates later), revealed something invisible to the naked eye. The critic Francis Wey, one of the champions of photography and Realism in the arts at the beginning of the 1850s, sums it up as follows, "This prodigious device shows what one can see and what the eye cannot distinguish."[15]

3. Louis-Jacques-Mandé Daguerre
View of Pont Neuf, 1839
Daguerreotype, 7.3 x 10 cm
Paris, Musée des arts et métiers,
inv. 16597

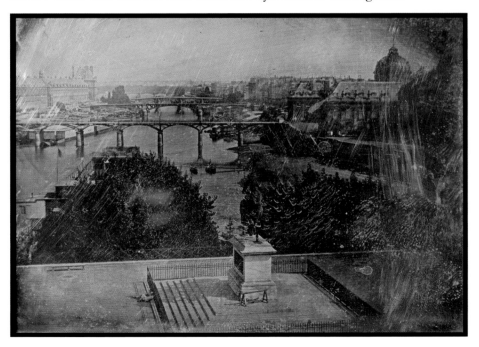

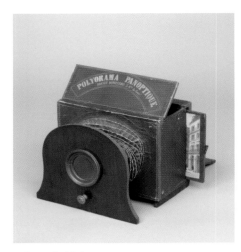

4. *Panoptical Polyorama*
Toy derived from Daguerre's Diorama,
18 x 22 cm
Bièvres, Musée français de la
Photographie, inv. 84.4515.1

Here lies the whole paradox of these representations, which, in spite of their numerous imperfections, pass "not for copies of nature but for parts of nature itself",[16] thanks to their extreme precision and sharp details.

Despite everything that was against them, despite the shiny reflecting surface, despite the absence of colour, despite their small size, the Daguerreian plates aroused a kind of wonder and uncertainty (Were they reality or illusion? Art or facsimile?) very similar to what was felt when viewing the popular attractions of the time, the panoramas or Daguerre's other great invention the Diorama (Fig. 4). When confronted with these the viewer experienced a kind of perfect mimesis, a faultless analogon. One is mindful of Van Gogh's words on leaving the Mesdag panorama, "The only fault of this canvas is that it has none."[17] In the eyes of its contemporaries, the Daguerre image combined the qualities of being both totally naturalistic and utterly supernatural. Nathaniel Hawthorne in *The House of the Seven Gables* – doubtless the first work of fiction to give such importance to a character who is a daguerreotypist – plays quite rightly on the dual aspect of the photographic image: it is both a mirror that precisely and faithfully reproduces nature and a magical mirror resembling sorcery or black magic.[18] These two aspects coexist in the writings on photography during the years 1840 to1850, and to consider it only as verisimilitude or impression would be very imprecise. Remembering the early days of the process, Abraham Bogardus writes that "at the beginning of the daguerreotype, the general public considered it a wonder."[19] The terms used to describe the technique and its results, like the many manifestations they trigger in the collective imagination, frequently place these in the realm of the fantastical (Fig. 5). For the American Philip Hone, who visited one of the first daguerreotype exhibitions staged in New York in December

5. Jules Platier
The Daguerreotrap, 1839
Lithograph
Paris, Bibliothèque nationale
de France, Département des
estampes et de la photographie,
inv. Dc283a, pt. fol.

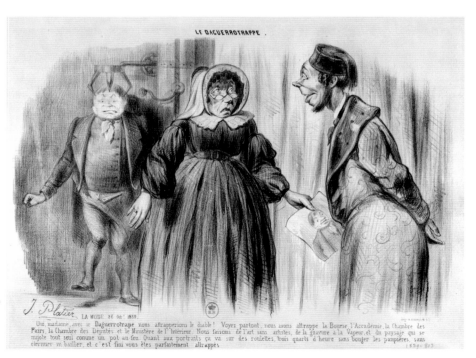

1839, "the manner of producing them constitutes one of the wonders of modern times, and, like other miracles, one may also be excused for disbelieving it, without seeing the very process by which it is created."[20] For the English journal *The Spectator* the process seems "more like some marvel of a fairy tale or delusion of necromancy than a practical reality." In "My Lost Art", a short story published in *The Atlantic* in 1852, the daguerreotype is directly linked to alchemy and to other esoteric rites. The hero claims that he has a daguerreotype of Jupiter made by using a telescope, which when examined revealed a tower, a spaceship, and living beings who looked him straight in the eye.[21]

The period from the mid-1840s saw the emergence of numerous processes of mechanical reproduction, physionotype and galvanoplasty, with which nascent photography is sometimes associated, and to which should be added the very many machine-assisted drawing from nature techniques (physionotrace, pantograph, coordonograph [for making perspective drawings], and Gavard's diagraph of 1839) whose precision was admired but whose coldness was deplored.[22] However, it was the photographic process which, since the beginning of the 1840s, had rapidly become established as the paradigm of an exact reproduction of nature. When the initial amazement of 1839–40 had subsided, the words daguerreotype and photograph were used more and more frequently in a pejorative sense, both by the Salon critics and by artists hostile to the temptations of Realism.[23] They replaced or were added little by little to the terms facsimile, verbal process, statement of fact, exact copy of reality and mirror that had been used until then. In 1859, when Baudelaire railed against photography in his famous text "Le public moderne et la photographie" he placed himself, with his exceptional literary talent, in a long critical tradition that had begun a decade earlier. "Since photography gives us all the desirable guarantees of exactitude (that is what the crazy believe), art is photography [...] I believe that art is and can only be the exact reproduction of nature [...] in fact the industry that gives us a result that is identical to nature will be absolute art."[24] Baudelaire was only concerned up to a certain point about photography. He reproached it not so much for its claim to art as because it constituted in his eyes a kind of Trojan horse of the Realism in painting within the fine arts system. Rather than the idea that photography represented a direct threat to painting – the naïve idea of one technique replacing another was not very widespread at the time, since the differences between the two media (size, colour, mechanical process) seemed considerable – it was more of an indirect threat. Namely, that photography would accustom the public to an exact imitation of reality and to its reproduction, and thus gradually undermine the very foundations of the traditional edifice of the fine arts. While he himself in one of his earlier texts notes "the cruel and surprising charm of the daguerreotype" that can be found in the drawings by the artist Henri Monnier, it was at the same time to distinguish them and thus go back to the reference to the mirror and

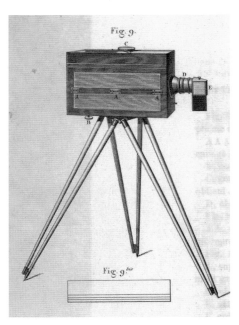

6. Camera obscura on its stand with erecting prism in front of the lens. Taken from Charles Chevalier, *Nouvelles instructions sur l'usage du daguerréotype*, Paris 1841

to claim that "Monnier cannot create anything, cannot idealise anything, cannot arrange anything. To return to his drawings, which are the main subject here, they are generally cold and hard and, strangely, they remain a vague thing in one's mind, despite the sharp precision of the pencil. Monnier has an odd quality, but he has only one. Namely the coldness, and limpidity of a mirror, of a mirror that does not think and is merely content to reflect passers-by.[25]

This idea that links, regardless of the terms employed – realism, naturalism, materialism – photography to the advent of the popular taste for a certain anti-idealistic vulgarity seems to have been an argument used since the early years of the medium. In 1840 Töpffer underlined that "today the infatuation with Daguerre plates is survived by the ideas about them expressed at the time, and more than ever materialism in Art walks the streets, spreads in the *feuilletons*, becomes ensconced in the boutiques, and finds disciples."[26] At almost the same time as Baudelaire, Théophile Gautier, despite his interest in Courbet's technique, was railing against "those dirty heavy tones", "those faces rubbed with vermilion" and "the ugliness of the daguerreotype" to be found in the canvases of this painter who "claiming realism, maligns nature horribly."

Certainly the term Realism resisted definition. For Baudelaire, "He who calls himself a realist, a word with a double meaning and whose sense has not been determined, whom we call, to better characterise his mistake, a positivist, says, 'I want to depict things as they are, or as they would be supposing I did not exist.' The world without man. And he who is imaginative says, 'I want to illuminate things with my spirit and project its reflection onto other spirits.'"

The comparison between the photographic process and Realism had few supporters outside the world of photography. Even the theoretician of Realism Champfleury sought by every means possible to distinguish himself from this cumbersome ally. A passage from his pivotal work *Le Réalisme* is even devoted, in the form of a short story, to rejecting the comparison between photographic and realist depiction of nature, "Ten daguerreotypists are gathered together in the country and they submit nature to the action of light. Alongside them ten students of landscape painting depict the same view. When the chemical operation has been completed, the ten plates are compared; they render the landscape precisely without any variation. By contrast, after two or three hours' work, the ten pupils (though they are under the guidance of the same teacher, and they have learnt the same principles whether good or bad), show their sketches side by side. Not one of them is alike. […] While the ten daguerreotype machines were trained on the same subject, the machines' ten eyes of glass rendered the same subject ten times without the least variation in form or coloration."[27]

"The machines' ten eyes of glass". Champfleury's text stresses the exclusively mechanical nature of the photographic process.

He continues along these lines, arguing that, unlike the daguerreotype machine, "man, not being a *machine*, cannot render objects

mechanically. Subject to the law of the *Self*, he can only interpret them." The fascination, then the fear indeed loathing of the machine is one of the essential ingredients of the anti-photographic discourses of the period. In the same text that is so hostile to the daguerreotype being considered art, Töpffer insists on numerous occasions on the mechanical process of what he calls the "Daguerre machine". (Fig. 6) At the end of the decade, the attitude of a painter like Delacroix was symptomatic. After taking a polite yet distant interest in the daguerreotype, it was actually only with the arrival in France of the photograph on paper, that the painter began to show a keen interest even going so far as to become a member of the Société Française de Photographie. At the beginning of the 1850s, his journal describes the disturbing fascination that the photographic process and its results held for him. He was fully aware of the real potential of the technique, and that it would radically throw into question certain old methods, "In truth, if only a man of genius would use the daguerreotype as it should be used, it would rise to unknown heights. [...] Until now this machine-made art has only rendered us a detestable service; it spoils the masterpieces for us without completely satisfying us."[28] Later he attempted to shake off this fascination and appealed to painters to beware of a too faithful transcription of photographic images, on pain of becoming "a machine harnessed to another machine."[29] Moreover, one can note how contemporary depictions of the photographic operation, in which the photographer disappeared under a black cloth to become one with the camera, probably contributed to reinforcing this obsession. The artist's fear of "becoming a machine" – which as we know vanished in the twentieth century when the artist embraced the idea – was recurrent in the art criticism of the time. In 1842, the critic Delécluze wrote, "It [the daguerreotype] has only served, as I have said recently, to distinguish and separate the painters who tend to become machines, from those who aspire to the quality of poets." But during the 1840s and 1850s, it was the chief exponent of Realism,

7. Gustave Courbet
A Burial at Ornans, 1849–50
Oil on canvas, 315 x 668 cm
Paris, Musée d'Orsay

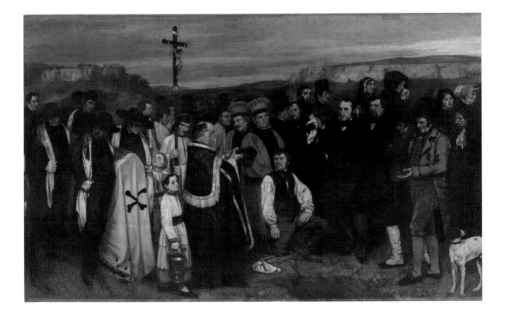

Courbet, who best embodied the artist who had become a *machine*. Confronted with *A Burial at Ornans* (Fig. 7) Delécluze considered that "it is a choice, I would say a seemingly impossible challenge the artist sets himself to become, as I said, a daguerreotype machine, and to deny his intelligence in order to put on the canvas everything he sees."[30] Yet again it is a good idea to place these attacks in a more general context. This feeling of repulsion towards the machine is also very revealing as regards the political stances of the time. One must remember that Arago's support of Daguerre in 1839 was certainly that of a scholar interested in scientific popularisation, but also that of a Republican deputy and Saint-Simonian, who was convinced of the importance of industrialisation for the progress of humanity and of industrial progress for the advance of Republican values. For Arago, Daguerreian machine-made art was an art of progress, a democratic art, in which science, art and industry converged.

However, the disappearance of the author, the absence of choice and the imagination, which were the criticisms launched against the photographic process in the 1840s and 1850s were not new. They reprised, renewed and extended most of the arguments developed at the beginning of the nineteenth century, and particularly in the 1820s, against another process that made impressions of reality, namely life casting. The exclusion of life casting from the arts had its roots in a long Humanist and Platonic tradition stemming from the Renaissance.[31] Most scholars agreed that this was a slavish technique, both marginal and threatening to the traditional fine arts. It was mechanical as it only reproduced the inanimate appearance of the subject, rendering all the details with equal precision, it was in opposition to the profound truth so dear to the classical school, nurtured by idealism and achieved by sacrificing secondary details. For the supporters of classical aesthetics the process belonged to the domain of reproduction not to that of idealisation. In July 1839, Sir John Robinson, secretary of the Edinburgh Royal Society, pointed out, without stigmatising them, the similarity between the two processes, both as regards procedure and the precision of their results: "It is a curious circumstance that, at the same time that M. Daguerre has made this beautiful and useful discovery in the art of delineation, another Parisian artist [Hypolite Vincent, a moulder] has discovered a process by which he makes solid casts in plaster of small animals or other objects, without seams or repairs, and without destroying the model. I am in possession of several specimens of his work, among which are casts of the hand of an infant of six months, so delicately executed, that the skin shows evident marks of being affected by some slight eruptive disease."[32]

This parallel with life casting became very common in the 1840s, when it was most often used in the field of art criticism to discredit photography. Throughout the nineteenth century, and particularly between 1840 and 1860, the two techniques were quite frequently associated both in critical and legal debates, and served as models that allowed one to judge what was art and what was not.[33] The famous

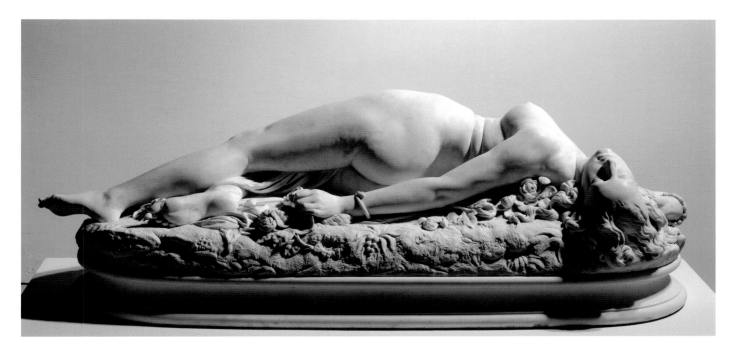

8. Auguste Clésinger
Woman Bitten by a Snake, 1847
Marble, 56.5 x 180 x 70 cm
Paris, Musée d'Orsay

protest that the critic Gustave Planche made to the 1847 Salon about Auguste Clésinger's *Woman Bitten by a Snake* (Fig. 8) suspected of being the result of life casting, is well known, "The process employed by M. Clésinger is to statuary what the daguerreotype is to Painting." In the thick of the battle about Realism, the two terms were explicitly associated and publicly disowned, they were accused of undermining the foundations of an age-old practice. In his journal, Delacroix, who had conflicting ideas with regard to the photographic process, also wrote, "I have been to see Clésinger's statue. Alas! I think that Planche is right: it is a daguerreotype in sculpture, unless it is a truly skilful execution in marble."[34] In 1844 the critic Théophile Thoré had already established a parallel to heap opprobrium on the two techniques, "Where is art? All we find is industry instead of art. Ask these workers without inspiration what the principle of painting is. They don't know anything. Most of them will say it is the imitation of reality. Then we could refer them to the daguerreotype and the camera obscura. We could replace the *Venus de Milo* with a pink wax figure."[35] Casted or modelled, the wax – a recurrent allusion to a process of illusionistic sculpture – already anticipated Planche's phrase.

The two processes, life casting and photography, remained linked and described as the two principal symptoms of this aspiration to Realism throughout the century. The idea is clearly explained in the theoretical book that formed the basis of art teaching in France for a long time, *La philosophie de l'art*, by Hyppolite Taine, published in 1865. "Must it be concluded that absolutely exact imitation is the aim of art?" he queried. "If that were so, gentlemen, absolutely exact imitation would produce the most beautiful works. But in fact, it is not thus. Because firstly, in sculpture, casting is the process that gives the most faithful and minutely detailed impression of the model, and certainly a good moulding is not worth the same as a good statue.

On the other hand and in another field, photography is the art which on a flat support, with lines and tones, reproduces most completely and without possible error, the outline and the contours of the subject it must imitate." This idealistic conception was widely held until the end of the century, also by a number of artists, including Rodin who frequently practised life casting. In 1888 he wrote, "Many life casts, namely they replace an artwork with a photograph, which is fast but it is not art." Some years later Paul Gauguin echoed him, when asked about the art of his time, "Do you know what will be the height of truth soon? Photography when it renders colours, which will not be slow in coming. And you would want an intelligent man to sweat for months to create the illusion that he can do as well as an ingenious little machine! In sculpture it is the same thing; one can make perfect life castis."[36]

In France it was only at the end of the 1840s that the question of the artistic status of photography arose for the first time in legal terms, and no longer merely on a critical and aesthetic basis. In June 1847 the first trial was held at the Seine court about counterfeiting a photographic image. The plaintiff was nonsuit because "the production of daguerreotype portraits cannot be considered a liberal art but a mechanical art", subject to trial in a commercial court. This verdict refused to extend to photography the law of 17 July 1793 that protected "all works of literature and engraving and every other production of the intellect and the genius in the field of the fine arts". When the status of photography with regard to this law was first called into question, the example of life casting, which was also excluded, was put forward. The *Traité des droits d'auteurs* published in Paris in 1849 specifies that "works produced by mechanical processes such as casting and daguerreotype are not works of art." The main legal publications of the period also took up the argument. In 1856, the *Annales de la propriété industrielle, littéraire et artistique* stress the common principles that govern the right of photography and life casting. It was not until the mid-1850s that the rise in trials for counterfeit regarding photography which, like the various processes of mechanical casting, was then in full commercial expansion, and the domination of photography on paper that permitted further "artistic" intervention by the operator, gradually led to legal precedents being questioned. Voices were raised in protest and pleaded for a more open interpretation that would also take photography into account. The champions of a shift in the legal stance called into question the mechanical nature of the incriminated process and insisted on the new creative dimension of the medium by introducing the idea of an active operator, which went against the general opinion at the time. (Fig. 9) Their arguments were sometimes in line with the critical debates that developed widely in the photographic literature of the period, particularly in the columns of the journal *La Lumière*, following the advent of photography on paper. At the beginning of the 1850s the critic Francis Wey applied to photography on paper the Romantic theory of Sacrifices (suppression

Proverbes et Maximes.

RÉOTYPE

hD

B.R

Chez Bauger. R. du Croissant 16. Chez Aubert gal. Vero-Dodat. Imp. d'Aubert & Cⁱᵉ

La patience est la vertu des ânes.

of superfluous details, simplification of masses), governing every creation of an art image. At the end of the 1850s, the jurists Rendu and Delorme further insisted on "the dexterity and precision" which in photography, according to them, were the qualities that "add a personal element to the work of nature". At this time, too, a number of jurists recommended not insisting on the methods used but on the results achieved and considering photography (and casting) a product of work. They encouraged an approach that was more similar to English legislation in this regard, which guaranteed authors more extensive protection of their work, regardless of the process used. The ambitions of the battle fought by a number of professional photographers to get photography included in the 1793 law, however, should not be overestimated. Their seeking protection was above all governed by commercial concerns, at a time that saw the rapid expansion of the portrait market, and the photographic *carte de visite* increased the possibility of copies and counterfeits being made.

Far from dreaming of bringing an aesthetic issue to a conclusion, the aim was first and foremost to put a stop to commercial disputes by granting the title of author, instead of that of artist. In 1862, the Societé Photographique de Marseille did not petition the minister of state to include photography in the "arts of pure creation", but more modestly to recognise that "the technique itself involves a certain amount of research and artistic invention". Certainly in the 1850s, some photographers from Le Gray to Nadar and Roger Fenton, on both sides of the Channel, declared that they wanted photography to be recognised as a fully-fledged artistic discipline far removed from commercial interests. In fact, the famous profession of faith in Le Gray's 1852 treatise, where he expresses the wish that photography, instead of being included in the field of industry and commerce, might be included in that of art, is explicitly followed by a warning against seeking profit to the detriment of quality, "Seeking to lower the price of prints, before finding the means to make complete works, would be to expose ourselves to forfeiting the future of our most interesting art." But such protests were rare.

It was on the occasion of a commercial dispute, a trial about the counterfeit of *carte de visite* portraits, that for the first time in France it was recognised that in certain cases photography could from then on benefit from the protection of the 1793 law. In 1862, the photographers Ernest Mayer and Louis Pierson took their colleagues Pierre Betbeder, Pierre Eugène Thiebault, and Schwabbé to court for counterfeit, accusing them of having reproduced and sold some of their portraits of personalities. The first hearing was a nonsuit, but Mayer and Pierson won their appeal. Though the sentence was seen at the time as an indisputable victory for the photographic cause and though it was certainly the first significant step in the law taking into account the protection of photography, we should, however, put this victory in perspective. The sentence appears extremely weak and the artistic recognition of photography very moderate, the grounds for the decision specified that photography was "a process whose products

must not be necessarily and in all cases considered devoid of an artistic character." As can be seen, the sentence does not establish any principle, and limits itself to inviting the courts to evaluate the merit of the incriminated prints on an individual basis. Until the end of the century, the proliferation of conflicting legal decisions only added to the confusion that reigned about the status of photography. Some courts refused to grant photography the protection of the 1793 law out of principle, while others, by contrast, extended it to all photographic production whatever it might be. This legal confusion, which reveals even greater incertitude with regard to the aesthetic status of photography was not confined to France. While in England the 1862 Copyright Act guaranteed the protection of works registered at the Copyright Office in London, particularly for the trade in *cartes de visite* portraying celebrities, in the United States the law passed by Congress in 1865, extending copyright protection to photographic negatives, was only really applied at the beginning of the 1880s, after Napoléon Sarony took a counterfeiter to court.

This uncertainty about the status of the photographic image, whether it was the Daguerre plate or the different processes on paper that succeeded it, was most evident in the way that photography was viewed in the exhibitions and Salons from the 1840s to the 1860s. It was here that the issue of the *place* of photography arose in a very literal and concrete fashion. From the outset it had been seen as an industrial product in the various exhibitions in which it had featured. In the Exposition des Produits de l'Industrie, held in Paris in 1844, for the first time in the Daguerreian era, the process appeared in a category of its own, "daguerreotype", along with musical instruments, tapestries and rubber, to which must be added various exhibitors in the "optical" section, who also showed Daguerreian products.[37]

Due to its size and independent character, the sign of its high profile, this section could be compared with the one devoted to reproduction techniques in sculpture. But its reception was lukewarm, indeed indifferent, since the process had by then become a part of everyday life and no longer set people dreaming. In 1849, the title changed, the exhibition of industrial products included all the photographic processes under the name "heliography", and announced that the daguerreotype would soon disappear. At the Exposition Universelle of Paris in 1855 photography remained a technical process and was included with the devices in the section of industrial arts.

It was in the 1850s, with the developments and later the commercial launch of photography on paper, that the first photographic societies were established, which then organised the first salons. During those years recognition of the artistic status of photography depended on photographs being exhibited in art venues. This had its negative effects, in fact, Gustave Le Gray's photographic prints were rejected twice in 1850 and 1852 by the jury of the painting exhibition to whom he had submitted them. Symptomatically, it was in 1859 – approximately at the same time that the law began to change – that photography gained access to the Salon de Peinture, after an intense

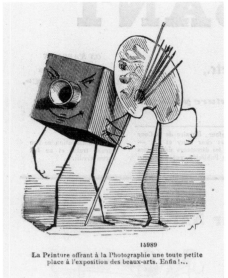

13492
Ingratitude de la peinture, qui refuse la plus petite place de son exposition à la photographie, à qui elle doit tant.

15989
La Peinture offrant à la Photographie une toute petite place à l'exposition des beaux-arts. Enfin !...

13508
La photographie sollicitant une toute petite place à l'exposition des beaux-arts.

10a–c. Nadar
Three drawings about photography being admitted to the Salon des Beaux-Arts
Journal Amusant, no. 55, 17 January 1857 (a and b) and *Journal Amusant*. No. 172, 16 April 1859 (c)
Paris, Bibliothèque nationale de France, Département des estampes et de la photographie

public-awareness campaign by the international networks of the Société Française de Photographie. (Fig. 10) The event was celebrated yet again as a victory for photography like the sentence in the Mayer and Pierson case three years later. And a victory it certainly was, but it did not dispel the ambiguity surrounding photography, far from it. Photography (or rather the Société Française de Photographie) was only accepted in an adjacent though separate space, with a different entrance from that of the Salon. Its presence is not mentioned in the official programme, nor on the posters.[38] This was merely a half measure and was not repeated in the near future At the dawn of the 1860s, the issues regarding the status of photography were far from being settled. In 1862, the Universal Exhibition in London once again relegated photography to the section of "Industrial Instruments", far removed from the fine arts. The Photographic Society of London expressed its indignation and a compromise was found. Symptomatically photography was placed in the category of "Philosophical Instruments", which was the term used since the eighteenth century for experimental, and particularly optical instruments, such as the camera obscura, microscope and telescope, without forgetting the kaleidoscope invented by David Brewster. From Industry to Science certainly, but still very far from Art.

[1] Text attributed to Lewis Gaylord Clark, *The Knickerbocker*, New York, vol. 1, no. 6, December 1839.
[2] Tiphaine de La Roche, *Giphantie*, Paris, 1760.
[3] Quoted in Alan Trachtenberg, 'Photography the Emergence of a Keyword' in *Photography in Nineteenth-Century America*, Martha Sandweiss ed., New York, Harry N. Abrams, 1991, p. 26.
[4] Rodolphe Töpffer, *De la plaque Daguerre. A propos des excursions daguerriennes*, Paris,

Lerebours, 1840. Reprinted, Paris, ENSB-A, 1998.
[5] Quoted by Louis Marin, *Des pouvoirs de l'image: gloses*, Paris, Editions du Seuil, 1993.
[6] Quoted in Bernard Comment, *Le XIXe siècle des panoramas*, Paris, Adam Biro, 1993
[7] Humboldt's text is notably reproduced and analyzed in Roland Recht, *La lettre de Humboldt*, Paris, Christian Bourgois, 1989.
[8] On the principle of viewing through a magnifying glass, see André Gunthert, 'La boîte noire de Daguerre', in *Le daguerréotype*

français – un objet photographique, Q. Bajac and D. de Font-Reaulx eds., Paris, RMN, 2003.

[9] Ronald Recht, *La lettre de Humboldt*, op. cit.

[10] Samuel Morse, letter to his brothers from Paris, 9 March 1839.

[11] Jules Janin, 'Le Daguerotype' (sic), *L'Artiste*, 2nd series, vol. II, part 2, 27 January 1839.

[12] Rodolphe Töpffer, *De la plaque Daguerre*, op. cit.

[13] Samuel Morse, letter to his brothers, op. cit.

[14] Quoted by Michel Frizot, ' Le diable dans sa boîte ou la machine à explorer le sens (la photographie est-elle un art au milieu du XIXe siècle', *Romantisme*, vol. 13, no. 41, 1983.

[15] Francis Wey, 'Du naturalisme dans l'art, de son principe et de ses conséquences', Paris, *La lumière*, no. 9, 6 April 1851.

[16] Samuel Morse, letter to his brothers, op. cit.

[17] Bernard Comment, *Le XIXe siècle des panoramas*, op. cit.

[18] Quoted in Alan Trachtenberg, 'Photography. The Emergence of a Keyword', op. cit.

[19] Quoted in Alan Trachtenberg, 'Photography. The Emergence of a Keyword', op. cit.

[20] Philip Hone, *The Diary of Philip Hone, 1828-1851*, New York, Dodd, Mead and Company, 1889.

[21] Quoted in Alan Trachtenberg, 'Photography. The Emergence of a Keyword', op. cit.

[22] Michel Frizot, 'Le diable dans sa boîte', op. cit.

[23] On this issue see Paul-Louis Roubert, *L'image sans qualités, les beaux-arts et la critique à l'épreuve de la photographie, 1839-1859*, Paris, Monum-éditions du Patrimoine, 2006

[24] Charles Baudelaire, 'Le public moderne et la photographie', letter to the editor of *La Revue française* on the Salon of 1859, *La Revue française*, 20 June, 1859.

[25] Charles Baudelaire,'Quelques caricaturistes français', *Curiosités esthétiques*, Paris, Michel Levy frères, 1868.

[26] Rodolphe Töpffer, op. cit.

[27] Champfleury, *Le Réalisme*, Paris, 1857.

[28] Eugène Delacroix, *Journal, 1822-1863*, Paris, Plon, 1893.

[29] Ibid.

[30] Paul-Louis Roubert, *L'image sans qualités*, op. cit.

[31] A number of issues developed here are also to be found in Quentin Bajac 'Les procédés compromettants, moulage et photographie face à la loi' in the catalogue *A Fleur de peau. Le Moulage sur nature au XIXe siècle*, E. Papet ed., Paris, RMN-Musée d'Orsay, 2002.

[32] Sir John Robinson, 'Perfection of the Art', *The American Journal of Science and Arts*, New Haven, vol. 37, no. 1, July 1839.

[33] See Paul-Louis Roubert, op. cit.

[34] Eugène Delacroix, *Journal*, op. cit.

[35] Quoted in Quentin Bajac, 'Les procédés compromettants', op. cit.

[36] Quoted in Bajac, 2002.

[37] Quentin Bajac, 'Une branche d'industrie assez importante, l'économie du daguerréotype à Paris, 1839-1850' in *Le daguerréotype français un objet photographique*, op. cit.

[38] Paul-Louis Roubert, '1859. Exposer la photographie', *Etudes photographiques*, no. 8, November 2000.

- Louis-Jacques-Mandé Daguerre
- William Henry Fox Talbot
- Anna Atkins
- "Exhibition of Recent Specimens of Photography"
- Maxime Du Camp
- Giacomo Caneva
- Roger Fenton
- Levi L. Hill
- Charles Piazzi Smyth
- Francis Frith

Louis-Jacques-Mandé Daguerre

Historique et Description des Procédés du Daguerréotype et du Diorama

Paris: Alphonse Giroux et Cie, 1839

Historique et Description des Procédés du Daguerréotype et du Diorama, 1839
New York, George Eastman House

7 January 1839 is the date commonly associated with the birth of photography. It is a mere convention, however, since this is not the day on which the first photographic image was captured, nor even when an important patent was taken out. Instead, it was the day that François Arago, an astronomer and member of the French Chamber of Deputies, officially announced at the Parisian Académie des Sciences the discovery of "a method for fixing images that depict themselves in a *camera obscura*", as anticipated in an article in the *Gazette de France* twenty-four hours earlier. This technique was named daguerreotypy, after Louis-Jacues-Mandé Daguerre, who developed it after many years of research and study.

In mid-1827, Nicéphore Niépce, a well-off gentleman from Provence with a keen interest in mechanics, chemistry, and engraving, created the earliest sufficiently clear and durable photographic image made from life. There had been many previous attempts (Niépce himself had been pursuing this aim from the end of the eighteenth century at least), which were defeated by the fact that the figures impressed on the support were extremely indistinct, and that moreover it was impossible to fix them permanently. The solution was arrived at by adopting a material that had never been used in this field but was well-known to Niépce, since it was used in lithography. This was bitumen of Judea which, because light caused it to harden, proved to be the key to success. The first heliograph (the name Niépce gave to his process, which literally means "writing with the sun"), created with a *camera obscura*, which shows the view from a window of the photographer's house at Saint-Loup-de-Varennes, required a very long exposure because of the scant photosensitivity of bitumen. Indeed, we may presume that the exposure time was about eight hours, due to the fact that the sun is shining on both sides of the image; however, apart from this inconsistency with reality, it can be said that the most powerful device that had ever existed for reproducing the appearance of the world was now available. This was the reason Niépce and Daguerre soon came into contact. The latter had already inaugurated his Diorama in Paris in 1822. It consisted in a spectacle created with large paintings on both opaque and transparent surfaces which, illuminated by windows, skylights and lamps, gave

an audience of 350 the impression that they were looking at the real thing rather than an image of it, whether it was an alpine village or the basilica of Saint Peter in Rome. To make the illusion more convincing, Daguerre included three-dimensional objects in the scene (a real chalet, real fir trees, and live goats, accompanied a panorama of Mont Blanc), transmitted a variety of sounds, and painted the majority of his subjects with the aid of a *camera obscura*, with which he also attempted some "photographic" experiments in order to reduce the time it took to complete the drawing process and to reproduce his models more faithfully. He did not achieve any satisfactory results in this area, but the men who built his *camera obscura*, the Chevalier brothers, told him all about the extraordinary progress made by Niépce, since they were the ones who had supplied the inventor from Saint-Loup with the necessary equipment to record the *point de vue* (the expression he himself coined to describe an image made with a lens) from his window. Thus, the two experimenters began to correspond regularly, although at the beginning Niépce was less forthcoming, knowing that the many skills he had already acquired in the field gave him the

advantage. Nonetheless, their working relationship gradually developed into one of equal standing, as confirmed by the fact that in December 1829 they set up a company with the aim of perfecting heliography and exploiting its commercial benefits. From the outset, Daguerre showed himself to be most enterprising, making substantial changes in the original method in an attempt to find a substance that could replace the bitumen, since its slow reaction to light was the main drawback to the technique, that is until 1831, when he discovered that silver iodide was photosensitive. But in this case too the material did not appear to respond to the light stimuli with the right degree of intensity, generating on the metal support a "latent image" that was temporarily invisible. When Daguerre discovered how to reveal it through the action of mercury vapours and, subsequently, to fix it with a bath of saline solution, the problem was definitively solved. With an exposure time of between three and thirty minutes it was possible to obtain a perspective image of the real filtered through the *camera obscura*. The earliest daguerreotype to come down to us, which depicts a still-life deliberately composed of bas-reliefs

and a bottle in wicker casing, dates to 1837. However, Niépce had been dead for four years, and his contribution was considerably minimised. Indeed, the new discovery was virtually attributed solely to Daguerre when it was announced on 7 January 1839, despite the fact that the French government later awarded Nicéphore's son Isidore a life annuity in exchange for the acquisition of the patent on the invention. Niépce (or rather the memory of the inventor) was not the only one who was damaged by the announcement made at the Académie des Sciences, since Daguerre's supremacy inevitably cast a shadow over the researches carried out in the same period by many others, who consequently hastened to make their respective successes public. The two who suffered most were Hippolyte Bayard, who in March 1839 showed that he had developed an effective method for making positives directly on paper, but was ignored to such a degree that the following year he produced a self-portrait of himself as a "drowned man" to express his overwhelming disappointment; and the Englishman William Henry Fox Talbot, whose negative-positive process had already been executed in 1835, after which various improvements were

made, and which achieved a certain consensus in his homeland, as well as offering a viable alternative to daguerreotypy. All this happened after the January meeting of the Paris Académie, during which no mention was actually made of the technical aspects of the method used by Daguerre to produce his images. Arago would only reveal these later at an extremely well-attended joint assembly of the Académie des Sciences and the Beaux-Arts, called especially for this purpose on 19 August of the same year. Daguerre did not take the floor, making the excuse that he had a sore throat, but when he reappeared a few days later his technical description had already been written in a handbook, *Historique et Description des Procédés du Daguerréotype et du Diorama*, commissioned by the government and printed by Alphonse Giroux.
The seventy-nice-page manual contained a history of his invention (including a description of Niépce's heliographic method, with respect to which daguerreotypy was presented as completely independent and superior); the technical details of the process, accompanied by scale drawings of the necessary instruments; the transcripts of parliamentary speeches made by Arago, Duchâtel and Gay-Lussac; and an overview of dioramic painting. Since only a small number of copies were printed, the book rapidly sold out, but it was soon reprinted by other publishers, some of whom made hardly any changes to the content, while others limited themselves to a summary of the various technical stages. In next to no time, Daguerre's triumph was repeated on an international scale: before the end of 1839 translations came out in English, German, Swedish, and Spanish, and over thirty editions were published throughout Europe and in the United States in all, which made the work a phenomenon on the publishing scene at that time. Notwithstanding the objective difficulties of a method which only a small percentage of those who bought the manual were able to apply correctly, this publication offered a considerably wider public the means of mastering the process, thus prefiguring the extensive use of the camera today. It was undoubtedly a major turning point, and while Niépce must be given the credit for having developed the first photographic process in history, Daguerre must be acknowledged as having perfected and introduced it to the general public.

The revolution was complete: the social history of photography could begin.

Bibliography
Bajac, Quentin. *The Dawn of Photography. French Daguerreotypes, 1839–1855*. New York and New Haven: The Metropolitan Museum of Art / Yale University Press, 2003.
Batchen, Geoffrey. *Burning with Desire: The Conception of Photography*. Cambridge, Mass.: The MIT Press, 1997.
Coe, Brian, and Mark Haworth-Booth. *A Guide to Early Photographic Processes*. London: Victoria and Albert Museum, 1983.
Galassi, Peter. *Before Photography: Painting and the Invention of Photography*. New York: The Museum of Modern Art, 1981.
Gernsheim, Helmut, and Alison Gernsheim. *L.J.M. Daguerre: The History of the Diorama and the Daguerreotype*. London: Secker and Warburg, 1956.
Jay, Paul. *Niépce: Genèse d'une Invention*. Chalon-sur-Saône: Société des Amis du Musée Nicéphore Niépce, 1988.
Lo Duca, Gian Maria. *Hippolyte Bayard: Der Erste Lichtbildkünstler*. Paris: Prisma, 1943.
Newhall, Beaumont. *Latent Image: The Discovery of Photography*. New York: Doubleday & Co., 1967.
Newhall, Beaumont. *An Historical and Descriptive Account of the Various Processes of the Daguerreotype and the Diorama by Daguerre*. New York: Winter House, 1971.
Potonniée, Georges. *Histoire de la Découverte de la Photographie*. Paris: Publications Photographiques Paul Montel, 1925.
Wood, John. *The Daguerreotype: A Sesquicentennial Celebration*. Iowa City: University of Iowa Press, 1989.

Joseph Nicéphore Niépce
View from a Window of Niépce's House at Le Gras, Saint-Loup-de-Varennes, ca. 1827
Photograph on glass
(original destroyed, reproduction from photoengraving)

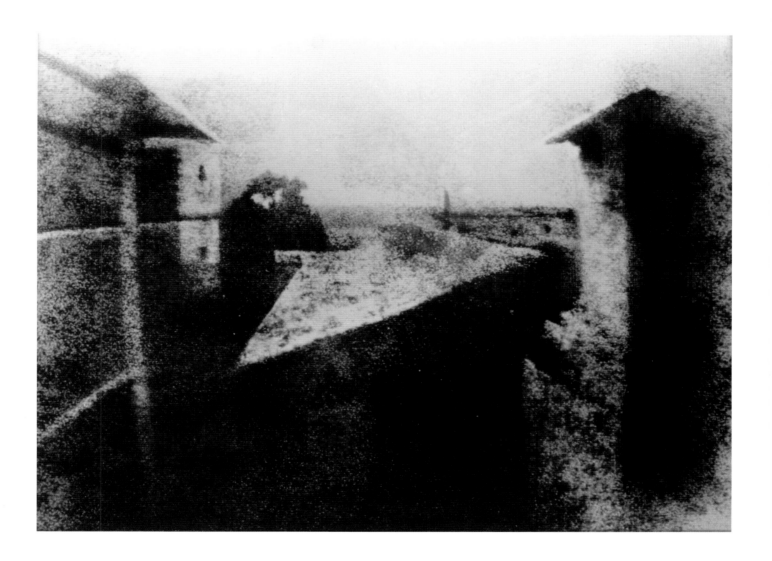

Louis-Jacques-Mandé Daguerre
Still Life, 1837
Daguerreotype, 16.5 x 21.5 cm

Louis-Jacques-Mandé Daguerre
*Daguerréotype. Experiénce
publique faite par M. Daguerre*,
ca. 1840
Litography, 14.9 x 10.8 cm
New York, George Eastman
House

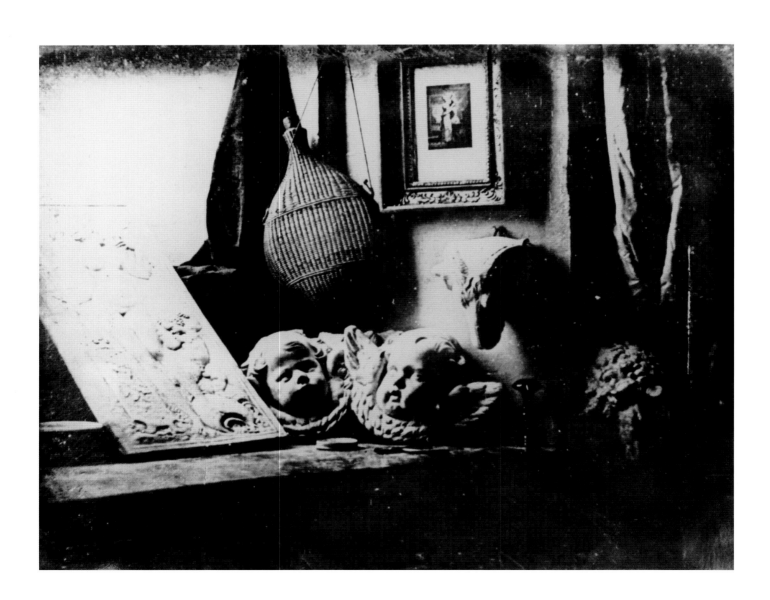

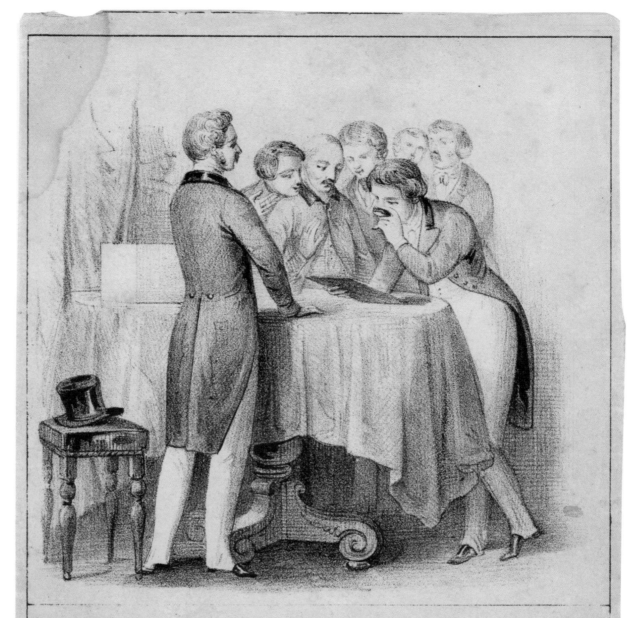

Daguerréotipe.

Expérience publique faite par M.ᵉ Daguerre.

Un Physicien Napolitain J.B. Porta, trouva la Chambre noire il y a environ deux siècles. Les images qui se peignaient sur le papier, pouvaient être reproduites en suivant leurs contours avec la pointe d'un crayon. Au 19.ᵉ siècle, notre compatriote Charles fit les premiers essais de l'art photographique, mais son secret mourut avec lui. De nouveaux essais furent tentés depuis par des Anglais, mais les images produites se détruisaient au grand jour. M.M.ᵉˢ Daguerre et Niepce sont parvenus aujourd'hui au moyen d'une plaque d'argent recouverte d'une préparation chimique à fixer les images de la Chambre noire.

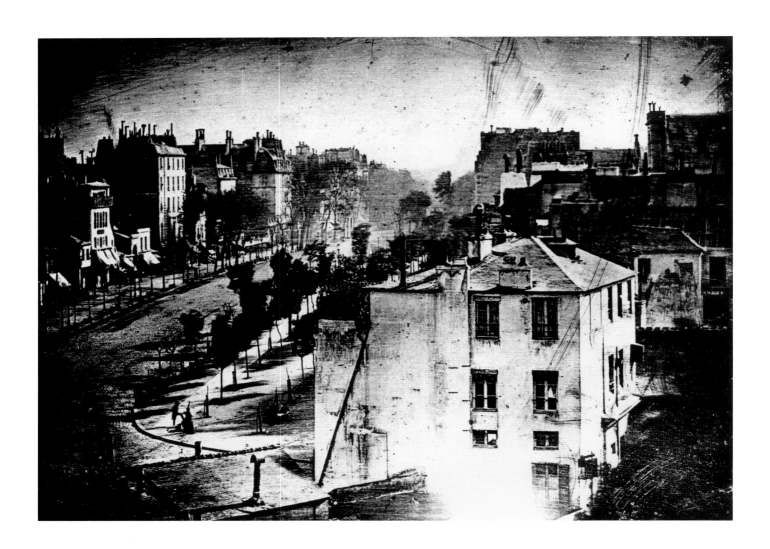

Hippolyte Bayard
Self-Portrait as a Drowned Man,
1840
Direct positive print, 14.2 x 14 cm
Paris, Société française de
photographie

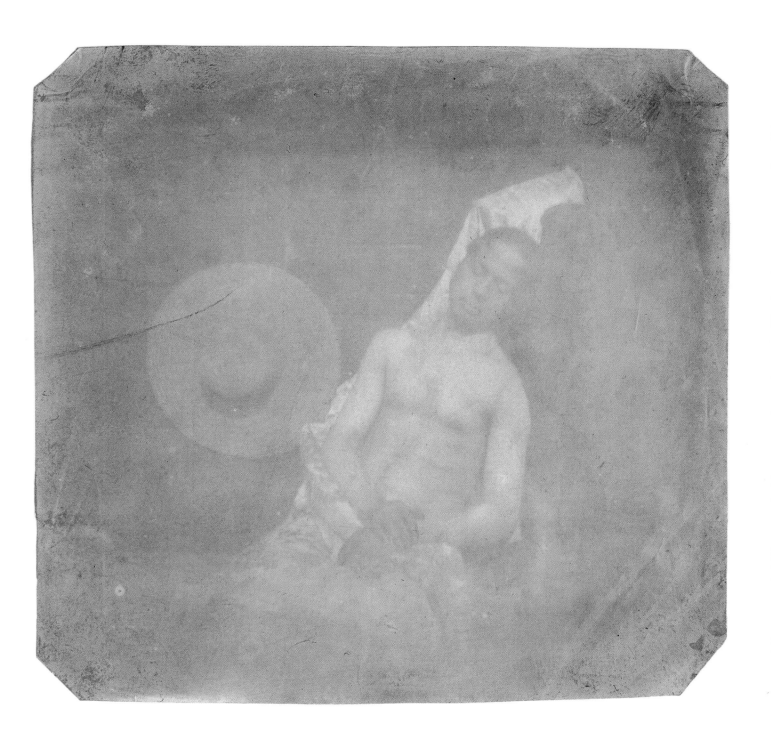

William Henry Fox Talbot

The Pencil of Nature

London: Longman, Brown, Green, and Longmans, 1844–46

The Pencil of Nature, 1844–46
Book cover
London, Science and Society
Picture Library

William Henry Fox Talbot first considered the possibility of inventing a photographic process to depict the surrounding world in perspective in October 1833. An English nobleman with an extensive and varied culture acquired according to a concept of knowledge that was still pre-modern and all-embracing, which led him to show an interest in mathematics, optics, chemistry and biblical antiquities simultaneously, Fox Talbot developed his original idea during a stay in Italy. It all began on the shores of Lake Como where, for his own pleasure, he made a few sketches of the local landscape with the help of Wollaston's Camera Lucida, an optical instrument that superimposed the image of the subject to be depicted on a sheet of drawing-paper. The resulting sketches did not do justice to the beauty of the place, so Talbot tried substituting Wollaston's device with a *camera obscura*, and tracing the image that formed inside it, just as many painters did, but he found this method rather difficult; moreover, it did not enable him to reproduce every minute detail of the scene he was looking at. Then he suddenly got the idea of trying to solve the problem by finding a way to imprint images through the action of light rays on a suitably treated surface. He made some notes regarding this and, as soon as he returned home, began a series of experiments. In 1834 he had already obtained the first successful results by using silver chloride (a solution of salt and silver nitrate) to sensitise the paper support, onto which the subject was placed directly and exposed to light. Using this technique, which he named "photogenic drawing", Talbot obtained an imprint of everything he placed on the sheets of paper he had prepared: flowers, leaves, lace, fabrics, but also other representations, such as *clichés-verre* or engravings, that could thus be duplicated (some examples of these images were sent to the Bolognese botanist Antonio Bertoloni, who collected them in a rare album now held by the Metropolitan Museum, New York).

The sensitivity of the materials developed so far was still too low to enable them to be used in a *camera obscura*, unless one accepted the drawback of obtaining extremely small miniatures because of the need to increase the light to the maximum by concentrating it on the focal plane; in fact, the first image Talbot

produced with this method in August 1835, which depicted a window in his ancient family seat at Lacock in the south of England, measured only 2.8 by 3.6 centimetres. The breakthrough came in 1840 with the formulation of the concept of the "latent image", by which it was not necessary to expose the support until a visible image actually appeared, since the sensitive base could subsequently be developed to reveal an imprint that remained "potential", hidden after a considerably shorter exposure time, and could not be perceived immediately. Hence, in practice, this important step forward was based on a discovery very similar to the one made in 1835 within the sphere of daguerreotype research, but with two distinct differences: first and foremost, here the developing agent was not mercury but gallic acid; second, while Daguerre had not fully understood the phenomenon of latency, believing that his plates needed to undergo at least some kind of superficial change during exposure, Talbot saw development as an actual transformation process instead of a further procedure aimed at enhancing something that already existed to some degree. After he had absorbed this, all the processes he

subsequently invented up to and including the last – which he called the calotype (from the Greek *kalòs* = beauty and *typos* = print) to emphasise his concept of photography as an imprint – displayed another characteristic that substantially distinguished them from what Daguerre, and Niépce before him, had done. In fact, these processes produced an image in which the tones were reversed: the white became black and vice versa. This was a negative from which many positive prints could be made during a subsequent printing stage, during which the process used to directly darken the "photogenic drawing" was adopted again, causing another tonal reversal. This constituted a watershed because, although the fragility of the paper limited the amount of duplicates that could be made from each support, it is to this process that we owe the fundamental prerogative of photography: the possibility of producing multiple prints. Talbot's revolution of the recently invented medium hinged on the negative and its reproducibility. While the heliograph and daguerreotype were "one-off" creations, the calotype (or the Talbotype as it was later renamed) supplanted them with an original,

designed to produce multiple copies of the same image.

This enabled Talbot to embark on what may be considered the first photographic book in history, if the participation of a publisher (which implies a commercial distribution) and a sizeable run of copies are sufficient for it to qualify as such. *The Pencil of Nature* was published by Longman, Brown, Green in six parts between June 1844 and April 1846. The first edition came out in countless copies, ranging from the 286 that comprised the first fascicle to the eighty-nine of the last. The images consisted in a collection of twenty-four original prints (out of the 50 to 60 envisaged for the project at the beginning) that were made at the Talbotype Establishment, which the pioneer had opened with Nicolaas Henneman in Reading, a town halfway between Lacock and London, and were glued onto the pages by hand. As regards its actual significance, *The Pencil of Nature* was both a book *of* photographs, in which the images themselves were proof of Talbot's technical skill and artistic sensibility, and *on* photography, since the text explored historical and theoretical issues. Moreover, the fact that it is about photography can be deduced

from the title, which clearly refers to the "automatic" nature of the new medium. This principle is explained more fully in a "Notice to the Reader" enclosed on a separate sheet with fascicles II, III, and VI, which states: "The plates of the present work are impressed by the agency of Light alone, without any aid whatsoever from the artist's pencil". This was the "pioneering" period of photography, when the image was seen as a spontaneous manifestation of the subject and, above all, this could be considered a value, even though it reduced to a minimum the author's part in the process involved in making an image. The above notice is followed by a general introduction and an excursus on the main stages in the development of the calotype method (since the book was also a means of presenting and promoting it). After this there are twenty-four short texts, each accompanied by the figure to which it refers. This forms the core of Talbot's grammatical elucidation, in which he also deals with the fundamental elements of photography by dissecting and reconstructing his own working methods through clear, precise analyses. Here are a few examples: *Plate IV: The Open Door*. Here the

photographer sees his medium as inevitably lending itself to the most ordinary subjects, but immediately points out, with a reference to Dutch painting, that this does not mean a reduction in quality: "We have sufficient authority in the Dutch school of art, for taking as subjects of representation scenes of daily and familiar occurrence ... A casual gleam of sunshine ... a time-withered oak, or a moss-covered stone may awaken a train of thoughts and feelings, and picturesque imaginings."
Plate VIII: A Scene in a Library. What the camera sees is different from what a human being sees. Talbot elaborates on this insight by giving an example of a dark room in which "the eye of the camera would see plainly where the human eye would find nothing but darkness" and illustrates it with a calotype of the spines of some books in the manner of the famous painting *Shelves with Music Books* by Giuseppe Maria Crespi, leaving us to imagine the contents.
Plate X: The Haystack. "One advantage of the discovery of the Photographic Art will be that it will enable us to introduce into our pictures a multitude of minute details which add to the truth and reality of

the representation, but which no artist would take the trouble to copy faithfully from nature."
Plate XI: Copy of a Lithographic Print. The author uses a lithograph by Louis-Léopold Boilly to comment on photography's peculiar ability to modify the size of the subject while maintaining the same proportions: "it enables us at pleasure to alter the scale, and to make the copies as much larger or smaller than the originals as we may desire".

We would have to wait a long time to find a photographer with a similar understanding of the specific characteristics of the medium. This was because Talbot had personally developed his own method, and had been obliged to unravel a series of technical and philosophical knots in the course of his work. Later, photography became a set of principles, since it could be practised without any explicit knowledge of its foundations. This happens to all forms of language, however, and can thus be considered another innate characteristic of this medium.

Bibliography
History of Photography (monographic edition about Félix Bonfils and William Henry Fox Talbot) 1, vol. 25, Taylor & Francis Group / Routledge, 2001.

Copy of a litographic print, 1844
Print on paper from calotype
negative

Armstrong, Carol. *Scenes in a Library: Reading the Photograph in the Book, 1843–1875*. Cambridge, Mass.: The MIT Press, 1998.

Arnold, Harry John Philip. *William Henry Fox Talbot: Pioneer of Photography and Man of Science*. London: Hutchinson Benham, 1977.

Batchen, Geoffrey. *William Henry Fox Talbot*. London: Phaidon Press, 2008.

Gray, Michael, Arthur Ollman, and Carol McCusker. *First Photographs: William Henry Fox Talbot and the Birth of Photography*. New York: PowerHouse Books, 2002.

Newhall, Beaumont (Introduction). *The Pencil of Nature*. New York: Da Capo Press, 1969.

Parr, Martin, and Gerry Badger. *The Photobook: A History*, vol. I. London: Phaidon Press, 2004.

Schaaf, Larry J. *H. Fox Talbot's The Pencil of Nature: Anniversary Facsimile. Introductory Volume*. New York: Hans P. Kraus, 1989.

Schaaf, Larry J. *Out of the Shadows: Herschel, Talbot and the Invention of Photography*. New Haven: Yale University Press, 1992.

Schaaf, Larry J. *The Photographic Art of William Henry Fox Talbot*. Princeton: Princeton University Press, 2000.

Signorini, Roberto. *Alle origini del fotografico. Lettura di The Pencil of Nature (1844–46) di William Henry Fox Talbot*. Bologna and Pistoia: CLUEB / Petite Plaisance, 2007.

Sketch of Villa Melzi,
5 October 1833
Drawing
Bradford (West Yorkshire),
National Media Museum

Lace or Ribbon Veil, 1839
Photogenic drawing,
21.6 x 18 cm
New York, The Metropolitan
Museum of Art
Leaf 13 Recto, Harris Brisbane
Dick Fund, 1936.36.37 (8)

Cordella o Nastro a velo.

A scene in a library, 1844
Print on paper from calotype
negative

Giuseppe Maria Crespi
Shelves with Music Books,
1720–30
Oil on canvas, 165 x 153 cm
Bologna, Museo Bibliografico
Musicale

The Open Door, 1844
Print on paper from calotype
negative

Haystack, ca. 1842
Print on paper from calotype
negative, 18.26 x 23.42 cm

Anna Atkins

Photographs of British Algae: Cyanotype Impressions

Halsted Place: 1843–53

Title page *Photographs of British Algae: Cyanotype Impressions* /
Part I, 1843
Cyanotype
New York, The New York Public Library, Stephen A. Schwarzman Building, Spencer Collection

Anna Atkins was born in Tonbridge, Kent, on 16 March 1799. Her mother died as a result of complications during delivery, and she was brought up by her father John George Children, a chemist, mineralogist and zoologist involved in the development of the British Museum and a member of the Royal Society. Inculcated with a passion for science, in 1839 Anna became a member of the Botanical Society of London, of which her father was vice president. This was also the year of the official birth of photography, in which she began to take an interest a few months later, becoming its first ever female practitioner. Children was in any case well-informed about the technique developed by William Henry Fox Talbot, having chaired the meeting of the Royal Society at which the latter explained the details of his invention and subsequently kept in contact through scholarly correspondence. It was probably some of Fox Talbot's images of flowers and leaves that inspired Anna Atkins to develop the project of a vast visual catalogue of the algae of the British seas, starting with the specimens in her own collection. She used the method of his early "photogenic drawings" to capture their silhouettes, placing the subjects in direct contact with light-sensitised paper, without the mediation of a lens, but combined this with a different chemical procedure developed by Sir John Herschel, a celebrated friend of the family, who invented the cyanotype in 1842. This technique was chosen for various reasons, including its low cost, the greater stability of the image, and the fact that the resulting deep-sea blue coincided perfectly with the aquatic environment referred to by the research project as a whole. Entitled *Photographs of British Algae: Cyanotype Impressions*, the result was a vast and interminable work built up over a period of nearly ten years. The most complete version is in three volumes with a total of 389 plates. Publication began in October 1843 and took place in thirteen successive instalments. As Fox Talbot's *The Pencil of Nature* did not appear until eight months later, Anna Atkins should be acknowledged as the author of the first photographic book of all time, but is often denied this recognition in official histories on the grounds that *Photographs of British Algae* was not produced by a publisher, but brought out privately by Atkins herself and distributed among

a small group of friends and acquaintances. This means in particular that the copies placed in circulation under this title (the seventeen known to exist today are scattered between England, Scotland, the United States, and Israel) were not produced in series, but differ considerably as regards the number of pages, and even show some variations in format. Leaving aside the dispute over primacy, which hinges on the linguistic question of whether the work is to be called a book or an album, we can state that it is unquestionably a unified composition conceived as a whole rather than a simple collection of individual illustrations, so much so indeed that the pages of text are also produced by means of the cyanographic process. (It can thus be described at least and with no fear of refutation as the first book photographically produced in every part.) In short, Atkins also entrusted her "verbal writing" to the action of light. In any case, the work already offers a complex interpretation of photography understood both as a primary support of scientific research and as a medium of artistic expression, at the same time, thus foreshadowing an entire line of development that was to characterise the next century and be governed by this duality in the very structure of the typological atlas. The primary examples include Edward S. Curtis's *The North American Indian* (1907–30), Karl Blossfeldt's *Urformen der Kunst* (1928), and August Sander's *Antlitz der Zeit* (1929). The sophisticated elegance with which Anna Atkins arranged her specimens on the sheet for printing recalls the decorations laid out on an equally blue background in the factory of Josiah Wedgwood.

Bibliography
Armstrong, Carol, and Catherine de Zegher. *Ocean Flowers: Impressions from Nature*. Princeton: Princeton University Press, 2004.
Schaaf, Larry J. *Sun Gardens: Victorian Photograms by Anna Atkins*. New York: Aperture, 1985.
Rosenblum, Naomi. *A History of Women Photographers*. New York: Abbeville Press, 1994.

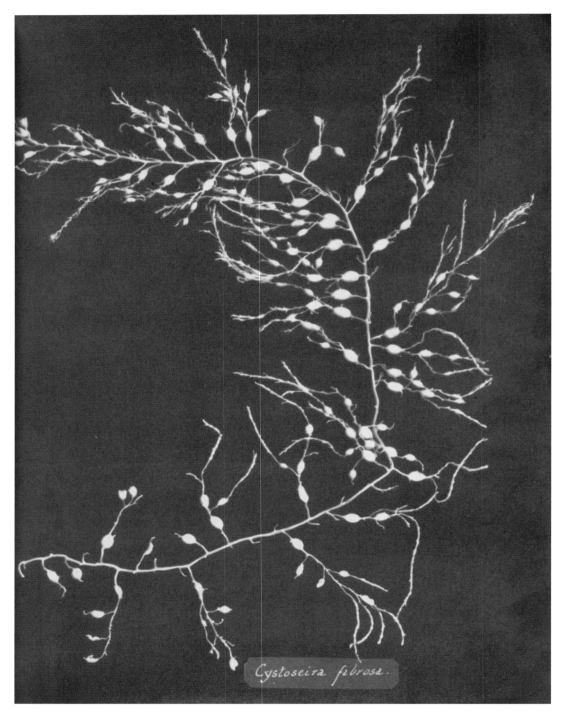

Cystoseira fibrosa
(*Photographs of British Algae:*
Cyanotype Impressions / Part II),
1843–44
Cyanotype
New York, The New York Public
Library, Stephen A. Schwarzman
Building, Spencer Collection

Myriotrichia claviformis
(*Photographs of British Algae:*
Cyanotype Impressions / Part V),
1844–45
Cyanotype
New York, The New York Public
Library, Stephen A. Schwarzman
Building, Spencer Collection

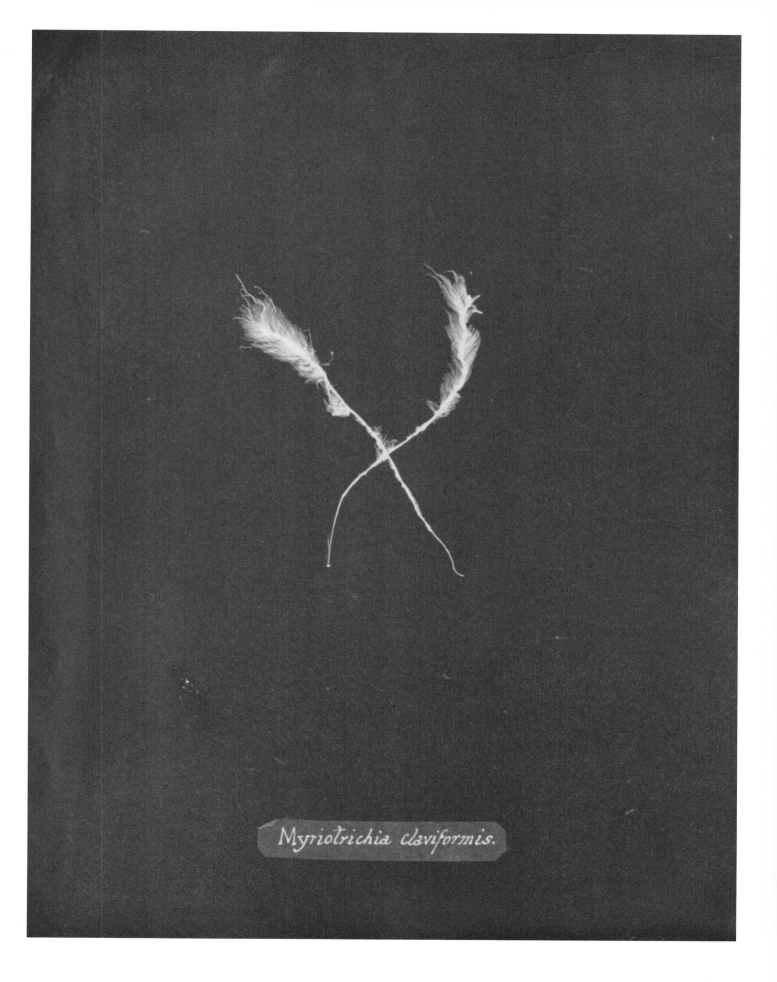

Myriotrichia claviformis.

"Exhibition of Recent Specimens of Photography"

The Royal Society of Arts, London,
22 December 1852 – 29 January 1853

The earliest major exhibition devoted solely to photography opened at the Royal Society of Arts (RSA) in London on 22 December 1852. During the inaugural evening, Roger Fenton presented a paper entitled *On the situation and the future prospects of the art of photography* which identified the main question raised by this historical event: Can photography be considered an art in its own right? To be precise, this issue had been part of the photographic debate from the beginning, since the three most well-known pioneers of the medium all had a certain amount of artistic experience (Niépce was an engraver, Daguerre painted dioramas, and Talbot dabbled in drawing and painting), as well as reasonably developed scientific skills in the fields of optics and chemistry; but the issue became definitively central to the debate when photographic images began to be widely exhibited to the public. Moreover, the inclusion of a vast quantity of photographs (approx. 800 in all) among the items displayed in the national pavilions of several countries participating in the Great Exhibition in London in 1851, held at Crystal Palace, which had been built especially for the occasion, had already prompted a series of

considerations on the subject. These sprang from a completely new development, namely, that the photographs from various parts of the world, displayed together in the same place for the first time, presented specific characteristics traceable to their geographical origin and to an original style, as was precisely the case with Art with a capital A. In the case of the London exhibition, however, the context was extremely varied, and tended to favour the technological and industrial aspects, that is the innovative quality of what was displayed, thus giving less importance to an analysis of the specific characteristics of photography (besides, the majority of the photographic images were placed in Section X together with scientific and musical instruments, while only a small group were exhibited in the Fine Arts section). By contrast, in the Royal Society of Arts exhibition photography was separated from all the other inventions of man's intellect, which implied its independence from them, but without excluding the possibility of its being a useful support to the sciences and to other arts. At any event, the crux of the controversy lay

in the "mechanical" nature of photography, since the images were seemingly produced by an automatic process rather than by a creative act. This confusion was caused above all by the lack of any manual intervention in the image, which was thus seen to resemble too closely the way in which the subject represented was usually perceived by the naked eye. That was why the daguerreotype, which produced a remarkably descriptive image due to the use of a metal support, was generally dismissed by those who saw photography as a means of artistic expression, and by the organisers of the exhibition themselves. They saw the calotype's graininess, which derived from the fact that the negative and positive were made on paper, and the tonal nuances of more recent techniques that used collodion to bind the photosensitive emulsions, as clearly linked to the previous figurative tradition.

A total of 784 photographs were displayed at the Royal Society of Arts. Again, they came from different European countries (hence it was possible to find in them a series of specific regional characteristics), and they were selected primarily by Roger Fenton, Philip Henry Delamotte, and Joseph Cundall. All three were founder members of the Photographic Society, established the same year as the exhibition, which provided the thrust for it, with the aim of promoting both the science and art of photography. As well as benefiting from the vast number of works in terms of viewer impact, the exhibition was given a further boost by the actual space, known as the Great Room, where all the most important events organised by the RSA were held, and which was dominated by the cycle of six large canvases painted by James Barry between 1777 and 1784. The photographs were hung like paintings, which also brought them closer to the fine arts, but apart from the purely conceptual value of such an arrangement, it proved completely inadequate for evaluating the small works that needed to be studied close up, since a photograph's specific characteristics and content had to be ascertained for it to achieve artistic status. Hence, this exhibition was unable to provide a definitive answer to the question raised by Fenton, but it did perform the ground-breaking and invaluable function of instigating a dispute which, destined to last for at least fifty years, was initially held in the ambit of important exhibitions where photography's invasion of imagery hitherto governed by the canons of traditional art forms, was more evident. It also resulted in France taking the same path as Britain, first with the founding of the Société Française de Photographie in 1854, then the organisation of a special section devoted to photography at the second Exposition Universelle in Paris in 1855; and lastly, the crucial inroad into the Salon of 1859, where 1,295 photographic works were shown, albeit in a separate venue at the Palais des Champs-Elysées. Instead of being a historic admission – which it would be if we ignored the fact that the works were displayed under a different roof – this episode clearly confirms the schizophrenic nature of the relationship between photography and the art system in the second half of the nineteenth century.

Note on the images
The following images may not be the exact ones displayed in the Royal Society of Arts exhibition, but possibly variants taken by the same

photographers of identical subjects indicated in the catalogue.

Hugh Owen – Great Exhibition, *View of Transept*, 1851
Hugh Owen, from Bristol, and the Frenchwoman Claude-Marie Ferrier were given the assignment of documenting photographically the venue of the 1851 Great Exhibition, and some of the items on show in the individual pavilions for the purpose of illustrating, with 155 images, the 130 copies of the report presented to members of the jury. For this publication, Owen's calotype negatives were printed at the establishment set up by Talbot and Nicolaas Henneman at Reading, while Ferrier's glass plates were probably processed in France.

Juan, Count of Montizón – *The Hippopotamus*, 1852
Probably the first hippopotamus to arrive in Europe since Roman times, Obayasch was given to Queen Victoria by the Pasha of Egypt in 1849 in exchange for several greyhounds. The Queen immediately had the hippo put in Regent's Park Zoo in London. The animal was such a major attraction that it became one of the most photographed specimen

in the zoo, in this case by Juan, Count of Montizón, heir to the Spanish throne and an extremely keen photographer.

Roger Fenton – *Moscow, Domes of Churches in the Kremlin*, 1852
In the summer of 1852 Roger Fenton made a trip to Russia to document the progress on the construction of a bridge across the Dnieper River, designed by Charles Vignoles (fellow of the Royal Society, civil engineer and calotypist). While he was in Russia, Fenton took the opportunity to make various images, using wax-coated paper, of panoramas and architecture in the cities of Kiev, Saint Petersburg, and Moscow. Meanwhile, the Board of the RSA had accepted the proposal of staging a photographic exhibition in the Great Room, where Fenton displayed, among others, some of his Russian images, which are his earliest works to come down to us.

Philip Henry Delamotte – *Croxton Abbey*, 1850–52
Son of an artist specialising in landscape and architectural drawings, Philip Henry Delamotte belonged to the Calotype Club, established in London in 1847. A co-founder with

Roger Fenton of the Photographic Society, he was commissioned to document the demolition of Crystal Palace in Hyde Park when the Great Exhibition ended, and its reconstruction as a permanent venue in Sydenham, where the first column was erected on 5 August 1852. A hundred and sixty albumin prints from the vast collection of photographs he took were subsequently published in a two-volume work entitled *Photographic Views of the Progress of the Crystal Palace, Sydenham* (1855), an impressive publication commemorating the most important monument erected to a positivist and capitalist Britain.

Paul Pretsch, *Ansicht von Wien*, 1850
Paul Pretsch was born in Vienna, where he gained considerable experience in printing with Anton von Haykult. He later travelled through Germany and Romania, and executed a series of photographs of his native city and other places in Austria at the end of the 1940s. He came into contact with the circle of British photographers when some of his images were shown in the Austrian pavilion at the 1851 Great Exhibition at Crystal Palace. Shortly afterwards

he perfected a new printing process called photogalvanography, which was contested by Talbot, who claimed that it violated an earlier patent of his own. In 1854 Pretsch moved to London, where two years later he set up the Photogalvanographic Company with Roger Fenton's help, which was not sufficient to prevent the venture from soon collapsing.

Bibliography
Delamotte, Philip Henry. *Photographic Views of the Progress of the Crystal Palace, Sydenham*. London: Directors of the Crystal Palace Company, 1855.
Figuier, Louis. *La Photographie au Salon de 1859*. Paris: Hachette et Cie, 1860.
Fiorentino, Giovanni. *L'Ottocento fatto imagine*. Palermo: Sellerio, 2007.
Gernsheim, Helmut. *Le origini della fotografia*. Milan: Electa, 1981.
Keeler, Nancy B. "Photographing the Reports of the Juries of the Great Exhibition of 1851: Talbot, Henneman, and their Failed Commission". *History of Photography* 3, vol. 6, Taylor & Francis Group / Routledge, 1982.

List of authors participating in the show

Archer, Frederick Scott	(6)
Bagster, C.B.	(3)
Bagster, J.	
Barker, George	(22)
Berger, Frederic W.	(13)
Bianchi, Jean	(2)
Bingham, Robert Jefferson	(6)
Buckle, Samuel	(20)
Caneva, Giacomo	
Cocke, Archibald Lewis	(15)
Constant, Eugène	(7)
Contencin & Co.	(13)
Crette, L.	
Cumming, John	(3)
Cundall, Joseph	
Cundell, Henry	(12)
Delamotte, Philip Henry	(19)
Delatouche	
Diamond, Dr. Hugh Welch	(7)
Du Camp, Maxime	(13)
Dudgeon, Patrick	(4)
Eaton, Thomas Damant	
Fenton, Roger	(41)
Ferrier, Claude-Marie	(54)
Flachéron, Comte Frédéric A.	(4)
Flech, M.	
Fry, Peter Wickens	(11)
Galton, Robert Cameron	(16)
Goodeve, Thomas Minchin	(13)
Hennah, Thomas Henry	
Henneman, Nicolaas	
Heritage, J.	(2)
Hilditch, George	(20)
Horne, Fallon	(21)
Ibbetson, Captain Levett Landson Boscawen	
Jones, Baynham Jr.	(6)
Kater, Edward	
Le Blanc, C.L.	
Le Gray, Gustave	(5)
Le Secq, Henri	(4)

Leberg, N.	
Lodoisck	(3)
Martens, Frédéric	(3)
Meates, William Clapham	(10)
Montizón, Don Juan, Comte de	(21)
Nevill, Lady Henrietta Augusta	
Nevill, Lady Isabel Mary Frances	
Newton, Sir William John	(6)
Owen, Hugh	(39)
Pecquerel, Edmund	(49)
Petley, Lieutenant R.	
Piot, Eugène	(2)
Player, J.	(7)
Plumier, Pierre Victor	
Pretsch, Paul	(23)
Reeves, Walter W.	(13)
Regnault, Henri-Victor	(9)
Renard, François-Auguste	(4)
Rosling, Alfred	(24)
Ross & Thomson	(17)
Sanford, J.C.	(7)
Shaw, George	(7)
Sherlock, William	(41)
Sims, T.	(22)
Spencer, John A.	(6)
Stewart, John	(4)
Stokes, George B.	(6)
Talbot, William Henry Fox	(7)
Thoms, B.A.	
Thoms, Merton	
Thoms, William John	
Thomson, T.	(3)
Turner, Benjamin Brecknell	(6)
Urie, J.	
Weddell, George	(6)
Wilks, Joseph	(4)
Missing record	(11)
Unknown	(41)

Hugh Owen
Great Exhibition, *View of Transept, Looking South*, 1851
Salted paper print from paper negative, 21.6 x 16.3 cm
New York, The Metropolitan Museum of Art, Purchase, Emanuel Gerard Gift, 1982

Paul Pretsch
View of Vienna, 1850
Salted paper print from paper negative, 24.7 x 38.2 cm
Wien, Albertina, Inv. Foto 2001/3/1

Don Juan, Comte de Montizón
Obaysch the Hippopotamus, 1852
Salted paper print, 11.4 x 14.7 cm
London, The Royal Collection

Philip Henry Delamotte
*August 1852: The first column
of the original Crystal Palace
is erected in Sydenham, south
London, after it was moved from
its original site in Hyde Park*
Albumen print
London, The British Library

Roger Fenton
*Moscow, Domes of Churches
in the Kremlin*, 1852
Salted paper print from paper
negative, 17.9 x 21.6 cm
New York, The Metropolitan
Museum of Art, Gilman
Collection, Gift of The Howard
Gilman Foundation, 2005
(2005.100.66)

Maxime Du Camp

Egypte, Nubie, Palestine et Syrie, dessins photographiques recueillis pendant les années 1849, 50 et 51, accompagnés d'un texte explicatif et précédés d'une introduction par Maxime Du Camp, chargé d'une mission archéologique en Orient par le Ministère de l'Instruction Publique

Paris: Gide et J. Baudry, 1852

NIt was in November 1839 that the history painter Horace Vernet and his travelling companion Frédéric Goupil-Fesquet took the earliest documented daguerreotypes of the Middle East, first in the city of Alexandria and then, with long exposures of 15–20 minutes, of the pyramids in the Giza Valley. Egypt was therefore the first country in this geographical area to be photographed, and remained for many years by far the favourite subject of those choosing this medium to document their exotic travels, either for pleasure or professional reasons. The period of the birth and spread of photography coincided in fact with the peak in Europe of the upper-class custom of making long pilgrimages to the East, something derived partly from Napoleon's dream of creating an empire of the East at the time of his campaigns in Egypt (1798), and Syria (1799).

Cataloguing and measurement, combined in photography with the capturing of an image of the subject, constitute a sublimated form of conquest. Maxime du Camp thus received an unpaid but official commission from the Ministry of Education to photograph all the archaeological remains of ancient Egypt, and sailed from Marseilles on 4 November 1849 in the company of his friend Gustave Flaubert, who had been assigned the task of providing the French administration with reports on the imports and exports of local traders. Their journey of nearly three years took them to Egypt, and then on through Syria, Palestine, Turkey, Greece, and Italy.

Du Camp was not a professional photographer, and set out with a very limited amount of knowledge and practical familiarity gleaned from lessons with Gustave Le Gray in Paris shortly before departure. The difficulties of applying the technique of dry waxed paper in a particularly hot climate and in awkward situations, initially proved very taxing, but all the problems were soon resolved thanks to a lucky encounter with Baron Alexis de Lagrange, who was passing through Cairo on his way to India. He introduced Du Camp to the calotype method as modified by Louis-Désiré Blanquart-Évrard, which was subsequently used for all the images of Du Camp's expedition, totalling over 200, 125 of which were later printed by Blanquart-Évrard himself, and published in 1852 by the Parisian publishers Gide et J. Baudry in a volume entitle *Egypte, Nubie, Palestine et Syrie*. This was one of

the first books to come out with original photographs glued onto the pages and protected with tissue paper. Though very stable and extremely quick to reproduce (the process was capable of turning out over 4,000 prints per day), the images left something to be desired as regards quality, with their very dark greyish hues and lack of contrast. Owing to his being a photographer through contingent circumstances rather than by vocation or specific interest – such that he never returned to this medium after his Middle Eastern experience – Du Camp took a wholly different approach from any of his contemporaries involved in similar situations. Far from any artistic pretensions or attempt to beautify, he simply confined himself to using the camera to record what he found in front of him, thus developing direct, rigorous, and pseudo-scientific documentation diametrically opposed to the romantic spirit of the settings that surrounded him. All this is made perfectly evident by the inclusion in a large proportion of the photographs of Hadji-Ismaël, a Nubian sailor attached to the group (sometimes replaced by Louis Sasseti, who accompanied the two travellers as their valet for the entire length of the journey). Serving as a term of comparison to give an empirical idea of the size of the subjects (as is known, one of the characteristics of the photograph is to revise the scale of its content), this also eliminated any attempt at scenic portrayal. As Du Camp remarked in this connection to his friend Théophile Gautier, "Every time I went to see monuments, I had my photographic equipment carried by Hadji-Ismaël, one of the sailors at my service, a strong and handsome Nubian. I got him to climb up onto the ruins I wanted to photograph and thus always obtained an exact scale of proportion. The greatest difficulty was to make him keep perfectly still while I was working, and I succeeded with the aid of a somewhat bizarre trick that will give you an idea of the childish naïveté of those poor Arabs. I told him that the copper tube of my lens sticking out of the camera was the barrel of a gun that would go off if he had the misfortune to move while I was pointing it in his direction. Thus convinced, Hadji-Ismaël kept motionless to the very end, as you will have noted on looking through my shots." Even though the photographer's attitude reveals prejudices and ingenuousness both as regards his medium and in terms of open-mindedness and understanding with respect to a foreign culture, his work provided scholars of art, architecture, history, and geography with a crucial tool of learning, and gave an early example of a purely photographic "style" intent on asserting its objectivity with no need to imitate other forms of representation.

Bibliography
Du Camp, Maxime. *Souvenirs Littéraires*. Paris: Hachette et Cie, 1882–83.
Jammes, André, Robert Sobieszek, and Minor White. *French Primitive Photography*. New York: Aperture, 1969.
Howe, Kathleen Stewart. *Excursions Along the Nile. The Photographic Discovery of Ancient Egypt*. Santa Barbara: Santa Barbara Museum of Art, 1994.

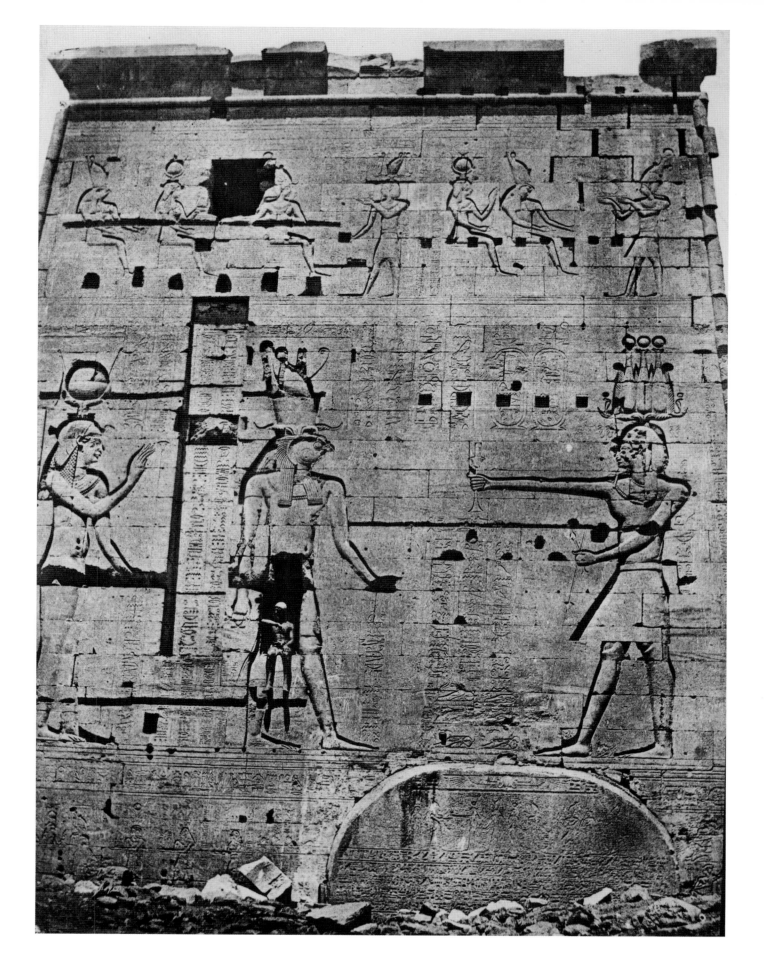

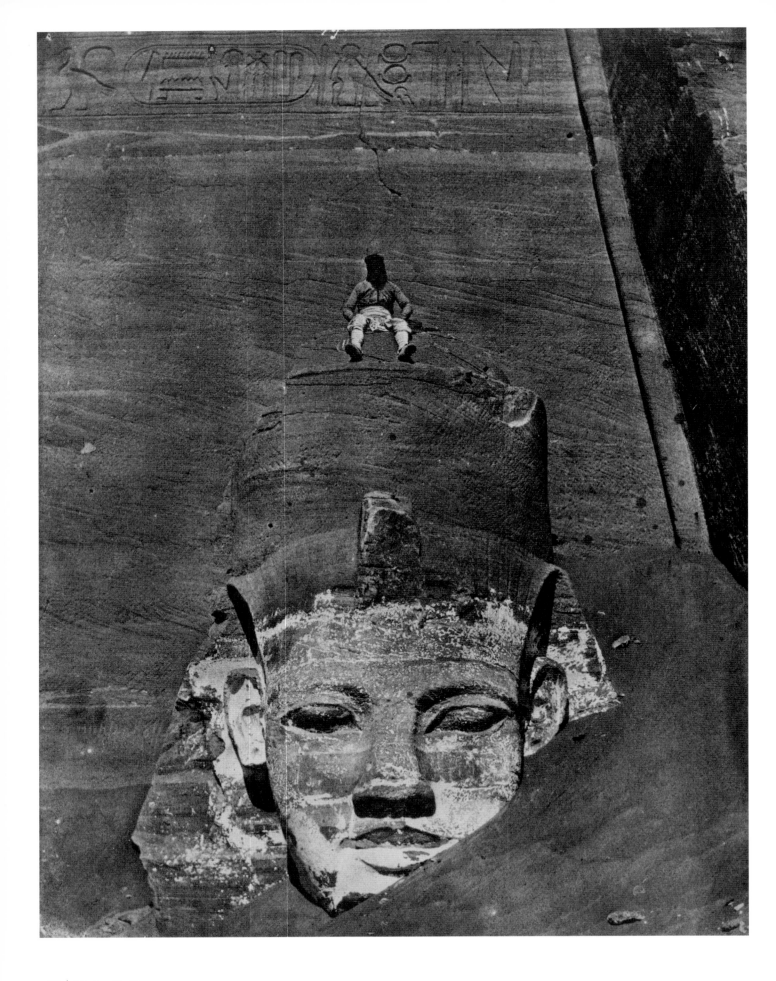

*Nubia, Abu Simbel, Middle
Colossus from the Temple of
Ramses II*, 1849–50
Salted paper print from
paper negative, 21.5 x 16.8 cm
Paris, Musée d'Orsay, Collection
Roger Thérond, 1983

*Palestine. Jerusalem.
Western Quarter*, 1852
Salted paper print from
paper negative, 16.8 x 20.8 cm
Paris, Musée d'Orsay

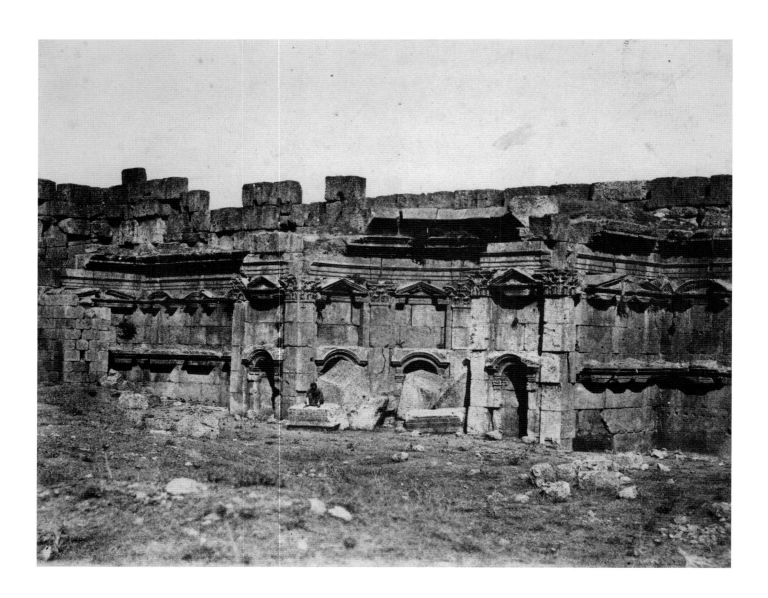

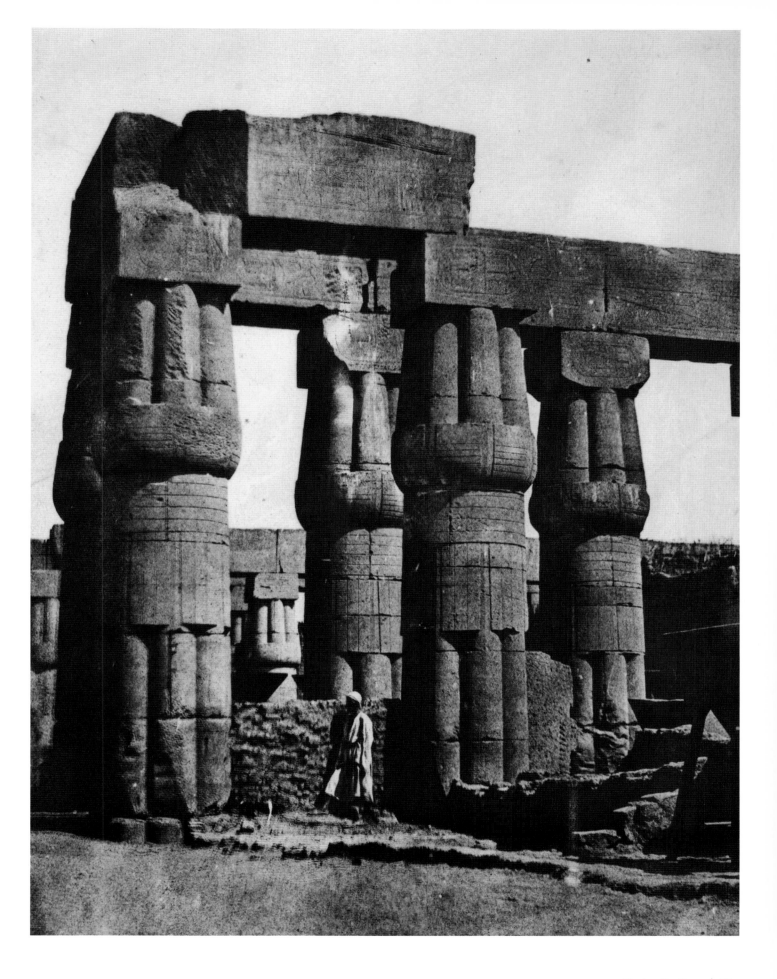

Giacomo Caneva

Della fotografia, trattato pratico
di Giacomo Caneva, pittore prospettico

Rome: Tipografia Tiberina, 1855

In the second half of the 1840s, a number of intellectuals and practitioners of the new art of photography began to gather at the Caffè Greco in Via Condotti in Rome, a short distance from the Spanish Steps. It was an international group composed largely of Frenchmen, some of whom taking advantage of the accommodation offered by the Académie Française at the nearby Villa Medici, together with some Englishmen and a minority of Italians. The primary and most assiduous participants in these large gatherings were Frédéric Flachéron, their guiding spirit, Alfred-Nicolas Normand, Eugène Constant, James Anderson, and Robert MacPherson. As attested by the register of all those using the café's address to receive mail, Giacomo Caneva from Padua was an habitué from 1845 on. Known to history as the Roman School of Photography (but also as the Caffè Greco Club), this free association with no rules or statutes made a decisive contribution in the crucial period of its activity to spreading the basics of the theory and technique of photography in Italy. Less than a decade after the revelations of Daguerre and Talbot, the participants in these meetings used photography as a means of artistic expression, or at least applied aesthetic and cultural categories derived from painting and the figurative arts in general, in the creation of their images. Most of the leading figures had in any case educational and professional backgrounds developed in these spheres. Among those mentioned above, Flachéron was an engraver of medals and gemstones, Normand an architect and restorer, Constant a genre painter, Caneva a "perspective painter", and Anderson a watercolourist. The only one with a very different background was MacPherson, a physician with the hobby of painting, who moved to Italy in order to benefit from a climate favourable to the treatment of his serious rheumatic ailments. It was in particular the tradition of the eighteenth- and nineteenth-century Roman view painting – from the canvases of Giovanni Paolo Panini and Carlo Labruzzi, to the engravings of Giovanni Battista Piranesi – that constituted their primary sphere of reference. The same interest in the description of archaeological remains and the quality of the Mediterranean light can in fact be detected in their photographs. The first known photographic prints by Giacomo Caneva is already a perfect synthesis of all this. Taken in 1847, it shows

the Temple of Vesta behind the fountain by Bizzaccheri, filling the foreground and the middle ground, and establishing a dialogue between the sharp outlines of the two monuments. (Caneva had already produced an oil painting of the same subject some years earlier, again juxtaposing the temple with the fountain, but adopting a different viewpoint and including a series of incidental figures which, paradoxically enough, gave the work a snapshot quality that is missing in the photograph.) In addition to capturing the rigorous majesty of the whole, Caneva was well aware that he was also presenting himself through the image, as attested by the fact that his that signature appears at the bottom. Regardless of any claim that the procedure was purely automatic, the photograph belonged to him, and was signed, just like a painting. Caneva used the calotype process in his work, as did many of his colleagues at the Caffè Greco. The technique was easier to use than daguerreotype, and better able to capture the complex intermingling of past and nature, especially in a variant developed by Flachéron. Known as the "Roman Process", this is based on the method simplified by Guillot-Saguez, a Parisian physicist who stayed in Rome

between 1846 and 1847, and adapted to the intensity of Italian light through a decrease in sensitivity. As regards technical matters, Caneva was the author of the first compendium issued in Italy on these subjects. Published in 1855, when the gatherings in Via Condotti had largely come to an end with the return of many of the group's members to their own countries, *Della fotografia, trattato pratico di Giacomo Caneva, pittore prospettico* provides a detailed description of the major systems of photographic reproduction known at the time of writing, from the daguerreotype to the calotype and the wet collodion method, all of which the author claimed to have experimented with and used personally. Here too, albeit in the midst of a whole series of practical observations spread over fifty-two pages, Caneva's interest in harnessing this linguistic and technological apparatus in the sphere of art clearly emerges. This is how he presents stereoscopic photography: "A fine and enjoyable invention but not very useful, as it offers no advantages also in artistic terms. If the artist must remember how he sees nature in order to capture it on paper or canvas, he must also remember, and by no means without difficulty, what he see with the stereoscopic apparatus." His images nevertheless maintain a

dual relationship with the subject matter of art, pursuing an objective of aesthetic and conceptual elaboration first of all, while at the same time offering the public of artists a vast catalogue of antiquities to draw upon. (In this case, moreover, the same subjects often possess great value in both artistic and scientific terms.) This holds also for a lesser-known area of the Caneva's production, namely a series of portrait photographs taken in the street of common men and women, sometimes dressed in traditional costumes, which were undoubtedly appreciated by the (primarily foreign) painters who pursued in Italy the myth of the "noble savage" and a more primitive form of existence, proving themselves capable, however, of unprecedented social and psychological insight, through a sort of empathy.

Bibliography
Becchetti, Piero. *Fotografi e fotografia in Italia 1839–1880*. Rome: Edizioni Quasar, 1978.
———. *La fotografia a Roma dalle origini al 1915*. Rome: Colombo, 1983.
———. *Giacomo Caneva e la scuola fotografica romana (1847/1855)*. Florence: Alinari, 1989.
Cartier-Bresson, Anne, and Anita Margiotta. *Roma 1850. Il circolo dei pittori fotografi del Caffè Greco*. Milan: Electa, 2003.
Dewitz, Bodo von, Dietmar Siegert, and Karin Schuller-Procopovici. *Italien: Sehen und Sterben. Photographien der Zeit des Risorgimento*. Heidelberg: Edition Braus, 1994.
Zannier, Italo. *Segni di luce. Alle origini della fotografia in Italia*. Ravenna: Longo Editore, 1993.

Eugène Constant
*The rear façade of Villa Medici,
the home of the French Academy
in Rome*, 1857
Florence, Museo di Storia della
Fotografia Fratelli Alinari

Frédéric Flachéron
*The Forum and Trajan's Column
in Rome*, 1851
Salted paper print, 17 x 23 cm
Florence, Museo di Storia della
Fotografia Fratelli Alinari

F. Flacheron.
1851

Giacomo Caneva
View of the Temple of Vesta,
ca. 1840
Oil on canvas, 31.5 x 44.5 cm
Padua, Musei Civici, legato Adele
Sartori Piovene, 1917

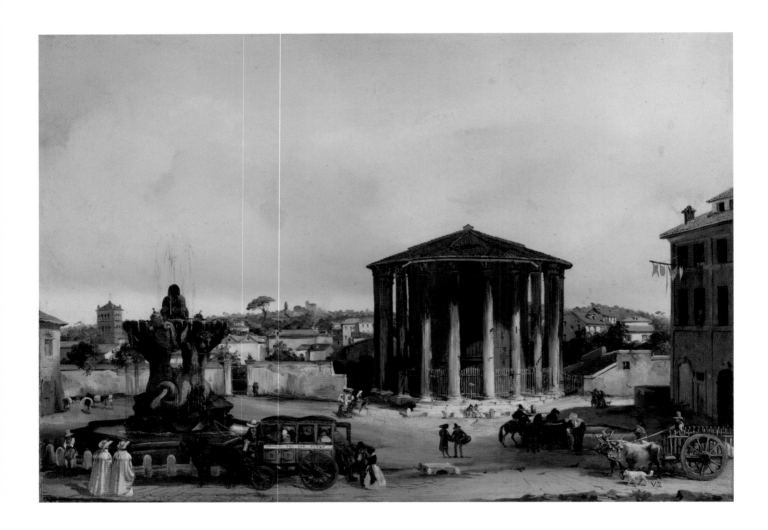

Giacomo Caneva
Temple of Vesta, 1847
Rome, Fototeca Nazionale, ICCD,
Mafos Fondo Tuminello. inv. 4143

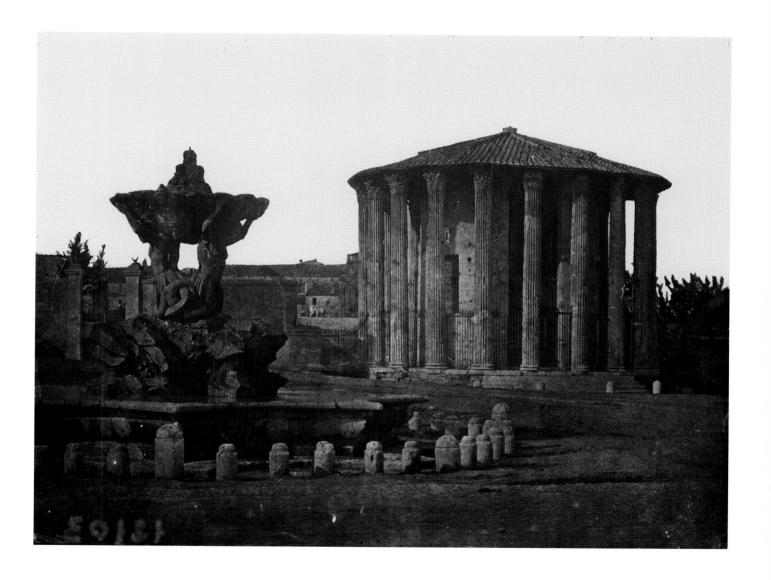

Giacomo Caneva
*The Flavian Amphitheatre
or Colosseum in Rome*, ca. 1850
Salted paper print, 24 x 35 cm
Florence, Museo di Storia della
Fotografia Fratelli Alinari

Giacomo Caneva
Woman removing lice, ca. 1850
Salted paper print, 35 x 24 cm
Florence, Museo di Storia della
Fotografia Fratelli Alinari

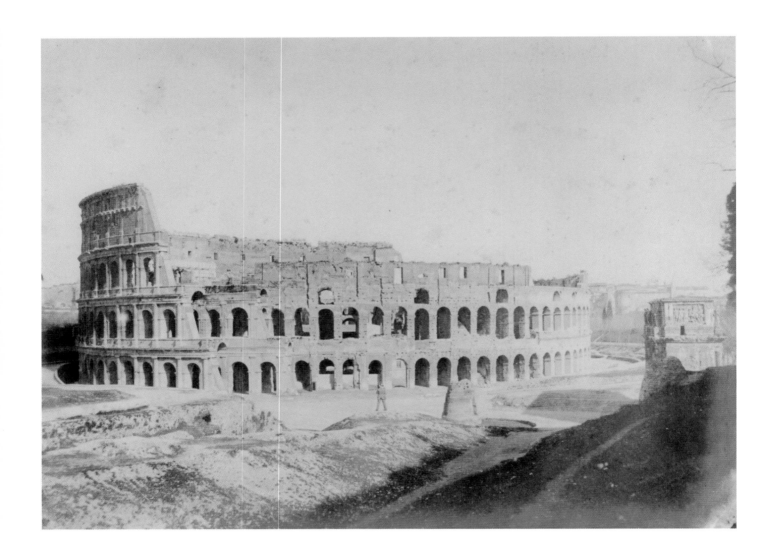

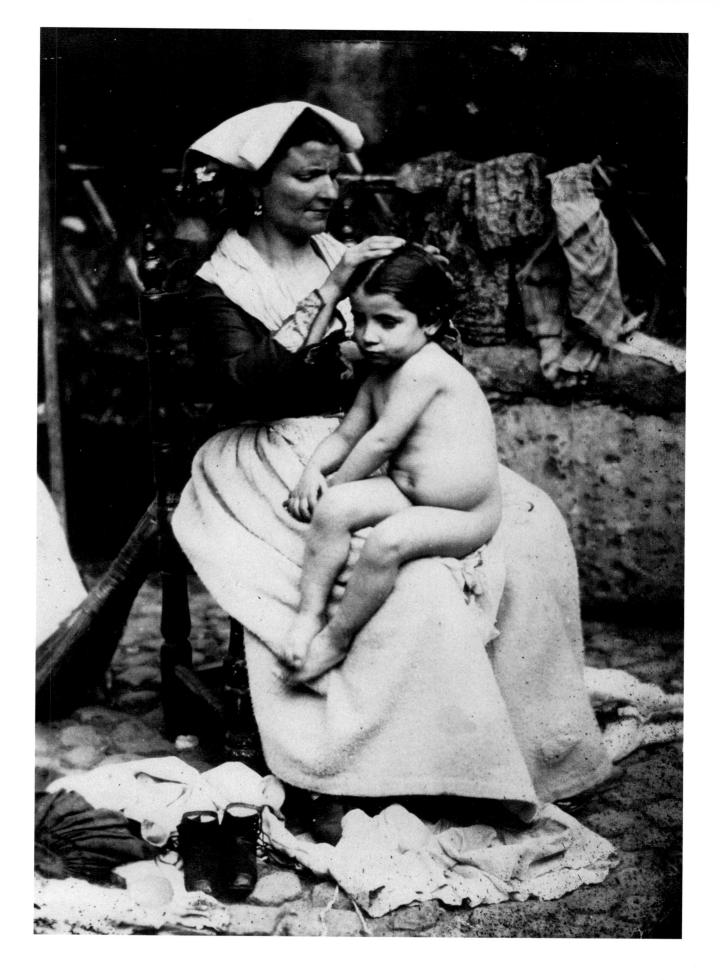

Roger Fenton

"Exhibition of the Photographic Pictures
taken in The Crimea, by Roger Fenton, Esq."

Water Colour Society, Pall Mall East, London,
inaugurated on 20 September 1855

The first lens in history unimpaired by optical flaws was produced by Galileo in 1609. While the primary function of this *perspicillum* was to facilitate astronomical observations, the Pisan mathematician and physicist took care when presenting it to the Doge of Venice to stress its military usefulness for detecting the approach of enemies while still at a distance for the Adriatic coasts. The immediate consequences for its creator were a stipend of one thousand florins a year, and the offer of a teaching post for life at the University of Padua. At the same time, war became inseparably bound up with photography, for which the lens is practically indispensable, two centuries before the medium was even born. War has indeed been a particularly important subject of photography in every time and place, to the point of undergoing a radical change in the canons of its representation. As John Szarkowski wrote in *Looking at Photographs*: "The most radical war photographs – those that have shown us what we had not before known – seldom concern the traditional humanistic values that painting had found in martial subjects. Heroism, cowardice, victory, defeat, high purpose, or villainy are seldom visible in war photographs, except in fragmentary and ambiguous symbol. What they show us is the strange impersonality of war, and its incoherence."

It all began with a series of daguerreotypes taken by an unknown photographer between 1847 and 1848 during the Mexican–American War in the vicinity of Saltillo, one of which immortalised the entrance of the victorious troops led by General Wool into the colonial town. While the images of the barricades erected in Paris during the workers' revolution taken by Hippolyte Bayard on Rue Royale date from June 1848, perhaps earlier still are those by a certain amateur daguerreotypist called Thibault, whose views looking down onto Rue Saint-Maur-Popincourt before and after an attack by the Republican army, were the first photographic images ever to illustrate a newspaper article. (Two woodblock-printed copies appeared in the magazine *L'Illustration* on the first of July.) More systematic documentation was produced the following year by Stefano Lecchi on the places that served as the setting for the key events in the French siege of Rome. The series, which has survived in about fifty prints on salted

Photographs Taken Under the Patronage
of Her Majesty the Queen
in the Crimea by Roger Fenton, Esq.

Manchester: Thomas Agnew & Sons, 1856

paper, tells a tale focusing in particular on streets, walls, and buildings devastated by cannon fire, and reconstructs a sort of map of the fighting that took place around the city all through the month of June. Then we have the calotypes taken by John McCosh, a physician attached to the British Armed Forces, during the second Anglo-Burmese war between 1852 and 1853, some of which show soldiers and artillery pieces in front of the great pagoda of Shwesandaw. (McCosh had previously been sent to India with his photographic apparatus to follow the fighting with the Sikhs in 1848–49, but only took portraits of the leading figures on both sides.) The first significant photographic coverage of the course of a war did not come, however, until the prolonged conflict in the Crimea, when photographers found themselves on the different sides of the lines for the first time. The earliest surviving images are the work of the Romanian Carol Szathmari, who first took portrait photographs of numerous high-ranking Russian, Austrian, and Turkish officers in his studio in Bucharest, and then, in the spring of 1854, courageously moved along the banks of the Danube to capture the concrete reality of the trenches. Presented in a selection of some 200 images at the Universal Exposition of 1855 in Paris, this documentation was produced about eleven months before the arrival in the Crimea of Roger Fenton, one of the best-known photographers of the time. Even though he was not the first British photographer to work on this event, due to a series of circumstances (the views of the fortifications on the Black Sea taken by Gilbert Elliott in March of 1854 on board the *Hecla* were lost, and Richard Franklin went down together with his work during the terrible hurricane that struck the harbour area of Balaclava in the November of the same year), his images ended up being the first ever western views of the East in yet another military campaign.

When Fenton disembarked at Sebastopol on 8 March of 1855, his still very short "career" as a photographer already included experiences and assignments of considerable importance. Born into a wealthy family, he studied painting in Paris from 1841 to 1843 in the studio of Paul Delaroche, which was frequented in the same period by many future photographers, including Charles Nègre, Henri Le Secq, and Gustave Le Gray. It was there that he developed particular artistic sensitivity and probably, while continuing to paint, became convinced of the importance of photography. Although not a practitioner himself, Delaroche took a keen interest in the medium, and was indeed quoted by Daguerre in his *Historique et Description des Procédés du Daguerréotype et du Diorama* (1839) as having declared that the invention carried certain essential conditions of art to such a stage of perfection, that they would become a subject of observation and study, even for the ablest of painters. Fenton's earliest known photographic images date from a trip to Russia of 1852 to document the building of a suspension bridge over the Dnieper, during which he took the opportunity to capture views of Kiev, Moscow, and Saint Petersburg with Le Gray's waxed-paper procedure. On his return, he played the leading role in the founding of the Photographic Society, which took place on 20 January 1853. The same year saw his appointment as official photographer of the British Museum, where until 1859 he took pictures of countless items in its collections, from zoological specimens to the

sculptures in the Department of Antiquities. Commissioned by the publishing firm of Thomas Agnew & Sons to supply photographic documentation of events in the Crimea, Fenton spent the autumn of 1854 preparing for this perilous expedition. He bought a van from a wine-merchant, transformed it into a darkroom, and took it into the countryside of Yorkshire to practise with the wet collodion technique, evidence of which survives in some extraordinary views of abbeys and monasteries. Despite the help of two assistants, the use of this method proved difficult after he reached his destination. The negative on glass must be made light-sensitive just before exposure, and developed immediately after, but the heat accelerated the natural drying of the emulsion considerably, and thus reduced to time available to take the shot. Moreover, dust and flies were a constant and unbearable problem in the cramped space of the mobile laboratory. All this did not prevent Fenton from returning to England at the end of June with about 360 negatives in his luggage, as well as a touch of cholera and a few broken ribs. The very first to see them included Prince Albert and Queen Victoria, who played a crucial part in the success of the undertaking by granting special patronage that enabled the photographer to move freely among the troops. The presentation of Fenton's work to the public took place shortly afterwards with an exhibition of 312 prints, which opened at the Water Colour Society of London on 20 September 1855, and then toured numerous towns in the United Kingdom. It was the first exhibition of such size to be devoted to a single photographer, and the largest of its kind in the whole of the nineteenth century. A selection of 160 albumin prints was then published at the beginning of 1866 with the title *Photographs Taken Under the Patronage of Her Majesty the Queen in the Crimea by Roger Fenton, Esq.* Both the exhibition and the book constituted unprecedented examples of the use of photographic images for purposes of propaganda. These sophisticated channels of communication served in fact to convey two elements at the same time: on the one hand, fine artistic sensitivity expressed in the balance of compositions that already heralded of photographer's later still-life works; on the other, a precise interpretation of the war. Even though the absence of any action is due primarily to technical reasons, since the cumbersome nature of the equipment available and the slowness of the light-sensitive materials made it impossible to take photographs on the battlefield, there is no doubt that this work was influenced by considerations which were both commercial, as the client was a publisher seeking a financial return on the capital invested, and political, as it all took place under the auspices of the royal family and the War Office. The tragic everyday reality of the war was thus completely excluded from Fenton's images, which focus on the faces of the people involved and on the settings in which the events took place. All this is clear in the most celebrated photograph of the corpus, *The Valley of the Shadow of Death*, where countless cannonballs lie scattered between two hills. There are two versions, differing in the number of the projectiles on the ground. As only one was made public, it is possible to infer that the photographer altered the situation in order to make the image more spectacular. It is, however, also possible that some balls were removed in order to clear the road or

to reload the guns between the two shots, the order of which is not known. In any case, what were certainly eliminated from this image of extraordinary evocative and emotive impact (taken from a position that would have meant certain death a few moments before) were the most immediate effects of war, namely, horror and death.

The first photographs showing the corpses of soldiers, which are completely absent here, came a few years later, when Felice Beato, an Englishman of Venetian origin, placed them in the centre of some images taken in India in 1857–58, after the Sepoy Rebellion, and during the closing stages of the Second Opium War in China in 1860. There was, however, always a form of censorship, since the lifeless bodies were unfailingly those of enemy troops. Presentation of the dead remained for the moment a cruel display of superiority over the other side.

Bibliography
Baldwin, Gordon, Malcolm Daniel, and Sarah Greenough. *All the Mighty World: The Photographs of Roger Fenton, 1852–1860*. New Haven: Yale University Press, 2004.
Critelli, Maria Pia. *Stefano Lecchi. Un fotografo e la Repubblica Romana del 1849*. Rome: Retablo, 2001.
Gernsheim, Helmut, and Alison Gernsheim. *Roger Fenton: Photographer of the Crimean War: His Photographs and His Letters from the Crimea*. London: Secker & Warburg, 1954.
Hannavy, John. *The Camera Goes to War: Photographs from the Crimean War 1854–56*. Edinburgh: Scottish Arts Council, 1974.
Hannavy, John. *Roger Fenton of Crimble Hall*. London: Gordon Fraser Gallery, 1975.
Ionescu, Adrian-Silvan. "Szathmari, War Photographer". In *Războiul Crimeii: 150 de Ani de la Încheiere*. Brăila: Editura Istros, 2006.
Sandweiss, Martha A., Rick Stewart, and Ben W. Huseman. *Eyewitness to War. Prints and Daguerreotypes of the Mexican War, 1846–1848*. Washington, D.C.: Smithsonian Institution Press, 1989.
Szarkowski, John. *Looking at Photographs: 100 Pictures from the Collection of the Museum of Modern Art*. New York: The Museum of Modern Art, 1973.

*General Wool & Staff, Calle Real
to South*, 1847–48
Daguerreotype, 8 x 10 cm
New Haven, Yale University
Library

Thibault
*The Barricade in rue Saint-Maur-
Popincourt after the attack
by General Lamoricière's troops,
Monday 26 June 1848*
Daguerreotype, 12.7 x 10.4 cm
Paris, Musée d'Orsay

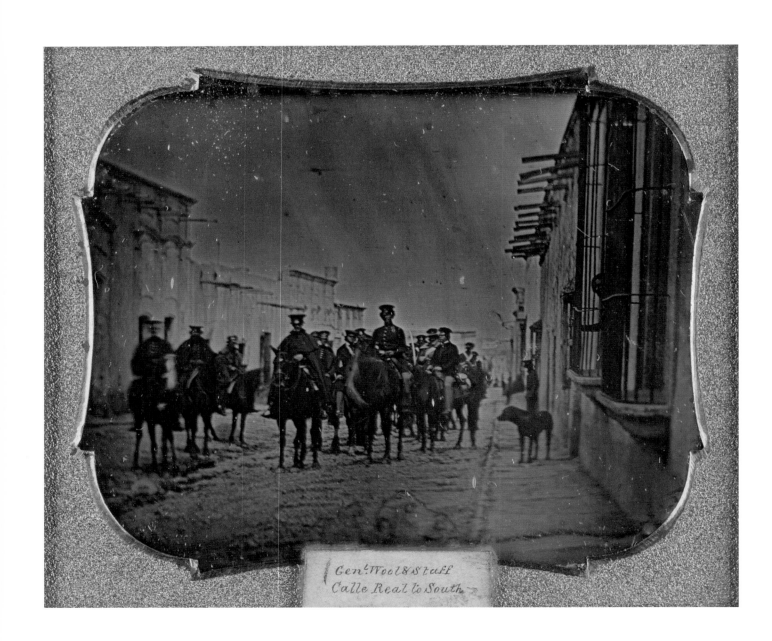

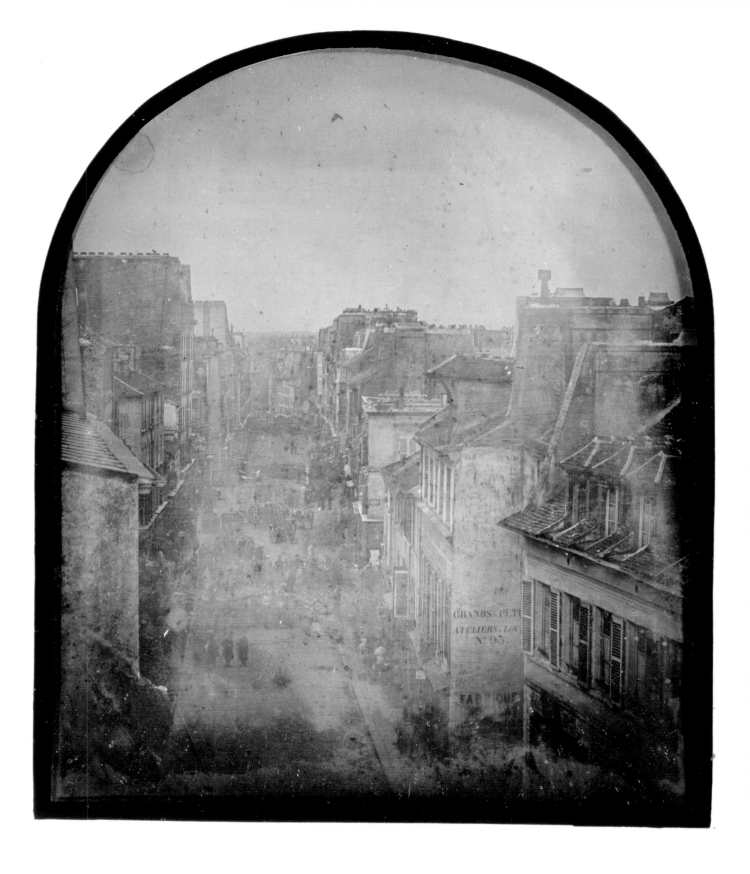

Stefano Lecchi
*Panoramic view of the French
trench in front of the Arch of the
Four Winds*, 1849
Salted paper print from
paper negative, 17 x 22 cm
Milan, Castello Sforzesco,
Civica Raccolta delle Stampe
"Achille Bertarelli"

Carol Szathmari
*The Russian Lancers' Camp
at Crajova*, 1855
Salted paper print, 14.4 x 21.1 cm
New York, George Eastman
House

John McCosh
North East View of the Great
Pagoda (Shwesandaw or Temple
of the golden hair relic) at Prome
(Pyay), 1852
Salted paper print from
paper negative
London, National Army Museum

Roger Fenton
Rievaulx Abbey, 1854
Albumen print
London, Victoria and Albert
Museum

Roger Fenton
*Harbour of Balaclava,
the Cattle Pier*, ca. 1855
Salted paper print, 28 x 36.5 cm
Austin, The University of Texas,
Harry Ransom Center, Gernsheim
Collection

Roger Fenton
*Fenton's Assistant, Marcus
Sparling, on the Photographic
Van, Crimea*, ca. 1855
Salted paper print
Austin, The University of Texas,
Harry Ransom Center, Gernsheim
Collection

Roger Fenton
Valley of the Shadow of Death,
1855
Salted paper print, 26.2 x 35.1 cm
Austin, The University of Texas,
Harry Ransom Center, Gernsheim
Collection

Roger Fenton
Valley of the Shadow of Death
(variant), 1855
Salted paper print, 26.2 x 35.1 cm
Austin, The University of Texas,
Harry Ransom Center, Gernsheim
Collection

Felice Beato
*Interior of Fort Taku Immediately
After Capture*, 1860
Albumen print, 24.4 x 31.5 cm
New York, George Eastman
House, museum purchase

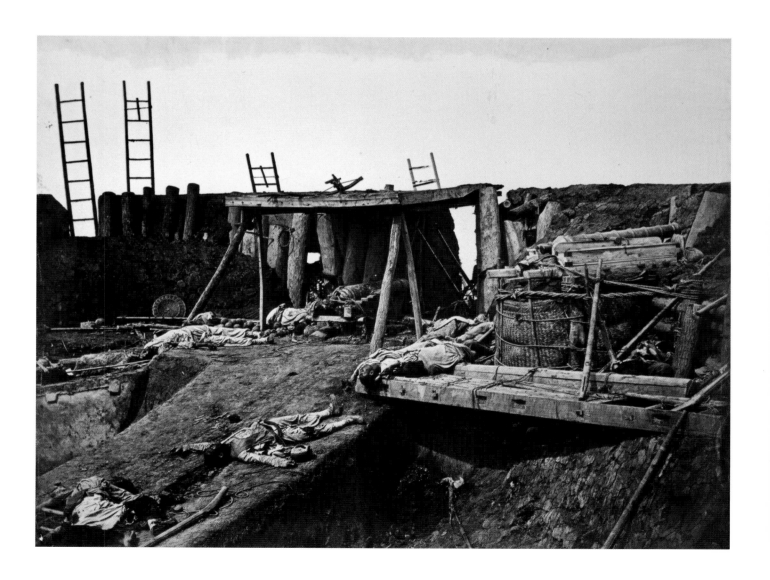

Levi L. Hill

A Treatise on Heliochromy; or, The Production of Pictures, by Means of Light, in Natural Colors

New York: Robinson & Caswell, 1856

All the techniques developed by the pioneers of the photography shared a macroscopic defect, namely the failure to capture colour. The practitioners of the new medium were largely aware of this shortcoming, as is shown by the correspondence and newspaper articles of the period. In a letter to his brother Claude outlining his progress, Nicéphore Niépce wrote of the need to "fix colours", and the subtitle printed on the frontispiece introducing the technical section of Daguerre's treatise of 1839 specifies that his images reproduce the subjects "not in their colours but with tonal gradations of great subtlety". Some significant results were achieved in this field over the next few years by the Englishman John Herschel and the Frenchmen Edmond Becquerel and Niépce de Saint-Victor (a second cousin of Nicéphore); but these too ran up against the difficulty that had previously hindered the very birth of photography, namely the fact that the colours were not adequately fixed on the plate, and thus proved unstable and precarious. The first effective photographic method was introduced an American. Levi L. Hill was a Baptist minister active in the area north of New York, which boasted so many experimenters in this field halfway through the nineteenth century that New Windsor, a town on the Hudson River, was nicknamed "Daguerreville" for a time. A serious form of bronchitis not only led Hill to abandon his pastoral work, but also prompted him to take up photography, as he was convinced that the bromine vapours used to increase the sensitivity of the plates were good for his physical condition. He announced his success at the end of 1850 in a pamphlet entitled *The Magic Buff*, declaring that he had managed to produce daguerreotypes in the colours of nature. Due to his incapacity to perfect the complex procedure involved, and the great difficulty he had in repeating his own results (22 compounds are listed as necessary in addition to those required for a normal daguerreotype), Hill was reluctant to disclose the details, however, or provide practical instructions, with the result that he gained a bad reputation among his contemporaries and remains largely unrecognised among the pioneers in the history of photography. The fact is that when *A Treatise on*

Heliochromy; or, The Production of Pictures, by Means of Light, in Natural Colors came out in 1856, the daguerreotype had been superseded by the introduction of the wet-collodion process, and there was no longer any interest in returning to a method regarded as slow and obsolete. Moreover, the great expectations raised in connection with the extraordinary revolution proclaimed by Hill had caused a significant decline in the sales of colleagues necessarily using monochromatic supports, who had become increasingly impatient and aggressive. (Hill talks in the *Treatise* of being obliged to get himself a gun and a guard dog.) All this naturally gave rise to great doubts as to the truth of Hill's claims, despite the support he received from Samuel Morse and many other illustrious experts of the time, and as to the authenticity of his technique, with numerous accusations of unreliability and fraud being made in the course of over 150 years. The definitive findings come from a study carried out in 2007 on sixty-two "hillotypes" in the collection of the Smithsonian National Museum of American History, Washington, D.C., mostly reproductions of European works of art and lithographs, as well as some landscapes of the region in which Hill worked. The findings cut both ways. While some plates present authentic (i.e., authentically photographic) colours, others reveal the presence of pigments subsequently applied by hand, probably in order to increase the variety of a still limited chromatic range, or as crude attempts to mask failures. This means that Levi L. Hill was both a genius who first succeeded in photographically capturing the colours of nature in 1850, and a fraud. In the same way, his treatise is both the earliest scientific work on this subject (even though none of the plates in the Smithsonian collection was produced by following the indications contained in it), and a sort of pataphysical and autobiographical narrative containing passages like this: "More than once I have been *etherealized, iodized, bromidized, oxydized, chloroformed,* and, in various other ways, *transformed* from the natural to a most unnatural state. These injuries were most of them *temporary*; worse ones have arisen from *continued* exposure to volatile poisons, lack of out-door exercise, late hours, over exertion of the physical and mental powers, and a tremendous and lengthened excitement of the mind."

Bibliography
Becker, William B. (Introduction). *A Treatise on Heliochromy* (facsimile). State College, Pennsylvania: Carnation Press, 1972.
Brunet, François. "Le point de vue français dans l'affaire Hill". *Études photographiques* 16. Paris: Société Française de Photographie, 2005.
Newhall, Beaumont. *The Daguerreotype in America.* New York: Duell, Sloan and Pearce, 1961.
Taft, Robert. *Photography and the American Scene: A Social History, 1839–1889.* New York: MacMillan, 1938.
Wood, John. *America and the Daguerreotype.* Washington, D.C.: Smithsonian Institution Press, 1995.

*Portrait of the Reverend
Levi L. Hill, Baptist Minister
and early daguerrotypist*
Albumen print
Washington, D.C., Smithsonian
Institution National Museum of
American History, Reverend Levi
L. Hill Collection

*A House in West Kill,
New York*, 1850–55
Hillotype, 16.5 x 21.5 cm
(monochromatic plate)
Washington, D.C., Smithsonian
Institution National Museum of
American History, Reverend Levi
L. Hill Collection

Last Supper (Photograph of a
European lithographic print),
1850–55
Hillotype, 16.5 x 21.5 cm
Washington, D.C., Smithsonian
Institution National Museum of
American History, Reverend Levi
L. Hill Collection

Four Species of Birds
(Photograph of a European
lithographic print), 1850–55
Hillotype, 16.5 x 21.5 cm
Washington, D.C., Smithsonian
Institution National Museum of
American History, Reverend Levi
L. Hill Collection

French Army Soldiers
(Photograph of a European
lithographic print), 1850–55
Hillotype, 16.5 x 21.5 cm
Washington, D.C., Smithsonian
Institution National Museum of
American History, Reverend Levi
L. Hill Collection

Charles Piazzi Smyth

Teneriffe, An Astronomer's Experiment; or, Specialties of a Residence Above the Clouds

London: Lovell Reeve, 1858

The English photographer Charles Piazzi Smyth was born in 1819 in Naples, where his father Admiral William Henry Smyth of the Royal Navy was posted. His middle name derived from the admiral's recent meeting with Giuseppe Piazzi, the first man to discover an asteroid, and his resulting interest in astronomy, which led to the creation of an observatory in Bedford after his return to England in 1825. It was there that young Charles completed his preliminary training before embarking at the age of just sixteen for the Cape of Good Hope as assistant to Thomas Maclear, at whose side he witnessed the passage of Halley's comet and the Great Comet of 1843. In addition to a particular gift for science, he demonstrated a specific interest in figurative representation during the ten years spent in South Africa, producing numerous sketches of the events observed, and taking up photography, which was developed and became a widespread practice in that very period. John Herschel, who had been involved for many years in experiments with light-sensitive substances, also happened to be in Cape Town from the end of 1833 to 1838. Having left in order to extend his studies to the southern skies, Herschel succeeded at the same time in producing over a hundred drawings of the local flora with the aid of his wife Margaret and a *camera lucida*, an optical apparatus for reflecting an object on a surface so that its outline can be traced. His influence on the adolescent scientist was evidently crucial. Having returned to Great Britain, Herschel exhibited his photographs alongside Fox Talbot during a reception held by the Marquis of Northampton on 9 March 1839. Making use of the calotype process, Smyth took the Royal Observatory as his subject and produced the first photographic images ever taken on South African soil in 1842–43. Eleven years after Smyth's return to Europe in 1845, and his immediate appointment as Astronomer Royal for Scotland, he set off on a new and important journey. Having obtained funds of £500 from the British Admiralty and the loan of the yacht *Titania* from Robert Stephenson, he led an expedition to Tenerife in 1856. Its purpose was to ascertain the possible advantage of making astronomical observations from a significantly high altitude, and thus eliminating the interference of the lower part of the atmosphere. The stimulus came from a passage in the second edition (1717) of Isaac Newton's *Optics*: "If the Theory of making Telescopes could at length be fully brought into practice, yet there would be certain Bounds beyond which Telescopes could not perform. For the Air through which we look upon the Stars is in perpetual Tremor [...] The only remedy is a most serene and quiet Air, such as may perhaps be found on the tops of the highest Mountains above the grosser Clouds." With the aid of the crew and the cooperation of the islanders, he accordingly transported his instruments first to the top of Mt Guajara, 2,700 metres above sea level, and then to Altavista, 3,260 metres up the slopes of the volcano Teide, the highest mountain on Spanish territory and in the entire Atlantic. Finding confirmation of Newton's hypothesis in both locations, Smyth carried out measurements and made drawings providing evidence of this and published both in an official report (*Report on the Teneriffe Astronomical Experiment of 1856, Addressed to the Lord Commissioners of the Admiralty*), and in Vol. XII of the periodical *Edinburgh Observations*.

His personal account was published together with twenty stereoscopic photographs in a less specialised work of greater literary quality entitled *Teneriffe, An Astronomer's Experiment*, the first book in history to appear solely with illustrations of this type. It appeared in 1858, when stereography, a technique creating the illusion of depth by combining two images so as to reproduce binocular vision, was undergoing great expansion due to the introduction onto the market of simple devices making it possible to enjoy the three-dimensional effect to the full. Sir David Brewster, who invented the first stereoscope of sufficiently small size for production on a large scale in 1849, wrote as follows in 1856: "[The stereoscope] is now in general use over the whole world, and it has been estimated that upwards of half a million of these instruments have been sold [...]. Photographers are now employed in every part of the globe in taking binocular pictures for the instrument" (*The Stereoscope. Its History, Theory and Construction. With its Application to the Fine and Useful Arts and to Education*). Charles Baudelaire made this comment in the scathing criticism of photography that he sent to the

Révue Française after visiting the Paris Salon of 1859: "A thousand hungry eyes were bending over the peepholes of the stereoscope, as though they were the attic-windows of the infinite. The love of pornography, which is no less deep-rooted in the natural heart of man than the love of himself, was not to let slip so fine an opportunity of self-satisfaction."

While Charles Piazzi Smyth's "photo-stereographs" were of no artistic importance and of no particular scientific utility, the author and his publisher Lovell Reeve sensed their potential attraction for the public. By detaching the small prints from the pages to which they were glued and observing them through a viewer, readers found themselves immersed in the exploration of Tenerife, face to face with heaps of lava, assorted technological devices, and some of the oldest trees on the planet. The narrative runs parallel to this in an adventurous vein, emphasising the risks of the undertaking, and the fascination of new encounters. The result was an extraordinary success for a scientific publication, with about 1,600 copies sold at the price of one guinea each, and further confirmation of the

importance of this vehicle in introducing the general public to photography.

Bibliography
Brewster, Sir David. *The Stereoscope. Its History, Theory and Construction. With its Application to the Fine and Useful Arts and to Education.* London: John Murray, 1856.
Henisch, Heinz K., and Ann Bridget. *The Photographic Experience 1839–1914: Images and Attitudes.* University Park: Pennsylvania State University Press, 1994.
Smyth, Charles Piazzi. *Report on the Teneriffe Astronomical Experiment of 1856, Addressed to the Lord Commissioners of the Admiralty.* London: Taylor and Francis, 1858.

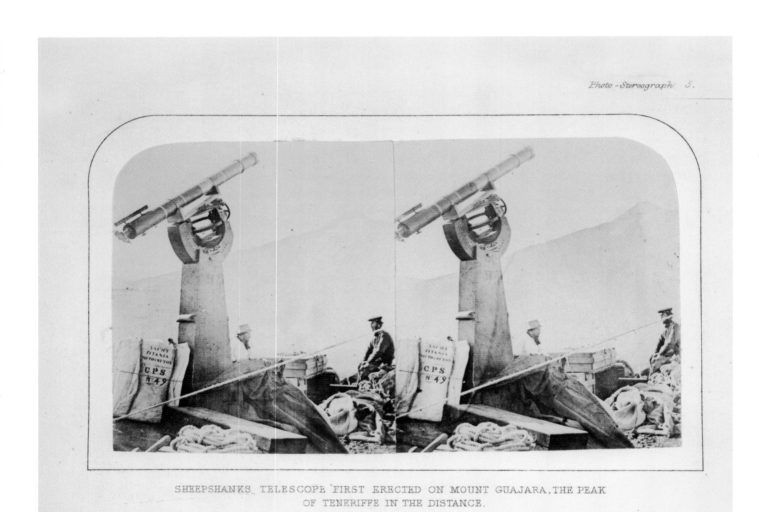

SPECIMEN OF THE MALPAYS OF BLACK LAVA NEAR ALTA VISTA.

p. 248. 297. 363.

*Printed by A. J. Melhuish under the superintendence of James Glaisher, Esq.ʳ F.R.S.
and published by Lovell Reeve.*

The *"Great Dragon Tree"*
at the Villa de Orotava, 1858
Albumen print, 6 x 7 cm
New York, George Eastman
House, Gift of Alden Scott Boyer

D.J. Pound
Engraving from a photograph
by John Watkins of Sir David
Brewster with His Stereoscope,
ca. 1860
London, Science Museum

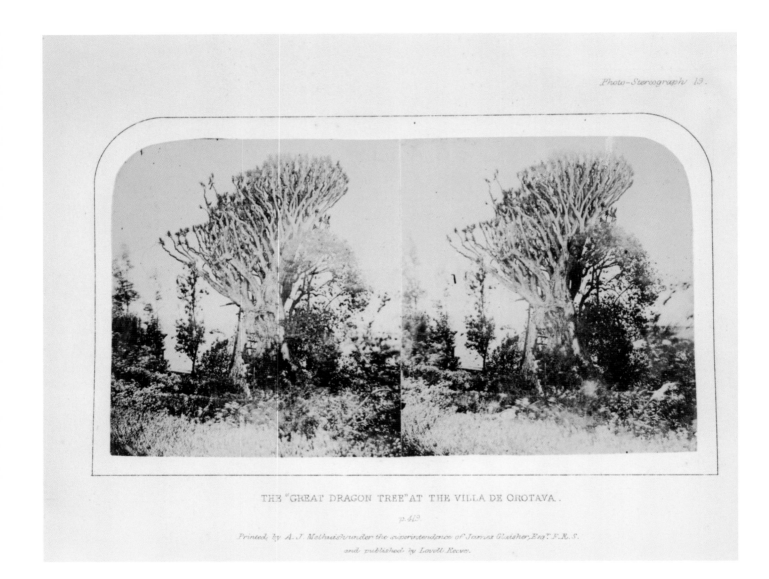

Photo-Stereograph 13.

THE "GREAT DRAGON TREE" AT THE VILLA DE OROTAVA.

p. 419

Printed by A. J. Melhuish under the superintendence of James Glaisher, Esq.ʳ F.R.S.
and published by Lovell Reeve.

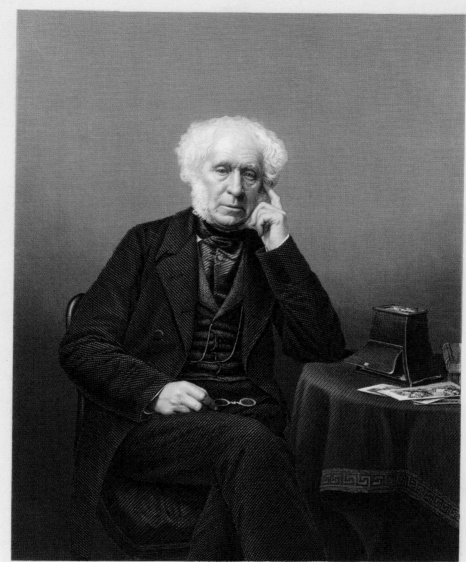

Engraved by D. J. Pound from a Photograph by John Watkins Parliament St.

SIR DAVID BREWSTER, LL.D. K.H.

Principal of the University of Edinburgh.

THE DRAWING ROOM PORTRAIT GALLERY OF EMINENT PERSONAGES.
Presented with the Illustrated News of the World.
THE LONDON JOINT STOCK NEWSPAPER COMPANY LIMITED
198 STRAND LONDON

Francis Frith

Egypt and Palestine, Photographed and Described by Francis Frith

London: James S. Virtue, 1858–59

Francis Frith was born in Chesterfield, Derbyshire, in 1822 and brought up a Quaker. A founding member of the Liverpool Photographic Society in 1853, Frith set off in September 1856 on an eleven-month tour of the Middle East, which was followed by two more trips in 1858 and 1859. These adventures served as the basis for about ten photographic books brought out in quick succession and often repeating the same images. The first of these, *Egypt and Palestine, Photographed and Described by Francis Frith*, was offered to subscribers in 1858 by James S. Virtue in twenty-five instalments of albumin prints in a run of 2,000 copies and reappeared the following year in two volumes with thirty-seven and thirty-nine plates. Even though many Europeans had already visited the places documented by Frith in his expeditions, his undertaking was by no means easy and the logistic difficulties were accompanied by others specifically connected with photography. He used the wet-collodion process, which combines the advantage of precision (the support for the negatives is glass, rather than the paper of

talbotypes) with the disadvantage of having to prepare the plate just before taking the shot and develop it immediately after. Frith was therefore obliged to travel with a darkroom that he had specially constructed in London, using it occasionally as very cramped sleeping quarters. The photographer tells of the curiosity aroused among the locals by this equipment in the description accompanying the image entitled *Doum Palm, and Ruined Mosque*: "This carriage of mine, then, being entirely overspread with a loose cover of white sailcloth to protect it from the sun, was a most conspicuous and mysterious-looking vehicle, and excited amongst the Egyptian populace a vast amount of ingenious speculation as to its uses. The idea, however, which seemed the most reasonable, and therefore obtained the most credit, was, that therein, with right laudable and jealous care, I transported from place to place my – harem! It was full of moon-faced beauties, my wives all! – and great was the respect and consideration which this view of the case procured for me!" In any case, the temperatures inside this contraption were sometimes so high that Frith probably had to perform his

operations in tombs and caves. As he wrote in the introduction to this volume, "When (at the Second Cataract, one thousand miles from the mouth of the Nile, with the thermometer at 110 in my tent) the collodion actually boiled when pouring upon the glass plate, I almost despaired of success."

Francis Frith faced these obstacles in pursuit of two fundamental and very different objectives. The first was financial. In addition to selling the images he captured on plates of 8 x 10 (20,3 x 25,4 cm) and 16 x 20 inches (40,6 x 50,8 cm) through a large-scale publishing operation, he had signed a contract with Thomas Agnew for the marketing of copies available individually in larger formats, and circulated a further series of stereoscopic views aimed at a broader and less prosperous public through the Negretti & Zambra company. (This naturally means that Frith photographed every subject on the spot with three different cameras, as well as a variety of poses in most cases.) His flair for business also led him in 1860 to found an authentic factory of photographic reproductions in Reigate, which processed his own negatives as well as those of other photographers, either commissioned or purchased. The second was the strong religious faith that supported Frith in his labours. It was with a missionary spirit that he rediscovered the traces of episodes from the Old and the New Testament in the Middle East. Bethlehem, Nazareth, Jerusalem, the Dead Sea, and the Sea of Galilee, where the miracle of the loaves and fishes took place, contemplated from above in a plate from *Egypt and Palestine* – these are some of the subjects that were later reused to illustrate numerous editions of the Bible. Anything but a neutral geographical and archaeological inventory, Frith's work was an unprecedented tool of propaganda combining both religious and political significance, as Great Britain had considerable military, strategic, and commercial interests in an area still strongly under French influence, especially North Africa. This connection to tourism would be of key importance: a photograph of the Ramesseum in Thebes shows a man and a woman in western dress at the foot of the ruins beside other figures and a camel. In London, the travel agent Thomas Cook was ready with the first package holidays – the invasion was about to begin.

Bibliography
Haaften, Julia van, and Jon E. Manchip. *Egypt and the Holy Land in Historic Photographs. 77 Views by Francis Frith*. New York: Dover Publications, 1980.
Howe, Kathleen Stewart. *Revealing the Holy Land: The Photographic Exploration of Palestine*. Santa Barbara: Santa Barbara Museum of Art, 1997.
Jay, Bill. *Victorian Cameraman: Francis Frith's Views of Rural England 1850–1898*. Newton Abbot, Devon: David & Charles, 1973.
Nickel, Douglas R. *Francis Frith in Egypt and Palestine. A Victorian Photographer Abroad*. Lawrenceville: Princeton University Press, 2004.

Doum Palm, and Ruined Mosque,
ca. 1857
Albumen print, 16.4 x 22.3 cm
Florence, Museo di Storia della
Fotografia Fratelli Alinari

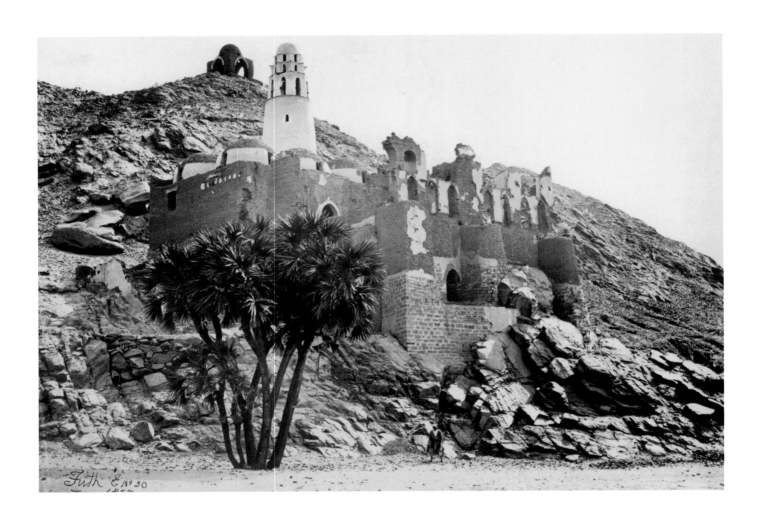

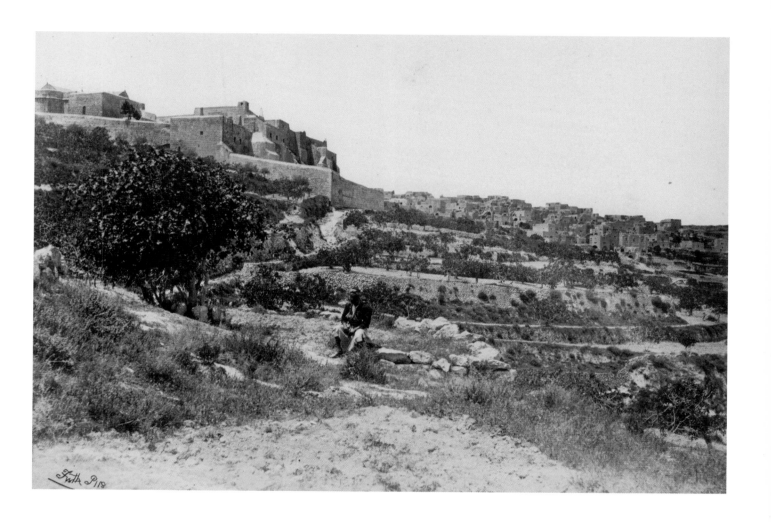

The North Shore of the Dead Sea,
ca. 1857
Albumen print, 16 x 23 cm
New York, The New York Public
Library, Stephen A. Schwarzman
Building, Photography Collection,
Miriam and Ira D. Wallach
Division of Art, Prints and
Photographs

The Town and Lake of Tiberias,
from the North, Palestine,
ca. 1857
Albumen print, 15.3 x 22.4 cm
Florence, Museo di Storia della
Fotografia Fratelli Alinari

Osiride Pillars and Great Fallen
Colossus, the Ramesseum
Thebes, ca. 1857
Albumen print, 16.3 x 23.1 cm
Florence, Museo di Storia della
Fotografia Fratelli Alinari

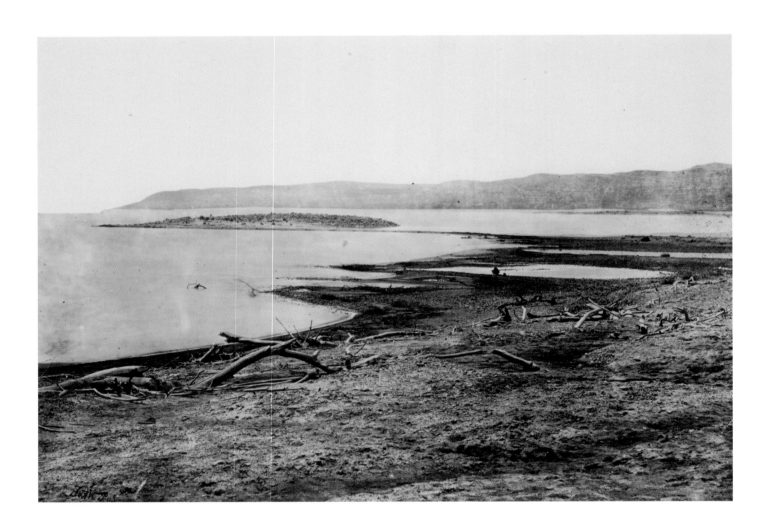

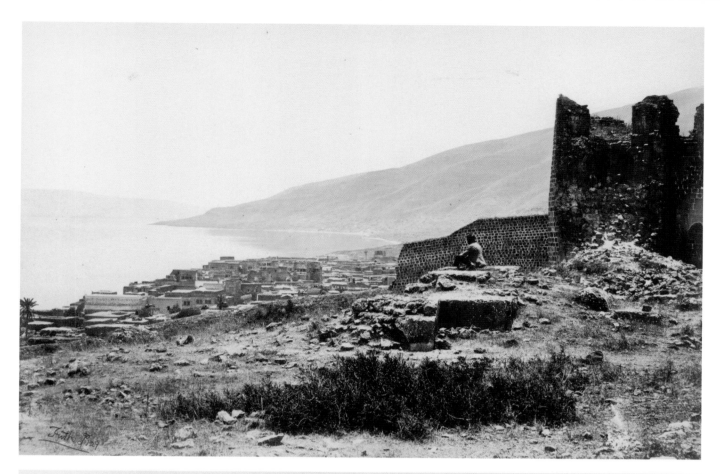

Walter Guadagnini

The Journeys of Photography

Among the innumerable monuments of architecture constructed by the Romans, how many have escaped the notice of history, how few have resisted the ravages of time and barbarism! And yet even the majestic ruins that are still scattered over Italy and the provinces, would be sufficient to prove that those countries were once the seat of a polite and powerful empire.[1]

If the traveller can forget that he is treading on the grave of a people from whom his religion has sprung, on the dust of her kings, prophets and holy man, there is certainly no city in the world that he will sooner wish to leave than Jerusalem. Nothing can be more void of interest than her gloomy, half-ruinous streets and poverty stricken bazaars.[2]

You soon forget the print. Objects are assimilated by the imagination, and one catches oneself dreaming. What is this country, after all, but a vision, a mute tableau, an inert image of the past?[3]

Whilst attending a new conquest of Egypt by whoever it may be, these soldiers of ornament, these opéra-comique sentinels have no other duty than to pose for any itinerant photographer that might honour them with his patronage.[4]

1. Francis Frith
Street view in Cairo, 1857
Albumen print, 48.3 x 38.9 cm
Salzburg, Museum der Moderne
Salzburg, FF 113 Fotografis Collection

In the mid-seventeenth century, or thereabouts, the journey undertaken in France and Italy by the young aristocracy of northern Europe became institutionalised and, in the latter half of the century, developed into what might be termed a social necessity, thus going beyond its original educational aims. In the eighteenth century this mode of travel changed again, in keeping with cultural and technological progress: the protagonists of the Grand Tour, as it was then known, were no longer the young scions of the nobility, but the bourgeoisie, and intellectuals, who saw the journey as an indispensable means of verifying – in the field – the knowledge they had acquired through study. This social change coincided with a cultural development which, between the Enlightenment and the first signs of Romanticism, shifted the accent from an educational function to an interpretative one, stressing the increasing importance of the journey as an individual experience, which is clearly evinced by the well-known and oft-quoted Italian journey made by Goethe between 1786 and 1788.

A vast literature concurs that this era came to an end precisely at the close of the eighteenth century, following the improvement in travel conditions and its being more affordable, which led to the philosophy of the Grand Tour actually becoming the philosophy of first individual- and then mass-tourism. The gradual spread of the railway as a means of transport as from the 1830s, and the birth of the organised tour with Thomas Cook's historic rail trip from Leicester to

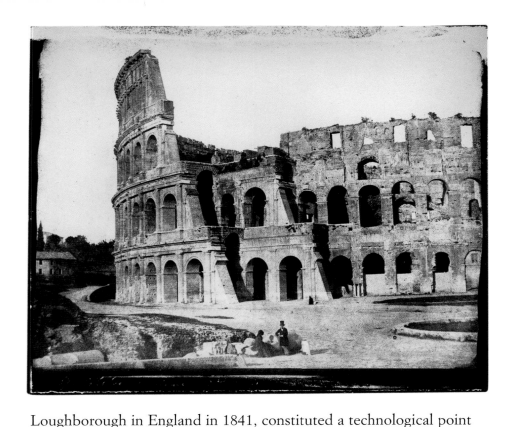

Loughborough in England in 1841, constituted a technological point of no return, in both the concrete and symbolic sense. A point of no return that was also partially defined by Louis-Jacques-Mandé Daguerre's discovery of "a method for fixing images that depict themselves in a camera obscura", as announced by François Arago at the Académie des Sciences in Paris on 7 January 1839.

In the course of the nineteenth century, these technological advances led not only to the now metaphorical Grand Tour being extended to far more distant regions from the original destinations of Italy and the Middle East, but also offered a new possibility of visually appropriating the "Other" to representatives of Western civilisation, which was the dominant culture from a technological and military standpoint. It is important to note, however, that this development was the product of a cultural perspective which, at the same time, made it necessary to reflect on a series of issues that had a profound effect on reality and, even more so, on the image. In the case of the former these issues were economic, political and scientific, while in the case of the latter these were interwoven with issues concerning history and art, with frequent overlappings.

The following considerations focus on the latter, using photography as the favoured key to understanding.

Rise and Fall

The two opening quotes reveal one of the crucial underlying themes of travel from North to South, as it evolved between the seventeenth and the beginning of the nineteenth century. Undertaken by cultured

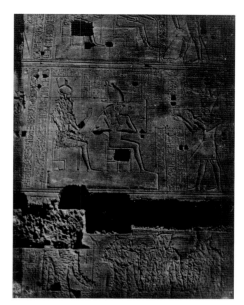

3. Maxime Du Camp
*The Great Temple of Isis at Philae,
west side, Nubia*
Salted paper print from paper
negative, 25.5 x 17 cm
Paris, Musée d'Orsay

4. Maxime Du Camp
*Western stretch of the city walls
of Jerusalem*, ca. 1850
Salted paper
Florence, Raccolte Museali Fratelli
Alinari (RMFA)

individuals, the journey was not only a spatial but also a temporal experience. The direct encounter with the remains of the great civilisations of the past – considered the cradle of the art and religion of the visitors' native lands – accentuated the theme of the alternating fortunes of humanity, and especially its political institutions. The glories of Greek art and that of the ancient empires of Egypt and Rome, and the link between the geographical region of the Middle East and the birth of the Jewish and Christian religions, which filled the imagination of British, French, and German intellectuals, clashed with the reality of countries devoid of political clout, whose monuments were falling into ruin, and where the majority of inhabitants lived in conditions of wretchedness. This gave rise to a series of reflections, expressed as much in written as in visual accounts, the most important being the possibility of the empires in northern Europe actually declining one day, and ending up – to borrow a phrase from Gibbon – in the hands of those "savage nations of the globe [that] are the common enemies of civilised society", in other words, the colonies.

To what degree and in what way did this doubt – which must have accompanied travellers on their journeys from the outset – affect the visual production of the period, first that of the daguerreotype, and later of the photographic process as we know it?[5] Before answering this question, we must consider the following: Arago's announcement of Daguerre's invention to the French Chamber of Deputies on 3 July 1839 already contained more than one specific reference to ancient Egypt: "Pour compter les millions et millions d'hiéroglyphes qui couvrent, même à l'extérieur, les grands monuments de Thèbes, de Memphis, de Karnak, etc., il faudrait des vingtaines d'années et des légions de dessinateurs. Avec le Daguerréotype, un seul homme pourrait mener à bonne fin cet immense travail. Munissez l'Institut d'Égypte de deux ou trois appareils de M. Daguerre."

Functionality was linked to the objectivity of the medium, to the presumption that it faithfully reproduced reality according to a principle that was immediately clear to detractors and supporters of photography alike. On the basis of this assumption, as well as the wonder aroused by the new invention, the first travellers armed with cameras confined themselves to a basic documentary style, albeit in many cases accompanied by an equally basic artistic intent that derived from the pictorial formation of many of the protagonists of this early period.

These two principles were not seen as contradictory but as convergent, in which the indisputable factual evidence could be enriched by the particular compositional and chromatic sensibility that an artistic eye (and no longer a hand) possessed.[6]

This overlapping, this doubling of aims and roles, enables us to begin to answer the above question, since the images made in these situations span time, documenting the present and evoking the past simultaneously. They document reality as it is, the actual state of the monuments and the places – including the locals populating the streets

5. Maxime Du Camp
*Nubia, Temple of Dakkeh,
general view*, 1852
Salted paper print, 16.2 x 21.3 cm
Salzburg, Museum der Moderne
Salzburg, FF 79/1-2/1, Fotografis
Collection

and the squares, who are nevertheless considered part of the crowd rather than individuals – while also conjuring the past, providing evidence of greatness that has diminished but not completely disappeared. These images confirm what was already known conceptually with glaring, irrefutable visual proof. In fact, early travel photography did not question the readings of reality proposed by those philosophers and historians who, in centuries past, had developed their theories concerning the reasons for travel and the decline of civilisation, as well as the places and the people encountered while crossing the continent from north to south. Concerning the role of images in the Grand Tour, As Eric J. Leed believed that they functioned as content in a form of code – often unconscious – of the places of memory inculcated in young cosmopolitan Europeans through their studies, offering the *genius* of each *locus*. For Leed, images played a fundamental role in the perception of the past, in the personal experience of collective memories. He considered that the image connects past and present, because it makes it possible to stop time, to freeze the moment, to stop the ceaseless flow of light. By this logic, seeing is a way of affirming the present and our presence in pasts that are brought into focus through us, whether we realise it or not (Fig. 2).[7]

Fragments of the East

While a broad reading of these events enables us to consider, in many respects, journeys to Egypt and the Middle East as a kind of extension of the Grand Tour from Italy to more distant regions, it is equally clear that this widening of geographical boundaries gives rise to other considerations concerning both the premises and outcomes.
There are, however, certain constants that must be pointed out immediately. First of all, although it was in a decline and did not become a unified state until 1861, Italy was considered an integral part of European culture, not only due to its past history, but also because its decline was relatively recent, dating to two centuries previously at the political level, and only one at the artistic level. In other words, the gap that separated it from the European powers was relatively narrow, and the manner in which it was regarded is best described as picturesque.[8]
On the other hand, the themes that concerned the Middle East, especially Egypt and Palestine, were quite different. Aside from the fact that these countries were much farther away, the glories of the former were rooted in ancient times, the cultural interest was specifically archaeological, and the political interest was linked to European imperial expansionism, as attested by Napoleon's abortive attempt to conquer Egypt at the beginning of the nineteenth century. The reasons for, and consequences of, this expansionism were economic, and it was achieved primarily through the opening of the Suez Canal in 1869, and with the British occupation of Egypt in 1882. In this context, we find a factor that concerns both lifestyle and

6. Félix Teynard
Doum Palm and mimosa, Kalabsha,
1851–52
Salted paper print from paper
negative, 30.5 x 25.3 cm
London, The British Library

Félix Teynard phot.

Publié par Goupil et C.ᵉ éditeurs, Paris, Londres, Berlin, New-York.

KALABCHEH.

PALMIER DOUM ET MIMOSA.

Pl. 120.

7. Felice Beato
Karnak, row of great columns,
ca. 1857
Albumen print, 36.6 x 26 cm
Salzburg, Museum der Moderne
Salzburg, FF 126/1-2/2, Fotografis
Collection

culture, and is fundamental to the reconstruction of the events under examination, namely the origin and spread of one of the many Egyptian revivals that took place in Western culture through the centuries, a real case of Egyptomania that invaded all walks of European life from the mid-eighteenth century, and which in the early decades of the nineteenth gave way to the more generic vogue of Orientalism.[9] In short, Egypt truly was "Other" for nineteenth-century European society, which constructed and projected its images on this otherness, seeking to confirm its own imagination. When photographers like Maxime Du Camp, Francis Frith, John Beasley Greene, Auguste Salzmann, Félix Teynard, Louis de Clercq, Francis Bedford, James Robertson, Felice Beato, Antonio Beato, and Félix Bonfils – just to mention the best-known, then and now – worked in the Middle East in the 1850s and 1860s, they brought with them not only their photographic equipment, but also the expectations of the Europeans who had financed their trips and would see the results.[10] In fact, it should be remembered that these were long, costly, and often dangerous expeditions, whose results were only partially guaranteed and which, in the majority of cases, were born from specific interests. These were mostly archaeological – as Arago himself had intuited – and what might be called topographical, in the sense of territorial reconnaissance, which explains the large number of images by diplomats and soldiers, which were either commissioned or made for their own enjoyment (Figs. 3–7). A third, strictly economic interest, was soon added to these, which was manifested in the collection of images in albums that were then sold, and above all in the popularisation of individual images, often in a stereoscopic format, which invaded European homes from the beginning of the 1870s.[11] Lastly, it should be noted that the protagonists of these photographic journeys were often individuals extremely well-versed in art, men of letters, painters, or archaeologists, and they brought to their experience of Egypt an already formed cultural and visual baggage that was also common to their native lands.

8. David Roberts
*Great Sphinx, Pyramids of Geezeh
(Giza),* 1839
Lithograph coloured by hand,
33.5 x 53 cm
New York, The New York Public
Library, Stephen A. Schwarzman
Building, Asian and Middle Eastern
Division

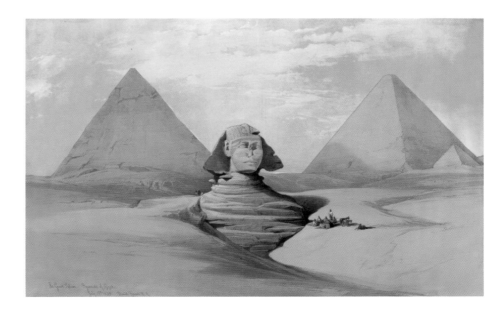

9. Robert Branston
Pyramids and Sphinx: Sunsetting, 1831
Engraving, from M. Russell, *View of Ancient and Modern Egypt with an outline of its Natural History*, Edinburgh 1831, 7.9 x 11.1 cm
New York, The New York Public Library, Mid-Manhattan Library, Picture Collection

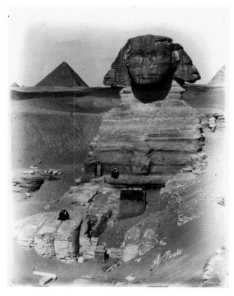

10. Antonio Beato
The Great Sphinx of Gizeh [Giza], n.d.
Aristotipo
Venice, Fondazione di Venezia
Fondo Italo Zannier – Collezione della Fondazione di Venezia

It was no accident, therefore, that we find in the subjects of their works, among other things, an overlapping of the principles of draughtsmanship and of photography. If we compare a plate made by the moderately talented English engraver, Robert Branston – whose works were featured in the volume by the Reverend Michael Russell entitled *View of Ancient and Modern Egypt: With an Outline of its Natural History* published in Edinburgh in 1831 – and a hand-coloured lithograph from a drawing, dated 1839, by the Scottish painter and set-designer David Roberts and published in one of the six volumes of *The Holy Land, Syria, Idumea, Arabia, Egypt and Nubia*, issued between 1842 and 1849,[12] with photographic images of the same subject, we find that they share a common cultural perspective in which the desire to give authenticity to the image predominates (Figs. 8–10).

At the same time, these images possess an underlying, though equally important, symbolism that was comprehensible to a vast public, since the meanings associated with the pyramids and the sphinx were known as much to the potential viewership in Europe as they were to the photographers. In many respects, there were more similarities between these works than differences, contrary to what the graphic invention/photographic documentation dichotomy would lead one to suppose. In this regard, it suffices to observe the arrangement and proportions of the figures – those depicted by the engraver Branston are busy working, while those by Roberts are relaxing – in relation to the monuments, and to compare them with those in many photographs, to realise that, in both cases, we are dealing with *topoi* that were seamlessly transferred from one medium to another.

What actually differentiates the drawn and engraved images from the photographic ones are certain elements that appear marginal but are in fact central to the transition from one technique to another: in the case of Branston's engraving, this is a natural element, which also has a symbolic function, namely the setting sun (recurrent in other engravings in the volume), while in the work by Roberts the element is the vastness of the space represented on the sheet, the "invention" of a point of view that permits an ideal, though realistic, visualisation of the scene. Since these elements are not present in photographs – they could only have been achieved through manipulation or by forfeiting the sharpness of the image – we may deduce that the fundamental difference between the two media lies in quality, and in the nature of the information given to the viewer, which is synthetic where drawing is concerned, and analytical regarding photography.

Francis Frith's famous consideration on the difficulties encountered by photography in a direct confrontation with art pivots precisely on this point. He claimed that nobody was as painfully aware as the photographer that the lights and shadows of Nature are generally terribly fragmentary and ineffective compared with those of Turner; and, in sum, no matter how perfectly adequate his knowledge of chemistry, how impeccable his manipulation, it is a miracle, an accident, a chance in a thousand if the photographer's image is as *artistic* from every point of view as his educated taste would desire.[13]

What Frith attributes to nature – even though, of all the travelling photographers of his day, he was the most preoccupied with quality and the spectacular visual – can, instead, be attributed to the nature of photography, although it was precisely the medium's fragmentary aspect that demanded a new strategy of the gaze, which was already being developed during that period. A strategy that is fully applied, for instance, in the works of Salzmann, who made homing in on detail and breaking up the visual unity of the subject the main feature of his research in an archaeological key, which, in many respects, constituted a remarkably important conceptual shift, although this would be more evident in the future than at the time.[14]

It is not difficult to understand what Frith is saying, however, if we consider his comment within the cultural perspective of the time, especially with respect to the theme of the East and its representation. If a photographer chose to follow the Orientalist vogue he found it almost impossible to compete with the over-the-top yet legendary sets designed by Karl Friedrich Schinkel for the performance of Mozart's *Magic Flute* at the Berlin Opera House in 1815, or with the paintings by Charles Gleyre, Horace Vernet, John Martin, Jean-Léon Gérôme, David Roberts, Lawrence Alma-Tadema, Luc-Olivier Merson, and the many other artists who dominated the major international exhibitions of the period with their pictorial syncretism that combined Neo-Hellenism and Orientalism to create an extraordinary visual impact. These artists were truly able to transform historical and religious elements into spectacles and pictorial scenes that spoke to and shaped both the cultivated and the popular imagination in the mid-nineteenth century. In sum, European culture had delegated, at least until the end of the 1880s, the task of depicting the dream of the Orient to the fine arts, and that of confirming its credibility to photography (Figs. 11–14).[15]

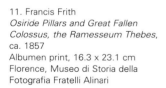

11. Francis Frith
Osiride Pillars and Great Fallen Colossus, the Ramesseum Thebes, ca. 1857
Albumen print, 16.3 x 23.1 cm
Florence, Museo di Storia della Fotografia Fratelli Alinari

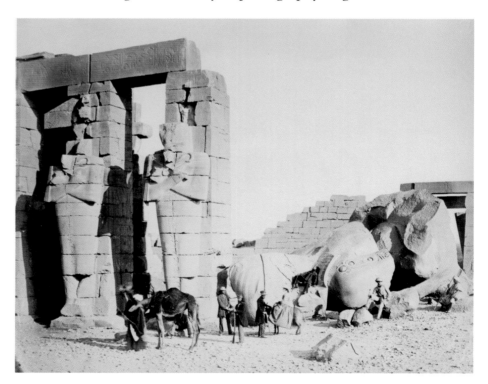

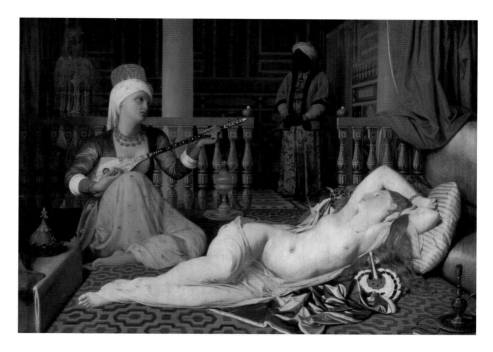

12. Jean-Auguste-Dominique Ingres
Odalisque with a Slave, 1839–40
Oil on canvas, 72.1 x 100.3 cm
Cambridge (Mass.), Fogg Art
Museum, Harvard University Art
Museums, Bequest of Grenville
L. Winthrop

Yet it was precisely a development in the career of Jean-Léon Gérôme, one of the leading lights of pictorial Orientalism, which opened a new chapter in this relationship. In 1859 the already well-known artist, who in 1856 had spent eight months in Egypt and entered what is known as his Orientalist Period, began working with the French publisher and art dealer Adolphe Goupil, whose daughter he would marry in 1863. Endowed with an equally keen business and artistic sense, Goupil had been one of the first to see the enormous commercial potential of photography in general, and of travel images and artistic reproductions in particular. He had published his first photo albums in 1853, and launched, in 1858, his *Galerie Photographique*, a complete series of photographic reproductions of artworks that was destined to become a resounding success.

By 1859, Goupil had already published three of the painter's works, setting in motion a process that was to achieve staggering results with respect to both the number of subjects reproduced in photographs and photogravures, and the amount of reproductions sold.[16]

In addition, it should be noted that on his first expedition to the Middle East the painter took with him a sculptor who was also a photographer, Auguste Bartholdi; and on the third, in 1868, he was accompanied by, among others, his son-in-law, Albert Goupil, as official photographer (Fig. 15). As we have shown, Gérôme used the photographic notes made by his travelling companion for his compositions, which confirms that he considered the medium useful, but strictly as an aid to drawing from life.[17]

These events embody nearly all the aspects of the relationships that were established between photography, painting and the economics of art during this period. While in the hierarchy of the arts photography was still the "servant" – to use Baudelaire's famous definition – of painting, it played a dominant part in the popularisation of images, including artistic ones, making a crucial contribution to the success of

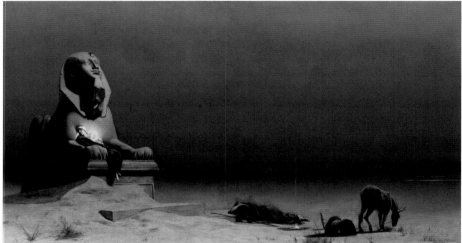

artists, whose talents were gauged not only by their critical reception on official occasions, but also, and perhaps even more so, by the popularisation of their style through albums and individual photographs (Figs. 16–17). This, along with the invention of the *carte de visite* for portraiture during the same period, evinced the democratising nature of the new tool.

Evidence

Thus the twofold criterion of documentary value and market value was adopted by many of the photographers and artists who travelled in the Middle East, inevitably bringing with them their own image and the collective image formed in their own country of these lands. As we have seen, religion was a fundamental element in these images, the main point of reference being Palestine. In 1844 the Reverend Alexander Keith published a new edition with eighteen engravings from daguerreotypes made by his son George, of a volume whose title clearly reveals the author's aims: *Evidence of the Truth of the Christian*

15. Albert Goupil
Ourselves, 1868
Albumen print, 16.2 x 22 cm
Paris, Bibliothèque nationale de
France, Département des estampes
et de la photographie

Religion Derived from the Literal Fulfillment of Prophecy Particularly as Illustrated by the History of the Jews and the Discoveries of Modern Travellers. Here we find an acute drawback that was typical of travel photography during this period: images that were supposed to document the reality of a particular place ended up merely confirming an opinion of that place and its history. By this logic, photography, and also its graphic adaptation, was strictly required to prove a hypothesis: the theories upheld were corroborated by the images, regardless of whether those theories held up historically. Once a place had been photographed and a suitable caption provided, it became what one wanted it to be.

In any event, the trip to the Holy Land was one stage on the journey through the East. It was no accident, therefore, that it was undertaken by all the protagonists we have already met in Egypt, with the same expectations but with the accent more on religion. In a radical shift of perspective, the places associated with the pharaohs were replaced by those linked to Moses and Christ.

It has been rightly noted that French photographers saw Palestine in a more detached way than their British counterparts, due to the more prominent role played by the Bible in the Protestant religion: "While religious training in England was intimately concerned with reading the Bible and integrating its lessons into secular life, French religious instruction centred instead on the elements of the Catholic creed. As a result, the geography of the Bible was as familiar to an Englishman as the geography of his own village or estate, while most Frenchmen would recognise places as being 'biblical' without the specificity that came from long study of the Scripture. An English traveller probably could quote scriptural references for every location he passed on his Holy Land tour."[18]

Moreover, Palestine was crucial to Britain's control of the area, where it firmly established its presence through a carrot-and-stick strategy of economic support and political domination, which would bring results at the close of the century.[19] Sergeant James McDonald, a photographer

16. Goupil & Cie
Bachi-Bouzouk (after Jean-Léon
Gérôme), 1869–70
Galerie Photographique n. 753
Albumen silver print, 21.2 x 17.2 cm
Bordeaux, Musée Goupil Collection

17. Goupil & Cie
Slave Market, 1890–93
*Galerie photographique sur bristol
noir*, n. 468
Albumen silver print, 24.6 x 18.9 cm
Bordeaux, Musée Goupil Collection

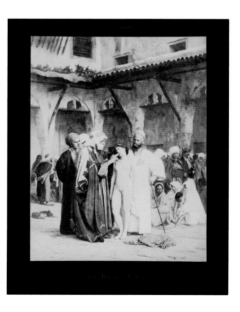

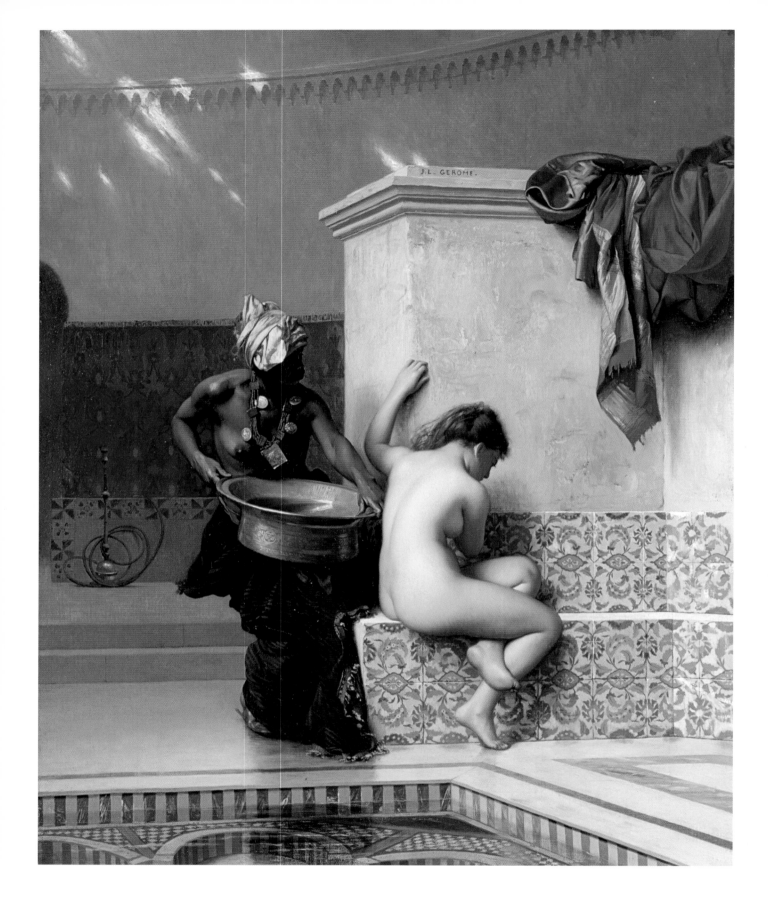

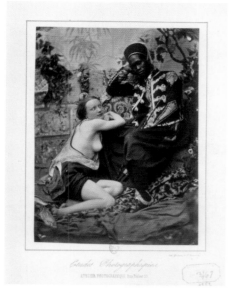

19. Félix-Jacques-Antoine Moulin
Young, half-naked woman, 1852
Paris, Bibliothèque nationale de
France, Département des estampes
et de la photographie

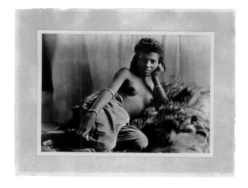

20. Anonymous
Young woman, ca. 1870
Aristotype
Venice, Fondazione di Venezia,
Fondo Italo Zannier – Collezione della
Fondazione di Venezia

21. Anonymous
*Half-naked woman reclining
on a sofa*, 1852
Stereoscopic daguerreotype
Austin, The University of Texas, Harry
Ranson Center, Gernsheim Collection

Opposite
18. Jean-Léon Gérôme
Moorish Bath, 1870
Oil on canvas, 50.8 x 40.6 cm
Boston, Museum of Fine Arts

with the Royal Engineers who participated in a British mission to the area, provided one of the most complete pictures of the places and their inhabitants between 1864 and 1869, by alternating characteristic architectural views with skilled renderings of landscape and local colour. One only has to look at McDonald's *Entrance to the Church of the Holy Sepulchre* of 1864 to see that his approach differed enormously from the strictly documentary and archaeological gaze of Du Camp or Salzmann, and also from the widespread practice of eliminating contemporary figures and everyday life from the holy places.[20] A practice that reflects the dismay experienced by photographers on seeing the decline of Jerusalem, as if by focusing their gaze solely on the architecture they could in some way eliminate the present and continue to evoke the past, an approach which, as we have seen, pervaded the entire European experience of the Orient. There were two options: eliminate the inhabitants or reduce them to walk-ons. In images of Egypt the figures were often present in the streets as well, as is evident from Lenoir's comment about the "soldiers of ornament" in the fourth opening quote, or were products of the imagination where eroticism and exoticism met in fabled harems (Figs. 18–21);[21] whereas in Palestine the link between the Christian imagination and actuality is not so easily established. An extreme solution that was effective in its way, and certainly revealing, was the one reached by Frank Mason Good, a moderately talented English photographer and former assistant to Francis Frith – who not only accompanied his views of landscapes with Bible quotes, but literally staged *tableaux vivants*, as in *Jacob's Well near Shechem* (Fig. 22). It is interesting to note that Mason Good does not push the language of photography beyond the limits of realism, but plays with considerable skill on the conventions of representation underpinning the Western painting tradition: in fact, the five characters are all contemporary, even in their dress, thus lending realism and credibility to the image, while their arrangement in the space, with the standing figure in the middle, is unquestionably reminiscent of Christian iconography. Conscious of not being able to compete with the visual reconstructions of biblical events in painting, Mason Good chose to exploit the presumed realism of photography to affirm, yet again, a truth assumed

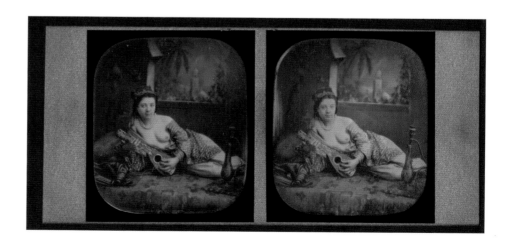

a priori, updating it solely in technical terms.[22] In this regard, Francis Frith's lesson was certainly crucial: following his three trips to the Middle East between 1856 and 1860, Frith had published an edition of the Bible illustrated with fifty-five photographs in 1862, which met with remarkable success and was reprinted several times.

In actual fact, the photographs were not taken with this specific aim in mind, indeed many of them had already been published in the album *Egypt and Palestine, Photographed and Described by Francis Frith* that came out in 1858. What Frith had intuited and realised was the actual possibility of transferring images from a documentary to a symbolic plane, since he was well aware of his public's expectations. A combination of aesthetic, religious and economic motivations informed the work of this photographer and entrepreneur, who was extremely adroit at managing images. Indeed, it was certainly not by chance that his enterprise was set up in exactly the same period as the partnership between Goupil and Gérôme, and that another English photographer, Francis Bedford, was officially appointed to document the tour in the East made by the Queen Victoria's son, the Prince of Wales. When you think about it, this was only seven years before the Thomas Cook travel agency organised its first cruise on the Nile.

Commerce and Punishment

In the year 1856, among those who travelled the Middle East armed with photographic equipment were Felice Beato and James Robertson, who had undertaken, and survived, an expedition to Crimea the previous year, where they had documented the war between Tsarist Russia and several European powers. The two photographers, accompanied by Felice's brother Antonio, were in fact just passing

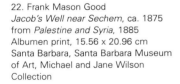
22. Frank Mason Good
Jacob's Well near Sechem, ca. 1875
from *Palestine and Syria*, 1885
Albumen print, 15.56 x 20.96 cm
Santa Barbara, Santa Barbara Museum
of Art, Michael and Jane Wilson
Collection

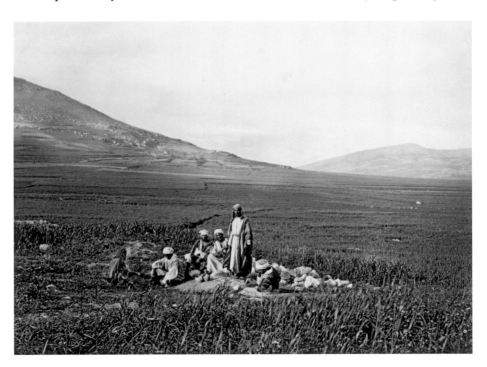

23. James McDonald
Entrance to the Church of the Holy Sepulchre from *Photographs of Jerusalem*, 1864
Albumen print, 19.7 x 24.8 cm
Santa Barbara, Santa Barbara Museum of Art, Michael and Jane Wilson Collection

24. James McDonald
Ecce homo Arch from *Photographs of Jerusalem*, 1864
Albumen print, 19.7 x 24.8 cm
Santa Barbara, Santa Barbara Museum of Art, Michael and Jane Wilson Collection

25. Félix Bonfils
The Tomb of Rachel, ca. 1870
Albumen print, 17.8 x 24 cm
Santa Barbara, Santa Barbara Museum of Art, Michael and Jane Wilson Collection

26. Félix Bonfils
Gate of Justice, The Seventh Station of the Cross, ca. 1870
Albumen print, 22.3 x 28 cm
Santa Barbara, Santa Barbara Museum of Art, Michael and Jane Wilson Collection

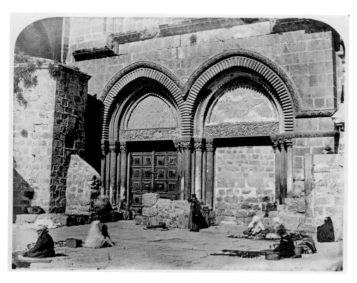

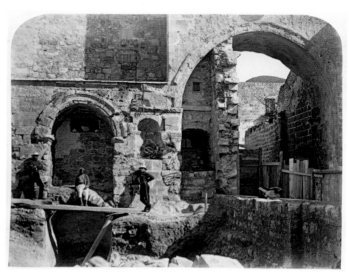

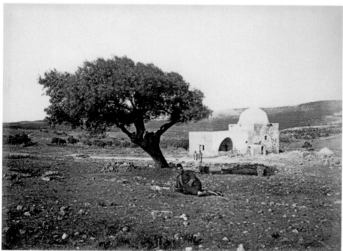

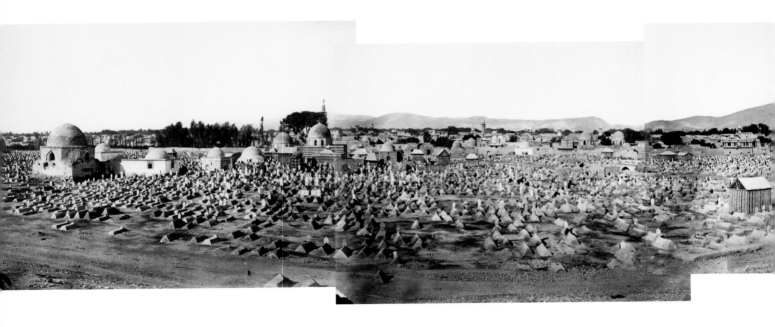

through, since their main aim was to reach India, where they would arrive in 1858. Two years later, Felice Beato headed towards China, and finally moved to Japan in 1863. The Grand Tour no longer appeared to have any geographical limits, and, above all, its original character had changed completely. The aims of travelling photographers like Du Camp, Teynard, and Salzmann were, as we have seen, mostly cultural and concerned with acquiring greater knowledge of the past. Through the years these aims did not disappear, but became secondary to financial motives linked to the possible commercial exploitation of photographs, and others linked to obtaining extensive information about areas to which the imperial European powers were extending their dominion.

The assignments undertaken by Felice Beato are illustrative of this. In Crimea, India and China he was always engaged in documenting episodes of war. In the former, he recounted the events involving British troops; in India, the Great Rebellion of 1857–58, quashed bloodily by the British army, and following which the country was proclaimed a British protectorate; and in China, the Opium War, which again saw Queen Victoria's army implementing a policy of colonial expansion. Beato was mainly a war photographer, but later on in his career he engaged solely in commercial activity. In fact, in 1863 he opened a photographic studio in Yokohama (Fig. 28). And again it was perhaps not by chance that another English photographer, Samuel Bourne, arrived in India that same year and soon went into partnership with his fellow countryman, Charles Shepherd, to open a studio in Calcutta, under the name Bourne & Shepherd, which was destined to do exceedingly well.

From "discovery" to conquest to commerce: a progression that paralleled the political developments of the period as much as the gradual industrialisation of the photographic product.

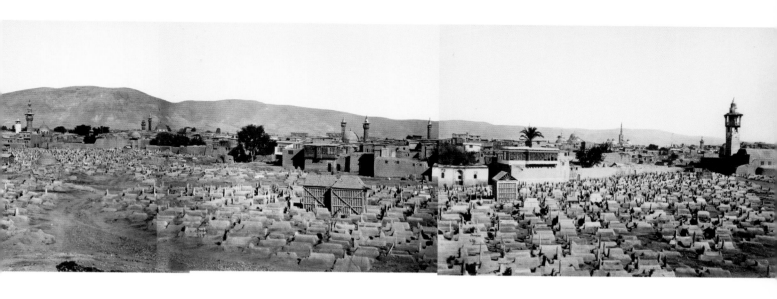

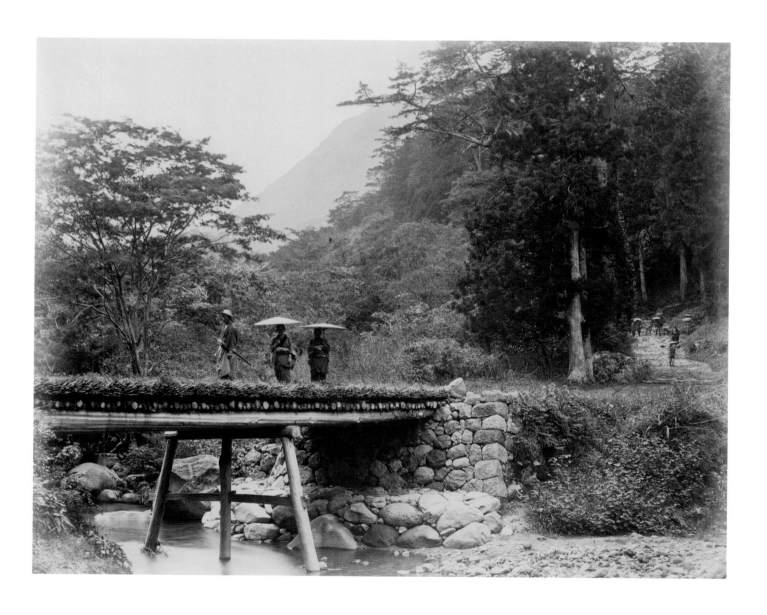

29. Willoughby Wallace Hooper
Indian servant and Master, Madras,
ca. 1870
Albumen print, 18.1 x 24.2 cm
London, The British Library

30. *Lurka Cole, aboriginal ('Fighting cole'), Chota Nagpoor*, plate 18, from *The People of India*, 1868–75
Albumen print
New York, The New York Public Library, Stephen A. Schwarzman Building, Photography Collection, Miriam and Ira D. Wallach Division of Art, Prints and Photographs

31. *Cole national dance, Chota Nagpoor*, plate 17, from *The People of India*, 1868–75
Albumen print
New York, The New York Public Library, Stephen A. Schwarzman Building, Photography Collection, Miriam and Ira D. Wallach Division of Art, Prints and Photographs

The Far East not only aroused curiosity, but also sold as well as the Middle East. Exoticism found new and fertile fields of application, but the cultural context within which photographers worked in India, China and Japan was substantially different from that in Egypt and Palestine. Rather than the remains of the origins of European civilisation, here it was a question of completely different civilisations, which could not even be classified as inferior. Hence the photographer's task was twofold, as was the attitude assumed by Europeans towards these places and peoples. On the one hand, it was still a question of documenting, studying, and introducing the Other to those back home (and possibly turning a profit); on the other it was a question of becoming familiar with and studying the Other, to make sense of a reality that was difficult to interpret precisely because it was radically other than oneself (Fig. 29).

In this regard, the fundamental stages of the activity of European photographers in India were symptomatic.[23] In 1855 the East India Company, the British trading enterprise that played a key role also in military and governmental affairs, was engaged in a census of Indian monuments and decided to replace draughtsmen with photographers once and for all – Arago's prophecy concerning the transcription of hieroglyphics had come true. The assignments were often given to army officers, such as Thomas Biggs, W. H. Pigou, and Linnaeus Tripe, who completed extensive photographic campaigns, to the extent that between 1857 and 1858 Tripe published as many as ten volumes illustrated with more than 300 photographs of exceptional documentary value.[24]

These were also the years of the Indian Revolt, which led to a bloody war that ended in 1858 with a British victory. As we have seen, Felice Beato went to India to photograph such events, and on part of his trip he was accompanied by a British officer, Robert Tytler, and

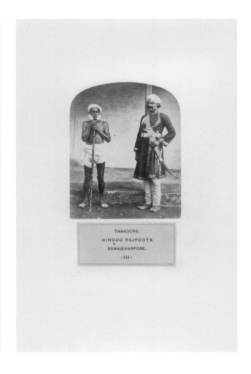

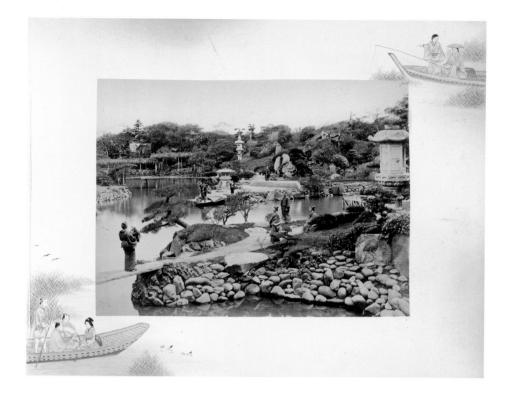

Opposite, bottom right
32. *Thakoors, Hindoo Rajpoots, Shahjehanpore*, plate 111, from *The People of India*, 1868–75
Albumen print
New York, The New York Public Library, Stephen A. Schwarzman Building, Photography Collection, Miriam and Ira D. Wallach Division of Art, Prints and Photographs

33. Kazuma Ogawa
The Hotsuta Garden, Tokyo, ca. 1880
Albumen print coloured by hand with watercolours, 19.8 x 25.2 cm
London, The British Library

34. Felice Beato
Japanese Woman Putting on Make-up, ca. 1863
Hand-coloured albumen print, 20 x 16 cm
Florence, Raccolte Museali Fratelli Alinari (RMFA), collezione Malandrini

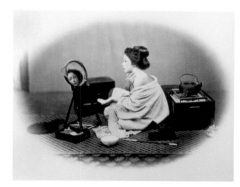

35. Samuel Bourne
Gateway Hosseinabad, Group of Thatch Shelter with Food and Goods Nearby, 1863
Albumen print, 30.48 x 22.86 cm
Washington, D.C., Smithsonian Institution, National Anthropological Archives

his wife, Harriet, who also took some photographs of the battlefields. These scenes were never shot live, but always after the event; indeed, Beato reconstructed some episodes in a particularly violent way, and of course these were the ones that were sent home, and of which engravings were made for publication in the press. Photography assumed yet another role as a propaganda tool, and the images from India contributed in no small way to forming British public opinion on the events there.[25]

Although "second-hand" and interpreted by those who executed the graphics for the press on the basis of the photographs of those distant worlds, the accounts of current affairs took their place beside historical documentation. Once a tool of knowledge, photography had now become an instrument of persuasion, in much the same way as it had in Palestine, where it was used to confirm the truth of stories narrated in the Bible. But with one important difference: in Palestine the photographer was still concerned with the past, with a cultural heritage, while in this case he had a direct effect on contemporary life. This was an important development because it paved the way, at a conceptual level, for the most ambitious photographic project undertaken in India during this period: the ethnographic reconnaissance that was published in the eight volumes of *The People of India* between 1868 and 1875 (Figs. 30–32).

The idea of documenting not only the landscape and various types of architecture, but also lifestyles and people, in what would prove to be the most extensive classification of the Indian civilisation of the past and present, was realised thanks to the then Governor General Lord Canning, himself a keen photographer, and other English amateurs who in the mid-1850s had founded the first photographic societies in

the main Indian cities. In gathering the material, special importance was given to the depiction of different "types" that made up the Indian population. In 1865, when this work was considered complete, about a hundred thousand images were sent to London. In the next few years, two officials at the India Office, John Forbes Watson, and John William Kaye, selected about 500 photos. These were all portraits of the local population taken by various photographers, which, accompanied by a suitable caption, made up the volumes of *The People of India.*

Tool of knowledge, tool of persuasion, tool of ethnography: exoticism no longer seemed to be enough, not so much for the photographers or their European public, but for those in power. The magnificent images that Samuel Bourne created in the Himalayas on his three trips between 1863 and 1866 already belonged to the past to some extent, and in 1870 Bourne went back to England, leaving Shepherd to run the photographic studio, and devoting himself to photography in his spare time. Felice Beato was able to open a studio in Japan and to colour his landscapes and oriental-style genre scenes (Fig. 35–37).[26] In a subjugated India, photography was actually used as an instrument of power, through which the superiority of the white man could be shown, and hence British colonial policy justified, by means of another presumed truth, that of ethnography.

Heart of Darkness

Two years after Bourne had returned to his homeland, another great English travelling photographer, John Thomson, ceased his wanderings in the Orient and devoted himself to publishing and selling his images. From 1862 he had been active in China, also travelling and photographing in Thailand and Cambodia. Although there were not many foreign residents in China at this time, there was a flourishing photographic business that mainly took the form of portraiture and views for the European market. In many cases, the studios were run by the Chinese themselves, such as the most renowned ones belonging to Afong in Hong Kong, and Gong Tai in Shanghai. The situation was, therefore, quite different to the one analysed so far, in which Europeans played a dominant role in the creation of the photographic image of a country.[27] As a result, and despite the large number of photographs produced in China in the second half of the nineteenth century, Europe's image of the country was still linked to literary visions of it and to the objects that reached the Old Continent, especially on the occasion of Universal Exhibitions, which were crucial to the meeting of cultures and technologies (Fig. 38).[28] There is an observation in Thomson's preface to his collection *Illustrations of China and its People,* published between 1873 and 1874, that is quite in keeping with the cultural climate that developed in Europe during this period with respect to the relationship with the "Other". It is a well-known piece, part of which I would like to quote

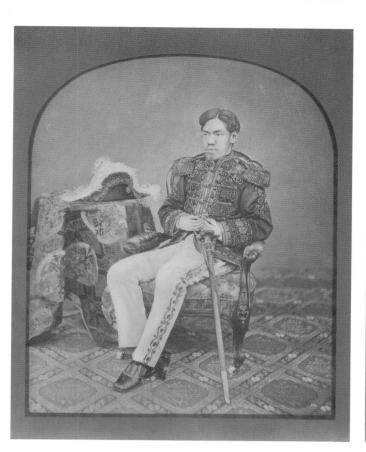

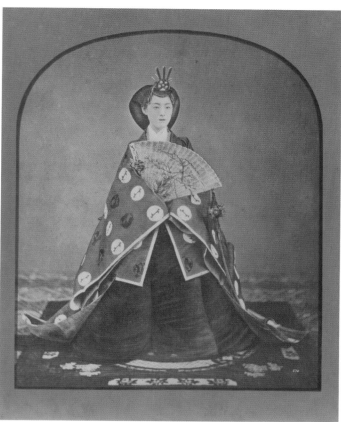

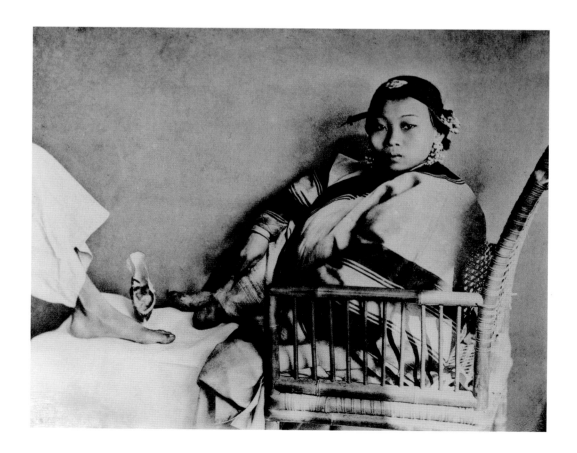

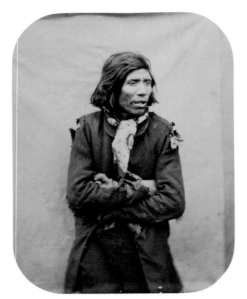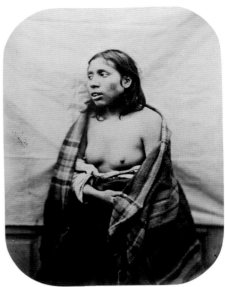

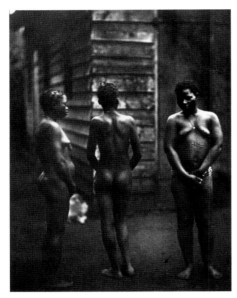

here: "I therefore frequently enjoyed the reputation of being a dangerous geomancer, and my camera was held to be a dark mysterious instrument, which, combined with my naturally, or supernaturally, intensified eyesight gave me the power to see through rocks and mountains, to pierce the very souls of the natives, and to produce miraculous pictures by some black art, which at the same time bereft the individual depicted of so much of the principle of life as to render his death a certainty within a very short period of years."[29] Even supposing that superstition existed to such a degree in various rural areas of China, Thomson's construct reveals his aim of meeting readers' expectations, on two counts: the first was the usual one of exoticism; the second that of stressing Europe's supremacy in the field of technology (although, given the many photographic studios run by Chinese, this supremacy is questionable to say the least). In addition, the shamanic nature of the photographer was accentuated in an ironical comment made by the author from the lofty height of his scientific knowledge, which was intended to further demonstrate the superiority of his own culture.

It was precisely these mechanisms that underpinned the photographic conquest of the last part of the world examined here, namely Sub-Saharan Africa. A conquest made relatively later than the others and modelled on similar lines, but with one important difference: the inhabitants of Sub-Saharan Africa were seen primarily and wholly as savages, as the most complete embodiment of "other than oneself". There was no past, no temple, no "civilisation" to document or to gaze at nostalgically, so the only thing to do be done was to justify the actions of the coloniser. This task was partly entrusted to morality and religion – as in the civilising mission that originated in the Napoleonic era – and partly to science, whose job it was to demonstrate the superiority of the whites to the blacks. For these reasons, we can legitimately conclude that the principle followed by travellers to Africa in the second half of the nineteenth century was diametrically opposed to the one followed by those who took the Grand Tour. In fact,

42. Albert Frisch
Amaus Indian of Amazon Basin,
ca. 1865
Albumen print, 23.7 x 18.5 cm
London, The British Library

43. Maurice Vidal Portman
*Keliwa, a woman of the Tàkéda tribe,
Andaman Island*, ca. 1893
Platinum print, 34.8 x 25.7 cm
London, The British Library

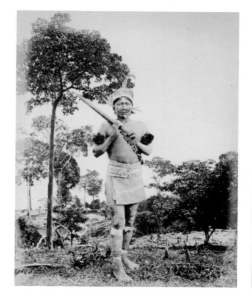
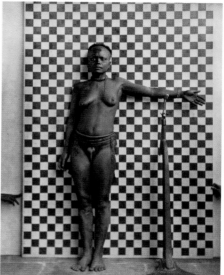

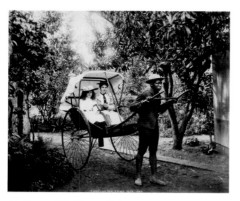

44. George Washington Wilson
Durban, Natal, South Africa, ca. 1890
Albumen print, 23.7 x 28.3 cm
London, The British Library

the latter travelled to gain knowledge and to enrich themselves intellectually, while the former went to Africa to bring knowledge and to enrich the savage with the achievements of their own civilisation and the righteousness of their own religion.

This interweaving of cultural, military, scientific, and religious motives characterised the conquest of black Africa also from a photographic point of view. Very few testimonies of the conquest have survived, at least until the 1860s, although the presence of daguerreotypists and photographers on scientific and military expeditions of the period is documented. It is therefore important to emphasise two aspects underlying Western culture's relationship with the "Other", which are extremely telling in this particular sphere.

The first concerns the centrality assumed by photography in the ambit of the "new" sciences of ethnology and anthropology. In fact, the populations of central and southern Africa were immediately subjected to scientific classification, as is clearly shown by the example given recently by Christine Barthe regarding certain daguerreotypes in the collections of the Musée de l'Homme in Paris. These images reveal a common approach that was both objective and documentary, whether the pictures were taken with specific ethnographic aims in the French capital, or by travellers in far-off lands and then brought back to France.[30] Photography proved to be an excellent means of demonstrating racial theories, and again Arago's urgent recommendation that the Institut d'Egypte be equipped with daguerreotype machines to count all the hieroglyphics comes to mind. The step from archaeology to anthropology was, in this case, shorter than it first appeared (Figs. 39–43).

The second concerns the exoticism linked to the pictures. Also in this case the subjects are the conventional ones, though taken to the extreme. John Thomson's view of the native populations as reacting in astonishment to the "magic box" is taken up almost obsessively in the narratives of the travellers in Africa. Indeed, it truly becomes a *topos* designed to confirm the technological superiority of Western

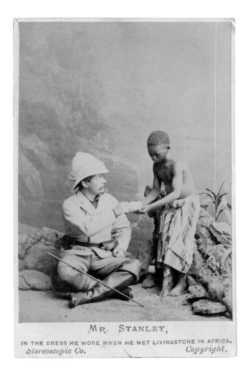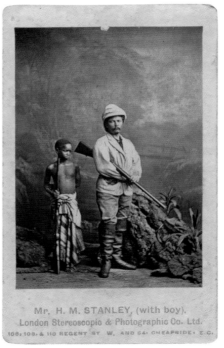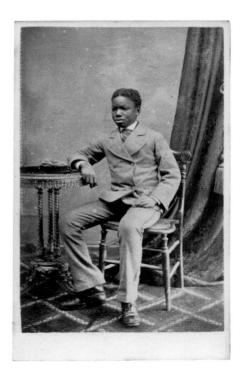

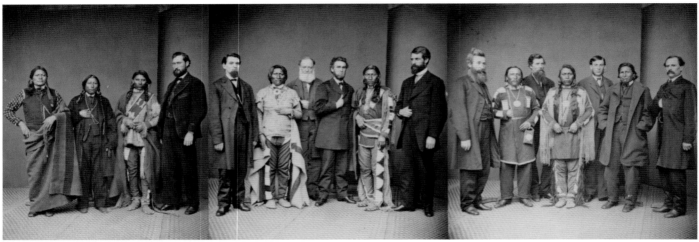

45. London Stereoscopic
& Photographic Company
*Sir Henry Morton Stanley and Kalulu
(Ndugu M'hali)*, 1872
Carte-de-visite, albumen print,
9 x 6.2 cm
London, National Portrait Gallery,
purchased, 1995
Photographs Collection NPG x45981

46. London Stereoscopic
& Photographic Company
*Sir Henry Morton Stanley and Kalulu
(Ndugu M'hali)*, 1872
Carte-de-visite, carbon print,
8 x 5.4 cm
London, National Portrait Gallery,
Gift of Roger Altass, 2006

47. H. Morris
Kalulu (Ndugu M'hali), ca. 1870
Carte-de-visite, albumen print,
9.3 x 6 cm
London, National Portrait Gallery,
Purchased, 1996
Photographs Collection NPG x76514

civilisation, which has its equivalent in the military one, and both of which are a natural consequences of the religious and racial ones (Fig. 44). The first *topos* has always been linked to another, as the testimonies of the Spanish and Portuguese conquests of the Americas in the fifteenth and sixteenth centuries show, on which Europe's image of the "Other" to be conquered was founded: the myth of the "noble savage".[31] A most complex theme, but here we shall concentrate on two developments that took place in the last part of the nineteenth century.

One consists in images of the tamed savage, different types of which appeared during this period. The first is to be found in the postcards printed in 1872 depicting Henry Morton Stanley – the explorer who found Dr Livingstone in the heart of Africa, which gave rise to the story that did the rounds of Great Britain and the rest of the world – together with his young servant Kalulu, who unfortunately died at the age of thirteen on a Congo expedition. The scene represented, with a

Opposite, bottom
48. Mathew Brady Studio
Ute Delegation, ca. 1868
Silver print, 17.8 x 49.8 cm
Washington, D.C., National Portrait
Gallery, Smithsonian Institution

49. Benedicte Wrensted
Pat Tyhee in Native Dress, ca. 1898
Carte-de-visite, albumen print
Washington, D.C., Smithsonian
Institution, National Anthropological
Archives, Eugene O. Leonard Collection

50. Benedicte Wrensted
Pat Tyhee after Conversion, ca. 1899
Carte-de-visite, albumen print
Washington, D.C., Smithsonian
Institution, National Anthropological
Archives, Eugene O. Leonard Collection

Bottom
51. J. Davis
Samoa's Princess Fa'ane, Apia, 1893
Albumen print
Salem (Mass.), The Peabody Essex
Museum

typical African setting reconstructed in the studio, is literally one of submission, without any attempt at masking it (Figs. 45–47).

The other typical depiction of the subject can be described as "before" and "after", as shown in two photographs taken in a different geographical and cultural area, but whose ideological premises were basically similar to those of images linked to the colonisation of Africa. They are two portraits of Pat Tyhee, an American Indian of the Shoshone tribe, taken at Pocatello, Idaho, by a female photographer of Danish origin named Benedicte Wrensted, who emigrated to the United States in 1894. While the background remains the same, the subject undergoes radical changes, in the sense that in one picture he is dressed in the American Indian tradition (or rather according to the codified image of that tradition), and in the second photo, probably taken the following year, he is wearing Western dress, after becoming a Christian (Figs. 49–50). Religion and culture were assimilated following subjugation, the education of the "noble savage" was complete and he could be part of civilised society (Figs. 48, 51).

However, as we have said, there was another development in this area that consisted in Western culture questioning itself precisely as a result of its confrontation with the Other. When the Grand Tour was no more, and empires had been formed and firmly established also visually, there were those who began to have doubts about the very individual and collective concepts on which the conquests were founded.

At the end of the nineteenth century, while Europe was being flooded with images which, between ethnography and cheap exoticism, confirmed its superiority to the rest of the world, a series of events occurred that brought to an end this chapter in the history of travel photography, among other things. Thomas Cook organised his first trip around the world in1872; George Eastman gave tourists the Kodak

52. Kader Attia
The body as target and object of power, 2010
Slide projection on maps, series of three unique works
UniCredit Group collection, on permanent loan at Mart, Museo di Arte Moderna e Contemporanea di Trento e Rovereto

camera in 1888, with which they could snap the exotic places they visited themselves; Paul Gauguin left for Tahiti in 1891; Joseph Conrad's *Heart of Darkness* – actually inspired by a trip he made on the River Congo in 1890 – was published in *Blackwood's Magazine* in 1899, and Victor Segalen began to wander the world, making notes for his *Essai sur l'Exotisme*, never completed, in which he poses the following question: "Ils ont dit ce qu'ils ont vu, ce qu'ils ont senti en présence des *choses* et des gens inattendus dont ils allaient chercher le choc. Ont-ils révélé ce que ces choses et ces gens pensaient en eux-mêmes et d'eux?" The twentieth century could begin. At the dawn of the twenty-first century, that part of history lives on in the maps and the exotic postcards that comprise a work by the artist Kader Attia, a poetic yet ruthless reflection on visual appropriation and an exhortation not to forget history and how much of it has been constructed by images (Fig. 52).

1 E. Gibbon, *The Decline and Fall of the Roman Empire,* Strahan & Cadell, London 1776–1788, Vol. I, Ch. 2, "Of the Union and Internal Prosperity of the Roman Empire in the Age of the Antonines", cited by http://www.ccel.org/g/gibbon/decline/home.html

2 W. H. Bartlett, *Walks about the City and Environs of Jerusalem,* London 1843 (cited in K. Stewart Howe, *Revealing the Holy Land,* exhib. cat., Santa Barbara Museum of Art, 1997, p. 16).

3 F. Wey, "Voyages héliographiques: Album d'Égypte de M. Maxime Du Camp", in *La Lumière,* September 1851 (cited in J. Ballerini, "Orientalist Photography and Its 'Mistaken' Pictures", in various authors, *Picturing the Middle East – A Hundred Years of European Orientalism,* Dahesh Museum, New York 1996, p. 24).

4 P. Lenoir, cited in E. Strahan, *Gérôme: A Collection of the Works of J. L. Gérôme in 100 Photogravures,* Samuel L. Hall, New York, 1881 (cited in S. R. Edinin, 'Gérôme's Orientalisms', in various authors, *Gérôme & Goupil – Art and Enterprise,* Réunion des Musées Nationaux, Paris 2000, p. 124).

5 Among the many examples, it is worth noting, with regard to the Middle East, the daguerreotypes that had already been made by Frédéric Goupil-Fesquet at the end of 1839 in Egypt while travelling there with Horace Vernet; the ones taken by Pierre-Gustave Joly de Lotbinière in February of the following year, and those executed by Joseph Philibert Girault de Prangey in 1842–43, the latter being the only ones that have survived. Where Italy is concerned, more testimonies have come down to us, the 28 plates (out of a total of 111) devoted to Italian monuments to mention just one, from which aquatints were made for the celebrated volume by Noël Marie Paymal Lerebours, *Excursions daguerriennes: vues et monuments les plus remarquables du globe* published between 1842 and 1844. In the mid-1840s, the popularisation of photographs printed on paper produced a wealth of images, albums and volumes that played a crucial part in the creation of Italy's image and that of the Middle East, also in the years to come, some of which will be treated separately later. On the daguerreotype in France, see Q. Bajac and D. Planchon-de Font-Réaulx (eds.), *Le Daguerréotype français. Un objet photographique,* exhib. cat., Musée d'Orsay – Réunion des Musées Nationaux, Paris 2003, and the bibliography contained therein.

6 The most revealing example of this is the so-called "Scuola romana di fotografia" that met at the Caffé Greco in Rome from the 1840s on, and whose leading lights were the Frenchmen Frédéric Flachéron and Eugène Constant, the Italians Giacomo Caneva, Gioacchino Altobelli and Pompeo Molins, the Englishman James Anderson, and the Scotsman Robert MacPherson. Fundamental to Roman photographic culture was the visit of Calvert Richard Jones, who introduced the calotype in 1846. However, 19th-century photography in Italy was represented entirely by photographers who combined their knowledge of the new tool with an artistic and archaeological education, from the daguerreotypist Lorenzo Suscipj to John Ruskin, Carlo Naya, Tommaso Cuccioni and Giorgio Sommer. On the relationship between painting and photography during this period, see the classic P. Galassi, *Before Photography: Painting and the Invention of Photography,* Museum of Modern Art, New York 1981. For a concise overview of 19th-century Italian photography, see M. Miraglia, "Note per una storia della fotografia italiana (1839–1911)", in *Storia dell'arte italiana,* vol. 9, Einaudi, Turin 1981.

7 E.J. Leed, *Memoria e ricordo : il ruolo dei dipinti nel Grand Tour in Italia,* in C.De Seta (eds.), *Grand Tour. Viaggi narrati e dipinti,* Electa, Napoli 2001, p. 19. It should be noted that although Leed refers expressly to painting and drawing, he uses terminology that is completely photographic. By Leed see also *The Mind of the Traveller: From Gilgamesh to Global Tourism,* Basic Books, April 1991.

8 A vast literature exists on the photographic Grand Tour in Italy. For an overview, we refer the reader to the recent U. Pohlmann (ed.), *Voir l'Italie et mourir. Photographie et peinture dans l'Italie du XIX siècle,* exhib. cat., Musée d'Orsay–Skira/Flammarion, Paris 2009, and to the exhaustive bibliography contained therein.

9 Apropos of the presence of Ancient Egypt in European culture, see J. M. Humbert, M. Pantazzi, and C. Ziegler (eds.), *Egyptomania – L'Égypte dans l'art occidental 1730–1930,* Réunion des Musées Nationaux, Paris 1994. Clearly, the use of the term "Orientalism" is inextricably linked to Edward Said's considerations in his epoch-making *Orientalism,* Pantheon Books, New York 1978.

10 M. Du Camp, *Egypte, Nubie, Palestine et Syrie,* Paris, 1852; F. Teynard, *Égypte et Nubie,* Paris 1854; Louis de Clerq, *Voyage en Orient,* Paris, 1859–60, 6 vols. The bibliography on photography in the Middle East is vast, and we mention only the essential volumes: N. N. Perez, *Focus East: Early Photog-*

raphy in the Near East 1839–1885, Harry N. Abrams, New York 1988; K. Howe, *Excursions along the Nile: The Photographic Discovery of Ancient Egypt,* cat. Santa Barbara Museum of Art, Santa Barbara 1993; D. Gregory, "Emperors of the Gaze: Photographic Practices and Productions of Space in Egypt, 1839–1914", in J. Ryan and J. Schwartz (ed.), *Picturing Place: Photography and Geographical Imagination,* I. B. Tauris, London 2003, to which we refer the reader for a general treatment of the topics under examination.

[11] From the 1860s, many photographic studios were opened in this region, revealing a growing commercial as well as cultural interest. These included the one started by the German Wilhelm Hammerschmidt in Cairo in 1860, and by Bonfils, who set up in Beirut in 1867.

[12] David Roberts is one of the most typical representatives of European culture in the first half of the 19th century: first he depicted the Orient by drawing exclusively on literature then personally visited the places he had portrayed. His *Departure of the Israelites* of 1829, an extraordinary bric-a-brac of archaeology and religion, was transformed into a colossal diorama in 1833.

[13] F. Frith, in *The Art Journal,* London 1859, cited in H. Gernsheim, *The Rise of Photography – 1850–1880. The Age of Collodion,* Thames and Hudson, New York 1988.

[14] A. Saltzmann, *Jérusalem. Etudes et reproductions photographiques de la Ville Sainte depuis l'epoque judaïque jusqu'à nos jours,* 2 vols., Paris 1856.

[15] Apropos of pictorial Orientalism, see within the vast bibliography at least the essential L.Thornton, *Les Orientalistes Peintres-Voyageurs,* ACR, Paris 1994; J. MacKenzie, *History, Theory and the Arts* (though critical of Said's theories), Manchester University Press, 1995, the more recent G. G. Lemaire, *The Orient in Western Art,* Könemann, Cologne 2001 and K. Davies, *The Orientalists,* Laynfaroh, 2005, to whose bibliographies we refer the reader.

[16] In this regard, see op. cit. various authors, *Gérôme & Goupil – Art and Enterprise,* Réunion des Musées Nationaux, Paris 2000. By the beginning of the 20th century, for example Coupil's company had reproduced as many as 122 paintings by Gérôme in different formats and using diverse techniques.

[17] S. Aubenas, *Voyage en Orient,* Bibliotèque Nationale de France – Hazan, Paris1999. Due importance should also be given to the fact that Gérôme was a favourite pupil of Paul Delaroche who, although he himself did not practice photography, suggested that Gérôme make use of it.

[18] K. Stewart Howe, *Revealing the Holy Land,* op. cit., p. 28. On this topic see also Y. Nir, *The Bible and the Image: The History of Photography in the Holy Land 1839–1899,* University of Pennsylvania Press, Philadelphia 1985.

[19] In fact, the number of photographic representations of the Middle East attributable to amateurs who were in this region either as diplomats or soldiers is by no means small. A case in point is the photographic reconnaissance of Qajar Persia executed by the Italians Luigi Pesce, in the second half of the 1880s, and Luigi Montabone, at the beginning of the following decade. In this regard, and also for an exhaustive bibliographical reconnaissance of the history of the origins of photography in Iran, we refer the reader to the recent M. F. Bonetti and A. Prandi (eds.), *La Persia Qajar – Fotografi italiani in Iran 1848–1864,* exhib. cat. Istituto Nazionale per la Grafica – Peliti editore, Rome 2010.

[20] McDonald's photographs were published in *Ordnance Survey of Jerusalem* of 1864 and *Ordnance Survey of the Peninsula of Sinai* of 1869. Another photographer who offers a personal vision of these lands, though of unexceptional quality, is the Reverend George W. Bridges, whose volume *Palestine As It Is* was published in London in 1858.

[21] The interweaving of eroticism and exoticism was increasingly pronounced through the years and most widespread in the early part of the 20th century. Typical in this regard is the production of the company Lehnert & Landrock, set up by a Bohemian and a German who settled first in Tunis and later in Cairo, where they contributed to creating the most popularised image of the Orient modelled precisely on the principles of Orientalist painting in the previous century.

[22] Moreover, this approach is evident in the depictions of the harem that abounded in European painting during the 19th century, and were often based on photographs in which local female models were posed according to the canons of Western painting.

[23] Several daguerreotypists were active in India during this period, such as Alphonse Ittier, who later went to China, and Alexis de Lagrange, but extremely few testimonies remain. On the origins and early years of the history of photography in India, see C. Fontana, "Cronache di pittori, disegnatori e incisori, soldati fotografi, ambulanti e fotografi commercianti nelle Indie della Regina Vittoria", in *Rivista di Storia e Critica della Fotografia,* II,

no. 3, July–October 1981, pp. 8–36; V. Dehejia (ed.), *India Through the Lens. Photography 1840–1911,* Prestel, 2001; J. Falconer, *India Pioneering Photographers 1850–1900,* British Library, London 2002; M. A. Pellizzari (ed.), *Traces of India: Photography, Architecture and the Politics of Representation 1850–1900,* Yale University Press, New Haven 2003.

[24] A noteworthy contribution was also made by John Murray, a physician who documented the area of Delhi and Agra in particular, in a photographic book also published in 1858. In 1870, these materials and many others gathered through the years were systematised through the establishment of the Archaeological Survey of India.

[25] In this regard, see A. Blunt, "Home and Empire: Photographs of British Families in the *Lucknow Album,* 1856–57", in J. Ryan and J. Schwartz (eds.), *Picturing Place: Photography and Geographical Imagination,* op. cit., pp. 243–60.

[26] It is interesting to note that Beato created an actual school, the so-called "Yokohama School", whose leading exponent was Kusakabe Kimbei. There is now a vast bibliography on the evolution of photography in Japan. For an overview see A. Tucker, *The History of Japanese Photography,* Yale University Press, 2003, with relative bibliography.

[27] On the origins of photography in China, see C. Fontana, "Cronache di commercianti, ambulanti e indigeni fotografi nella Cina imperiale", in *Rivista di Storia e Critica della Fotografia,* op. cit., pp. 37–50.

[28] It was certainly not by chance that the concept of the Universal Exhibition was institutionalised in 1851 when the "Great Exhibition of the Works of Industry of All Nations" opened in London, attracting over six million visitors. The birth and spread of photography, Universal Exhibitions, and organised tourism can in fact be traced to the same cultural climate.

[29] J. Thomson, *Illustrations of China and its People,* Sampson Low, Marston Low and Searle, London 1873 (cited by R. Valtorta, *Il pensiero dei fotografi,* Bruno Mondadori, Milan 2008, p. 46).

[30] C. Barthe, "'Les éléments de l'observation'. Des daguerréotypes pour l'anthropologie", in Q. Bajac and D. Planchon-de Font-Réaulx (eds.), *Le Daguerréotype français. Un objet photographique,* op. cit., pp. 73–86. Barthe's long, in-depth study can be summed up by a consideration made in 1845 by E. R. A. Serres, who held the Chair of Anatomy and Natural History of Man at the Muséum National d'Histoire Naturelle in Paris, according to whom photography was "one of the most valuable acquisitions for furthering the progress of the science of man", and could be considered "a tool of discovery for the sciences". We should not underestimate the fact that this was the period in which ethnography, zoology, and the nascent science of anthropology, were considered part of the same system of scientific knowledge.

[31] For an analysis of these topics, see T. Todorov, *The Conquest of America,* Harper & Row 1984 (original edition, Editions du Seuil, Paris 1982). An interesting reading of issues linked to the subject of Western photography in Africa, even though the text itself makes specific reference to a later period, can be found in the chapter entitled "Photography at the Heart of Darkness", in N. Mirzoeff, *Bodyscape,* Routledge, London and New York 1995, pp. 135–61.

- Guillaume-Benjamin-Amand Duchenne (de Boulogne)
- André-Adolphe-Eugène Disdéri
- Mathew B. Brady
- Alexander Gardner, George N. Barnard
- Carleton E. Watkins, Timothy O'Sullivan
- Henry Peach Robinson, Julia Margaret Cameron

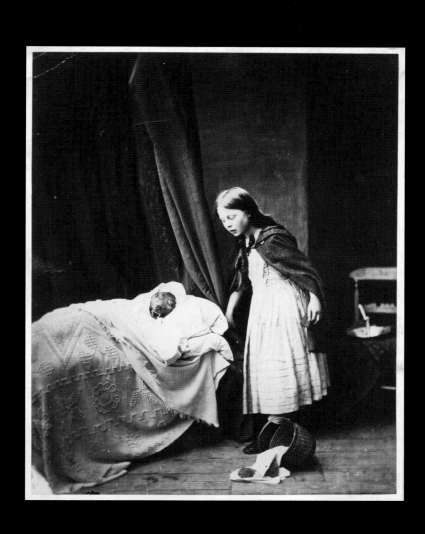

Guillaume-Benjamin-Amand Duchenne (de Boulogne)

Mécanisme de la physionomie humaine, ou analyse électro-physiologique de l'expression des passions applicable à la pratique des arts plastiques

Paris: Jules Renouard, 1862

The cultural climate halfway through the nineteenth century was characterised by a marked vein of positivism and determinism, the expression of an industrial middle class wholly committed to science and progress. This condition was unquestionably conducive to the birth of photography, the apparently automatic nature of which was initially celebrated (consider the expression "mirror with a memory" coined for the daguerreotype in 1861 by Oliver Wendell Holmes in the pages of the *Atlantic Monthly*, and above all the description of the calotype as the "pencil of nature" in the title of Talbot's first book). It was therefore adopted as a key scientific instrument for the investigation and objective transcription of the data of reality. Science made use of the photographic medium in order to demonstrate its theories, and it was within this system that a project was launched by the French neurologist Guillaume-Benjamin Duchenne de Boulogne, who published the first photographically illustrated study of facial expressions in 1862. In specific terms, Duchenne sought to examine the role of every single muscle in the formation of these particular forms of non-verbal communication, so as to catalogue them in an anthology constituting a sort of new grammar of the human drives. *Mécanisme de la physionomie humaine, ou analyse électro-physiologique de l'expression des passions applicable à la pratique des arts plastiques* is the complete title of this work, published by Jules Renouard in three editions with some differences in content and format. The seventy-four albumin prints presented in the most extensive version, which in turn include a total of 228 images, were taken with the aid of the photographer Adrien Tournachon, brother of the more famous Félix Nadar, five of Duchenne's patients at the Salpêtrière (then the major "lunatic asylum" in Paris), and a young sculptor specialising in the production of wax models. Despite the collaboration of a professional, the technique used was not particularly advanced, and the subjects evincing the broad range of expressions were required to hold their poses for prolonged periods with no effort to reduce their duration. At the same time, they were kept immobile through subjection for the entire period of exposure to electrical stimuli administer through probes attached to specific areas of the face in accordance with the expressions to be triggered. The expressions

recorded were thus artificially induced rather than discovered in normal situations. While this would be regarded as "staging" in the sphere of artistic representation, it was standard practice in science, and the results were so accurate that Charles Darwin took a particular interest in this work, of which he actually possessed two copies (a smaller *in-ottavo* edition, and a very rare and luxurious unbound *in-quarto* edition). By permission of the author, he also used eight illustrations from it for the publication of his own *Expression of the Emotions in Man and Animals* (John Murray, London 1872). Two of these, regarding the manifestation of the strongly dramatic feelings of terror and agony, were reproduced through copies specially engraved in order to eliminate the probes attached to the subject's face, thus avoiding any distraction and attenuating the cruelty of a process that displays a certain degree of sadism despite Duchenne's assurances that it was all substantially harmless. They were all accompanied by the photographs that Darwin commissioned for his study from Oscar Gustave Rejlander, a great artist of the time.

Despite the criticisms of *Mécanisme* for the use of sick and suffering subjects, its substantial disregard for elements of context, and the exaggeration of some grimaces – criticisms against which Darwin's appreciation provided some support – Duchenne also attached artistic significance to his images. It is for this reason that he apologises in the work itself for selecting as his primary iconographic subject "an old, toothless man, with a thin face, whose features, without being absolutely ugly, approached ordinary triviality, and whose facial expression was in perfect agreement with his inoffensive character and his restricted intelligence". This is justified on the grounds that the man was suffering from facial paralysis preventing any voluntary reaction, which therefore made him a perfectly suitable subject for the experiments with electrodes. The intention was in fact to "offer the art world a positivist corrective to the historically 'arbitrary' representation of emotion", while at the same time examining the idea of beauty and seeking to trace the canons of the aesthetic pleasure of human expressions. The third and final section of the work (*Partie esthétique*, An Aesthetic Section) was entirely devoted to this purpose after the initial series of general observations on physiology, and the subsequent scientific study (*Partie sceintifique*, A Scientific Section). An attractive and nearly blind female model was used to display very complex emotions, with or without the aid of electrical stimuli, including some of those evinced by Shakespeare's Lady Macbeth and her own authentic religious fervour. For Duchenne, the soul ultimately remains the original cause of the facial expressions, albeit mixed up with the human passions, to the point where the oval of a "woman's spirit being exalted by her ardent faith" reveals all the sexual ambiguity already carved by Bernini in the white marble of his *Ecstasy of Saint Theresa*. In putting together and exploring an immense compendium of the superficial emanations of the instincts of the species to which he belonged, Duchenne unquestionably expressed his own, first and foremost, through his pioneering and disturbing work.

Bibliography
Darwin, Charles. *Expression of the Emotions in Man and Animals*. London: John Murray, 1872.
Mathon, Catherine. *Duchenne de Boulogne*. Paris: École nationale supérieure des beaux-arts, 1999.
Prodger, Philip. *Darwin's Camera. Art and Photography in the Theory of Evolution*. New York: Oxford University Press, 2009.
Thomas, Ann. *Beauty of Another Order. Photography in Science*. New Haven: Yale University Press, 1997.

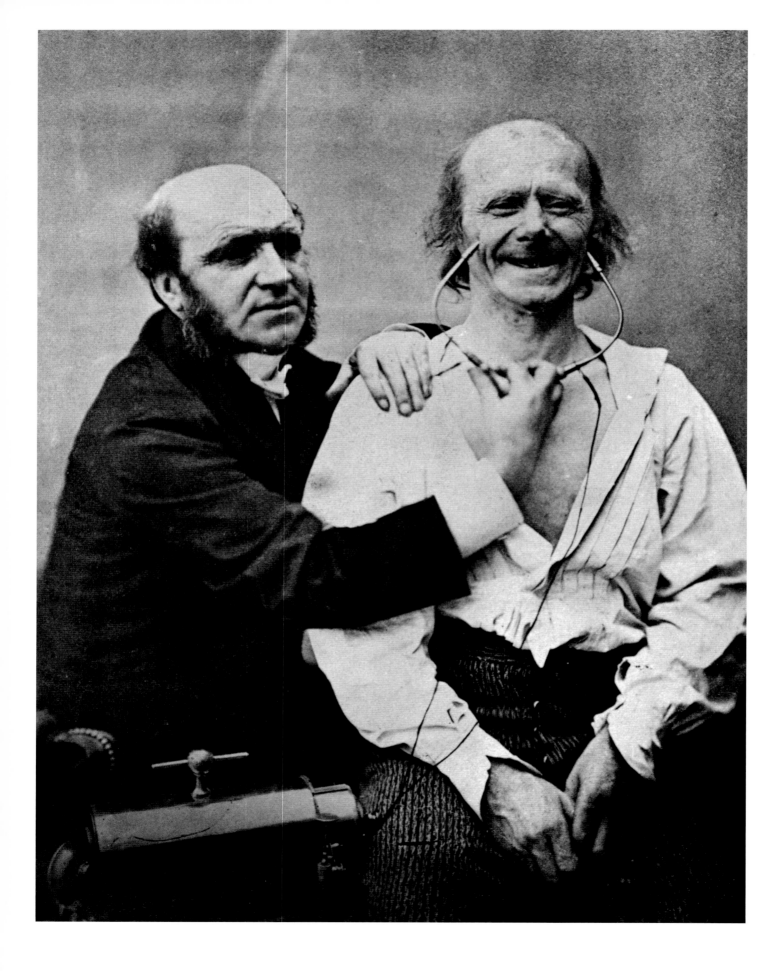

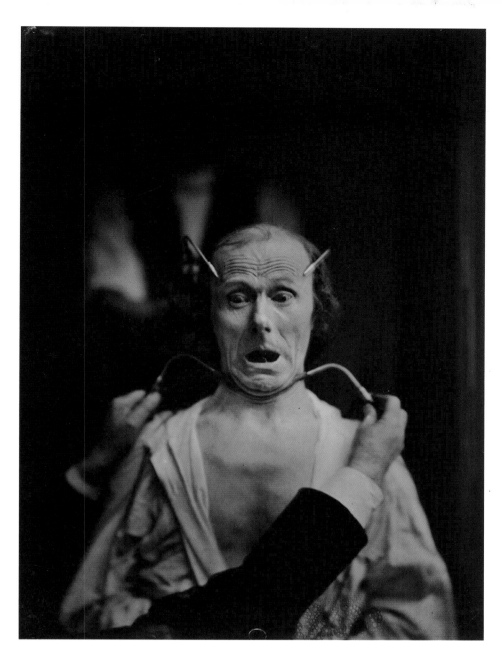

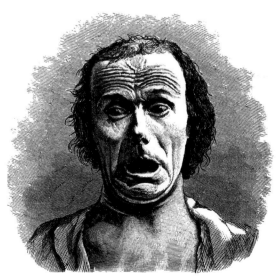

Physician Makes Patient Laugh,
ca. 1854
Albumen print
London, The British Library

James Davis Cooper
after Duchenne de Boulogne
Terror, 1872
Wood engraving
Cambridge University Art Library,
Darwin Papers

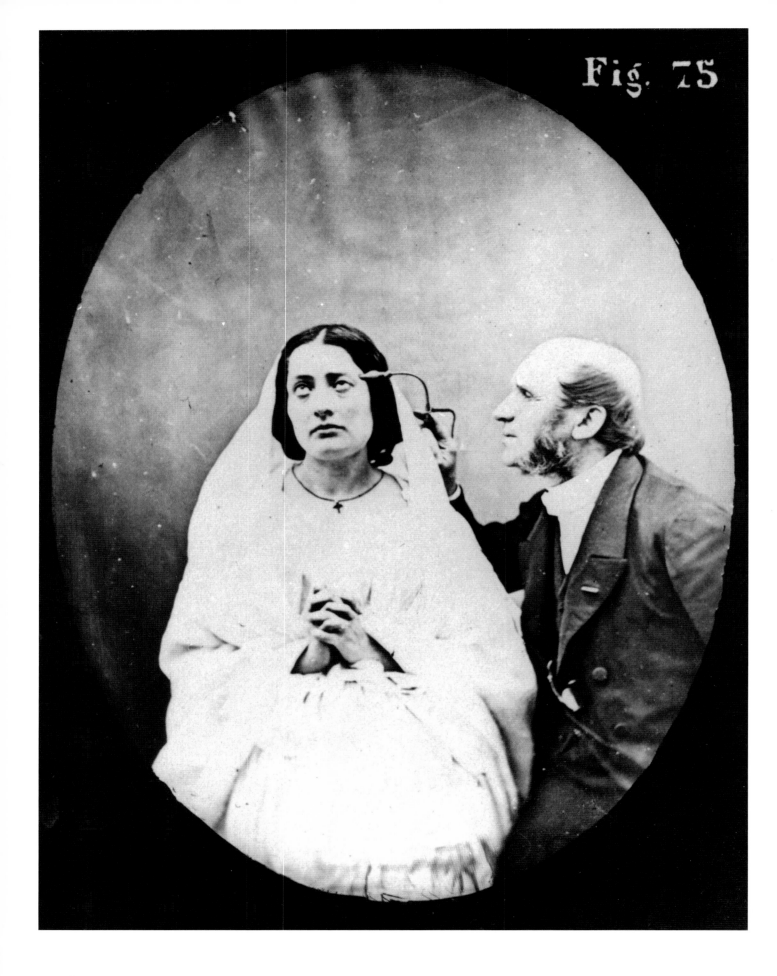

Fig. 75

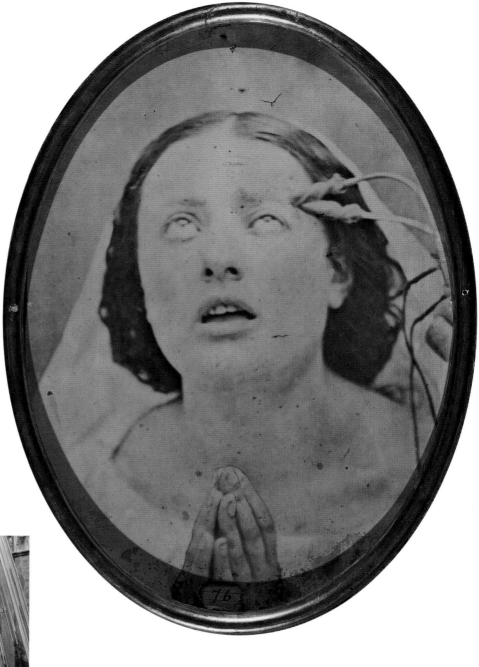

Physiognomical examination,
ca. 1862
Albumen print
Paris, Académie de Médecine,
Archives Charmet

*Woman's Spirit Being Exalted
by Her Ardent Faith*, ca. 1862
Albumen print
Paris, École nationale
des beaux-arts

Gian Lorenzo Bernini
Ecstasy of Saint Teresa,
1647–1652
Marble and gilded bronze,
h. 350 cm
Rome, Santa Maria della Vittoria,
Corsaro Chapel

L'art de la photographie

Paris: 1862 (self-published)

It was in 1854 that André-Adolphe-Eugène Disdéri, a French photographer of Italian origin, patented the *carte de visite*, a small photograph glued onto a card measuring about 10 by 6 centimetres. His process involved the use of a special camera equipped with four lenses to take four shots on each half of a normal glass plate, for a total of eight separate images on a single negative (later as many as twelve). It was a revolution, making photography definitively popular, by reducing not only the size of each shot, but also the possibility of error, and hence the cost. The change introduced by this mass social phenomenon consisted essentially in enabling also the lower classes to have their (photographic) likenesses taken, and in making it possible for prints to be exchanged and collected. Photographs became objects of collection and devotion, filling up the drawers of homes with images including not only the family circle, but also particularly famous monuments and views, as well as portraits of public figures, the most popular of which were printed in thousands of copies. (It was precisely by photographing Napoleon III and the Empress Eugénie with the royal family that Disdéri won wealth and fame in 1859.) As a result of the exponential increase in production, the frame gave way to the album as the most suitable and widely used way of keeping photographs, not least because of its peculiar narrative quality and ability to transform every member of the community into an occasional creator (or re-creator) of stories.

The *carte de visite*, or "visiting card", closed forever the chapter of the daguerreotype – restricted as it was to a unique and non-reproducible image – and rekindled debate about the status of photography and its relationship with art. The extraordinary success of Disdéri's technique led in fact to an vast increase in the number of professional practitioners, most of whom saw it as a commercial activity devoid of any artistic connotation. Photography thus revealed its industrial vocation, and undermined the possibility of simultaneous consideration as art, as though the two things were in a state of clear-cut and irreconcilable opposition. The gap was widened still further by two formal characteristics of the new technique. On the one hand, initially presented in sheets of 8 to 12

images, often showing the same subject in a succession of poses, the *carte de visite* conveyed a sense of accumulation and the absence of any hierarchy among the different shots arranged in rows, thus diminishing the importance of the individual item. On the other, a sort of compositional standard was instituted that involved the inclusion of the entire figure in the shot, and part of the setting reconstructed in the studio.

The photographer's autonomy was thus considerably restricted, and the subject's face lost its paramount importance, thus ruling out the possibility of significant psychological investigation (something hampered in any case by the very small size of the prints), and limiting the primary function of these images to the conferring of social status.

Disdéri tried to heal the rift for which he was largely responsible in a book that he published himself in 1862. (His three previous works had all regarded technical questions such as the collodion process, and ways of executing reproductions of art.) As clearly proclaimed from the outset in its title, *L'Art de la photographie* was a strenuous assertion of the dignity of photography against those regarding it exclusively either as a source of earnings, or merely as a tool for the automatic copying of reality. In expressing the highly modern view that artistic creation can coexist with the multiplication of the original and mass production (long before Walter Benjamin's pioneering work on these subjects in 1936), Disdéri ended up compiling a list of criteria to be applied by any portraitist in order to obtain good results: "1. Pleasing physiognomy (!); 2. general clarity; 3. pronounced darks, lights and halftones, glowing lights; 4. natural proportions; 5. precision of detail in the blacks; 6. beauty!" He also gave advice to the subjects. While counselling them often to wear a mask before the camera, as though to hide themselves or pretend to be someone else, he added that the photographic image would capture every nuance with absolute precision, and allow any mental conflict or indecision to show through. Herein lies the paradox. The photographer is an artist, but employs an instrument incapable of lying, that is, of allowing its users to stage and interpret the reality before them.

Bibliography
Benjamin, Walter. "Das Kunstwerk im Zeitalter seiner Technischen Reproduzierbarkeit". In *Zeitschrift für Sozialforschung* (French translation edited by Pierre Klossowski). Paris: Félix Alcan, 1936.
Frizot, Michel. *Identités: De Disdéri au Photomaton*. Paris: Centre National de la Photographie, 1985.
McCauley, Elizabeth Anne. *A. A. E. Disdéri and the Cart de Visite Portrait Photograph*. New Haven: Yale University Press, 1985.

Mr and Mrs Tacoloff
in eight poses, 1861
Albumen print, 20 x 23.2 cm
Paris, Musée d'Orsay, collection
Maurice Levert

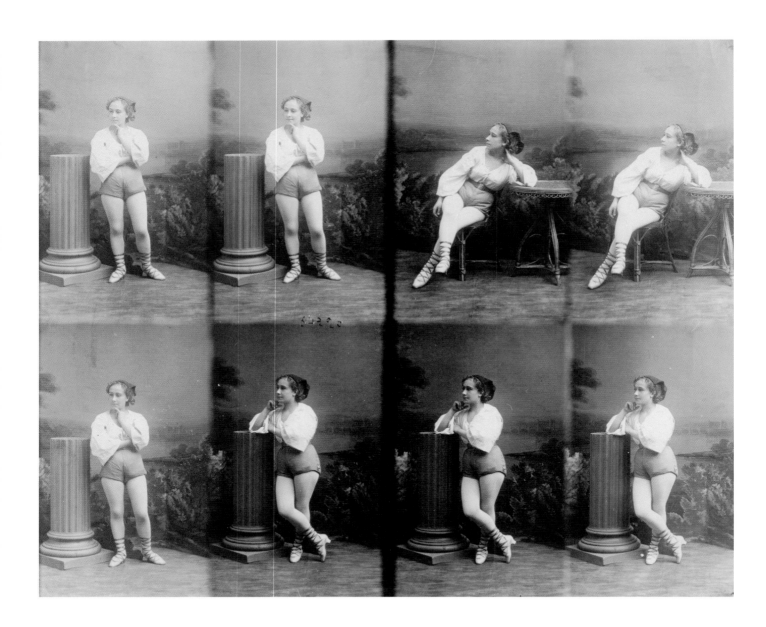

The Dead of Antietam

Brady's Gallery, Broadway, New York, October 1862

While the war between Mexico and the United States, the French Revolution, the Siege of Rome in 1849, the Crimean War, and the Second Opium War, were the first armed conflicts to be depicted by photographers, the American Civil War was the earliest to be exhaustively documented photographically, from the first major battle at Bull Run on 21 July 1861, to the ultimate victory of the Union army at Appomattox Court House on 9 April 1865. This considerable achievement was due mainly to the initiative of Mathew Brady who, following a suggestion probably made within the American Photographical Society, put together a team of trailblazing photojournalists who covered every stage of the epoch-making event.

A New Yorker of Irish origin, Mathew Brady learned photography from Samuel Morse, who had been able to study Daguerre's images firsthand during a trip to France in March 1839, and provided an interesting account of this in the *New York Observer*. The following year Morse set up one of the first American photo parlours (a simple glass construction inside of which several mirrors caused the sun's rays to converge on the subject)

on the roof of New York University, also instituting a kind of introductory photography course. Here Brady learned the basics of daguerrotyping, and in 1844 he opened his own portrait studio and gallery between Broadway and Fulton Street (he would later open another gallery in New York, and a third in Washington, D.C.), where, parallel to his daily activity, he began to photograph some of the most prominent men of the period. His aim was to collect portraits of twenty-four national figures, accompanied by their respective biographies, in a volume entitled the *Gallery of Illustrious Americans*. He succeeded by half, since only twelve lithograph copies of as many daguerrotypes, executed by Francis D'Avignon, were published by Charles Edwards Lester in 1850. All the same, Brady continued to build a vast library of portraits of celebrities, including artists, scientists, military figures, and politicians. He also revealed his profound grasp of photography's potential as a political communication tool by meticulously constructing a portrait of Abraham Lincoln in February 1860, which along with his address at the Cooper Union rally in New York, was instrumental in

Brady's Photographic Views of the War

New York: E. & H.T. Anthony & Company, 1862

Lincoln's gaining credibility with the public, and his subsequent election as president.

The inauguration of the new president took place on 4 March 1861. A few weeks later the Civil War broke out, and virtually formed the backdrop to Lincoln's whole tenure. Mathew Brady felt that it was his responsibility to provide a visual testimony of the individuals and events crucial to his time, and he very quickly got organised to record every aspect of the war. In actual fact his photographs, consistent with his previous experience, were mainly portraits of Union army offers, while he assigned the task of capturing images of the battlefields, the camps, the armaments, the monuments and the engineering infrastructures to a team of photographers that, at its largest, numbered twenty men, whose every move was directed by Brady. The role of impresario rather than author that he reserved for himself is symbolically represented in a photo where he appears next to a group of soldiers led by General Robert B. Potter. He is isolated from the rest of the composition by a tree that separates him from the main scene, as if he had a talent for looking without being seen and, above all, for being in front of the camera instead of disappearing behind it. At any rate, the fact that Brady did not press the button did not stop him from claiming the paternity of each and every shot by omitting the individual names of his "employees" from the credits, and signing the photos collectively as "Mathew Brady Studio", which was patently unfair. This enabled him to stage an exhibition in his gallery at 785 Broadway in October 1862, without including a single photograph he had taken himself, and by exploiting the gaze of one of his most expert collaborators, Alexander Gardner, flanked by his assistant James F. Gibson. The title, "The Dead of Antietam", displayed in the entrance hall introduced the theme – the most important battle fought on Northern territory during the entire conflict – and welcomed visitors to one of the most shocking photographic exhibitions ever mounted. In the name of realism and accurate information, Brady had ordered his photojournalists not to neglect a single detail of the tragedy taking place before their eyes, and the gallery walls were covered with corpses that were lying on the ground or piled up in merciless shots. In Brady's studio the dead, who were usually only lists of names in war bulletins, acquired a body and a face. In these photos, war, often referred to in abstract terms, was interpreted realistically and personally, as if to say: this is what happens to sons, fathers, and husbands who leave for the front. Even the most repugnant details were reproduced with surgical precision by the camera which, unable to discriminate or embellish – unlike like the artists who drew inspiration from these images for newspaper illustrations – riveted the attention of viewers drawn by the possibility of recognising their dear ones, or by the cruel fascination of death. In an article on the exhibition that appeared in *The New York Times* on 20 October 1862, the reviewer wrote: "Mr. Brady has done something to bring home to us the terrible reality and earnestness of war. If he has not brought bodies and laid them in our dooryards and along the streets, he has done something very like it."

Right from the outset, Mathew Brady sought to popularise his vast photographic corpus through other means than exhibitions. *Brady's Photographic Views of the War*, published at the time of the Antietam show, was one of the first and most

significant collections of images that he put together during and after the Civil War. He did not choose a book format but rather that of the photo album, which was becoming the most popular means of conserving photos, following their growing availability. In fact, he opted for an extensive series of individual prints in two formats [*carte de visite* (CDV) and ca. 11 x 15 cm] which, presumably, were assembled in standard binders so that buyers could create their own completely individual selection and sequence. The subjects were listed in the catalogue of E. & H. T. Anthony & Company in November 1862, according to the logic of classification. The inventory was the ideal form for publicising the work of Brady – who at the end of the conflict possessed over 10,000 negatives that had mostly been commissioned from his photographers or bought from others – since it communicated a sense of the whole rather than each individual tessera in a mosaic of epic style and importance. *Brady's Photographic Views of the War* consisted of a total of 554 images, divided geographically and thematically according to rational archival criteria. Hence there was a substantial lack of narrative, although

it cannot be a coincidence that, as the caption tells us, the last image is the spectre of a "Confederate Soldier, who, after being wounded, had dragged himself to a little ravine on the hillside, where he died".

Bibliography
Frassanito, William. *Antietam. The Photographic Legacy of America's Bloodiest Day*. New York: Charles Scribner's Sons, 1978.
Horan, James D. *Mathew Brady: Historian with a Camera*. New York: Crown Publishers, 1955.
Meredith, Roy. *Mr. Lincoln's Camera Man: Mathew B. Brady*. New York: Charles Scribner's Sons, 1946.
Miller, Francis; Lanier, Robert Sampson. *The Photographic History of the Civil War*. New York: The Review of Reviews, 1911.
Panzer, Mary. *Mathew Brady and the Image of History*. Washington, D.C.: Smithsonian Institution Press, 1997.
Trachtenberg, Alan. "On Reading Civil War Photographs". *Representations* 9. Berkeley: University of California Press, 1985.

Mathew B. Brady
Abraham Lincoln, candidate for U.S. President, three quarter lenght portrait, before delivering his Cooper Union address in New York City, 1860 February 27
Gelatin silver print
Washington, D.C., The Library of Congress

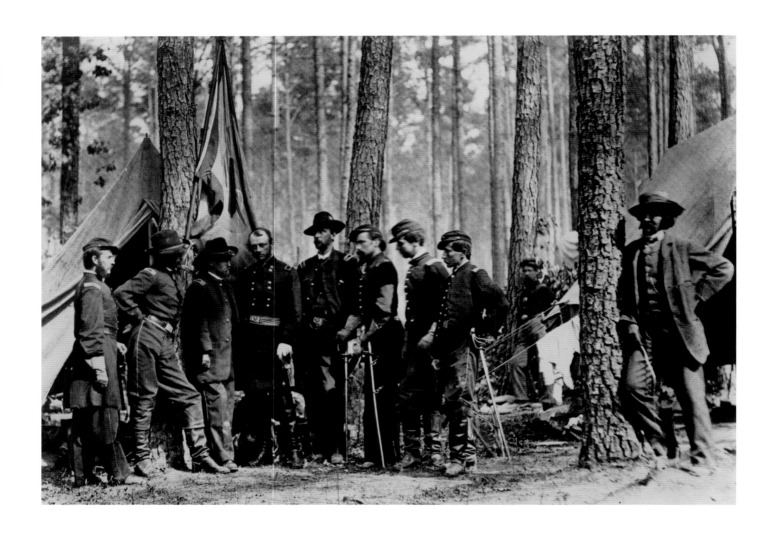

Alexander Gardner
*Dead Confederate Soldier on
the Battlefield at Antietam*, 1862
Albumen silver print from
glass negative, 6.1 x 9.8 cm
New York, The Metropolitan
Museum of Art
Purchase, Florance Waterbury
Bequest, 1970 (1970.537.4),
Brady's Album Gallery n. 554

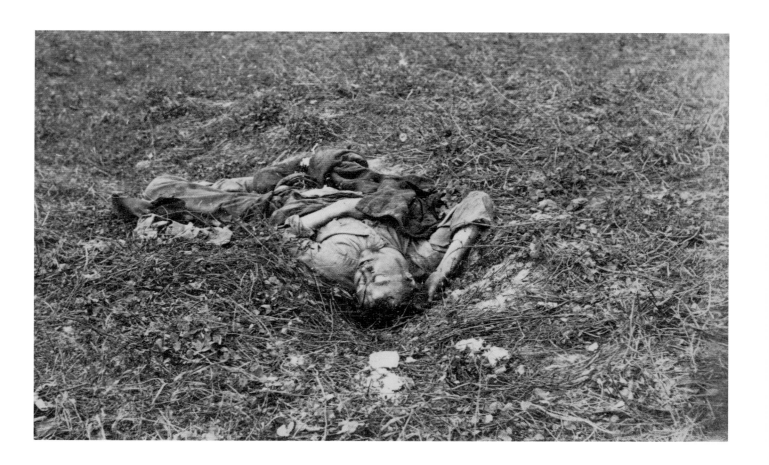

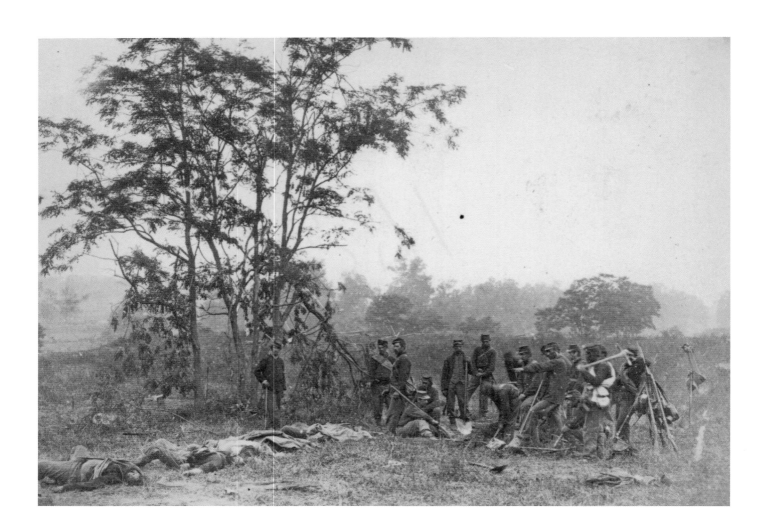

Alexander Gardner
*View in the Field, on the West
Side of the Hagerstown Road,
after the Battle of Antietam,
Maryland*, 1862
Albumen silver print
from glass negative
New York, The Metropolitan
Museum of Art
Purchase, Florance Waterbury
Bequest, 1970 (1970.537.3)

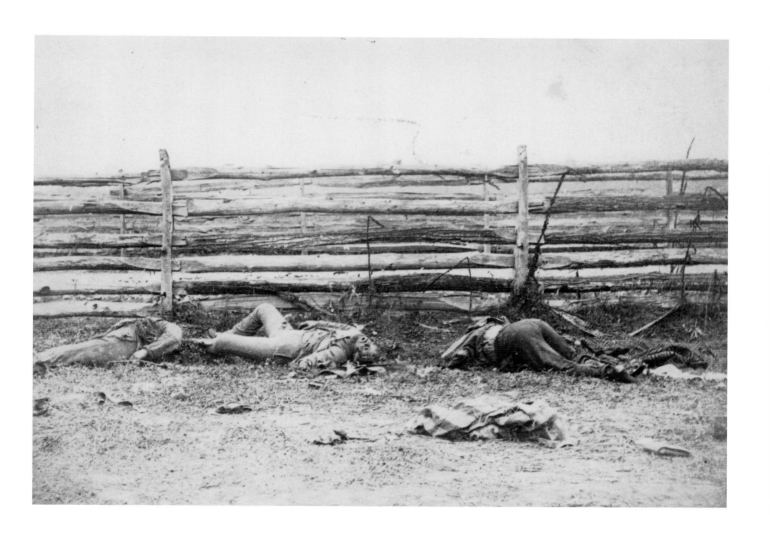

**Alexander Gardner
George N. Barnard**

Alexander Gardner
Gardner's Photographic Sketch Book of the War

Washington: Philp & Solomons, 1865–66

The American Civil War was an occasion for extensive photographic activity. Besides the twenty-odd collaborators hired by Mathew Brady, the Confederate and Union armies accredited hundreds of photographers, who were mostly engaged for brief portrait sessions (but also lengthy projects) during the four years that the conflict lasted. At the end of the hostilities, the photographers were able to view their production in retrospect (Brady was the only one to do this earlier), and it was precisely during the early months of peace that the two seminal volumes on this subject were published: *Gardner's Photographic Sketch Book of the War* by Alexander Gardner, the first edition of which had already come out between the end of 1865 and the beginning of 1866, and *Photographic Views of Sherman's Campaign* by George N. Barnard, published a few months later. Although their professional backgrounds were very different, Gardner and Barnard both started photographing the war for Brady. The former, of Scottish origin, had met his employer in 1856 and, after only two years, had been appointed to run his Washington gallery. It was a position of great responsibility,

since most of the political high-ups in the country passed through the gallery. The reason for his rapid rise lay, above all, in his mastery of the wet plate collodian process, which immediately came in extremely useful at the front for obtaining in a short time – approximately 10-second exposures and a process lasting no longer than 20 minutes from the sensitisation of the support to its development – sharp plates that could duplicated, in extremely precarious conditions. Gardner was then at the height of his technical and organisational prowess built up over the years, and he was often the one who led Brady's army of photojournalists into battle; however, in 1863 he decided to leave Brady, since he found some of the limitations imposed by his employer unacceptable, especially those concerning the publication of images under one's own name, and Brady's keeping all the negatives for himself, including those taken by his staff in their spare time. This does not mean that Gardner abandoned the field; on the contrary, he opened his own studio just a stone's throw from his former boss's establishment in the capital, taking with him all the plates he had made and a few colleagues

who were not happy about the way they had been treated. So, for *Photographic Sketch Book of the War* Gardner did not merely select his own images but, assuming the role of "editor", included them in a series of 100 shots that were (justly) attributed to the ten different authors who took them, with his brother James and Timothy O'Sullivan receiving the credit for at least forty-five photos. One of the other photographers was George N. Barnard, who had been on Brady's team since the first assignment at Bull Run, due to the experience he had accumulated first as a daguerreotypist in Oswego, New York – where he had already opened a portrait studio in 1843 and a decade later had taken two views of a factory in flames that constitute a unique example of reportage using this technique – and as an ambrotype photographer in Syracuse from 1854. Like Gardner, he followed an individual path in his documentation of the war, starting in 1863, but there are two substantial differences between the album he produced and Gardner's. It is basically a question of content: first and foremost, *Sketch Book*, as we have said, is a collective work, while *Photographic Views*

George N. Barnard
*Photographic Views of Sherman's Campaign.
Embracing Scenes of the Occupation of Nashville,
the Great Battles around Chattanooga and Lookout
Mountain, the Campaign of Atlanta, March to the Sea,
and the Great Raid through the Carolinas*

New York: Press of Wynkoop & Hallenbeck, 1866

contains shots taken solely by Barnard. Moreover, the former covers all the vicissitudes of the Civil War, whereas the latter, as the title suggests, focuses on a highly specific episode, namely General Sherman's advance through the southern states between 1864 and 1865. On the one hand, we have a generic compendium of the main events of four years, including the premises and the consequences (*Sketch Book* opens with an architectural view of Marshall House, in Virginia, where Colonel Ellsworth was killed while attempting to take down a Confederate flag from the building, becoming the first man to die for the Union cause, and ends with the inauguration of the monument commemorating the fallen at Bull Run, which took place in June 1865 after both sides had laid down their arms), and on the other, an exhaustive in-depth study.

The aims of the two projects were basically similar, however. Both were informed not only by a documentary and narrative concept, but also an artistic one. Although Gardner's and Barnard's production was destined in part for the general public in the form of small *cartes de visite* and stereographs, to the extent that they often took the same shots with different cameras in order to broaden the market for each image, their two collections are composed solely of large format albumin prints (approx. 20 x 25 cm in Gardner's case, and as large as 28 x 35 cm where Barnard's work is concerned) glued directly onto the pages. Both photographers also introduce a celebratory aspect, which in *Sketch Book* consists in a general reference to the triumph of the Union ideal, and in *Photographic Views* the glorification of General Sherman; in fact, the second volume begins with an inevitable portrait of the high-ranking officer surrounded by his collaborators, and ends with photographs of the devastated South, constituting both a testimony to unstoppable military might and a counterweight to the classical imagery of Greek and Roman ruins, as if rooting American history in the industrial archaeology that these events left behind. Apropos of industrial roots, it is interesting to note that during the war Andrew Joseph Russell created eighty-two mordant images to accompany Herman Haupt's treatise *Photographs Illustrative of Operations in Construction and Transportation*, published in 1863, which pivoted on railway development and its

importance in military strategies From a technical standpoint, it was still impossible to capture movement – in this case the action during combat – which had also conditioned the work of all the photographers who had previously taken on the theme of war. This was probably why Gardner and Barnard chose to manipulate the *mise-en-scène* by accentuating the symbolic aspect of images that were unable to record the actual fighting. In Gardner's work, the arrangement of the dead bodies, on which he dwells repeatedly as the series of shots progresses and which caused a tremendous uproar at the time, seems to have been carefully staged. This produced dramatic compositions reminiscent of Goya's engravings for *Los Desastres de la Guerra*, and of the brutal descriptions featured thirty years later in the novel *The Red Badge of Courage* by Stephen Crane, who presumably picked up this aspect in photographs and transposed it into literature: "Underfoot there were a few ghastly forms motionless. They lay twisted in fantastic contortions. Arms were bent and heads were turned in incredible ways. It seemed that the dead men must have fallen from some great height to get in such

positions. They looked to be dumped out upon the ground from the sky." Evidence that one of the most famous images in *Sketch Book* was actually "doctored" emerges from studies carried out by William Frassanito, who has identified a number of shots taken by Gardner himself and Timothy O'Sullivan for *Home of a Rebel Sharpshooter*, in which the same subject is seen from many more metres away than in the aforementioned image in which it is primed to become an icon of all the unknown soldiers who have gone to their eternal rest on the battlefield. By contrast, George Barnard did not point his lens at the lifeless bodies of the soldiers, nor was he interested in documenting the confused everyday nature of war. Therefore, he did not need to take his photos immediately after the event, but was able to let days or months go by; indeed, he actually returned, in 1866, to places he had passed through two years earlier, in order to complete his work. His imagery was basically topographical, but enriched by a series of symbolic references to specific events. That is why the terrain on which the Battle of New Hope Church was fought is scattered with felled trees and there is a horse's skull on the ground in the scene of General McPherson's death, which is possibly that of his charger, but we do not know if it originally lay where we see it in the photo, or if it was put there by the photographer. However, there can be no doubt whatsoever that the threatening clouds above the installations of the "rebels" (as Barnard described the Confederates) in Atlanta were taken from another negative.

Despite the fact that these "tricks" were designed to satisfy the viewer's expectations, the complex projects were a complete flop from a commercial standpoint. This fate – also reserved for the work of Brady, who was unquestionably the biggest investor in the business of war documentation – was determined by the public, who could not wait to turn the page after over four years of atrocious suffering, while the government poured all its resources into reconstruction. By avoiding mass consumption in the main, *Sketch Book* and *Photographic Views* ended up being incorporated in the system to which they had apparently aspired from the beginning, but which had looked on photography with suspicion at the time of their creation: that of fine art.

Bibliography
Bleiler, Everett F. (Introduction). *Gardner's Photographic Sketch Book of the War*. New York: Dover Publications, 1959.
Davis, Keith. *George N. Barnard: Photographer of Sherman's Campaign*. Albuquerque: University of New Mexico Press, 1990.
Frassanito, William. *Early Photography at Gettysburg*. Gettysburg: Thomas Publications, 1995.
Haupt, Herman. *Photographs Illustrative of Operations in Construction and Transportation, as Used to Facilitate the Movements of the Armies of the Rappahannock, of Virginia, and of the Potomac, including Experiments Made to Determine the Most Practical and Expeditious Modes to be Resorted to in the Construction, Destruction and Reconstruction of Roads and Bridges*. Boston: Wright & Potter, 1863.
Katz, Mark D. *Witness to an Era: The Life and Photographs of Alexander Gardner*. New York: Viking Press, 1990.
Lee, Anthony W., and Elizabeth Young. *On Alexander Gardner's Photographic Sketch Book of the Civil War*. Berkeley: University of California Press, 2007.
Newhall, Beaumont (Introduction). *Photographic Views of Sherman's Campaign*. New York: Dover Publications, 1977.

Wm. R. Pywell
*Marshall House, Alexandria,
Virginia,* 1862
Albumen print, 17.8 x 23 cm
New York, George Eastman
House, museum collection

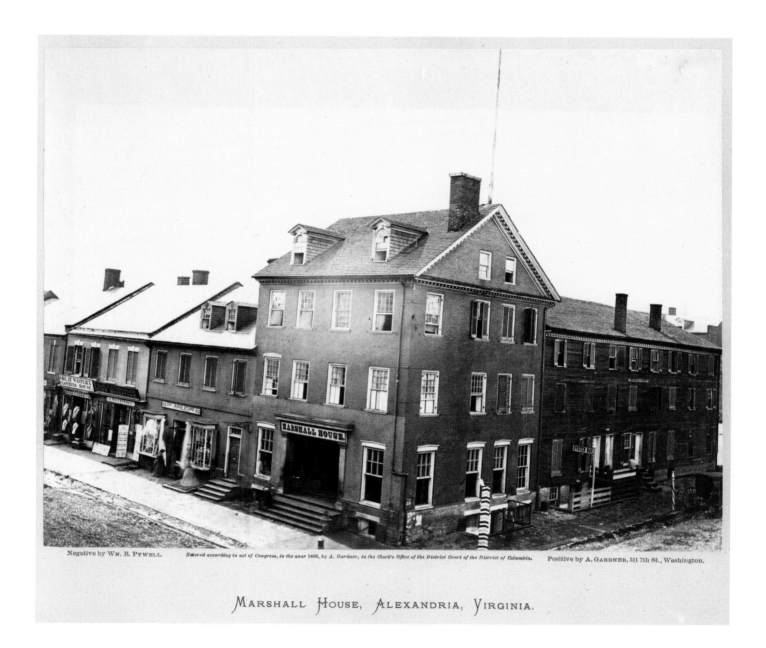

Negative by WM. R. PYWELL. Entered according to act of Congress, in the year 1866, by A. Gardner, in the Clerk's Office of the District Court of the District of Columbia. Positive by A. GARDNER, 511 7th St., Washington.

MARSHALL HOUSE, ALEXANDRIA, VIRGINIA.

Alexander Gardner
Home of a Rebel Sharpshooter,
Gettysburg, July 1863
Albumen print, 17.4 x 22.5 cm
New York, George Eastman
House

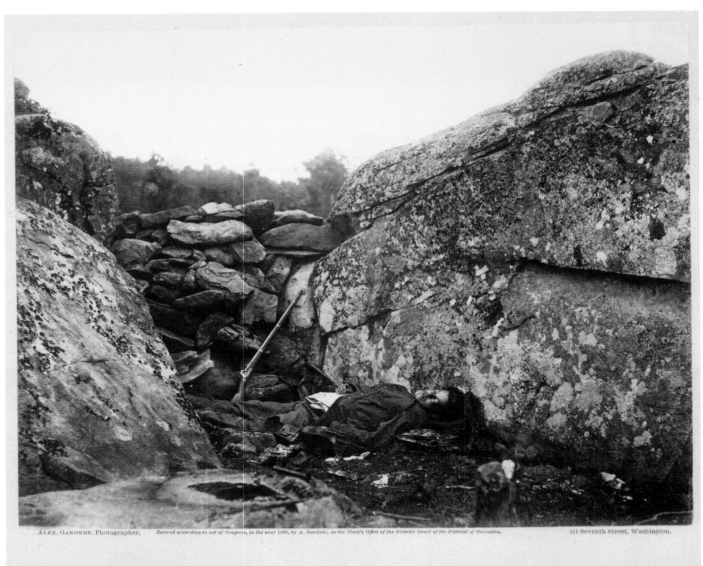

HOME OF A REBEL SHARPSHOOTER, GETTYSBURG.

Smith W. Morris
*Dedication of Monument
on Bull Run Battle-Field*, 1865
Albumen print, 18 x 23 cm
New York, George Eastman
House, museum collection

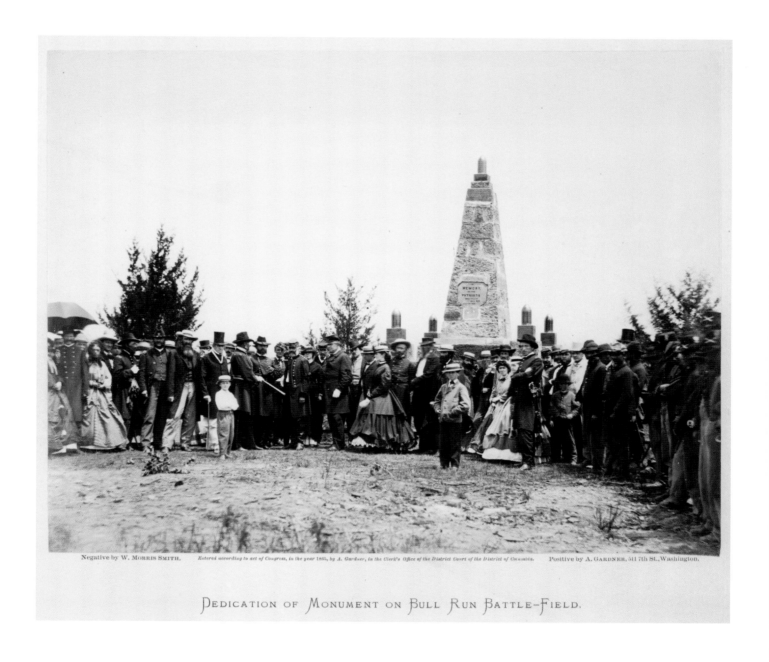

Negative by W. MORRIS SMITH. Entered according to act of Congress, in the year 1865, by A. Gardner, in the Clerk's Office of the District Court of the District of Columbia. Positive by A. GARDNER, 511 7th St., Washington.

DEDICATION OF MONUMENT ON BULL RUN BATTLE-FIELD.

George N. Barnard
*Fire at Ames and Doolittle Mills,
Oswego, New York*, 1853
Daguerreotype with
applied color, 7 x 8.3 cm
New York, George Eastman
House.
Museum Purchase; ex collection
James Cady

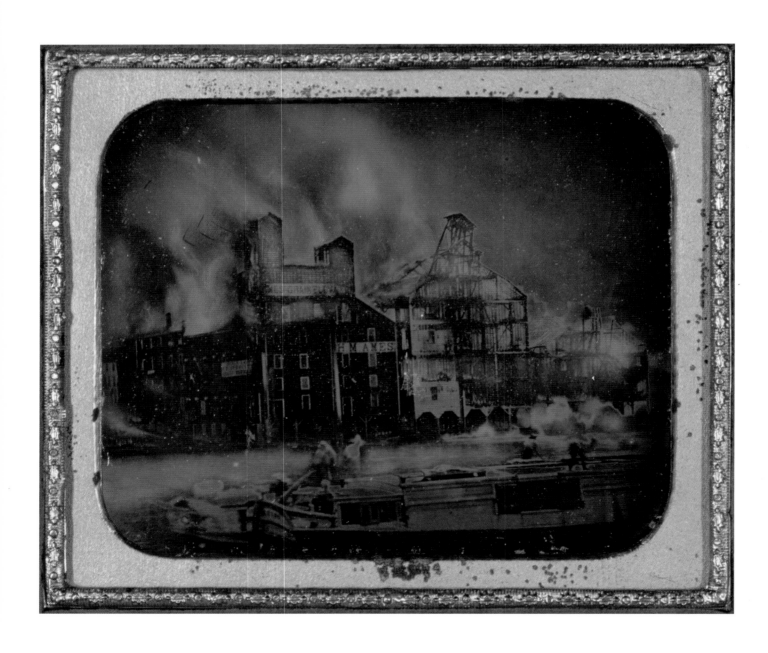

George N. Barnard
*Reception room of
George Barnard*, ca. 1873
Albumen print, 8.3 x 15.1 cm
New York, George Eastman
House, Gift of Donald Weber

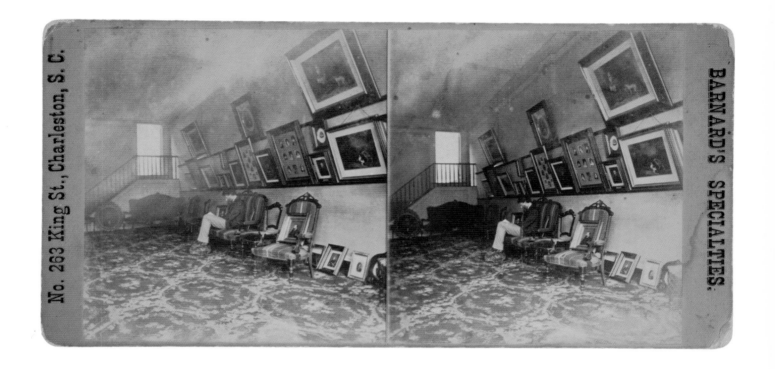

George N. Barnard
Sherman and his Generals,
1864–65
Albumen print, 25.6 x 35.9 cm
New York, Museum of Modern
Art, acquired from the Library
of Congress

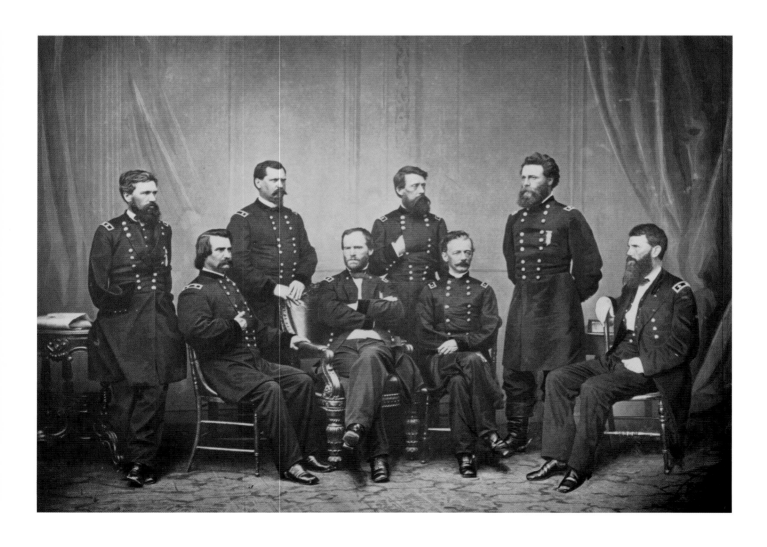

George N. Barnard
*The "Hell Hole", Battlefield
of New Hope Church*, 1864–65
Albumen print, 25.6 x 35.9 cm
New York, Museum of Modern
Art, acquired from the Library
of Congress

George N. Barnard
*Rebel Works in front of Atlanta,
No. 1*, 1864–66
Albumen print, 25.6 x 35.9 cm
New York, Museum of Modern
Art, acquired from the Library
of Congress

George N. Barnard
*Scene of General McPherson's
Death*, 1864–65
Albumen print, 25.6 x 35.9 cm
New York, Museum of Modern
Art, acquired from the Library
of Congress

**Carleton E. Watkins
Timothy O'Sullivan**

Josiah Dwight Whitney
(photographs by Carleton E. Watkins and W. Harris)
*The Yosemite Book: A Description of the Yosemite Valley
and the Adjacent Region of the Sierra Nevada,
and of the Big Trees of California*

New York: Julius Bien, 1868

The image of the American West was created by photography, in the sense that the world, near and far, became familiar with the features of the area beyond the frontier directly through photographic reproductions of the territory, without seeing it represented in other media first. There were two fundamental reasons for this. The first lies in the fact that the invention of photography and the conquest of the West virtually coincided (the celebrated undertaking embarked on by Meriwether Lewis and William Clark, who became the first to reach the Pacific Ocean after starting out from Saint Louis, then the most westerly outpost in America, dates to 1804–06, while the great invasion of explorers and pioneers did not occur until the 1850s). The second reason is that from 1839 nearly every expedition to the West included a photographer, who was usually assigned the task of providing accurate documentation to support scientific research in the geological, geographical and, of course, cartographical fields.

The first man to transport and use photographic material in the hinterland of the West was a military officer by the name of John Charles Frémont, who subsequently became known as the leader of several military campaigns during the U.S.–Mexican War and the American Civil War, and as the first presidential candidate of the new Republican Party in 1856. When he left for the Sierra Nevada, via the Oregon Trail, in 1842, he listed a complete set of photographic equipment among his baggage, but his skills in this field were so limited that the results were completely inadequate, and the experiment was a total failure. An equally negative outcome was reserved for the works of John Mix Stanley, who executed a series of portraits of American Indians in 1853 as part of a documentation project for the construction of a transcontinental railroad, none of which have survived; and the photographs taken by Solomon Nunes Carvalho, who was hired by Frémont to cover his last expedition to the Rocky Mountains, and who returned at the beginning of 1854 with a haul of about 300 plates, which were virtually all destroyed in a fire twenty-seven years later (only one original negative remains, in which we recognise the Big Timbers Cheyenne encampment). Furthermore, over 1,500 photographs taken by John Wesley Jones and his collaborators were discarded, then

Timothy O'Sullivan
*Photographs Showing Landscapes, Geological
and other Features, of Portions of the Western
Territory of the United States*

Washington, D.C.: U.S. Government Printing Office, 1875

lost, as soon as they had served their purpose as models for the design of the *Pantoscope of California*, a large panorama on canvas first shown in Boston during the Christmas period in 1852.

Apart from the above contingencies, the preservation of these materials was primarily rendered difficult by a structural drawback: all the photographs were taken using the daguerreotype technique, which yielded only one positive that could not be duplicated, greatly increasing the risk of loss or damage. This problem is further exemplified by the only major exhibition of daguerreotypes organised on the theme of the West, and more particularly California, which opened in New York in September 1851. The show featured 300 or so plates, all trace of which had already been lost in 1857, when they were recorded for the last time as being among the works in the private collection of the wealthy John H. Fitzgibbon, who was also a photographer. Hence, the widespread popularisation of the image of the territory of the West, which resulted in its first being invaded and then mythicised, could not have been achieved with daguerreotypes, despite the fact that this technique also became extremely popular in the West for making portraits of the settlers and gold prospectors who descended on the Pacific coast around 1849 (hence the well-known moniker "forty-niners"). It was the invention of the collodion process, first the "wet-plate" then the "dry-plate" variant, which was available from 1851 but only widely adopted at the end of the decade, that permitted the crucial spread of the West's image, since it considerably reduced the exposure time and produced negatives from which it was theoretically possible to obtain an infinite number of prints. Carleton E. Watkins used this process when he began to photograph the stunning scenery of the Yosemite Valley in 1861. After arriving in San Francisco with the great influx of migrants between the end of the 1940s and the beginning of the 1950s, he took up photography in 1854, replacing a cameraman at Robert Vance's photographic studio in Marysville. Here he learned the basic skills of the profession which, since the studio worked only with the daguerreotype, soon went beyond the technical, and mostly had to do with the commercial exploitation of the photographic images. In all likelihood, he had already set up his own small business in 1858, and when he set off for the Yosemite Valley three years later, he took with him a stereoscopic camera and another one that he had had custom-made for taking very large plates (18" x 22"). The former was used to take small photos that would sell well and, consequently, be widely circulated; the latter, to create impressive artworks. Watkins was not the first to photograph this area, which had already passed in front of Charles L. Weed's lens in 1859, let alone to document the entire Far West; however, no one else before him had brought an artistic approach to the subject. In fact, Watkins was the first photographer to create images of the West that did not merely serve scientific, documentary or simply illustrative needs, but conveyed his interpretation of the territory. This interpretation, shared by the majority of those who set up their tripods in the western territory of the United States until the end of the nineteenth century, was informed by two fundamental elements: on the one hand, the majestic, unspoiled scenery characteristic of the West, and on the other, its being the white man's most

recent conquest, and thus set the romanticism of a bucolic vista against nationalistic pride. To represent this dual vision in a single image, Watkins shot the majority of his views from a high angle that emphasised the magnificence of the sweeping panorama and, at the same time, placed the viewer in a dominant position. He varied this by including a human figure (or signs of man's presence, such as houses, railways, roads, stagecoaches), offering a means of comparison that revealed the enormous scale of the surroundings and evinced the growing involvement of photographer and viewer in the image.

The unsurpassable quality of his work led Watkins to play an important part in the enactment of the government legislation that made Yosemite the first park to be officially protected by the U.S. Congress in 1864. It also won him a medal for the best landscape photography at the Paris Exposition in 1867, and made him the chosen photographer of Josiah D. Whitney, the scientist responsible for the Geographical Survey of California, who in 1868 published twenty-four of Watkins's original prints (along with four attributed to William Harris) in *The Yosemite Book*, which came out

in only 250 copies. For this commission, which he completed in 1866, Watkins did not use the mammoth-plate – the large format that characterised most of his production – but "restricted" himself to the more common 8" x 10" format, in which he nonetheless incorporated all the elements on which his reputation was founded. In fact, we find symbols of place, from the Sierra Nevada peaks to the Mariposa Woods; perfectly balanced shots; tonal gradations that steadily progress from the dark (always readable) foreground to the impalpable grey of the background, and the signs through which the thought and poetics of the photographer are succinctly expressed. Apropos of these, in one photograph we start with a sweeping panorama of the Yosemite Valley seen from high up, then the eye is directed from the highest peaks down along the steep sides of the granite massifs until it comes to rest on the gigantic trunk of a sequoia in front of which the man who discovered it (if we do not count the American Indians), Galen Clark, is standing, leaning on his rifle. Nature at its wildest is tamed by man (armed with a gun).

In the wealth of photographic images

in which the landscape of the American West was recorded and popularised by those who came after Watkins, one environmental feature is conspicuously absent: the desert. In fact, its unmistakably hostile aspect was not at all consonant with the ideal of abundance and prosperity that photographers often wished to convey in their work. This omission was rectified by Timothy O'Sullivan, who came west in 1867 after gaining lengthy experience in the Civil War first as a member of Brady's team and later alongside the "rebel" Alexander Gardner. Conceived and developed on some of the most important expeditions in the heart of Colorado, Utah, Nevada, Arizona and New Mexico, the style of his imagery was based on the same principles as his earlier war photographs. Let us consider two of his most well-known images: *A Harvest of Death*, taken in July 1863 on the scene of the terrible Battle of Gettysburg; and *Sand Dunes*, dating to his first expedition with Clarence King in 1867. Both shots are synthetic and subtle, with few figures standing out against a simple setting. They contain some highly symbolic elements: the soldiers' corpses lying in the foreground, on the one hand, and the

desert, on the other; moreover, the sharply depicted horseman in the distance on the Gettysburg battlefield is echoed by the small caravan travelling through Nevada. Narrative is limited to small details, such as the bare feet of a soldier in the first photograph and a series of footprints between the dunes in the second. Thus, both images signal a breakthrough. In the first, life makes its way through death – since the soldier's shoes probably came in useful to another man who had emerged from the fury of the combat unscathed; while in the second, the footprints in the sand are evidence of man's having passed through, and an invitation to the viewer to walk right into the space represented. Lastly, there is an intense, dazzling light in both images, which is the most explicit indication of the possibility of redemption. Through this ever-present luminosity, O'Sullivan conveys the same promise of prosperity that is expressed through the force and vigour of nature in images of other areas of the West, intensifying the brightness simply by adding a little opaque colour to completely whiten the sky, so that a mysterious gleam (expressing the transcendental ideal) seems to

emanate from the inert surfaces of rocks and water. A selection of his prints was published in a series of albums – financed, like the expeditions that produced them, by the United States Government – entitled *Photographs Showing Landscapes, Geological and other Features, of Portions of the Western Territory of the United States*. What emerges from this is a complex palimpsest of scientific, political, and artistic content and interests. Indeed, it could not be otherwise: photography was America's first independent contribution to international art history (concerning all other forms of artistic expression the nation had to draw on a past that predated its founding), and the extraordinary geological phenomena of the West constitute a heritage in which the entire country is deep-rooted.

Bibliography
Current, Karen. *Photography and the Old West.* New York: Harry N. Abrams, 1978.
Dingus, Rick. *The Photographic Artifacts of Timothy O'Sullivan.* Albuquerque: University of New Mexico Press, 1982.
Jurovics, Toby, Carol M. Johnson, Glenn Willumson, and William F. Stapp. *Framing the West. The Survey Photographs of Timothy H. O'Sullivan.* New Haven: Yale University Press, 2010.
Kelsey, Robin. *Archive Style. Photographs and Illustrations for U.S. Surveys, 1850–1890.* Berkeley: University of California Press, 2007.
Nickel, Douglas R. *Carleton Watkins: The Art of Perception.* New York: Harry N. Abrams, 1999.
Palmquist, Peter E. *Carleton E. Watkins: Photographer of the American West.* Albuquerque: University of New Mexico Press, 1983.
Palmquist, Peter E., and Thomas R. Kailbourn. *Pioneer Photographers of the Far West: A Biographical Dictionary, 1840–1865.* Palo Alto: Stanford University Press, 2001.
Phillips, Sandra S. *Crossing the Frontier: Photographs of the Developing West, 1849 to the Present.* San Francisco: San Francisco Museum of Modern Art / Chronicle Books, 1996.
Sandweiss, Martha A. *Print the Legend. Photography and the American West.* New Haven: Yale University Press, 2002.

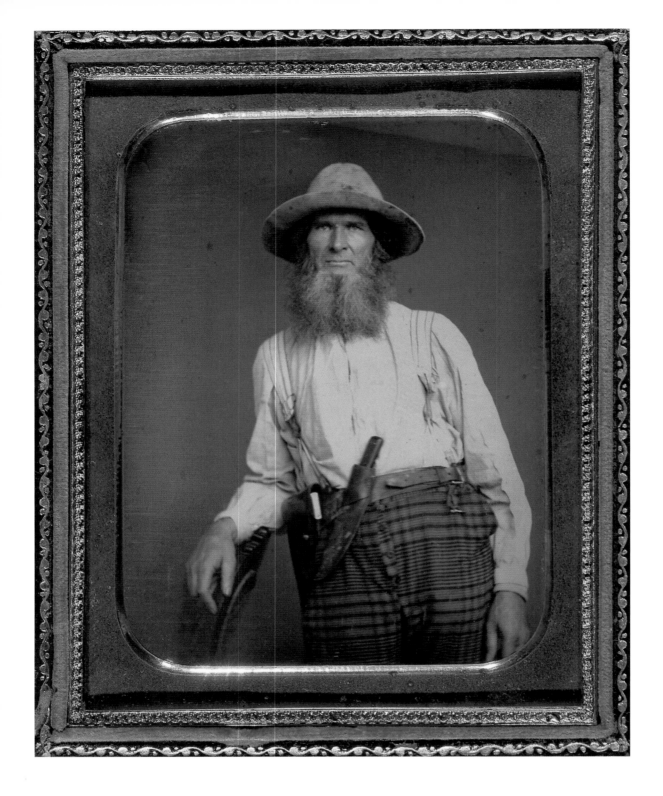

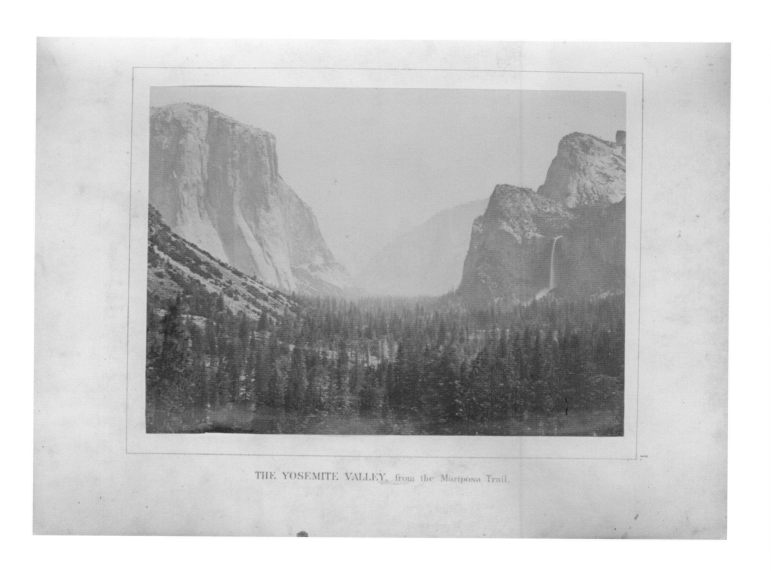

THE YOSEMITE VALLEY, from the Mariposa Trail.

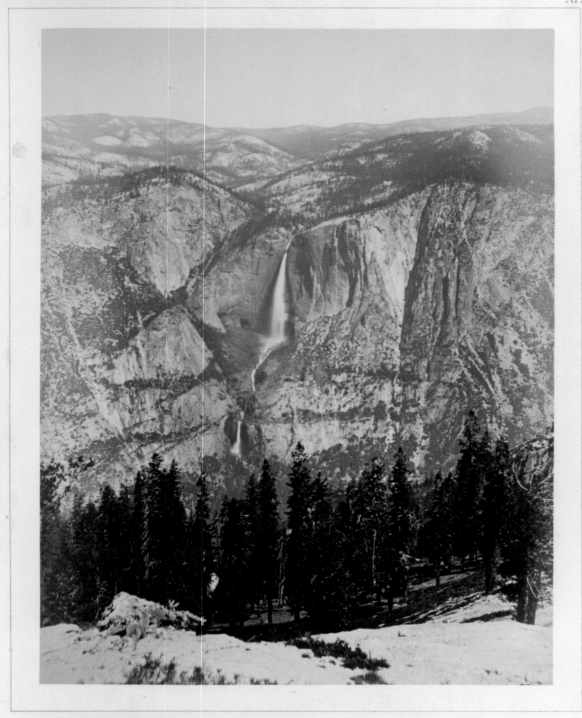

THE YOSEMITE FALLS. from Sentinel Dome.

XI.





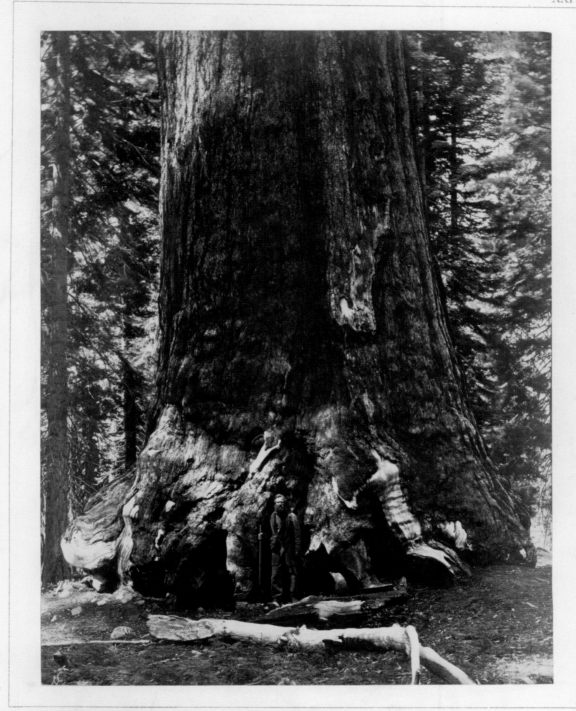

BASE OF THE GRIZZLY GIANT.

Timothy O'Sullivan
A Harvest of Death, Gettysburg
Pennsylvania, 1863
Albumen print, 17.2 x 22.2 cm
New York, George Eastman
House, museum purchase

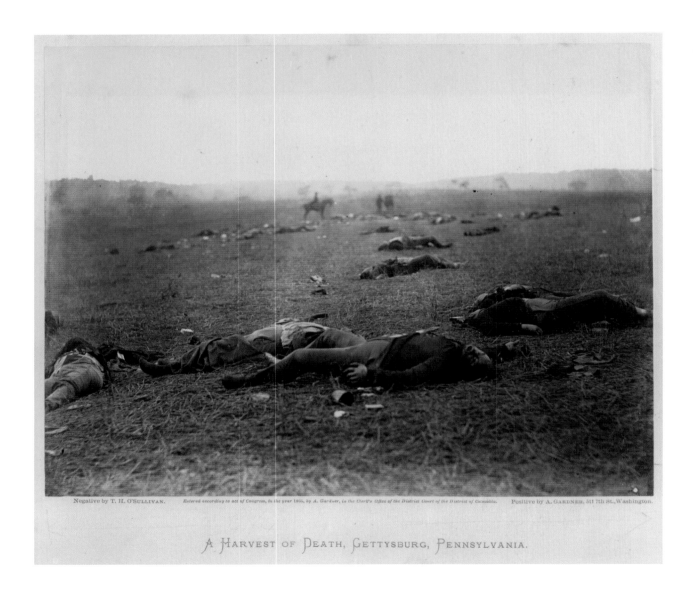

Negative by T. H. O'SULLIVAN. Entered according to act of Congress, in the year 1865, by A. Gardner, in the Clerk's Office of the District Court of the District of Columbia. Positive by A. GARDNER, 511 7th St., Washington.

A HARVEST OF DEATH, GETTYSBURG, PENNSYLVANIA.

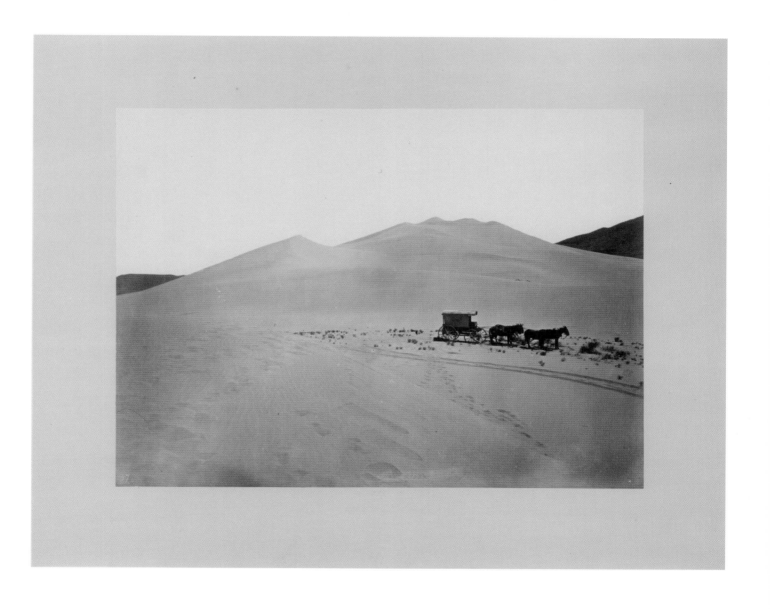

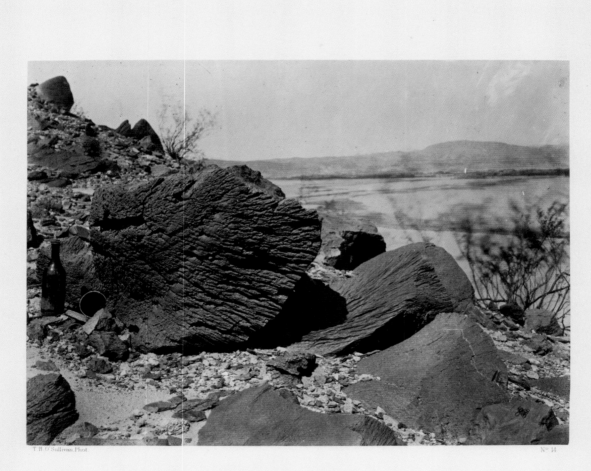

ROCK CARVED BY DRIFTING SAND, BELOW FORTIFICATION ROCK, ARIZONA

Timothy O' Sullivan
*Black Canyon, Colorado River
From Camp 8, Looking Above*,
1871
Albumen print
New York, The New York Public
Library, Astor, Lenox and Tilden
Foundation, Photography
Collection, Miriam and Ira
D. Wallach Division of Art, Prints
and Photographs

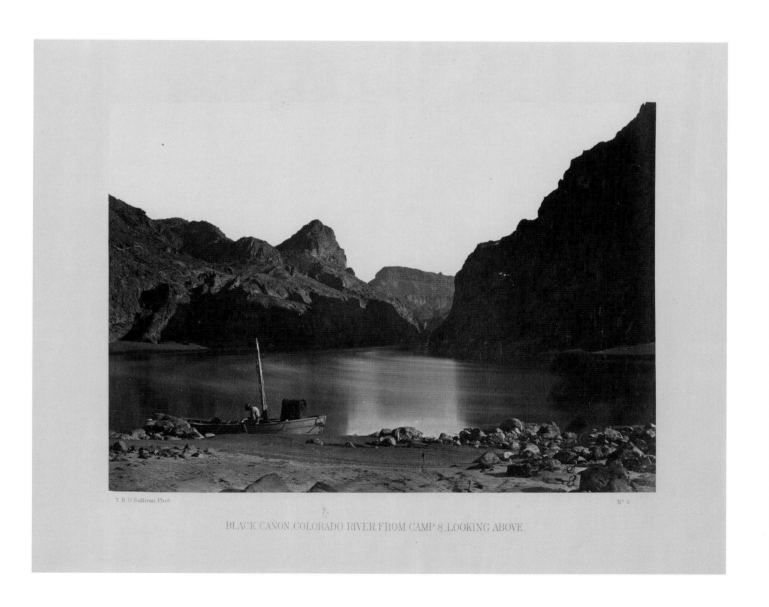

T. H. O'Sullivan Phot. N° 8

BLACK CAÑON, COLORADO RIVER, FROM CAMP 8, LOOKING ABOVE.

Henry Peach Robinson
*Pictorial Effect in Photography: Being Hints on
Composition and Chiaroscuro for Photographers*

London: Piper & Carter, 1869

If it is to be considered art, photography must comply with the rules of academic painting. This, in a nutshell, is the basic premise of the original approach of "pictorial photography", as first organically expressed in *Pictorial Effect in Photography: Being Hints on Composition and Chiaroscuro for Photographers*, published in 1869 by Henry Peach Robinson. Along the same lines as the earlier *A Manual of Photographic Manipulation* (1858) by his fellow Englishman William Lake Price, but of greater breadth and designed to have effect in the field of art rather than present a series of technical advances, it constitutes an authentic compendium on the subject, complete with theoretical principles, practical instructions, and a series of concrete figurative references drawn among other things from the work of Benjamin West, David Wilkie, William Mulready, Alfred Elmore, Frederick Goodall, Louis William Desanges and William Turner's engravings for his *Liber Studiorum*. Naturally put into practice by the author, these teachings had a great deal of influence in the early period, until photography began to seek a path to independence from the other forms of representation. Robinson took up photography around

1852, the year in which one of his oil paintings was selected for exhibition at the Royal Academy of Arts. After a period of apprenticeship during which he worked in a bookshop and frequented the salon of the calotypist Hugh Diamond in London, he decided to devote himself to this activity professionally in 1857 and opened a portrait studio. The innovation introduced in his early works was the use of vignetting all around the main subjects to recreate the "unfinished" effect of a drawing or watercolour. More complex but equally aimed at the imitation of a traditional model was the "combination printing" technique involving the reproduction of various negatives on a single sheet of light-sensitive paper. Five images were juxtaposed as early as 1858 for the composition *Fading Away*, Robinson's most celebrated creation with this procedure, which shows the grief of a family gathered around a young woman's deathbed. The impact on the public was extraordinary. Prince Albert, Queen Victoria's husband, is said to have purchased one of the five originals and given the photographer an order for copies of all the works subsequently produced with the same method. The procedure also involved a substantial degree of detachment in

Julia Margaret Cameron
Illustration to Tennyson's Idylls of the King, and Other Poems, 1875

London: Henry S. King & Co., 1875

ontological terms, given that what is shown in the photograph was never all together in front of the lens for the duration of the pose, but the result of placing objects apparently side-by-side that actually were quite separate in space and time. In short, the correspondence between the content of the final image, and the surface delimited by the four sides of the negative, disappears altogether. What is seen, understood as the relations between the different parts of the photograph, was not recorded by the camera.

The invention of combination printing should not, however, be attributed to Robinson, as the idea was first suggested by Hippolyte Bayard as a way of capturing in landscapes both subjects in the foreground and the sky, which was often overexposed due to the limited exposure latitude and the hyper-reactivity of the early light-sensitive materials to blue and ultraviolet. A reference was made to this technique in a description of a photograph by Thomas Annan that appeared in the *Journal of the Photographic Society* in September 1855, and the Frenchman Gustave Le Gray used it to heighten the density of the clouds in some seascapes exhibited in London in 1856.

The photographer Oscar Gustave Rejlander then displayed his extraordinary skill just one year later in *The Two Ways of Life*, a combination of thirty negatives on a support of 78 by 40 centimetres specially produced for the Manchester Art Treasures Exhibition of 1857, and again sold to the Queen.

Apart from this typical (but not exclusive) *modus operandi*, Henry Peach Robinson's link with the academic tradition is also expressed in other specific ways. First, his works were often based on preparatory sketches in which he established the principles governing their formal balance in advance, a standard practice in painting before the immediacy of Impressionism. Second, he worked on the allegorical genre, historical and religious versions of which unquestionably played a leading role in the exhibitions of the Parisian Salon. Rejlander's masterpiece *The Two Ways of Life*, in which Good and Evil are juxtaposed in the two halves of a setting that appears to have been modelled on the layout of Raphael's *School of Athens*, constitutes one of the peaks of this approach, subsequently developed by Robinson in numerous directions including illustrations of the seasons, day and night, dreams, love, and a whole series devoted to the fairytale of Little Red Riding Hood.

While photography endows the characters of the stories it represents with bodies of flesh and blood, like the theatre or the *tableau vivant*, its results are also widely regarded as fragments of reality. Hence its extraordinary power of involvement, even when associated with reconstructed images. This is why *Fading Away* made such a sensation upon its presentation, due to the unbearably dramatic nature of the situation portrayed, even though the subject was hardly new, and the part of the dying girl was played by a healthy fourteen-year-old. From the very outset, all the genres of literature constituted an enormous store of material for the "vivifying programme" of the photographic medium. To give just a few examples from an endless list of names and citations, the American John Edwin Mayall portrayed the Lord's Prayer in a series of daguerreotypes in 1843; the Scotsmen David Octavius Hill and Robert Adamson produced several calotype portraits based on the novels of Sir Walter Scott in the same period; William Lake Price used a great quantity of objects, customs, and stuffed animals for a sequence

inspired by the adventures of Robinson Crusoe, and his portrait of Don Quixote was indicated by Henry Peach Robinson as the best photograph of the year in 1855; and the writer Charles Lutwidge Dodgson – better known as Lewis Carroll, the father of *Alice in Wonderland* – turned the episode of Saint George and the Dragon into a fairytale for children in 1875.

The work of Julia Margaret Cameron, at the peak of pictorialism in this initial period of its development in Europe, was also based on similar references, and structured around the classical canons, albeit with a blurring of outlines that recalls the softness of the early calotypes and contrasts with the crystal-clear images of her colleagues. While Robinson fell in with the predilection of the critic John Ruskin and the Pre-Raphaelite painters for the legibility of every detail, in which divine perfection was supposedly hidden, Cameron instead experimented with a whole range of expedients (from the use of imprecise lenses, to equally imprecise focusing, motion blur, and the insertion of a sheet of glass between the negative and the light-sensitive paper at the moment of printing) to obtain the "blurred" effect that was to be taken up by her many

successors. All this is clearly visible despite the short duration of her photographic activity, which began in 1863–64 at the age of almost fifty, and substantially came to an end in 1875 as a result of her move to India, where she had spent part of her childhood. It was in this period that she captured the celebrated faces of the time in her unmistakable style, including John Herschel, Henry Wadsworth Longfellow, Robert Browning, George Frederic Watts, Charles Darwin, and John Everett Millais, as well as various images of the Madonna (with and without Child), angels, characters from Roman and Christian mythology, and the pages of Shakespeare's tragedies. It was towards the end of the photographer's artistic career that her literary production found a publishing outlet with *Illustrations to Tennyson's Idylls of the King, and Other Poems*, which appeared in two slim volumes containing a total of twenty-four albumin prints in 1875. The compositions of the poet Alfred Lord Tennyson, her neighbour on the Isle of Wight, were brought to life with the help of improvised acting on the part of friends and relatives dressed up as King Arthur, Lancelot, Merlin, Elaine (the Lady of Shalott), and so on. It was in following the narrative thread by

including elements making it possible to identify the images that Julia Margaret Cameron was also able in this series to express some of the linchpins of her thinking, including irreprehensible religious devotion, and a simultaneously marked and unusual position as regards the status of women, often giving prominence to the female roles. Moreover, she also addressed all the subjects from a dual viewpoint, on the one hand as characters in the narrative, and on the other as individuals whose innermost psychological aspects she probed by raising their masks.

Bibliography
Bunnell, Peter C. *The Photography of O.G. Rejlander.* New York: Arno Press, 1979.
Cox, Julian, and Colin Ford. *Julia Margaret Cameron: The Complete Photographs.* Los Angeles: Getty Publications, 2003.
Gernsheim, Helmut. *Julia Margaret Cameron: Her Life and Photographic Work.* London: Fountain Press, 1948.
Harker, Margaret F. *Henry Peach Robinson: Master of Photographic Art 1830–1901.* Oxford: Basil Blackwell, 1988.
Ovenden, Graham. *Pre-Raphaelite Photography.* New York, Saint Martin's Press, 1973.
Sobieszek, Robert A. (Introduction). *Pictorial Effect in Photography.* Pawlet: Helios, 1971.
Taylor, John. "Henry Peach Robinson and Victorian Theory". *History of Photography* 4, vol. 3, Taylor & Francis / Routledge, 1979.

Gustave Le Gray
Seascape, study of clouds,
1856–57
Albumen print, 31.5 x 38.7 cm
Paris, Musée d'Orsay

Henry Peach Robinson
Been a milking, 1858
Albumen print, 18.8 x 15.1 cm
New York, George Eastman
House

Henry Peach Robinson
Fading away, 1858
Albumen print, 24.4 x 39.3 cm
New York, George Eastman
House, Gift of Alden Scott Boyer

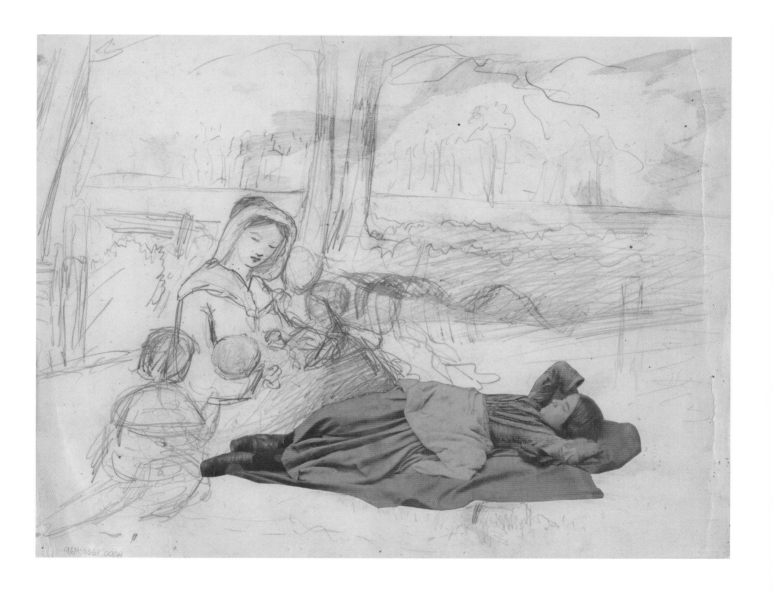

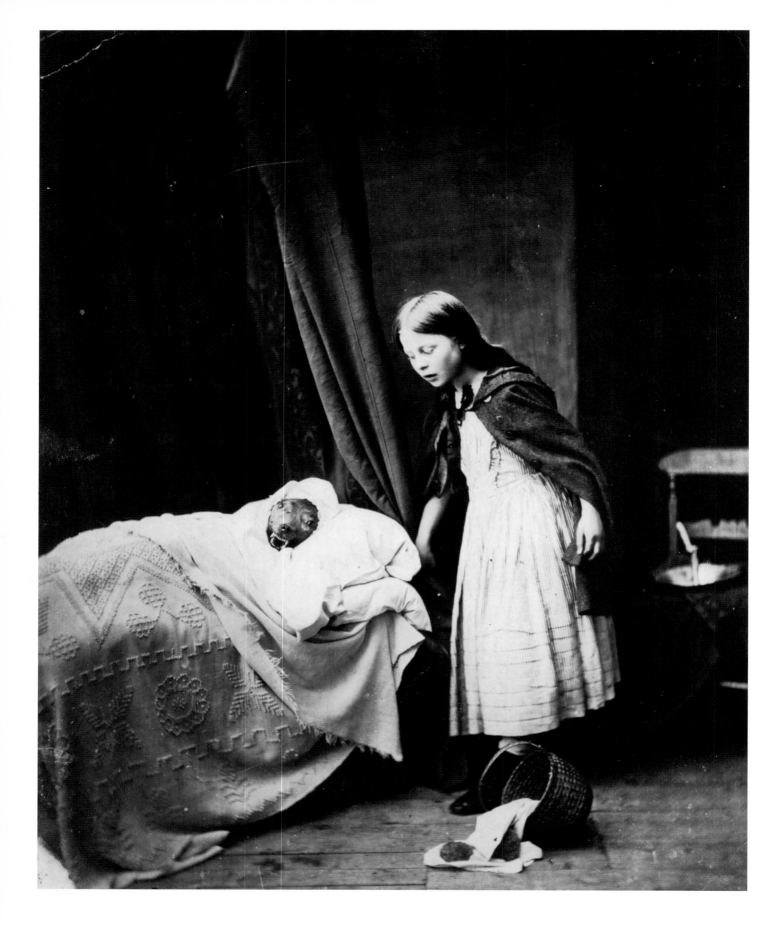

194 | Henry Peach Robinson, Julia Margaret Cameron

Henry Peach Robinson
Red Riding Hood, 1858
Albumen print
Austin, The University of Texas,
Harry Ransom Center

David Octavius Hill,
Robert Adamson
*John Henning as Edie Ochiltree
from Sir Walter Scott's
"The Antiquary"*, 1843–47
Salted paper print from paper
negative, 20.6 x 15.8 cm
New York, The Metropolitan
Museum of Art, Harris Brisbane
Dick Fund, 1937 (37.98.1.90)

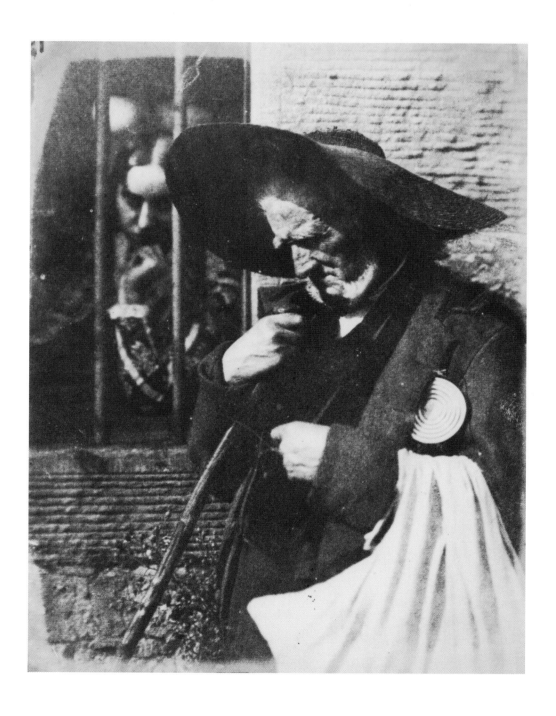

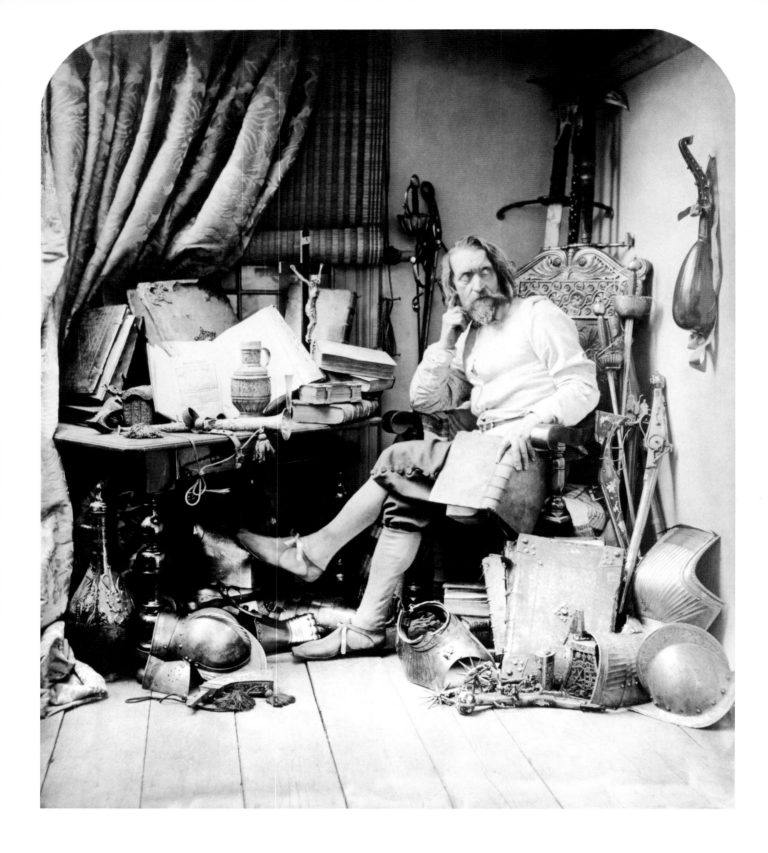

196 | Henry Peach Robinson, Julia Margaret Cameron

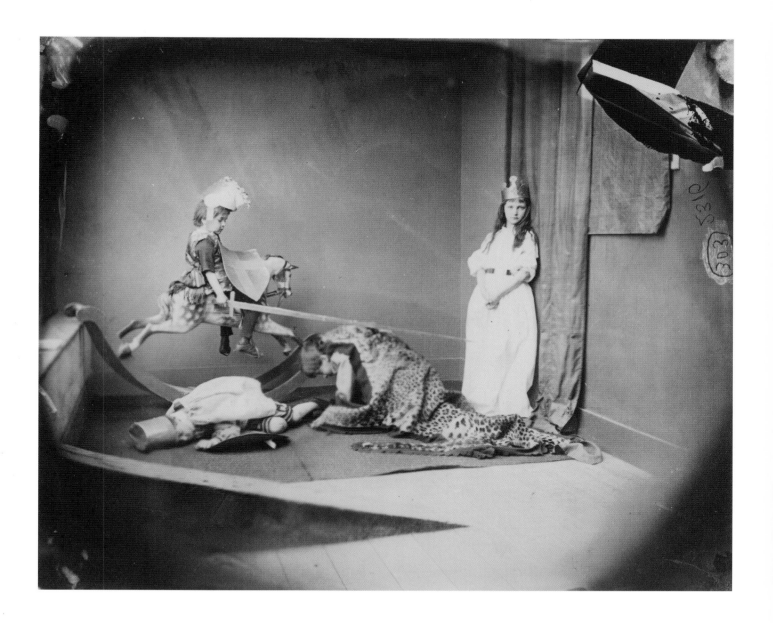

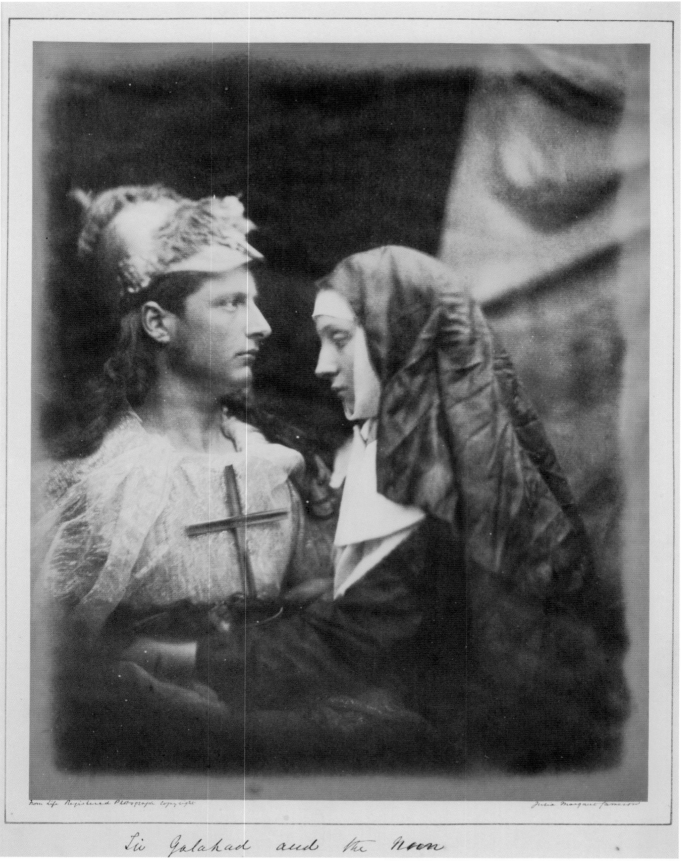

from life Registered Photograph copyright Julia Margaret Cameron

Sir Galahad and the Nun

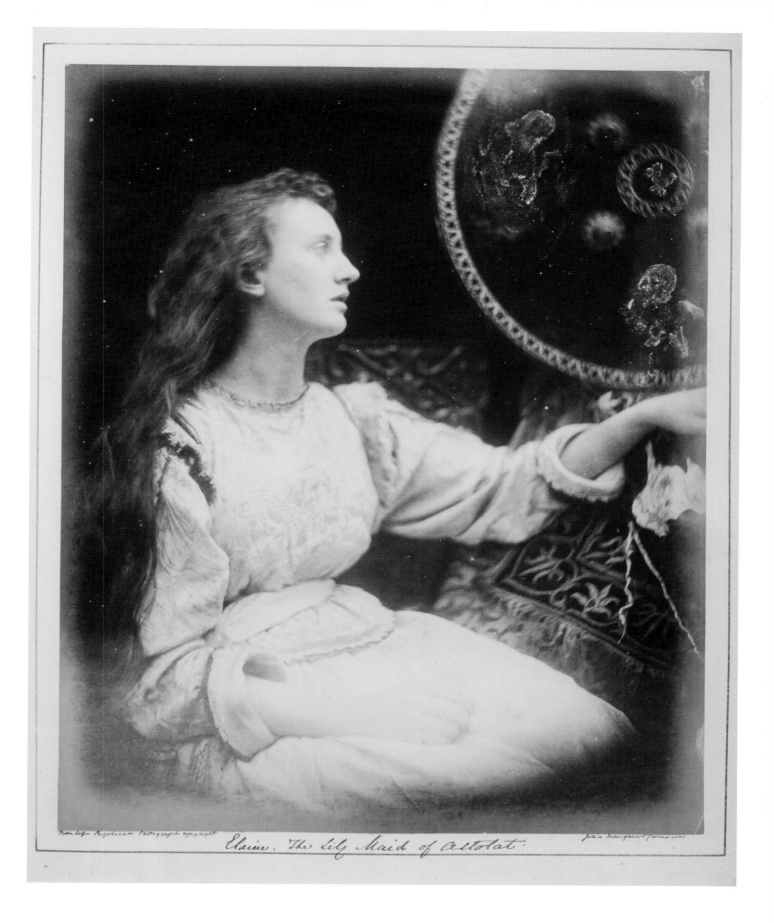

Elaine. The lily Maid of Astolat.

Elizabeth Siegel

An Age of Albums

The second half of the nineteenth century might be called an age of albums. Photograph albums were a way of domesticating and organising the world, of making sense of the past and paving the way for the future, of building an identity for the album-keeper, and sharing that identity with others. As collections of photographs, albums performed many more functions and possessed wider meanings than any single picture could alone. Beginning with amateur efforts in the 1850s, continuing on with the tremendous popularity of *carte de visite* albums through the 1860s and 1870s (and responses to that craze through such innovations as photocollage), and culminating with the snapshot album toward the end of the century, albums offer a window onto the lives, concerns, and legacies of people who were beginning to define themselves in photographs.

The word "album" derives from *albus*, the Latin word for white.[1] With connotations of potential – a blank slate – an album was its owner's to fill with appropriate contents. In the decades before photography, albums might hold drawings and watercolours, autographs and original verses, or essays and aphorisms clipped from the emerging popular press. Even before photographs joined the pages, albums were understood as more than simply collections of poems or sketches: they were metaphors for life itself. With written contributions from members of an intimate circle, an album began to form a portrait of its owner over the course of years. When photographs supplanted text and drawings, albums became a distinctly modern way of representing individuals, families, and communities. By the 1860s, with photographs accessible to nearly all classes, albums became repositories for newly visible memories, heredities, and histories. The parlour album was not just a book of photographs; it was also a link to the past and to the future, a display of status and social connections in the present, a family genealogy and, with the inclusion of celebrity figures, a national history. By understanding the myriad roles and purposes of nineteenth-century photograph albums, we begin to understand how the advent of photography has affected who we think we are, and how we show ourselves to others.

Dabbling in the new art of photography had become a common pastime of the leisured classes, especially in England in the early decades of the medium. Following the model of William Henry Fox Talbot, aristocratic amateurs got their hands messy making pictures on their country estates. Their photographs focused on the landscape, ancestral properties, and group portraits, often staged outdoors and casually posed, sometimes in *tableaux vivants* or narrative scenes. Such activity necessitated a knowledge of chemistry and optics, a familiarity with art history and literature, funds to purchase equipment and chemicals, and ample time to experiment – all requirements that effectively limited photography outside of the commercial studio to the upper classes.[2] Making albums and exchanging prints likewise became part of the exclusive

1. Anonymous
Group on steps at Broadlands, 1859
Page from the *George Cowper Album*
Albumen silver prints from
wet-collodion glass negatives
Chicago, The Art Institute,
Photography Gallery Fund, 1960.815

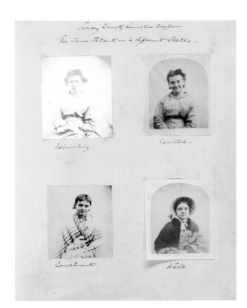

2. Anonymous, Hugh Welch Diamond
Patient in Four States, ca. 1850
Page from the *George Cowper Album*
Albumen silver prints from
wet-collodion glass negatives
Chicago, The Art Institute,
Photography Gallery Fund, 1960.815

3. Julia Margaret Cameron
*The Overstone Album: portraits,
tableaux and noted personalities*,
1864–65
Albumen silver
Los Angeles, The J. Paul Getty
Museum

4. Julia Margaret Cameron
Long-suffering, 1865
Albumen silver print, 25.4 x 19.8 cm
Los Angeles, The J. Paul Getty
Museum

activities of photographic societies that sprang up in the 1850s. The contents of these and more personal albums often varied tremendously. In the George Cowper album, for example, can be found typical high-quality domestic scenes, such as the family group at Broadlands (the seat of the prime minister Lord Palmerston, a Cowper relative; Fig. 1). But there are also photographs by Fox Talbot, Henry White, and Hugh Welch Diamond that have nothing to do with family; on the contrary, Diamond's pictures of a woman improving from melancholia to sanity strike a notable contrast.[3] (Fig. 2)

Photographers at a more determinedly artistic level, such as Julia Margaret Cameron and Lewis Carroll, employed albums as a way to control their imagery and promote their art. Cameron, for example, pulled together 112 of her best photographs in 1865 in a handsome presentation album for her early patron and supporter Lord Overstone (Figs. 3–4); in other cases, she made albums for close friends and family.[4] Lewis Carroll left some thirty-four albums upon his death (many have since been lost or broken up). He used them as "show" albums to exhibit to visitors or take with him on his travels to encourage prospective sitters. The images included therein were selected to show off his range and the diversity of subjects he could handle; he casually mixed portraits of the famous with images of family and colleagues, along with a variety of landscapes and still-lifes (Fig. 5).[5]

The most significant development in photograph albums, however – which came not from artistic amateurs but from the swelling ranks of professional photographers – was the rise the *carte de visite*.[6] Inexpensive, easily transportable, and reproduced in massive quantities, the *carte de visite* was the most popular form of photographic portraiture across Europe and the United States throughout the 1860s and 1870s.[7] (Figs. 6a–b) Patented by André Adolphe-Eugène Disdéri in France in 1854, the *carte de visite* (literally, "visiting card") was a photographic portrait on paper just

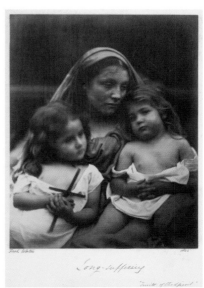

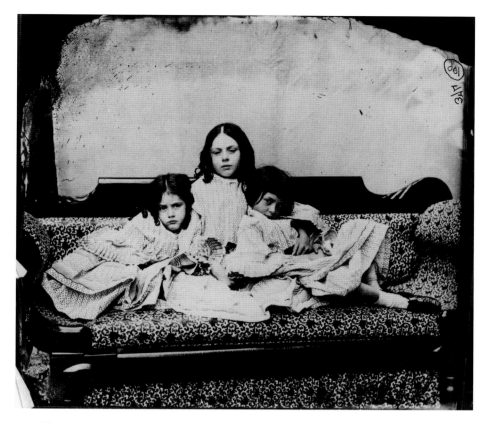

smaller than its four-by-two-and-a-half-inch vertical cardboard
mount. Disdéri configured a special camera with four lenses and a
plate-holder that could be moved from one side to the other,
allowing one exposure on each half of the plate. A single print of
the entire plate would thus yield eight different pictures that could
be cut up and mounted. With so many negatives to print from, the
reproductive capacity of the *carte de visite* increased tremendously
over that of any other portrait medium, and portrait photographs
became remarkably affordable.

Taking their cue from aristocratic painted portraits, *cartes de visite*
most commonly showed a full-length, vertical pose, which
presented the whole of the sitter's body and dress for the scrutiny
of the viewer. The goal of these images – as of photographic
portraiture in general – was to obtain the proper combination of an
accurate likeness and an elevated expression, in keeping with the
belief that outer features were clues to inner character. Numerous
manuals and articles in the photographic press guided
photographers in posing, lighting, and eliciting proper expressions
(see the example of suggested poses from a series in *Anthony's
Photographic Bulletin*; Fig. 7). In reality, however, the relatively tiny
face of the sitter was subsumed by the figure as a whole, and most
viewers understood the signs of gentility through his or her clothing
or setting as readily as they discerned character through his or her
countenance. Although customers coming for a photographic
sitting generally wore their own clothes, the photographer selected
the backdrops and props for the portrait, making the studio an
additional presence in these pictures. Backgrounds ranged from a

6a–b. *A few Cartes-de-Visites*, in *Harper's New Monthly Magazine 26*, no. 155 (April 1863), pp. 718–19

7. *Suggestions for Posing*, in *Anthony's Photographic Bulletin 1*, no. 5 (June 1870), p. 78 Photography, 22.6 x 13.9 cm New York, American Photo-Lithographic Company

standard curtain or solid painted backdrop, to an elegant balustrade or parlour setting, or an elaborately painted scene of verdant hills or far-off places. As in painted portraits, props might include columns, handsome chairs and tables, vases, books (often used to indicate the sitter's profession or intellectual calibre), or even photograph albums. Whereas such accessories were intended to define the personality of the sitter, many photographers employed them indiscriminately, placing their subjects in ready-made settings regardless of their manner or position. As one commentator caustically put it, "The *carte de visite*, even in some of the best show cases in London, is a pedestal with a man near it; it might be catalogued as the portrait of a pedestal, and a column, and a lord."[8] Thus, what was supposed to be indicative of individual character instead had a levelling effect, supplying all sitters with the same signs of gentility.

The result of such standardised poses, backgrounds, and props was that millions of portraits looked remarkably alike. Critics lamented the dulling uniformity seen on studio walls and in page after page of the photograph album, as seen in the repetitive pictures in this *carte de visite* album (Fig. 8). The resulting standardisation attests perhaps to the uniformity of family, but it also indicates that the photographer adhered to certain formulae in posing and accessories. The assembly-line practices of some photographers befitted an age of incipient mass-production and an industry in which pictures were being produced at an unprecedented rate for less and less money. Perhaps this sameness was actually desired by the consumer, who might have found, in the shared experience of sitting for and then circulating the *carte de visite*, assimilation and membership in a like-minded group. Its possession allowed one entry into the rituals of middle-class society; without a picture to distribute, one might literally be excluded from an album of friends and family.

Accolades for the *carte de visite* spilled out of the pages of the photographic and popular press as sitters streamed into studios and print shops. As an 1861 article in the *American Journal of Photography* noted, "They are such true portraits, and they are so readily obtainable, and so easily reproduced, that they may well aspire to become absolutely universal."[9] For the first time, it was possible for large numbers of people to obtain likenesses of loved ones and to create a visible genealogy, which had previously been reserved for the landed classes. Sitters would purchase their portraits by the dozens and distribute them to friends and family, receiving in exchange *cartes de visite* for their own collections. School chums exchanged pictures with each other, young men and women traded them as part of courtship rituals, and parents had their children photographed, sometimes several times. The craze for the *carte de visite* became known as "cartomania", a popular fashion with lasting consequences. Such mania was lampooned in journals of the time, as in an article in *Littel's Living Age*, which

Suggestions for Posing.

Reproduced from the ILLUSTRATED PHOTOGRAPHER.

by the

AMERICAN PHOTO-LITHOGRAPHIC COMPANY, NEW YORK, OSBORNE'S PROCESS.

reported that the chains of connection from sitter to claimant were growing ever weaker: "The demand for photographs is not limited to relations or friends. It is scarcely limited to acquaintances. Any one who has ever seen you, or has seen anybody that has seen you, or knows anyone that says he has seen a person who thought he has seen you, considers himself entitled to ask you for your photograph."[10]

If the ability to have one's own picture taken cheaply and distribute copies of it among friends seemed extraordinary, the sudden confrontation, in vast numbers, with the famous of the day was nothing short of astounding. In an 1864 article titled "Photographic Eminence", one writer tried to capture the immense flood of celebrity *cartes de visite*: "The private supply of *cartes* is nothing to the deluge of portraits of public characters which are thrown upon the market; piled up by the bushel in the print stores, offered by the gross at the book stands, and thrust upon our attention everywhere. These collections contain all sorts of people, eminent generals, ballet dancers, pugilists, members of congress, Doctors of Divinity, politicians, pretty actresses, circus riders, and negro minstrels."[11] Celebrity *cartes* could be purchased from stationers, booksellers, fancy-goods stores, by mail order, or in well-appointed photographic establishments such as Mathew Brady's Photographic Gallery, where private sitters might have their own photographs made (Fig. 9). *Cartes de visite* capitalised on the contemporaneity of celebrities first made possible with the daguerreotype: rather than depicting venerable heroes of the past, they showed the famous of the present. In England, for example, between 1860 and 1862 alone it is estimated that some three to four million *cartes* depicting Queen Victoria were sold, and over two million of the Prince of Wales and Princess Alexandra were sold following their wedding in 1863.[12] With the increasing popularity and accessibility of celebrity portraits came a greater familiarity and intimacy as well. The *carte de visite* brought the famous into the parlour, and made them seem more like family than heroes; it sparked a new relationship with the famous of the day. This fact was widely commented upon at the time, as in an 1862 article on the new

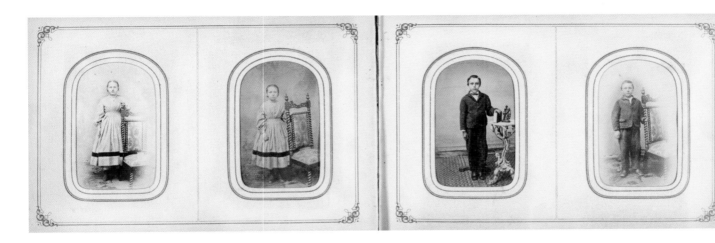

9. *M.B. Brady's New Photographic Gallery*, in *Frank Leslie's Illustrated Newspaper* 11, no. 267 (5 January 1861), p. 108

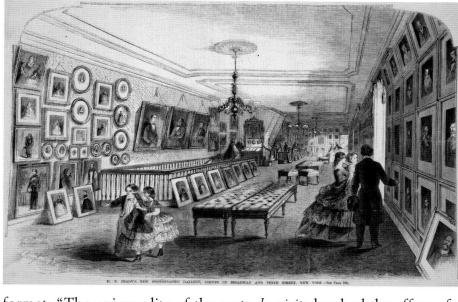

10. *N.C. Thayer & Co. album catalogue*, 1887
New York, George Eastman House

format: "The universality of the *carte de visite* has had the effect of making the public acquainted with all its remarkable men. We know their personality long before we see them. Even the *cartes de visite* of relatively unknown persons so completely picture their appearance, that when we meet the originals we seem to have some acquaintance with them."[13]

As the *carte* craze flourished, and stacks of pictures piled up in card-baskets and overflowed onto the parlour's centre-table, it became clear to consumers and suppliers alike that a more efficient system of storage and display was needed. "At a trifling expense we can have the pictures of all those we love, all we esteem, and all we admire and revere of our own family, of great men, of good men; the hero, the patriot, the sage, the divine," noted an editorial in *Godey's Lady's Book*. "But then, if we would have these interesting portraits in orderly array, and at hand for inspection, we require a fitting receptacle."[14] Album manufacturers rose to the challenge – first on the continent in the late 1850s and then in England and the United States beginning in the early 1860s – developing volumes with cardboard pages with a *carte*-sized opening so that two photographs could be inserted back to back, visible on each side of the page. Although the first *carte* albums were rather small and simple, with cardboard covers and room for about a dozen pictures, they evolved into elaborate affairs. Later albums held up to two hundred photographs of varying size, with leather or velvet covers, gold embossed designs, and chromolithographic page decorations (Fig. 10).

Photograph albums rapidly became "must-have" items, especially for young women. Fashion plates in the most prominent magazines portrayed ladies in the latest finery, sometimes holding albums in their hands as stylish accessories (Fig. 11). In one story in a photographic journal from the 1860s, a wife tries to convince her husband to buy a *carte* album by pleading, "Albums are all the rage – everybody has them. It's the fashion, and we must follow fashion,

11. *Home Toilet*, in *Harper's New Monthly Magazine 26*, no. 156 (May 1863), p. 864

you know."[15] Yet at the same time, what began as a stylish trend quickly established an enduring presence in homes. Family albums, in the commercial and popular discourse that surrounded them, seemed to define family itself. *The American Journal of Photography* called the arrival and wide public display of photograph albums "a sign and proof of the best feature in our civilization," claiming that "it tells of the universality and strength of the domestic affections."[16] Although albums were available for a wide range of prices, their very affordability meant that they were a minimum requirement of bourgeois family gentility. As albums became cheaper and filtered down to more purchasers, not owning one effectively defined one out of both the respectable middle-class and the category of family itself. By 1864, the American women's journal *Godey's Lady's Book* could write that "*photograph albums* have become not only a luxury for the rich, but a necessity for the people. The American family would be poor indeed who could not afford a photograph album."[17] In its transition from luxury to necessity, the family album became a symbol of middle-class life. The increasingly low cost of photographs and albums allowed unprecedented access to what had once been the sole purview of the wealthy in possession of oil paintings, and that fact was not lost on commentators of the day. As one observer put it, "It has placed within the reach of the most humble the great pleasure formerly reserved for the privileged classes – the pleasure of possessing the likenesses of those we love."[18] For the first time, the middle classes had access to a visible genealogy, beginning to compile a pictorial past and present that could be handed down to future generations. In many cases, the family album replaced the family Bible, which had been a common, if informal, way of marking the family milestones of births, deaths, and marriages. The notion of adding photographs to these pages, then, was the logical next step in the secularisation of family records, and publishers began to produce

12. William W. Harding *Bible with family register and photographs*, 1867 Courtesy American Bible Society Library, New York

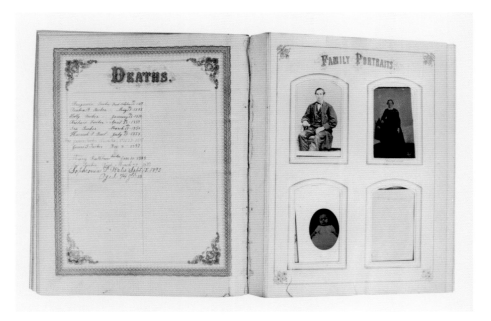

family Bibles with slotted pages for photographs and lines for inscribed names and life events (Fig. 12). (The connections between album and religious books were already in place: albums had adopted the look and feel of Bibles, with elegant leather covers, gilded pages, and brass clasps.) The remarkable shift of the family chronicle from Bible to album was not lost on contemporary commentators, one of whom referred to the photograph album as "an illustrated book of genealogy", and predicted that "it will supersede the first leaf of the family Bible".[19] This was a definitive shift in the keeping of family records, from a written chronicle to a visual – and visible – compilation. The secular photograph album completed the process begun with the insertion of portraits into family Bibles, and marks a particularly modern shift from an oral or textual tradition to a visible one: what had previously been a list of names, dates, and events had now become a history of appearances and physiognomies.

A family connection was now made tangible through common, repeated hereditary characteristics. The scrutiny that photographs encouraged, especially when placed side-by-side in an album, allowed for an unprecedented degree of comparison; that certain physical quality of belonging to a group made itself more apparent on the page than it might have been at even a family gathering. The features of heredity could be observed over time and distance and charted for all to see, with babies resembling one another across generations, or far-away cousins sharing the cut of a jaw or bridge of a nose. This new possibility inspired the rise of genealogical albums, such as one published by A. H. Platt in the wake of the Civil War in the United States (Figs. 13a–b). It came with elaborate instructions and separate pages for the father, mother, and up to eleven children; slots for two *cartes de visite*; space for a signature; and lines to be filled in on various characteristics of the family member. This album was intended as part family history, part document suitable for a court of law for those that might not have such a record. Platt in effect proposed two definitions of family – one legal, which related to inheritance of property, and the other scientific, which related to inherited characteristics. He envisioned the collection of this material as a national project – an infinite number of private genealogies adding up to a nation's history, a permanent record of a country's past. The potential to track heredity through photographs also intersected with the nineteenth-century interest in eugenics. Albums such as the *Life History Album*, devised by the father of eugenics Francis Galton in England in 1884, sought to help families assemble visual records that were personal in scope.[20] In Galton's scheme, each child would receive his own album at birth; along with a family medical history and updated charts of height and weight, two pictures would be inserted into its pages every five years. Ideally, these photographs were to be consistent enough in size and format to be compared fruitfully and accurately.

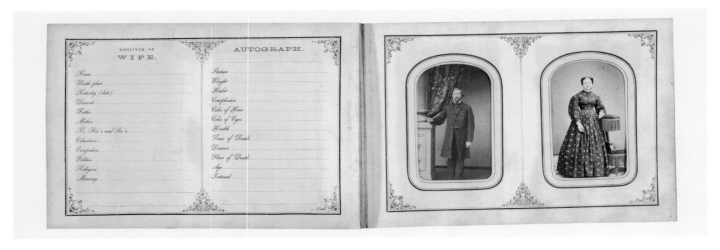

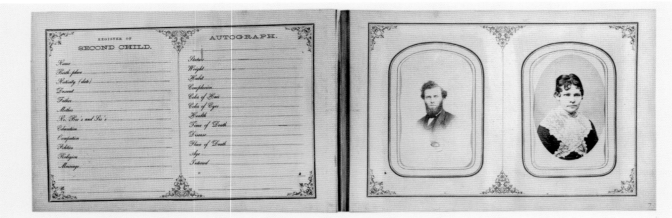

13a–b. A.H. Platt
The Photograph Family Record
(pages for "Wife" and "Second Child"),
1865
Image, 6.4 x 10.2 cm
Each page, 14.5 x 21 cm
Album overall, 15.5 x 23.5 x 4.3 cm
New York, George Eastman House,
Gift of 3M Foundation, ex-collection
of Louis Walton Sipley

Understanding that mental and physical characteristics were transmitted from parents to children, Galton realised that such an album would be valuable not only to a family's descendants, but also to the study of heredity and eugenics on a much larger scale. The photograph album became the receptacle for family memories and histories, an index to the faces and features of loved ones; it was an object of permanence and constancy to shield against the family's dispersal. A product of modern technology, it could also combat the dangers modernity was imposing on families, and symbolise continuity in an increasingly ruptured world. Album-keepers often added the additional memory trigger or relic of a lock of hair, which incorporated a physical piece of the person pictured. Poems on the topic of family albums commonly noted that photographs live on long after their originals, and that albums restored the departed to life. Consider a verse from an 1878 poem "The Family Album": "Thus often when with weary cares opprest, / I take the family album from its place, / To muse upon some well-beloved face, / Within the silent tomb, for aye, at rest."[21] Such poems suggest that the album's role was to comfort as it recalled memories, and that the volume itself would be pulled out on numerous occasions to serve this function. Photograph albums provided the means to reinforce memories through stories that could be told again and again. Once assembled together, the

portraits seemed to take the form of a narrative, due to the sheer fact of their being sequential; that one followed another implied a beginning, middle, and end. A viewer might "read" the pictures one after another, turning the pages like a book, linking the pictures into a cohesive story.

At the same time that photograph albums were cherished keepsakes and intimate collections of family, they also functioned as more public advertisements of their owners' character, social networks, and status. Displayed in the drawing-room or parlour, the room where people entertained visitors, albums enabled a new kind of self-presentation to others. As the noted French literary figure Ernest Legouvé put it, "Photographic collections … are found on almost every centre-table, and each one is both the portrait of those who are placed therein, and of the one who composed it."[22] Albums often comprised not only family collections, but groupings of society as well. The act of perusing an album often implicated the viewer, who might be asked to hand over his own portrait for the collection. A poem commonly found on *cartes de visite* in the first page of albums (Fig. 14) explained the ritual:

Yes, this is my album,
But learn ere you look:
That all are expected
To add to my book.

You are welcome to quiz it
The penalty is,
That you add your own portrait
For others to quiz.

In this fashion, visitors added to an accumulation of pictures that seemed to grow with every showing, and the observer in turn became the observed. This ritual was one of community and inclusion, as the viewer gained entrance into the social world pictured within an album's pages both by leafing through it and by reciprocating and becoming a participant. Collecting *cartes* and maintaining an album thus became a collective activity that formed and fostered bonds of identification and belonging.

Photograph albums also became a means of entertaining visitors. Etiquette manuals and home-decorating guides classed albums along with games, philosophical toys, and other objects of amusement. The photograph album seemed the perfect antidote to potential boredom, diverting guests by allowing them to scrutinise the faces and fashion of the famous, or remark upon views one had been fortunate enough to experience personally. "If the cook happens to be late for dinner (and cooks generally are), [hostesses] will find how invaluable these 'Heads of the People' are, and what agreeable reading they will supply to even the hungriest, as its illustrated pages present some new feature at every turn," claimed

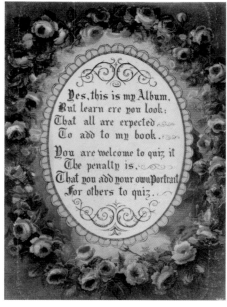

14. Mosaic *carte de visite*, ca. 1860s
Collection of Patrizia di Bello

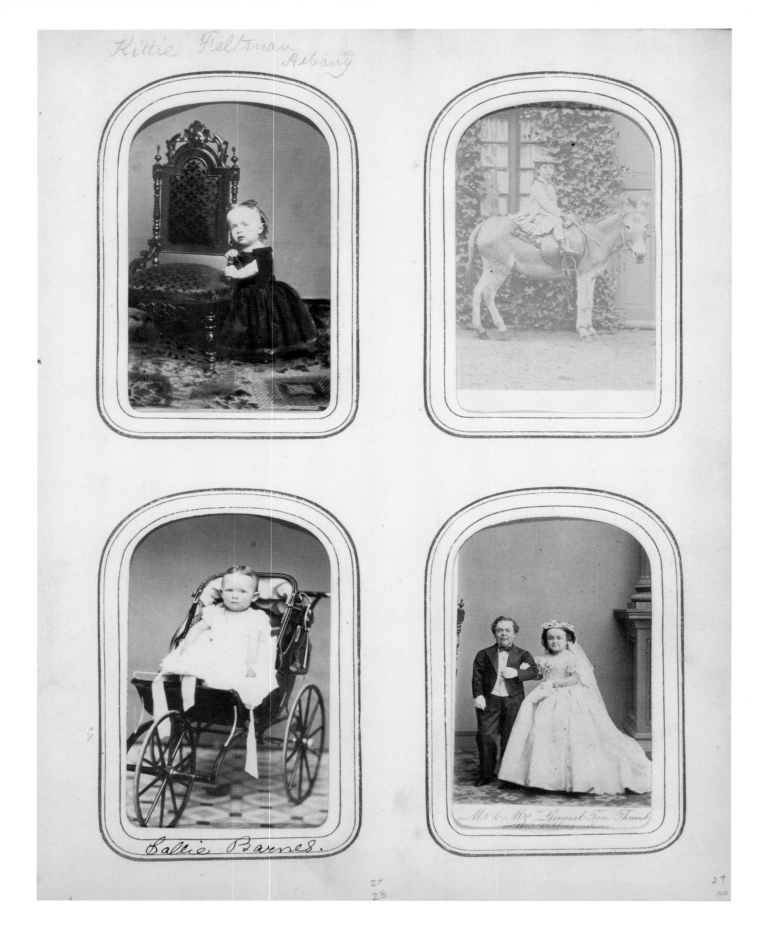

15. *Carte de visite album with Tom Thumb's wedding, juxtaposed with family portraits,* 1860s New York, George Eastman House

Punch's Almanack, concluding, "A photographic album is the most amusing anteprandial friend that a lady could have in her establishment."[23] Albums comprised entirely of celebrities became national portrait galleries in miniature, allowing their owners to collect, edit, and arrange the figures according to their own preferences or narratives. As part of a domestic collection, photographs of the famous seemed to provide a moral education and blueprint for self-improvement, and also revealed the sophistication of their owners. Pictures of artistic and literary figures might indicate an elevated mind, war heroes might reveal patriotism, or clergy religious rectitude. Often times, albums mingled the famous and the familiar in ways that seemed to insert public figures into private family histories. American album-keepers sometimes included Abraham Lincoln, while Queen Victoria and Prince Albert often found their way into British albums. Even more unconventional figures, such as P. T. Barnum's sideshow star Tom Thumb, might become part of a family collection (Fig. 15).

Because so many *carte de visite* albums (and their contents) looked the same, many keepers of albums attempted to individuate their family collections. They personalised their pictures by arranging them in particular hierarchies with the volumes, telling stories about them in the parlour or drawing-room, or by physically intervening on the page. The pages of women's magazines were filled with various craft projects that were intended to embellish both the home and the self, from bonnet trimmings and decorative frames, to terrarium displays, and albums were not exempt from this urge to beautify. In one 1860s album that is otherwise remarkably repetitive, one page stands out (Fig. 16): this collage seems to be a small memorial to a child that died young, and was probably constructed by his mother. A hand-tinted photograph of a boy has been cut out and stitched onto a valentine with a lace-mesh interior; above the boy's head is a golden cut-out circle, a halo that marks his place in a better world. Although post-mortem photographs, especially of children, were not uncommon at the time, this image seems special: its difference among the photographs seems intended to call out to the viewer and revive the memory of a lost child with a sensitivity that surpasses that of untouched post-mortem images. Carefully cut out and lovingly assembled, this memorial collage is an artistic creation inspired by mourning and remembrance.

Some producers of albums went far beyond such memorials to create completely new worlds. In England in the 1860s and 1870s, aristocratic Victorian women began experimenting with photocollage, uniting painted inventions with available photographic portraits (usually *cartes de visite*) to create entirely new compositions.[24] Producers of photocollage pasted cut photographs of human heads atop painted animal bodies, placed real people in imaginary landscapes, and morphed faces with drawings of common household objects and fashionable accessories

16. Collaged memorial photograph from *carte de visite* album, ca. 1860s
Private collection

17. Eustace Clare Grenville Murray
Illustration from *Side-Lights of English Society, Sketches from Life, Social and Satirical*, 7th ed., Vizetelly, London 1885

with a casual irreverence. Playful and witty, and at times surreal and subversive, these compositions flout both the conventions of nineteenth-century photography and the restrictions of middle-class Victorian society.

The ladies who made photocollages kept them in albums and used them to entertain their families and friends, to facilitate sly flirtations, to comment on society and toy with the social order, and to display their talent and wit. Appropriate accomplishments for a nineteenth-century woman of a certain class might include playing musical instruments, speaking French and other languages, dancing, needlework, and a variety of hostessing skills. Drawing, acknowledged as a polite and useful art, was a sign of such accomplishment and the status that accompanied it; it signalled not only refinement and talent, but also the ability of the artist to purchase manuals and private lessons.[25] Moreover, accomplishments like album-making were critical to courtship rituals. Besides affording young lovers the opportunity to sit intimately on the settee, the shared viewing of an album allowed women themselves to be discreetly on display for men (Fig. 17).

Albums of photocollage are strikingly different from the typical middle-class albums found on every centre-table. By cutting out photographs, pasting them into albums, and surrounding them with innovative watercolour drawings, makers of photocollage transformed the democratic, mechanical, and reproducible photograph into an object that was aristocratic, handmade, and unique. Photocollage albums were removed from the commerce of the masses, and instead became vehicles to display upper-class feminine accomplishments. Moreover, these photocollages undermined the rather serious conventions of portrait photography that commercial studios had established. While photographs for the middle classes signified stability, respectability, family, and assimilation, photocollages gleefully signalled wit, leisure, cultural references, social status, and exclusivity.

Although the collages vary depending on the age, station, marital status, children, and artistic education of their creators, there is a remarkable amount of overlap of subject matter and approach. Because so many albums share repeated motifs, it seems likely that the assemblers of photocollages viewed and perused each other's albums. In fact, when the imagery of photocollages is viewed together, what emerges is an overriding concern with social class, and we can read these images as a collective self-portrait of the Victorian aristocracy at play. We see urban entertainments along with more private amusements and games enjoyed by the upper classes, including archery, croquet, lawn tennis, and fox-hunting. Portraits are combined with key objects in daily social life, such as umbrellas, jewellery, china, and playing-cards. Photographs standing for ancestral paintings on the walls of great estates would have been readily understood as signifying both the material wealth of their present, and the genealogical continuity of their past.

And fantastical scenes reference contemporary Victorian visual and intellectual culture, from fairy tales to *Punch* magazine to Charles Darwin. As Victorian women carefully placed cut-out photographs into these painted scenes, they could define themselves as part of society, but also manipulate it with great wit and humour.

Many photocollages take place in the domestic drawing-room, which was the most public room in the house – the place where visitors would be received, and where women could show off their refined taste in furnishings and their ability to attract the "right kind" of people. The drawing room was the place where amateur theatricals might be staged, and was likewise a social staging ground for Victorian women. In this scene staged in her fashionably furnished drawing room, Lady Filmer (a minor aristocrat who used her beauty and cleverness to advance in society) has depicted herself as a collector of photographs, standing close to her albums, pot of glue, and paper-knife (Fig. 18). Albert Edward, the Prince of Wales – a highly sought-after guest and an impressive coup for any Society hostess – leans jauntily against the table in the centre of the room. Lady Filmer and the Prince of Wales enjoyed a well-known flirtation, one that was conducted in part through the exchange of photographs, and his picture appears frequently in her album. His larger figure contrasts with the more diminutive one of her husband, Sir Edmund Filmer, who is seated near a dog in the lower-right corner. This collage stages a visit that may or may not have actually taken place, either serving as a reminder of their flirtation or perhaps proof that it was all being conducted with propriety, in full view of her husband, friends, and extended family. By placing the prince next to her albums, she hinted that these volumes played a role in her social success and that the prince

18. Mary Georgiana Caroline, Lady Filmer
Untitled page from the *Filmer Album*, mid-1860s
New York, Paul F. Walter Collection

19. Frances Elizabeth, Viscountess
Jocelyn (attributed)
*Lady Fanny Jocelyn as bulls-eye
of archery target*, ca. 1860
Albumen silver, watercolour with
glaze, gold, pen and ink, pencil-collage,
printed image, 28 x 23.2 cm
Canberra, National Gallery of Australia

20. Alexandra, Princess of Wales
Untitled page from the *Princess
Alexandra Album*, 1866–69
London, The Royal Collection

might have enjoyed her visual games. Displaying this collage in her album allowed Lady Filmer to exhibit her accomplishment in painting, but also her smart wit in arranging the photographs, giving her viewers who were in on the joke a little thrill.

Beyond the domestic drawing-room, when photographic portraits are set in realistic scenes, these are often in the public sphere. In many of these compositions, men and women are depicted on the London streets, playing tennis, roller-skating, or attending the theatre, the opera, the circus, or church. Additionally, a large number of pages feature amusements and games enjoyed by the upper classes, particularly women, including archery, croquet, lawn tennis, and cards. An amusement such as archery, for example, encouraged poise and elegance in women; it allowed for socialising and the display of feminine beauty even as it promoted the healthy benefits of fresh air. Lady Jocelyn began with that common theme but produced a psychologically charged, if ambiguous, image of a woman's face occupying the centre of a target, with arrows that have missed the bull's-eye surrounding it (Fig. 19). Photographs also appear quite often in images related to communication (Fig. 20). Sundry *cartes de visite* spill out of envelopes painted in trompe-l'oeil fashion (the fact that the photograph represents itself only adds to the illusion). Portraits, along with printed crests, serve as seals to missives. Envelopes with convincingly drawn postmarks – possibly indicating the site and date of country-house parties – are adorned with photographic stamps.

Much of the source material for collage images – and the repetitions among albums – can be found in the shared cultural values and visual references of upper-class Victorian England. The witty caricatures of *Punch* magazine would certainly have been

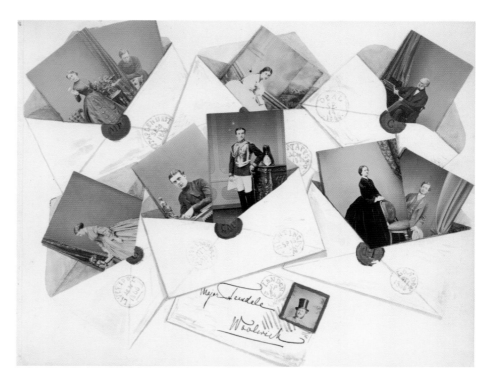

recognised by members of the upper society. Commonly appearing flowers, as explained in several illustrated books of the time, served as a symbolic language among the Victorians, allowing them to convey thoughts and emotions while still maintaining proper decorum. Some of the surrealism apparent in photocollage compositions can also be attributed directly to popular children's literature and fairy-tales, such as those by the Brothers Grimm, Hans Christian Andersen, and Lewis Carroll. In Andersen's stories, for example, transformations abound, from a mermaid changing into a human to an ugly duckling growing into an elegant swan. One of the most popular was the tale of Thumbelina, a tiny girl born from a tulip flower who endures misadventures until she happily ends up marrying a fairy-king. The fairy-tale setting was an attractive one for compositions featuring children; even Princess Alexandra made an album page with her children nestled among flower-buds and toadstools (Fig. 21). The nonsense and dreamscapes of Lewis Carroll provided another source for some of the more fantastical photocollages that have been found in albums. Published in late 1865, *Alice's Adventures in Wonderland* became immensely popular among children and adults alike. Imagery from the tale shows up in some albums, but the *Alice* story is also a useful lens for understanding the strange and unusual qualities of photocollage. The scale shifts experienced by Alice throughout her adventures – she grows and shrinks depending on what she consumes – mirror those seen in album pages, as portraits are cut from their backgrounds and placed in miniature in invented settings. And of course, just as the Queen recklessly demands the beheading of insubordinates (and Alice) with the refrain, "Off with her head!", decapitation becomes a prominent

21. Alexandra, Princess of Wales
Untitled page from the *Princess Alexandra Album*, 1866–69
London, The Royal Collection

24. Victoria Alexandrina Anderson-Pelham, Countess of Yarborough and Eva Macdonald
"Mixed Pickles"
Page from the *Westmorland Album*, 1864–70
Los Angeles, The J. Paul Getty Museum,

Pages 218–219
22. Kate Edith Gough
Untitled page from the *Gough Album*, late 1870s
Hand-painted photograph album
London, Victoria and Albert Museum, Gift of Guy Eardley-Wilmont

23. Kate Edith Gough
Untitled page from the *Gough Album*, late 1870s
Hand-painted photograph album
London, Victoria and Albert Museum, Gift of Guy Eardley-Wilmont

theme in photocollage compositions, as photographed heads are severed from their bodies.

During the heyday of photocollage, it would have been impossible for those in elite society to avoid the new ideas about man's connection to the family of apes put into circulation by Charles Darwin. Within a decade of the 1859 publication of *On the Origin of Species*, there were numerous different editions in circulation, and Victorians encountered Darwinian tropes in more indirect ways as well – in caricatures, songs, commercial products, and written satire in the popular press.[26] The evolutionary "tree of life" came to stand for the primary message of Darwinism, and Darwin himself was often portrayed as a monkey sitting or swinging in a tree. Thus, when Kate Gough assembled a collage of her family members as painted monkeys with photographed human faces huddled together on sturdy branches, the allusion was manifestly clear (Fig. 22). Gough's family tree cleverly links her personal genealogy with a global one, displaying both her knowledge of the latest scientific theories and a witty self-deprecation. In a less scientific nod to Darwin's link between humans and animals, a remarkable number of images found in photocollage albums combine humans and animals in fantastical ways; the temptation to cut out a photographed head and place it atop a painted animal seems to have been irresistible (Fig. 23). In this regard, many of the photocollages echo caricatures from *Punch* and other journals, in which artists placed comically large beaks on human faces, attached human heads to snail bodies, and dressed animals in bankers' clothes. As a satiric and descriptive tool, such hybrids could deliver a pronouncement with cutting wit.

The new medium of photocollage was wonderfully suited for compositions of the surreal and fantastic; indeed, the chance to combine photographic portraits with painted settings inspired dreamlike and often bizarre results(Fig. 24). For a Victorian viewer of photocollage albums, comprehending these images must have meant a welcoming of contrasts, a juggling of the real and the fantastic, and an understanding that the originally intended meaning could be drastically transformed in a new setting. For the maker of Victorian photocollage, that was precisely where the pleasure lay. In removing a photograph from its truthful mooring and reinserting it into fantasy, collagists aimed to amuse and entertain, to commemorate and strengthen relationships, to simultaneously display social belonging and toy with that social order.

When album makers combined the facts of photography with the fictions of painting, they created a new kind of representation, one that changed the rules of photography in a variety of ways. Photocollage allowed – even encouraged – them to expand the limitations of photography to incorporate fantasy, dreamscapes, whimsy, and humour. Indeed, this was all the more effective because of the power that a photographic portrait had to anchor a

specific sitter in reality. If photography in the mid-nineteenth century was generally understood to represent accuracy, fidelity to nature, and representational stability, photocollage undermined these values to the point of caricature (Fig. 25).

Instead of standing intact as images that referred to a person in a specific time and place, photographic portraits took on new meanings in newly invented contexts. Studio portraits possessed their own conventions that could be easily read, a form of self-presentation inflected with middle-class respectability, but these were carelessly discarded by aristocratic collagists, who snipped away at photographs to keep only what they desired. Collagists employed pictures of various sizes that had been made from numerous different sittings, with diverging angles and different lighting conditions, flattening the composition and creating awkward relationships among the subjects. The act of cutting up photographs and reassembling them into new combinations produced images that were never entirely coherent or whole, but rather fragmented and disjointed; a single point of view made by a faithful recorder was replaced by numerous images made from multiple perspectives. The typical family album was an artless record of the faces of friends and family, but photocollage albums were filled with staged encounters and dreamlike visions. Indeed, these early experiments in photocollage may have been symptomatic – or even unwittingly productive – of the kind of fluid understanding of photographic meaning that would later dramatically blossom in the twentieth and twenty-first centuries, with significant repercussions.

As Victorian aesthetics gave way to modern ones and the sentiment of the parlour yielded to the more casual associations of the living-room, *carte de visite* collections began to fall out of favour.

25. Constance Sackville-West or Amy Augusta Frederica Annabella Cochrane-Baillie
Untitled page from the *Sackville-West Album*, 1867/73
New York, George Eastman House

Historian William Culp Darrah suggests three different reasons for the fading popularity of the *carte de visite*: halftone illustrations displaced the *carte* as a source of amusement; the postcard took over the market for scenic views; and the box-camera and roll-film replaced the studio portrait for family photographs.[27] This last reason – the development of the snapshot photograph – had a dramatic and lasting impact on the way people kept their memories and presented themselves to the world throughout the twentieth century. With the slogan "You Press the Button, We Do the Rest", George Eastman's Kodak camera, first introduced in 1888, ushered in a revolutionary method of making pictures. No longer was photography in the hands of professional studio photographers, with their posing manuals, overstuffed chairs, and painted backdrops. Instead, the box-camera and roll-film allowed the most untrained amateurs to take pictures in the settings of their choice. It was sold ready-loaded with a roll of negative stripping paper film that allowed for one hundred circular pictures 2 1/2 inches in diameter; no focusing was required, the shutter was released by pushing a button, and the user advanced the film by turning a key. Once all the pictures on the roll were taken, the customer shipped the entire camera back to Eastman's factory, where it was unloaded, restocked with a fresh roll of film, and returned with prints.[28] Kodak photographs, later called "snapshots" after the hunting term, differed from their *carte de visite* predecessors in pronounced ways. They were made in a casual fashion, most often by friends or family members; having a more intimate relationship to the sitter, snapshots resulted in a more informal and spontaneous depiction than card portraits. In contrast to the comparatively low frequency of visits to the studio photographer, snapshots might be made over and over again, with tens or hundreds of pictures resulting. The accumulation of pictures over time added up to a more complete portrait of a person, who could now be seen at work or at play, with friends, relatives, and pets, abroad on vacation or at home in front of the family car. Such pictures no longer did the cumulative work of portraits – that is, they were not single images meant to represent the person as a whole – but instead acted as fragments that shifted depending on the circumstances. Snapshots, rooted in time and place, became pictures of events (weddings, vacations, picnics, bicycle rides, and so on) as much as of people. By contrast, the *carte de visite* had effaced time and place with artificial backgrounds that took little notice of the seasons, all in order to focus on the summary presence of the sitter.

Just as the *carte de visite* had done three decades earlier, the Kodak photograph helped produce an innovative mode of collection and display.[29] The new albums that arose to accommodate the snapshot heralded a break with Victorian style, even as many of the album's rituals remained the same. Featuring streamlined covers and paper pages, snapshot albums rid themselves of heavy cardboard leaves with slots for insertion, and eschewed plush covers with brass

clasps that recalled Bibles. Weighty connotations of seriousness and preciousness gave way to a more light-hearted and forward-looking approach. Often black or dark grey, the unadorned pages bore the look of the machine more than the gilded outlines of the domestic parlour. The album photograph no longer adopted the framing conventions of painted portraiture, with embossed vignettes or passepartouts of gold design, but instead stood out against the dark page with a simplicity that would later become a hallmark of modern photographic display.

During this shift from standardized cardboard mounts to the varied paper formats that characterized turn-of-the-century photographs, the contents of albums exhibited a great deal more variety than they had previously. In many extant early snapshot albums, both *carte de visite* portraits and snapshots are included, along with postcards, clippings, and other scraps. Annotations – about trips, events, characters – sometimes filled the pages as well. No longer limited to the portrait-gallery layout of pictures predetermined by the evenly spaced slots in the cardboard pages, album-keepers found a new freedom. This ability to manipulate, cut, collage, order, and juxtapose photographs stood in direct contrast to the constraints imposed by the more staid card album. Much more than their card-portrait predecessors, the new snapshots and albums fostered the construction of a narrative. With sequential pictures of events and places rather than portraits, and often an accompanying text, albums allowed for stories that featured characters and action over time.

In the process, the single album that traced the history and genealogy of the whole family now splintered into multiple albums unique to each individual member of that unit. After the arrival of the Kodak, the enhanced potential for self-presentation and personal narrative – along with the sheer number of images – meant that the maintaining of one's *own* album was much more common. A catalogue of albums, dating from around the end of the century, made this clear with a headline that announced the photograph album as "An Indispensable Possession for Every Person". "One Dictionary, or one Family Bible, may prove sufficient for a *whole household,*" the advertisement claimed, "but every *individual* takes delight in the ownership of an *Album* of portraits of friends and relatives."[30] While one family album had once contained the entire family's past as a cohesive whole, now a series of different but related pasts began to seem a more appropriate record for the times.

Throughout the twentieth century, both family and personal albums of snapshots became the primary means of remembering stories and presenting them to others. Today's twenty-first century photograph album may well be virtual, its viewers half a world away from each other. But even digital cameras, smart phones, many online storage systems, and social networking sites, still employ the term "album" to denote a group of pictures brought together for the purpose of

organization, narrative, or sharing. Although the format is strikingly different, this contemporary manifestation of the family album ultimately has its origins in the earliest photograph albums.

The card album of the nineteenth century first assembled family pictures in book form, creating a grouping which was greater than the sum of its parts. It first made this collection available for public display in the parlour, allowing album owners not only to create a record of their past, but also to show that record to others. And in the early albums there first originated the kinds of storytelling that link family photographs with family memories. Photograph albums have come to represent our past and our present, our ancestors and our friends. The album is more than a collection of recollections, a repository for faces and the stories they inspire; the album is us, ourselves. Today, we continue to understand the world – and our own place in it – in no small part through the pictures we take and, especially, through the pictures we keep.

[1] *Oxford English Dictionary*, second edition, prepared by J. A. Simpson and E. S. C. Weiner, vol. 1 (Oxford: Clarendon, 1989), p. 298. In ancient times, the album was a tablet on which public notices were recorded.

[2] On amateur photography and albums, see Grace Seiberling, *Amateurs, Photography, and the Mid-Victorian Imagination* (Chicago: University of Chicago Press, 1986).

[3] For more on this album, see Douglas R. Nickel, "From the Manor House to the Asylum: The George Cowper Album", in *Objects of Desire: Victorian Art at the Art Institute of Chicago, Museum Studies* 31, 1 (2005), pp. 57–67.

[4] See Mike Weaver, *Whisper of the Muse: The Overstone Album and Other Photographs by Julia Margaret Cameron* (Malibu: J. Paul Getty Museum, 1986).

[5] Edward Wakeling, "Catalogue of the Princeton University Library Albums", in *Lewis Carroll, Photographer* (Princeton: Princeton University Press, 2002), p. 123.

[6] For a complete history of the *carte de visite* album in America, see Elizabeth Siegel, *Galleries of Friendship and Fame: A History of Nineteenth-Century American Photograph Albums* (New Haven: Yale University Press, 2010).

[7] On the carte de visite in Europe, see Elizabeth Anne McCauley's groundbreaking *A. A. E. Disdéri and the Carte de Visite Portrait Photograph* (New Haven: Yale University Press, 1985); Steve Edwards, *The Making of English Photography: Allegories* (University Park, Pennsylvania: The Pennsylvania State University, 2006); Audrey Linkman, *The Victorians: Photographic Portraits* (New York: Tauris Parke Books, 1993), pp. 61–81; and Dan Younger, "Cartes-de-Visite: Precedents and Social Influences", *CMP Bulletin* 6, no. 4 (1987), pp. 1–24. On the carte de visite in America see Siegel, *Galleries of Friendship and Fame*; William Culp Darrah, *Cartes-de-Visite in Nineteenth-Century Photography* (Gettysburg: W. C. Darrah, 1981); and Andrea Volpe, "Carte de Visite Portrait Photographs and the Culture of Class Formation", in *The Middling Sorts: Explorations in the History of The American Middle Class*, ed. Burton J. Bledstein and Robert D. Johnston (New York: Routledge, 2001), pp. 157–69.

[8] "Harmony and Subordination in Portraiture", *The Photographic News* (Sept. 1862), as quoted in Younger 1987, p. 22.

[9] "Cartes de Visite", *The American Journal of Photography* 4, no. 12 (15 November 1861): pp. 265–66.

[10] "Fashions", *Saturday Review*, reprinted in *Littel's Living Age* 73, 936 (10 May 1862): pp. 299–300.

[11] "Photographic Eminence", *Humphrey's Journal* 16, no. 6 (15 July 1864): pp. 93–94 and *The American Journal of Photography* 7, no. 2 (15 July 1864): p. 45. See also Darrah, *Cartes de Visite in Nineteenth-Century Photography*, pp. 49–53.

[12] See Linkman 1993, p. 67.

[13] Andrew Wynter, "Cartes de Visite", *The American Journal of Photography* 4, no. 21 (1 April 1862): p. 486.

[14] "Editor's Table: Photography and Its Album", *Godey's Lady's Book* 68 (March 1864): 304.

[15] An Outsider, "My First Carte de Visite", *The American Journal of Photography* 5, no. 15 (1 February 1863): p. 337.

16 "Editorial Department", *The American Journal of Photography* 5, no. 13 (1 January 1863): p. 312.

17 "Editor's Table: Photography and Its Album", p. 304.

18 Ernest Legouvé, "A Photographic Album [continued]", *The Photographic Times* 4, no. 41 (May 1874): p. 69.

19 Uncited contemporary source in Linkman, *The Victorians: Photographic Portraits*, p. 71.

20 *Life History Album*, edited by Francis Galton (London: Macmillan, 1884). See also See Shawn Michelle Smith, *American Archives: Gender, Race, and Class in Visual Culture* (Princeton: Princeton University Press, 1999), which examines, in part, the reciprocal influence of popular and eugenicist uses of photography in archives such as albums.

21 "Sioux" Brubaker, "The Family Album", *St. Louis Practical Photographer* 2, no. 3 (March 1878): p. 84.

22 Ernest Legouvé, "A Photographic Album", *The Photographic Times* 4, no. 40 (April 1874): p. 54.

23 Reprinted from *Punch's Almanack* in "The Great Beauty of Photographs", *The American Journal of Photography* 6, no. 15 (1 February 1864): pp. 348–49.

24 For more on the topic of Victorian photocollage, see Elizabeth Siegel, *Playing with Pictures: The Art of Victorian Photocollage* (Chicago: The Art Institute of Chicago, 2009), which also includes entries on all the makers mentioned here; and Patrizia Di Bello, *Women's Albums and Photography in Victorian England: Ladies, Mothers and Flirts* (Aldershot: Ashgate, 2007).

25 See Ann Bermingham, *Learning to Draw: Studies in the Cultural History of a Polite and Useful Art* (New Haven: published for the Paul Mellon Centre for Studies in British Art by Yale University Press, 2000), especially "Chapter 5: Accomplished Women".

26 See Janet Browne, "Darwin in Caricature: A Study in the Popularisation and Dissemination of Evolution", *Proceedings of the American Philosophical Society* 145, 4 (Dec. 2001): pp. 496–509.

27 Darrah, *Cartes-de-Visite in Nineteenth-Century Photography*, p. 10.

28 For more of the technical details of Kodak cameras and films, see Brian Coe and Paul Gates, *The Snapshot Photograph: The Rise of Popular Photography, 1888–1939* (London: Ash and Grant, 1977).

29 There has been recent scholarly interest on the family album after the arrival of the Kodak. See Jo Spence and Patricia Holland, eds., *Family Snaps: The Meaning of Domestic Photography* (London: Virago, 1991); Philip Stokes, "The Family Photograph Album: So Great a Cloud of Witnesses", in *The Portrait in Photography*, ed. Graham Clarke (London: Reaktion, 1992), pp. 193–205; Annette Kuhn, *Family Secrets: Acts of Memory and Imagination* (New York: Verso, 1995); Marianne Hirsch, *Family Frames: Narrative Photography and Postmemory* (Cambridge, Mass.: Harvard University Press, 1997); Marianne Hirsch, ed., *The Familial Gaze* (Hanover: The University Press of New England, 1999); and Sarah Greenough and others, *The Art of the American Snapshot, 1888-1978* (Washington, D.C.: National Gallery of Art, 2007).

30 Scammel & Co. advertisement for agents, n.d. (ca. 1890s), Warshaw Collection, Smithsonian Institution National Museum of American History; emphasis in original.

- John Thomson
- Thomas Annan
- Eadweard J. Muybridge
- Richard Buchta
- Jacob A. Riis
- Peter Henry Emerson

John Thomson

Illustrations of China and Its People. A Series of Two Hundred Photographs with Letterpress Descriptive of the Places and People Represented

London: Sampson Low, Marston, Low, and Searle, 1873–74

It was between 1868 and 1872 that John Thomson, a photographer of Scottish origin temporarily resident in Hong Kong, took the photographs of the most extensive documentary project carried out with this medium in China during the nineteenth century. Entitled *Illustrations of China and Its People. A Series of Two Hundred Photographs with Letterpress Descriptive of the Places and People Represented*, it came out in four volumes between 1873 and 1874 with a total of 218 photographic illustrations.

The work stands out in the vast bibliography of those regarding the discovery of exotic, faraway places for a series of fundamental peculiarities, including its narrative structure, and the variety of subjects as well as the quality of the images. As regards the first, *Illustrations of China and Its People* follows the course of a journey through the endless territories of the largest country in the Far East. As in a tale of adventure, the author takes his readers by the hand and guides them in the exploration of a land and a culture still shrouded in mystery for the western public. To this end, he accompanies the iconographic material with a large quantity of text

in a rigid framework involving a mathematical ratio between the images and the corresponding short descriptions. This was probably the reason for the decision to use the collotype printing process, which makes it possible to reproduce the overabundant and indispensable words on the same sheet as the photographs in a single operation. As in every well-organised journey, the route is completely outlined in the introduction to the first volume: from the British colony of Hong Kong to the end of the Great Wall by way of Canton, Macao, Formosa, the province of Fujian (traversed along the River Min with the help of the Protestant mission of Reverend Justus Doolittle), the island of Taiwan, Shanghai, the old capital of Nanking (Nanjing) up the Yangtze, and the growing city of Peking (Beijing) to the north. Showing a considerable flair for business, Thomson brought his work out at a time when China was beginning to arouse a great deal of commercial and tourist interest with the end of the Second Opium War and the completion of the Suez Canal. It thus constituted a sort of indispensable explanatory guide for all those intending to make the long journey eastward from Great Britain.

As regards the second, Thomson abandoned the conventional distinctions between genres borrowed by photography from painting and other forms of representation, whereby his selection included natural landscapes, urban views, and portraits. This hybrid mixture was almost unprecedented on such a scale, and appears to have been prompted first and foremost by considerations of narrative development, which requires the simultaneous presence of settings and characters. Added to this is unshakeable confidence – this time typical of the positivist legacy – in the ability of the photographic medium to provide an objective report, which led here to the application of formally typological assumptions in addressing some of the human subjects. This is a sign of the prejudice accompanying the evidently dominant imperialist attitude, whereby the camera is seen as a device furnishing indisputable proof of conquest, the subjects being submissively arrayed before it. In addition to emerging from the illustrations, all this was indeed explicitly and concisely stated by Thomson himself: "I made the camera the constant companion of my wanderings, and to it I am

indebted for the faithful reproduction of the scenes I visited, and of the types of race with which I came into contact. Those familiar with the Chinese and their deeply-rooted superstitions will readily understand that the carrying-out of my task involved both difficulty and danger." Given this attitude, it is hardly surprising that the author should linger over the description of Li-Chung-Chang, a government official with "an intense admiration [...] for the inventive faculties displayed by the races of the West [...] he is also ever ready to admit the superiority of our arts and appliances". In the same way, there are constant references to the consumption of opium among all classes without drawing sufficient attention to the fact that this was largely a vice "imported" by the European colonists. While everything works to establish the position of superiority assumed by Thomson, his sincere affection for the people he portrayed emerges nevertheless from the gracefulness of his forms.

Last but not least, the work stands out for the sophistication of the images, which reflect the classical canons of beauty. The shots are well-composed and orthogonal, with the primary elements often precisely symmetrical or centrally arranged, and the foreground distinguished from the background by means of calculated juxtaposition. The technique is also excellent, with tonal adjustments making it possible to read the shadows without losing density in the highlights, and the careful control of the depth of field. Unlike many of the photographers attached to geographical expeditions, Thomson had a finely trained eye that enabled him to elevate his work well above the level of mere documentation and attain the quality of an art that nevertheless regards not so much the individual components, as the whole resulting from their assemblage. Most of the photographs in *Illustrations of China and Its People*, including those of a more overtly typological nature, are visually appealing, calibrated to the point of being cut in variable proportions, but contributing at the same time to the formation of a further composition that takes shape through their sequence and arrangement. Starting from the presence of a narrative thread, the work develops like a poem recited in the first person by its hero. In creating it, Thomson harnessed the grammar of writing, photography, and publishing all at once, thus marking a crucial stage in the transformation of the photographic book from a box – albeit one in keeping with its content – to a tool of semantic articulation and artistic expression.

Bibliography
China: Through the Lens of John Thomson 1868–1872. Beijing: Beijing World Art Museum / River Books, 2010.
Maxwell, Elizabeth Anne. *Colonial Photography and Exhibitions. Representations of the Native and the Making of European Identities*. London: Leicester University Press, 2000.
Thomson, John. *China: The Land and Its People. Early Photographs*. Hong Kong: John Warner Publications, 1977.
White, Stephen. *John Thomson. A Window to the Orient*. New York: Thames and Hudson, 1986.

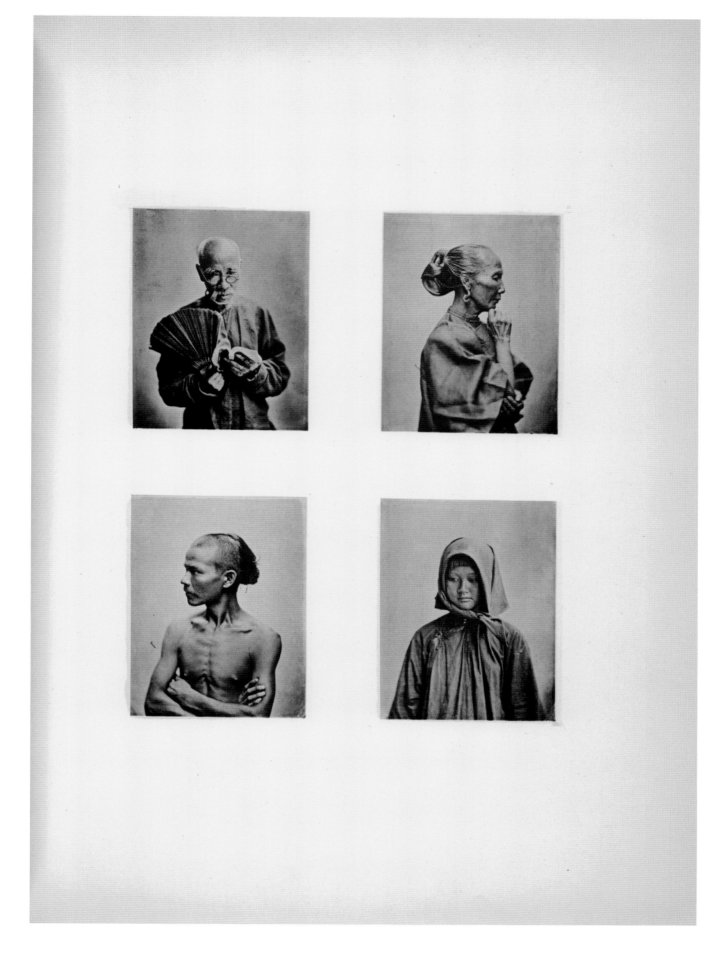

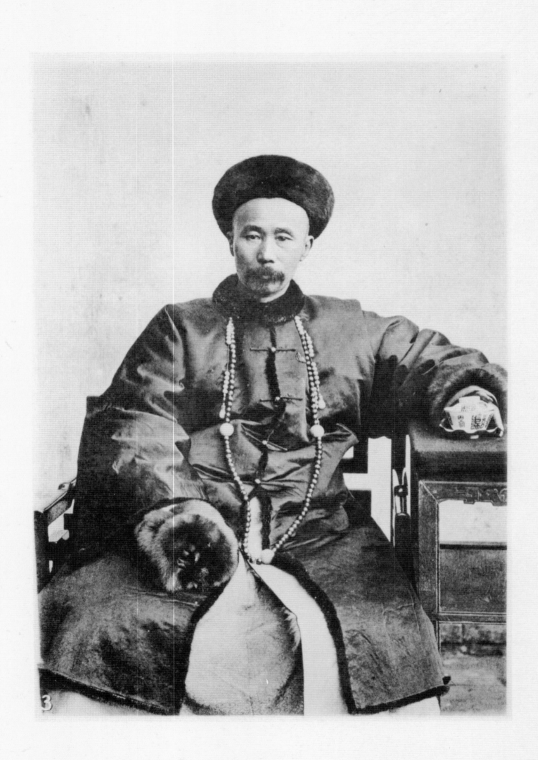

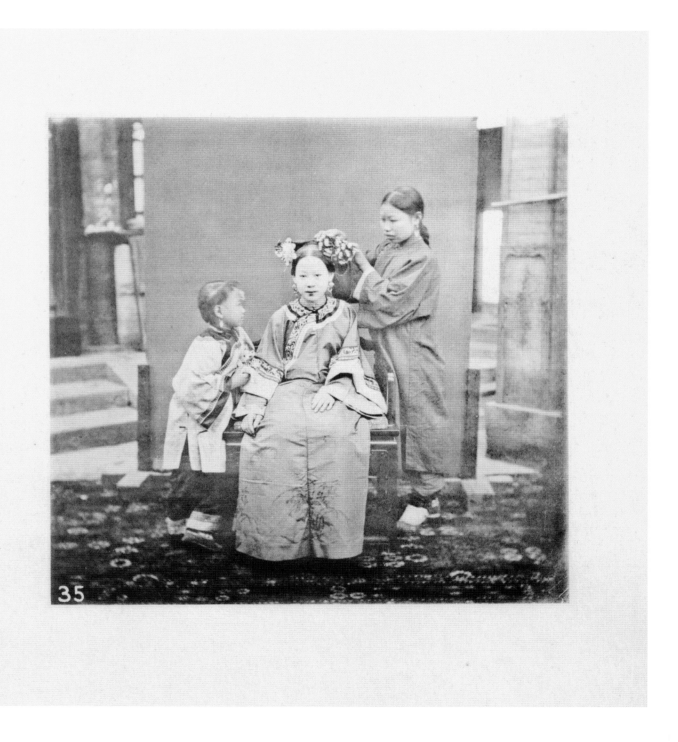

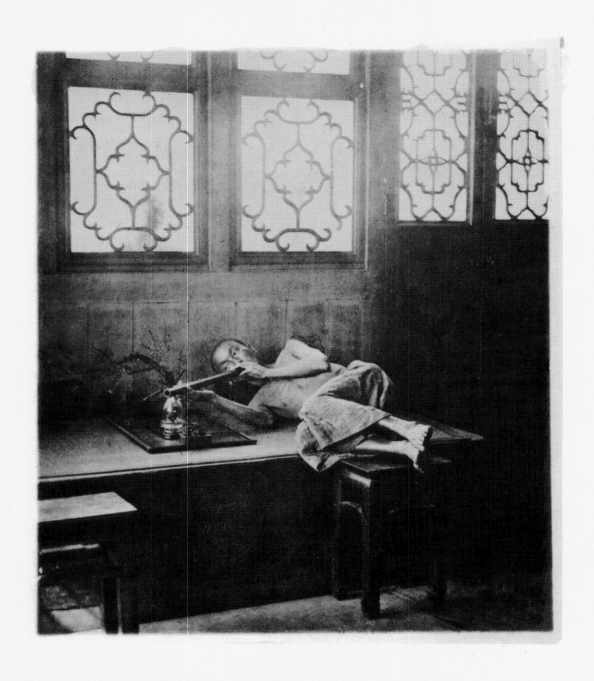

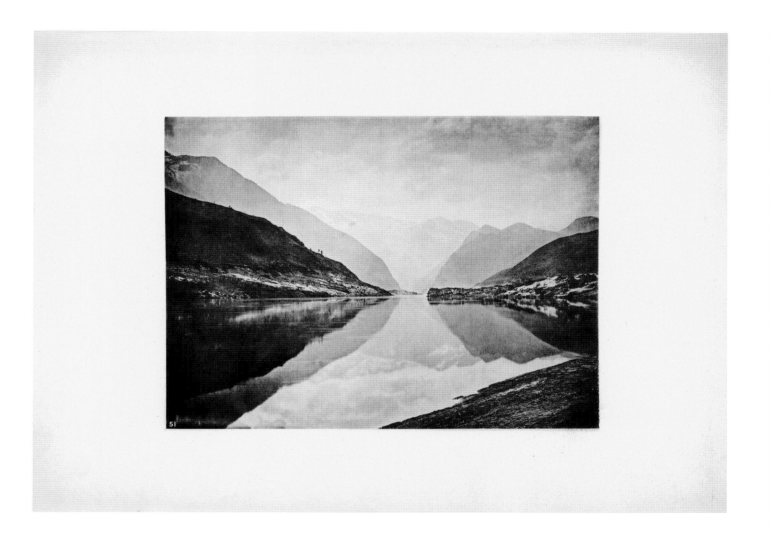

Thomas Annan

Photographs of Old Closes, Streets, etc., taken 1868-1877

Glasgow 1878

It was in May 1845, after a period of work in Manchester that gave him the opportunity to observe the consequences of industrialisation in numerous British cities, that the twenty-four-year-old Friedrich Engels published *The Conditions of the English Working Class*. He used the words of the public official J. C. Symons to describe the situation in Glasgow: "I have seen human degradation in some of its worst phases, both in England and abroad, but I can advisedly say that I did not believe until I visited the wynds of Glasgow, that so large an amount of filth, crime, misery, and disease existed on one spot in any civilised country [...]. These places are, generally as regards dirt, damp and decay, such as no person of common humanity to animals would stable his horse in." The Scottish authorities ordered the demolition of the city's worst slums twenty-one years later, and the Glasgow Improvement Trust commissioned a photographer to record their distinctive characteristics in 1868. The choice fell on Thomas Annan, a specialist in art reproductions and owner of a portrait studio, who had been awarded the prize of the Photographic Society of Scotland for the best landscape in 1865. The result was a series of views, first collected in a rare edition of albumin prints, and then made available to a broader public in an album (apparently produced in 100 copies) in 1878. *Photographs of Old Closes, Streets, etc., taken 1868–1877* contained forty carbon prints produced with the technique developed by Joseph Swan, for which Annan had secured the exclusive rights in his country. (An expanded photogravure edition entitled *The Old Closes and Streets of Glasgow* came out in 1900, thirteen years after the photographer's death.) It constituted the first large-scale photographic coverage of the slums of a metropolis, a milestone in the field of "social documentary", despite the absence of reforming intent, or any explicit interest in the human subjects, who instead played the leading role in the other works that laid the foundations for this type of approach, namely John Thomson's *Street Life in London* (produced between 1876 and 1877, and put on sale in instalments just before Thomas Annan's collection of carbon prints); and *How the Other Half Lives* by Jacob Riis (1890). The apparent lack of interest in the inhabitants, often barely perceptible in the

distance, blurred or hidden in the shadows, and the consequent concentration on the buildings and the fabric of the streets, identify this work among other things as an unavoidable point of reference for those using the camera to capture the traces of the urban body before an irreversible transformation. In this sense, it is second only to the vast investigation carried out by Charles Marville on certain medieval areas in the centre of Paris that were soon to give way to the great boulevards with the urban redevelopment plan implemented by Baron Georges-Eugène Haussmann, prefect of the Seine. The formal layout shared by most of the images in *Photographs of Old Closes, Streets etc., taken 1868–1877* is an important element of this project. With the exception of a few panoramic shots taken from an elevated viewpoint, Annan usually set up his apparatus in the middle of the dark, narrow alleys of old Glasgow, looking straight towards an invariable closed background. The walls of the houses occupy much of the view on the right and left, the paving forms a slender central axis scattered with puddles and irregularities, and the sky above is confined within minimal geometric spaces. While the repetitive nature of the whole satisfies the Victorian obsession with cataloguing, the spectator is made aware at the same time of the sense of apprehension and oppression that accompanies the everyday existence of the occupants of these slums. There is no way out. In performing the mandate of a commission focused on the subjects of architecture and topography, Annan provided reiterated and non-ideological evidence of the wretched living conditions of the working class in the closing period of the Industrial Revolution.

Bibliography
De Moncan, Patrice. *Charles Marville: Paris Photographié au Temps d'Haussmann*. Paris: Les Editions du Mécène, 2008.
Engels, Friedrich. *Die Lage der arbeitenden Klasse in England*. Leipzig: Wigand, 1845.
Mozley, Anita Ventura (Introduction). *Photographs of the Old Closes and Streets of Glasgow, 1868–1877: With a Supplement of 15 Related Views*. New York: Dover Publications, 1977.
Stevenson, Sara. *Thomas Annan, 1829–1887*. Edinburgh: National Galleries of Scotland, 1990.

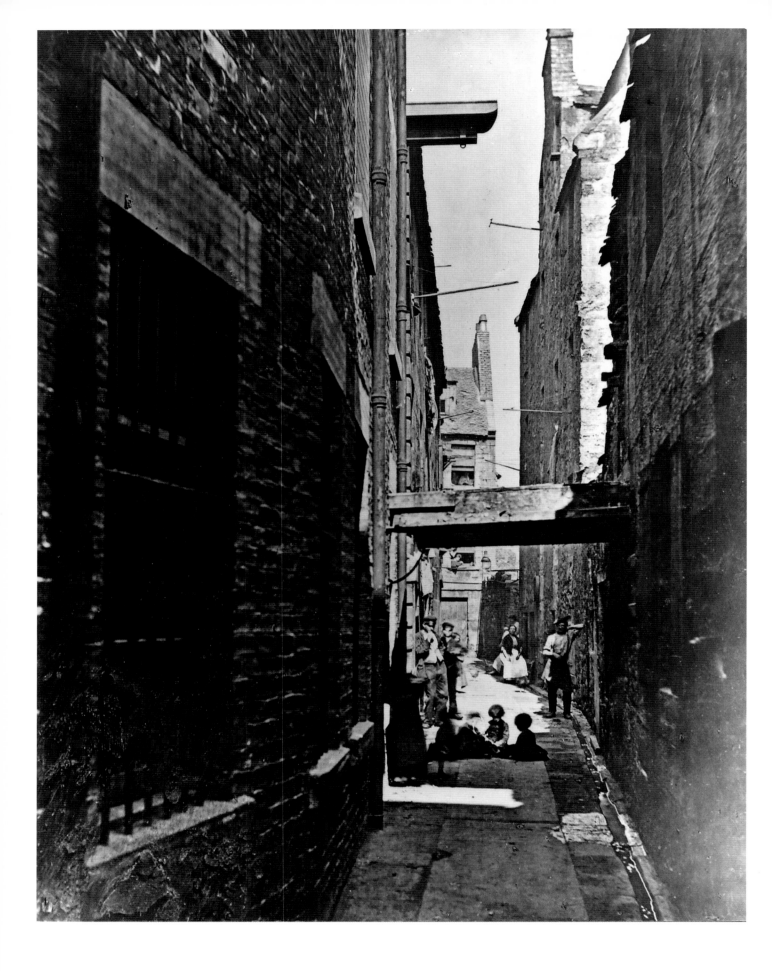

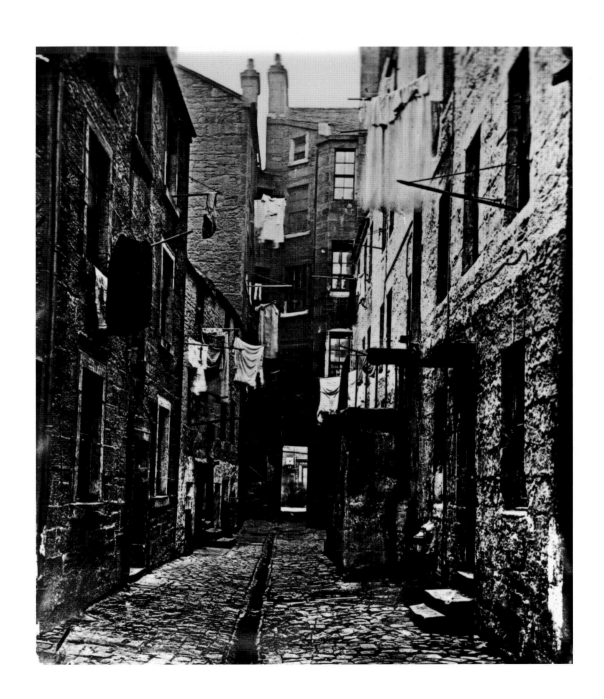

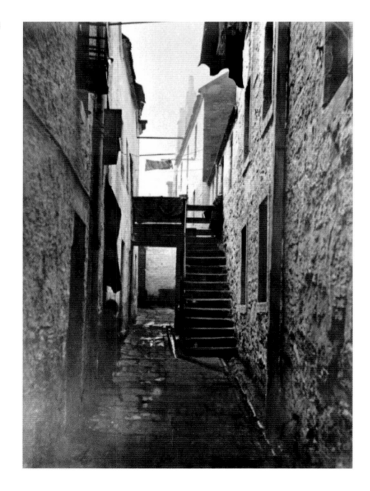

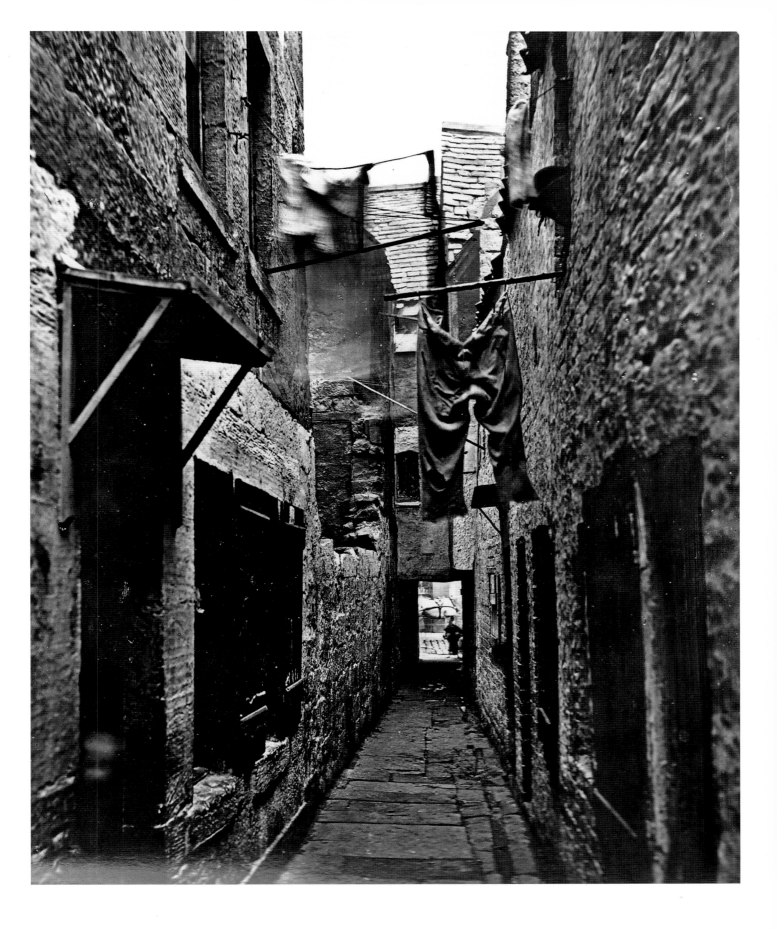

Eadweard J. Muybridge

"The Zoogyroscope: Illuminated Photographs in Motion"

San Francisco Art Association, 4 May 1880

Muybridge was born Edward James Muggeridge on 9 April 1830 at Kingston upon Thames, in England. He moved to America at the beginning of the 1850s, settling in San Francisco in 1855, where he went into business as a bookseller and publisher's agent under the name E. J. Muygridge. In July 1860 he was involved in a stagecoach accident, along with seven other passengers (one of whom died) on the way to Saint Louis, suffering serious brain damage in the frontal cortex. He spent a long rehabilitation period in England, where he made a complete recovery, although his personality seemed to have altered considerably; in fact, the shrewd businessman had become "eccentric and irritable" – according to friends interviewed by the *Sacramento Union* newspaper (4 February 1875). When he reappeared in San Francisco in 1866, he changed his surname yet again, this time to Muybridge (he would subsequently alter the spelling of his first name to Eadweard, possibly in honour of King Edward the Elder (Ēadweard se Ieldra in old English) who was actually crowned at Kingston upon Thames in 900 AD), and also adopted the pseudonym Helios to embark on a new career in photography. His favourite subjects

were the urban setting of the Bay Area and the Yosemite panoramas – which immediately placed him in direct competition with Carleton Watkins, whose images of the majestic scenery of the West were already an acclaimed success. Muybridge's interpretation of this land was similar to that of his celebrated forerunner, as can be seen in his glorious views taken from an elevated position, in which he occasionally included human figures caught in silent contemplation. He also shared Watkins's artistic aims, calling himself a "photographic artist" at his studio in Montgomery Street (which was exactly where Watkins's Yosemite Gallery was located), and his compositions reveal a particular concern with formal aspects. In addition, he showed a keen interest in atmospheric details. Indeed, he became truly obsessed with the density of the sky and the substance of the clouds, to the extent that he soon developed a device, the Sky Shade, with which he counteracted the ultra-sensitivity of the then available emulsions to blue and violet rays, by covering a portion of the lens while shooting. The principle according to which his invention functioned was described by the photographer himself in *Philadelphia Photographer* (vol. VI,

The Attitudes of Animals in Motion: A Series of Photographs Illustrating the Consecutive Positions Assumed by Animals in Performing Various Movements: Executed at Palo Alto, California, in 1878 and 1879

San Francisco: self-published, 1881

1869): "As the sky is apt to be over-exposed, it may often be advantageously shaded during part of the exposure. This may be done by holding the hand or other object in front of the upper part of the lens, and near to it, moving it continually [to avoid a halo effect on the plate]". By using this method, or occasionally transferring the sky from another negative during the printing stage, Muybridge not only filled the upper part of his images with infinite variations, but countered the monumental, timeless works of his contemporaries with images that captured (or created the impression of) a fleeting moment.

This transition from the eternal to the here and now constituted a watershed in Muybridge's landscape photography and, oddly enough, prefigured the main theme of his subsequent production. In 1872 he was asked by Leland Stanford, former Governor of California and future founder of the university that bears his name, to conduct various experiments with the aim of capturing the movements of a horse in sharp photographic images. The story goes that this commission was linked to a wager made by the Californian magnate, who in order to win had to demonstrate his theory that

there is a brief moment during the trot when all four hooves leave the ground. However, there is no evidence to support this story, and it is far more reasonable to suppose that it was Stanford's intention to carry out a study designed to improve the speed and staying power of the principal means of transport of that period. The first attempts did not produce satisfactory results, despite the invention of the first efficient shutter in history, a device composed of a magnet and two sheets of cardboard or metal that slid over each other, and seemingly permitted sufficiently short exposures. Then there was a major "hitch": on 17 October 1874 Muybridge shot his wife's lover dead with a Smith & Wesson revolver, but was later acquitted due to the extenuating circumstances of wounded pride, and the brain damage he had suffered during the accident almost fifteen years previously. To avoid further complications, Muybridge left the United States for a while, travelling for nine months in Central America where, under the name Eduardo Santiago Muybridge, he amply documented the faces, architecture and territory of Panama and Guatemala for the Pacific Mail Steamship Company. When he

returned to the United States, the incredibly rapid progress that had been made in chemistry enabled him to resume the tests at Stanford's ranch at Palo Alto with more sensitive materials. The big breakthrough came in 1877, when he finally succeeded in fixing on a plate the silhouette of the trotter Occident with a shutter speed of around 1/700th–1/1000th of a second. Thus the snapshot was born. The following year Muybridge continued his work by executing various series of images that fixed the sequence of the horse's different gaits. To do this he designed a complex mechanism consisting of twelve cameras (the number would soon increase to twenty-four) placed equidistantly along one side of a straight course, each of which was connected to a metal wire stretched across the track, which was broken by the thoroughbred as it passed, activating the shutter. Popularised in a set of six plates with the title *The Horse in Motion*, these photographs became the model for the study Muybridge conducted immediately afterwards on the characteristics of the movements of countless animals, including the human. The first volume in which he systemised his extensive research was entitled *The Attitudes of*

Animals in Motion, which he published himself in about 15 copies in 1881. The book contains 203 plates (plus 6 introductory illustrations) that reveal the importance of his invention as an aid in other disciplines, indeed it was of particular interest to physiologists and artists, who were able to copy the positions of the body for use in their own works; and also to photography itself, since it produced the snapshot, introducing the factor of randomness into the representation of the image, and at the same time provided definitive proof of the gap between human vision and the eye of the camera (in fact, Stanford was absolutely right in maintaining that there was a moment when the horse appeared to be airborne while trotting). Thus it was proved that actual experience contradicts conventional representation, and that what actually takes place does not tally with what one sees. *Animal Locomotion*, published in 1887 by the University of Pennsylvania press – which in the meantime had taken the place of the previous backer Stanford, due to disagreements concerning the ownership of the work – did no more than increase the collection of images to 781, making it available to a much larger public, while all the fundamental features of the work were already to be found in the album published six years previously, including the arrangement of the images within geometric grids that eliminated any kind of hierarchical relationship between the individual frames, and placed the whole project in a limbo, halfway between science and art. Muybridge went even further: not only did he master stop-motion, he also made his photographs move. Crucial in this sense was the event he organised on 4 May 1880 at the San Francisco Art Association under the title "The Zoogyroscope: Illuminated Photographs in Motion". On this occasion the spectators were able to watch, for the price of 50 cents, the projection of several series of his famous snapshots by means of the Zoogyroscope (later known as the Zoopraxiscope), a device invented by him on the lines of popular animation toys such as the Zoetrope, Phenakitiscope, and Praxinoscope. In practice the images, which were transferred according to the sequence in which they were executed onto a glass disk that was made to rotate, appeared in rapid succession, creating the impression that they were coming alive before the eyes of a packed house. This is the first documented public projection of moving photographic images. We would have to wait another fifteen years before the celebrated showing held at the Grand Café in Paris on 28 December 1895 by the Lumière brothers Auguste and Pierre took place, but the newspapers were already commenting: "Nothing was wanting but the clatter of the hoofs upon the turf and an occasional breath of steam from the nostrils, make the spectator believe that he had before him genuine flesh-and-blood steeds." (*San Francisco Morning Call*, 5 May 1880). The revolution enacted by Muybridge was complete: he had learned how to stop time and also how to set it in motion.

Bibliography
Bell, Geoffrey. "The First Picture Show". *California Historical Quarterly* 2 (54). San Francisco: California Historical Society, 1975.
Brookman, Philip, Marta Braun, Cory Keller, and Rebecca Solnit. *Helios. Eadweard Muybridge in a Time of Change.* Göttingen: Steidl, 2010.
Mozley, Anita Ventura (Introduction). *Muybridge's Complete Human and Animal Locomotion. All 781 Plates from the 1887 "Animal Locomotion".* New York: Dover Publications, 1979.
Prodger, Philip. *Time Stands Still. Muybridge and the Instantaneous Photography Movement.* New York: Oxford University Press, 2003.
Solnit, Rebecca. *River of Shadows: Eadweard Muybridge and the Technological Wild West.* New York: Viking Penguin, 2003.

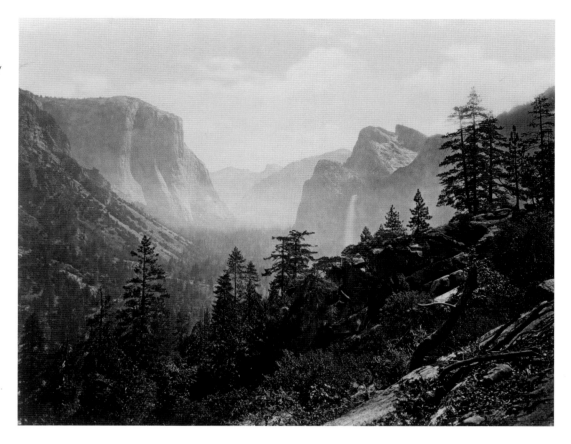

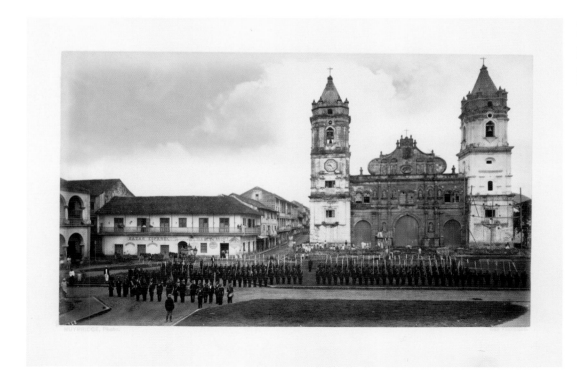

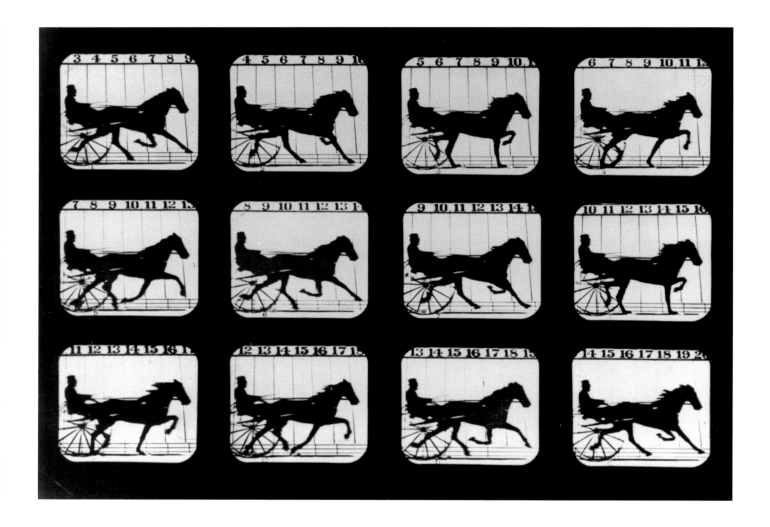

Skeleton of Horse, Running.
Off the Ground. Plate 199 from
"The Attitudes of Animals in
Motion", 1881
Albumen print mounted on heavy
weight paper, 11.4 x 18.9 cm
Andover (Mass.), Phillips
Academy, Addison Gallery
of American Art, partial gift of
The Beinecke Foundation, Inc.
1987.21.170

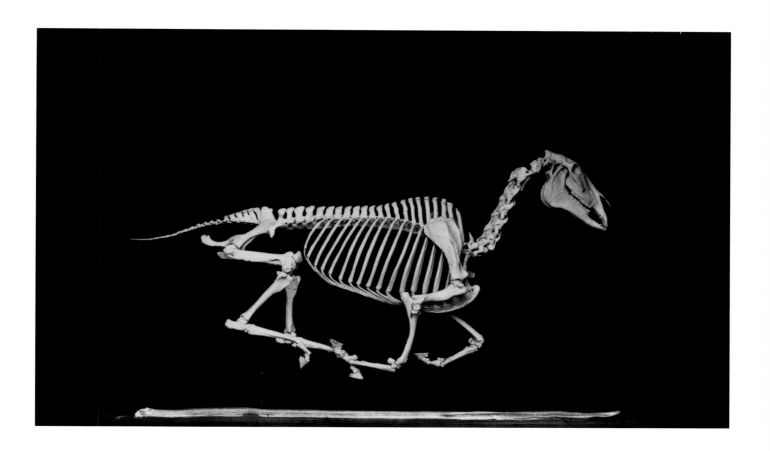

*Camera Shed, Plate D from
"The Attitudes of Animals in
Motion"*, 1881
Albumen print mounted on heavy
weight paper, 12.5 x 23.2 cm
Andover (Mass.), Phillips
Academy, Addison Gallery
of American Art, partial gift of
The Beinecke Foundation, Inc.
1987.21.4

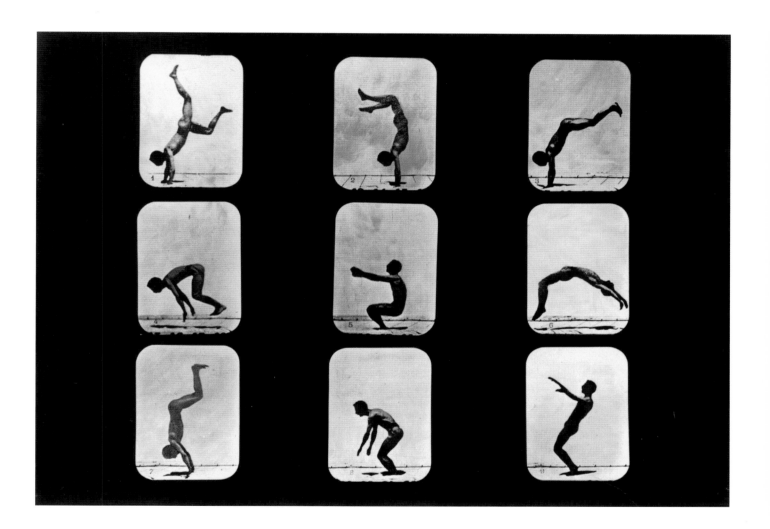

Richard Buchta

Die Oberen Nil-Länder: Volkstypen und Landschaften. Dargestellt in 160 Photographien, nach der Natur aufgenommen von Richard Buchta

Berlin: J.F. Stiehm, 1881

Photography is an excellent tool for gathering information. However, it involves the accumulation of such an overwhelming amount of data in such a short time that, inevitably, the viewer or reader is unable to decipher it at both quantitative and qualitative levels. At the same time, the photographic process presupposes a hierarchy, since the subject becomes subordinate to the photographer, who is able to look without being seen (in the past, his face was covered by a black cloth, now it is hidden behind the camera), and to capture with a predatory act an imprint of what is in front of the lens. For these reasons, as soon as it was invented, the photographic medium was used – and with increasing frequency after the technique was simplified and the equipment became lighter and easier to transport – by western explorers on their expeditions, whether they were interested in studying places or the people who inhabited them. In both cases, the image was an aid to research, and proof of a conquest, although the scientific frame of reference changed (geography and geology on the one hand, anthropology and ethnography on the other) and, above all, the approach associated with each. In fact, where territory was concerned, the main

considerations centred on the forces of nature and the unimagined wonders they created, while the populations of distant lands were often studied with a superior attitude. This conceptual approach was responsible for the spread of the stereotype typological portrait. It was characterised by a standard compositional layout (generally determined by the frontal position, or profile of the subject, who always occupied the same part of the shot, against a neutral background) in which veritable titans who were supposed to typify entire populations were incorporated. Following a pseudo-scientific logic, the simplicity of the formal layout was designed to permit the comparison of the samples gathered, thus providing a support for making accurate anthropometric calculations. As well as physical attributes, these photographs generally documented other elements associated with tradition, including hairstyles, face and body decoration, and dress, which constituted further characteristics of the group represented, or of its specific subcategories, with particular reference to social hierarchies, crafts, and rituals. In the majority of cases the result was a valuable account of a cultural heritage endangered by the

fierce colonisation that often preceded or followed the eye of the camera; but it was also a testimony of the widespread racial prejudice that postulated the intellectual supremacy of the white man. An emblematic example of this is the *Ethnological Photographic Gallery of the Various Races of Man* (1875), a volume put together by Carl and Frederick Damman, in which they assembled 167 photographs taken all over the world by anthropologists and ordinary tourists, in order to construct an evolutionary pyramid with various ethnic groups in Melanesia and Micronesia at its base and civilised Europeans at its apex.

This was the approach that underpinned the majority of projects carried out in every part of the world from the mid-nineteenth century onwards. Among the earliest images, developed in a more or less conventional way, which can still be traced are those taken by the American William S. Soule, who managed to immortalise several American Indians in western dress between 1867 and 1874; and by John K. Hillers, who in 1873 photographed the Paiute tribe while accompanying the explorer Major John Wesley Powell. Then there are the photos by the Dufty brothers depicting men and

women from the Fiji Islands in the 1870s, the *cartes de visite* made by the archaeologist Arthur Evans in Northern Europe around 1873; and, last but not least, the 468 albumin prints published by John Forbes Watson and John William Kaye, starting with the negatives by more than fifteen photographers featured in the monumental work entitled *The People of India* (1868–75). The project undertaken in Africa by the Austrian Richard Buchta is a case apart, not only because it was one of the earliest photographic forays into the hinterland of the dark continent (after the one made by the botanist John Kirk along the River Zambezi, and by Gerhard Rohlfs into the Libyan desert), and more precisely Sudan and Uganda, but mainly because the resulting images combined documentary rigour with a definite artistic slant. Besides, Buchta was a professional photographer who went to work in Cairo around 1870, which enabled him to accumulate a wealth of experience in Africa before undertaking, between 1878 and 1880, the explorations that permitted him to make the negatives for the book *Die Oberen Nil-Länder: Volkstypen und Landschaften*, which came out in 1881 after his return to Europe. This volume features 160 albumin prints

with subjects ranging from half-length portraits that stand out clearly against the white of the paper, to a series of portraits in settings, and even several compositions with everyday objects like crockery, knives, and musical instruments. While the first portraits adhere precisely to neutral scientific canons, others, while performing a descriptive function, bring out one or two things that are not indicated in the relative captions, by emphasising the individual character of the sitters, and the gaze that selected them. The individuality of the subject and the author clashes with typology. This in no way diminishes the truth of the result, which is still a two-dimensional perspective image in black and white, produced by a combination of choices made by the photographer. What changes is the context to which it belongs and the interpretation of the concept of "other", which previously concerned an approximate system of classification (race), and now concerns the self.

Bibliography
Belous, Russell E.; Weinstein, Robert A. *Will Soule: Indian Photographer at Fort Sill, Oklahoma 1869–74*. Los Angeles: Ward Ritchie Press, 1969.
Damman, Carl Victor; Friedrich Wilhelm. *Ethnological Photographic Gallery of the Various Races of Man*. London, Trübner, 1875.
Edwards, Elizabeth. *Anthropology & Photography, 1860–1920*. New Haven: Yale University Press, 1992.
Iles, Chrissie; Roberts, Russell. *In Visible Light.*
Photography and Classification in Art, Science and the Everyday. Oxford: Museum of Modern Art, 1997.
Killingray, David; Roberts, Andrew. "An Outline History of Photography in Africa to ca. 1940". *History in Africa*, vol. 16. New Brunswick: Rutgers, 1989.
Theye, Thomas. *Der geraubte Schatten. Photographie als ethnographisches Dokument*. Munich: Stadtmuseums, 1989.
Watson, John Forbes; Kaye, John William. *The People of India. A Series of Photographic Illustrations, with Descriptive Letterpress, of the Races and Tribes of Hindustan, Originally Prepared Under the Authority of the Government of India*. London: W.H. Allen & Co., 1868–75.

Acholi warrior, 1878–79
Albumen print, 14 x 9.5 cm
Paris, Musée du quai Branly

Portrait of a Shilluk girl, 1878–79
Albumen print, 14.2 x 9.3 cm
Paris, Musée du quai Branly

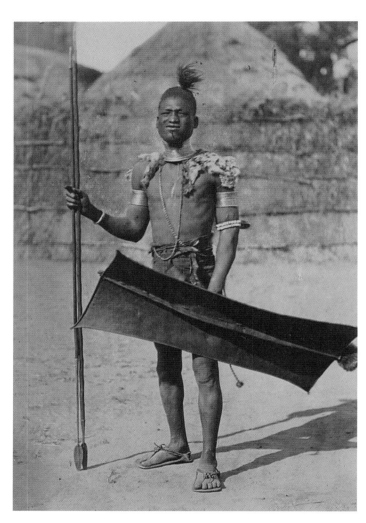

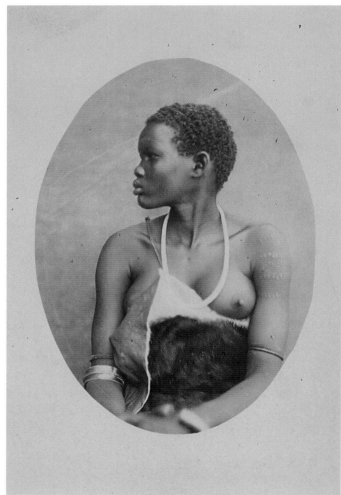

Acholi warrior, 1878–79
Albumen print, 14 x 9.5 cm
Paris, Musée du quai Branly

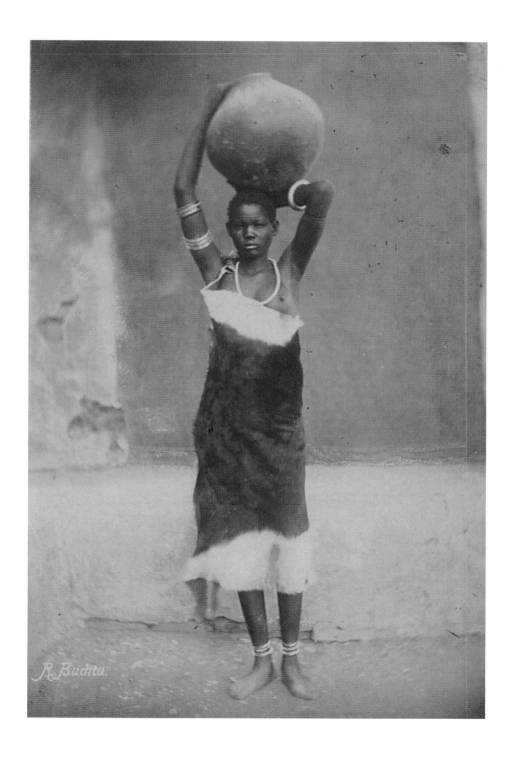

Zande Throwing Knives, 1878–79
Albumen print, 14 x 9.5 cm
Paris, Musée du quai Branly

William S. Soule
Pawnee, head-man
Wichita, Estate of William
S. Soule, Special Collections
and University Archives, Wichita
State University Libraries

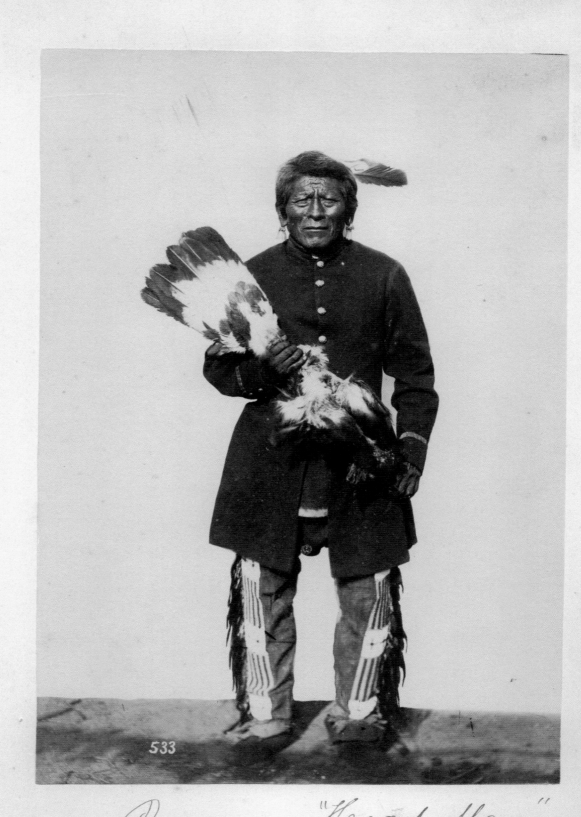

Pawnee – "Head Man"

Jacob A. Riis

How the Other Half Lives: Studies Among the Tenements of New York

New York: Charles Scribner's Sons, 1890

How the Other Half Lives
Book cover, first edition, 1890
New York, Museum of the City
of New York

"The belief that every man's experience ought to be worth something to the community from which he drew it, no matter what that experience may be, so long as it was gleaned along the line of some decent, honest work, made me begin this book." These are the opening words of the preface to Jacob Riis's first volume, *How The Other Half Lives: Studies Among the Tenements of New York*, published in 1890. The message was clear: the publication aimed to improve the living conditions of the "other half" in the title, the sea of humanity composed of immigrants and vagrants relegated to the slums in the southern part of Manhattan. As one might gather from the above quote, Riis himself had previously shared his subjects' fate. He, too, had arrived in New York as a foreigner just after the Civil War ended, in 1870 to be precise, when the country, caught between reconstruction, the generic industrialisation of manufacturing activities, and a dire economic recession at the global level, was in a state of complete confusion. He was originally from Denmark, which he left at the age of twenty-one with just a few dollars, a passion for Charles Dickens (passed on to him by his father, who was a teacher), and a

scant knowledge of carpentry. His first three years in New York were spent in lodging houses, with stray dogs and suicidal thoughts for company and the spectre of poverty constantly hanging over him – as it did the tens of thousands of immigrants who chose to leave their homeland and follow the American dream. Riis was able to rise above his condition by securing a job first with a news agency, and then by making the transition to crime-reporter with the *Tribune* in 1877. It was then that he began to frequent the poorest and most notorious area of the city around Mulberry Street, since this was where the police headquarters was located, and where most of the crimes he had to report on were committed. He covered the entire area, and even penetrated its very bowels – a district known as "The Bend", which had the highest number of prostitutes, robbers, killers, beggars, and drunks in the city. Here he heard countless stories of violence and desperation, and firmly resolved to expose the whole situation, so that things might change. Some of his indignant and melodramatic articles provided the thrust for the constitution of the Tenement House Commission in

1884, whose aim was to defend the thousands of indigent who were forced to live in overcrowded dilapidated tenements by property-owners who would stop at nothing to get rich.

In 1887 there was another turning point in Riis's life, which came when he read a newspaper article about the invention of a method for taking photographs with a flash, and knew instinctively that this tool would enable him to show a wider public the gloomy ratholes in which the population of the Lower East Side dragged out its miserable existence. To this end, he sought help from his friend John Nagle, director of the Bureau of Vital Statistics at the Health Department and an amateur photographer, who in his turn involved two members of the New York Society of Amateur Photographers, Henry G. Piffard, and Richard Hoe Lawrence. Together, the four of them ventured into the worst ghettos in the city, and took some of the first American photographs lit with a magnesium flash. The device they used was a kind of a pistol loaded with a highly inflammable mixture, which was both rudimentary and extremely dangerous, so much so that, as Riis

himself writes, he set his clothes on fire the first time he used it, and was nearly blinded the second. Although the photographs taken in the darkness were compelling, the two amateurs soon got tired of having to work at night and backed out. After another failed attempt with a dishonest professional photographer, Riis decided to take the shots himself. In January 1888, for 25 dollars, he purchased a 4 by 5 inch camera and all the necessary equipment to develop and print the negatives. He conducted his first experiments one cold morning at Potter's Field, the cemetery on Hart Island where the poor and unknown were buried, obtaining plates that were highly over-exposed but nonetheless expressed the desolation of the graveyard covered with a thick blanket of snow. Besides, the Dane was not aiming for technical perfection; on the contrary, he exploited a harsh, loose, and seemingly rough aesthetic to mirror the brutality of the world he wished to depict. His fierce realism was similar to that expressed some years previously first in Honoré Daumier's canvases and later Gustave Courbet's; however, in Riis's case, the precision of the camera eliminated anything

appealing that might have been created by the brush.

Riis organised public meetings where, with the help of his photographs, he described the tragic daily existence of the people who lived a stone's throw away from the places in which he spoke, whether they were churches, schools, or other institutions.
The powerful images, which were transferred to magic-lantern slides so that they could be projected, and were often hand-coloured to make them even more riveting, attracted an unusually large number of spectators, offering them the thrill of descending into hell and emerging unscathed (a photograph of an alley called Bandits' Roost lined with several men who seemed to be waiting for the photographer to approach, was a perfect introduction to the infernal living conditions). At one gathering, a journalist from *Scribner's Magazine* was so struck by Riis's forceful presentation that he commissioned an article from him that was published around Christmas 1889, and accompanied by as many as eighteen engravings handmade from the photographs. The feature caused an immediate sensation, and a few days later Riis was asked to do a book on the subject: the result,

presented after about ten months of intense work, was *How the Other Half Lives*. As well as an exhaustive text that was part reportage and part sociological study, and actually accompanied by various statistics, the volume featured all the illustrations that had appeared in the article, along with seventeen new mezzotint reproductions of as many photographs. Thus it was the first book to contain a large number of images printed with this innovative process using the halftone screen, which permitted large print-runs (certainly much larger than those obtainable with the previous collotype system).

The work pivots on an analysis of the living conditions in the New York slums whose intolerable state of decay was the main cause of the suffering experienced by its inhabitants, and of the criminal behaviour this produced. Within this framework, the photography is not intended to have any artistic significance, but this does not mean that it is secondary to the text, or that each image was not constructed by a refined consciousness. As inferred earlier, Riis could be described as a technically inept photographer (though deliberately so), but he had

such a gift for rhetoric that he was able to use his "illiteracy" on the very cultural and political system that made such representations possible, and to reveal its failures. This is exemplified by the image of an Italian woman rag-picker holding her baby (reproduced in an engraving in the first edition of the book), which is none other than a sophisticated debasement of the iconography of the "Madonna and Child", in which the drama of form, created with an over-contrasted black and white, and the unusual angle of the shot, fully reflects the drama of the subjects. Aside from its undisputed social value, the volume clearly reflects the prejudices of the author, for whom Germans were sticklers for order, and Italians slow to learn, and who said of the Jews "money is their God", and of the Chinese that they smoked opium and "would rather gamble than, while the people of Northern Europe, where Riis hailed from, were clean and hardworking. Aside from a naive racism, this attitude reveals the underlying approach and aims of *How the Other Half Lives*, which, in the final analysis, is more an impassioned propaganda tool than an accurate scientific document. However, its powerful message managed

nevertheless to reach Theodore Roosevelt who, while President of the Board of Police Commissioners, shut down some of the lodging houses and opened playing fields; and, as President of the United States, remembered Riis in his autobiography as "the best American I ever knew".

Bibliography
Alland, Alexander. *Jacob A. Riis: Photographer and Citizen*. New York: Aperture, 1974.
Frongia, Antonello. *L'occhio del fotografo e l'agenda del planner. Studio su Jacob A. Riis*. Venice, Italy: Studio LT2, 2000.
Leviatin, David (Introduction). *How the Other Half Lives: Studies Among the Tenements of New York* . Boston: Bedford / St. Martin's, 1996.
Strange, Maren. "Jacob Riis and Urban Visual Culture: The Lantern Slide Exhibition as Entertainment and Ideology". *Journal of Urban History* 3, vol. 15. Los Angeles: Sage, 1989.

Mulberry Bend, 1890
Gelatin silver print
New York, Museum of the City
of New York

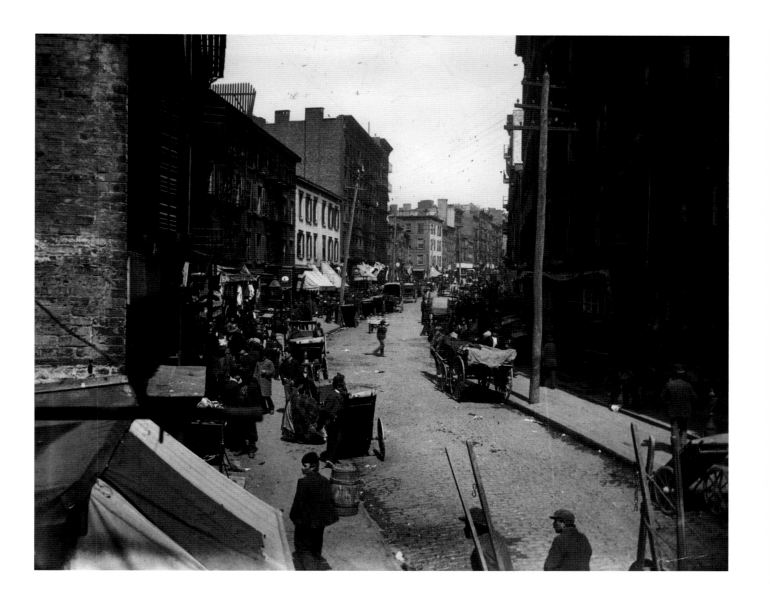

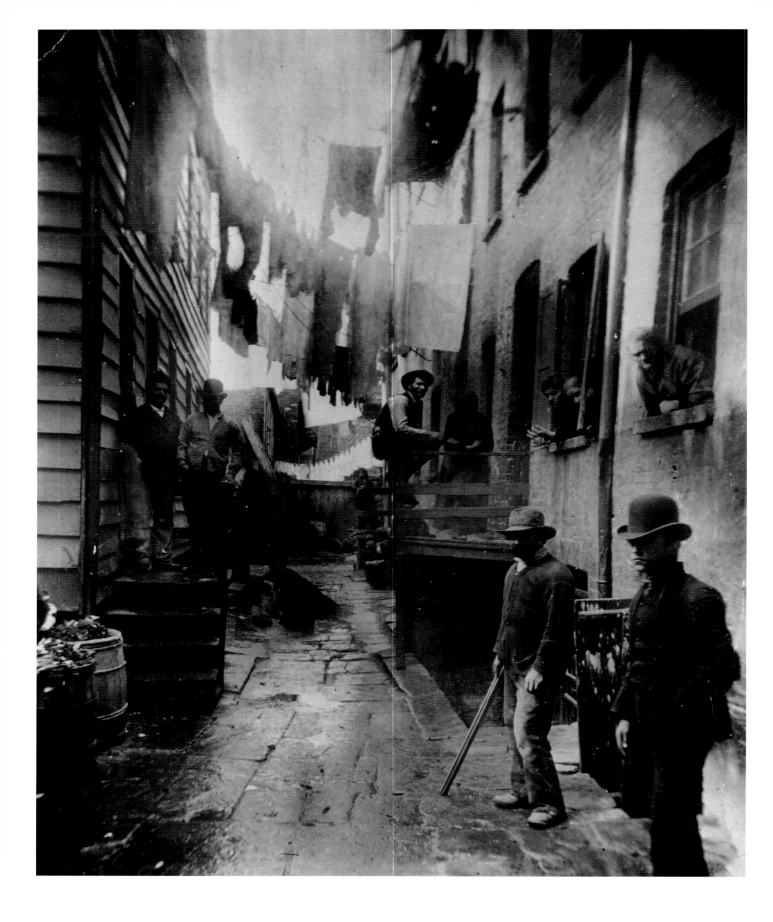

Bandits' Roost, 1887
Gelatin silver print
New York, Museum of the City
of New York

Bandits' Roost, ca. 1890
Lantern slide by Henry G. Piffard,
31.63 x 30.48 cm
New York, Museum of the City
of New York

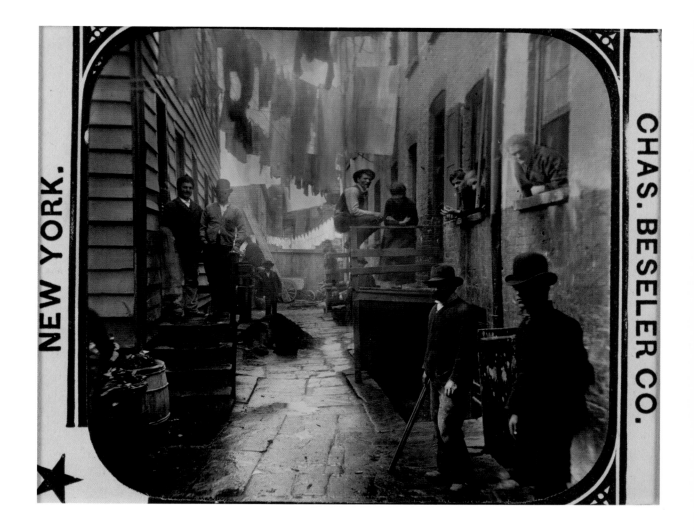

Five Cents A Night, 1890
Gelatin silver print
New York, Museum of the City
of New York

*In the Home of an Italian
Rag-Picker, Jersey Street*,
ca. 1890
Original line drawing
New York, Museum of the City
of New York

*In the Home of an Italian
Rag-Picker*, 1887
Gelatin silver print
New York, Museum of the City
of New York

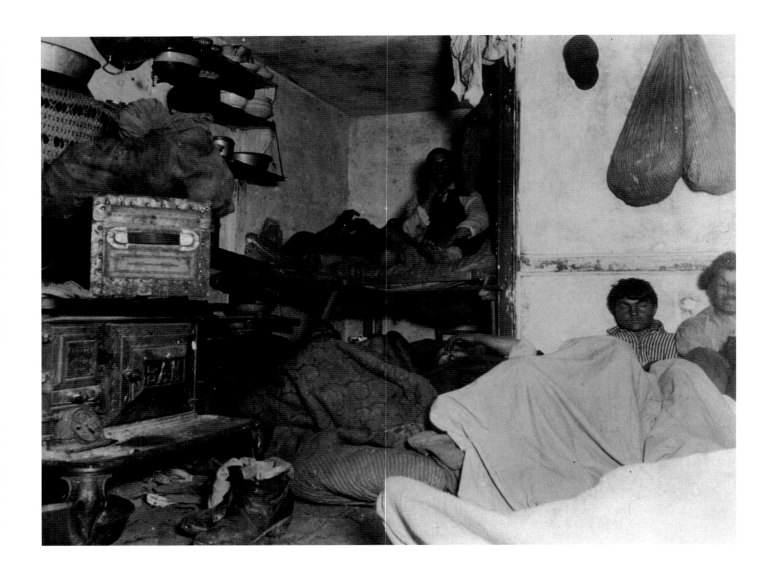

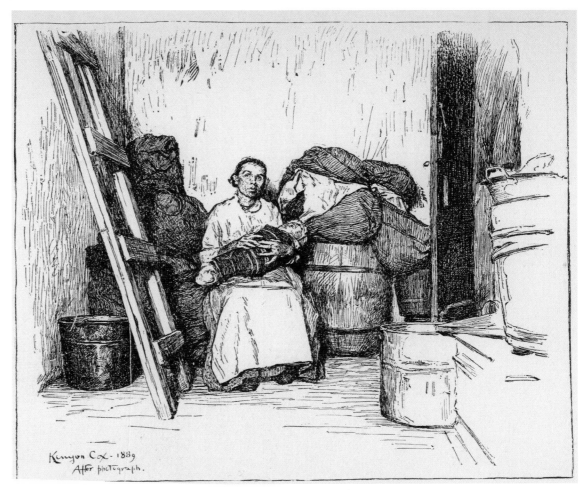

Kenyon Cox · 1889
After photograph.

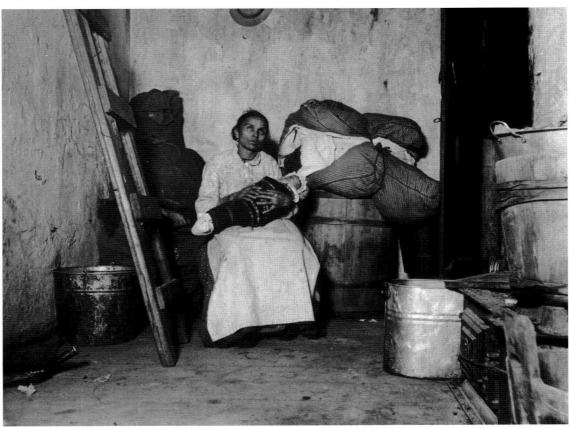

The British photographer Peter Henry Emerson, born in Cuba to an American father and an English mother, published a black-edged pamphlet complete with epitaph at the end of 1890. Entitled *The Death of Naturalistic Photography*, it contained a substantial repudiation of the approach that had previously informed his work, as summarised and expressed just the year before in the book *Naturalistic Photography for Students of the Art* (Sampson Low, Marston, Searle & Rivington). When the pamphlet appeared, Emerson was known as a strenuous champion of the self-sufficiency and artistic dignity of photography, which he saw as to be obtained not in the ways suggested by his celebrated predecessors Oscar Gustave Rejlander and Henry Peach Robinson, intent on "aping" the models of painting through "artificial" expedients such as montage and multiple exposure, but with an Impressionist spirit, getting as close as possible to the direct perception of reality. To be precise, Emerson's naturalistic photography was based on the studies of the German doctor Hermann von Helmholtz into human vision, using very limited depth of field to imitate the physiological need to concentrate the gaze on the main subject, and an almost imperceptible

defocusing in order to soften the incisiveness of the lens and thereby reproduce the imperfections of the eye's ability to pick up detail. Within this simple but rigorous conceptual framework, the operation of focusing constitutes one of the decisions that remain to the individual photographer, and which justifies the centrality of his role, in addition to the faculty of determining the shot and controlling the tonal values of the negative on the basis of personal experience and sensitivity. The radical curtailment of the latter possibility as a result of the findings made public in May 1890 by Ferdinand Hurter and Charles Driffield, which effectively reduced the operations of development to a simple mathematical formula, constitutes the scientific motivation behind Emerson's sudden change in direction. If photographers do not have sufficient freedom to introduce themselves into the work they produce, then theirs cannot be an art. For this and other reasons listed in the pamphlet – some conversations with a great artist whose name is not given (given Emerson's preferences, it may have been James McNeill Whistler, or more probably George Clausen), the viewing of an exhibition of works by Katsushika Hokusai, and the study of some works

in the National Gallery in London – the author concluded his observations as follows: "The limitations of photography are so great that, though the results may and sometimes do give a certain aesthetic pleasure, the medium must always rank the lowest of all the arts, lower than any graphic art." In turning back so decidedly, Emerson took a crucial step forward at the same time, breaking free of the purely imitative conception of photography, which he had helped to perpetuate, by making the human eye the point of reference previously identified by Rejlander and Robinson in the academic arts, and recognising the interpretive quality of this operation. In short, he established a form of authentic self-sufficiency and specificity of photography only at this point, but completely rejected it by falling into the trap of the apparently automatic nature of its instrument. Herein lies the crucial importance of the reversal brought about with *The Death of Naturalistic Photography*, which clearly expressed what was subsequently to constitute the foundation of both "direct photography" and pictorialism.

Although Peter Henry Emerson did not accept the limitation of photography, mistaking the grammar – which belongs to every language of art – for a structural impediment, he continued to use the medium even after 1890 to produce extremely meaningful and deeply meditated series. Freed from pressing demonstrative objectives, his last book was a composed triumph of images rarefied to the point of losing their subject, almost as though to challenge the approach of emptiness with the indisputable presence of its representation. *Marsh Leaves* (1895) was Emerson's last published work (followed only by the third edition, revised and corrected, of *Naturalistic Photography for Students of the Art* in 1899, where, among other things, the title of the closing chapter, *Photography – a pictorial art*, is eloquently changed to *Photography – non-art*). It comprises sixteen views alternating with about sixty short texts and reproduced by means of photogravure, a technique based on the use of typographical ink that does not use Benday dots to render chiaroscuro, but rather offers tonal continuity of exceptional softness and depth similar to the photographic print. The subject is rural, as in most of the work by Emerson, who was indeed one of the first to draw upon simple, everyday scenes, found in his case in the countryside of Suffolk and Norfolk, rather than travel in search of spectacular and unusual settings. While the figures featured in the previous series disappear almost completely in the silence of the landscape, every figurative reference is diluted in the atmosphere, dissolving on the thick paper of the book beneath the tissue paper that protects each illustration and emphasises its transparency in a crescendo, leading to the rarefaction of Whistler's nocturnes and the poetic minimalism of Japanese prints. No longer a support for documentation (of the subject represented or the behaviour of the human eye), the photograph now displays the translation process that mediates its relationship with reality.

Bibliography
Durden, Mark. "Peter Henry Emerson: The Limits of Representation". *History of Photography* 3, vol. 18. New York: Taylor & Francis / Routledge, 1994.
Emerson, Peter Henry. *Naturalistic Photography for Students of the Art.* London: Sampson Low, Marston, Searle & Rivington, 1889.
Emerson, Peter Henry. *Naturalistic Photography for Students of the Art. Third Edition, Revised, Enlarged and Re-Written in Parts.* New York: The Scovill & Adams Company, 1899.
Handy, Ellen. *Pictorial Effect and Naturalistic Vision: The Photographs and Theories of Henry Peach Robinson and Peter Henry Emerson.* Norfolk, Va.: The Chrysler Museum, 1994.
Newhall, Nancy. *P.H. Emerson: The Fight for Photography as a Fine Art.* New York: Aperture, 1975.
Taylor, John. *The Old Order and the New. P.H. Emerson and Photography 1885–1895.* Munich: Prestel, 2006.

Peter Henry Emerson
Polling the Marsh Hay, ca. 1885
Platinum print, 22.6 x 28.3 cm
New York, George Eastman
House, Gift of William C. Emerson

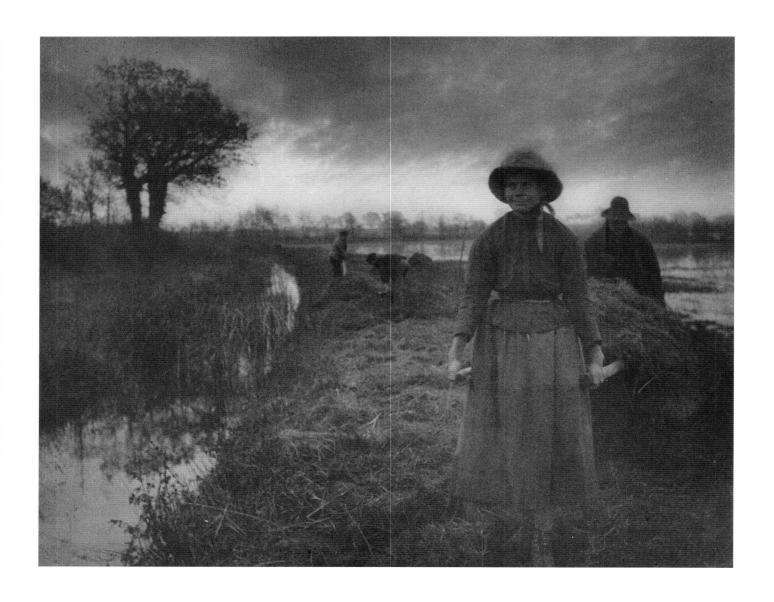

Peter Henry Emerson
A Waterside Inn, ca. 1890
Photogravure print, 8.1 x 12.5 cm
New York, George Eastman
House, museum purchase

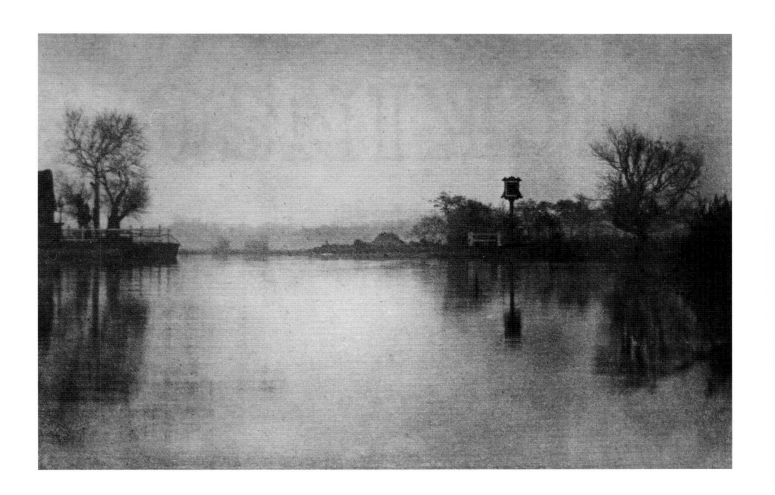

James Abbott McNeill Whistler
Nocturne, 1878
Litograph, 17.1 x 25.9 cm
London, The British Museum

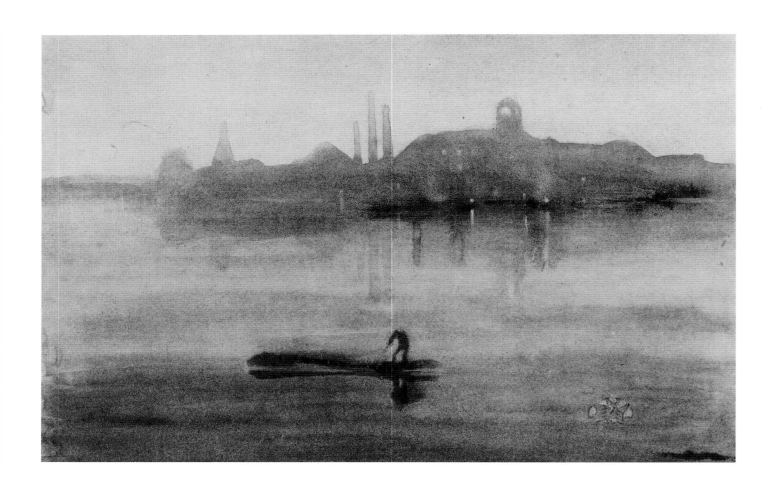

Peter Henry Emerson
The Fetters of Winter, 1890
Photogravure print,
11.3 x 18.7 cm
New York, George Eastman
House, museum purchase

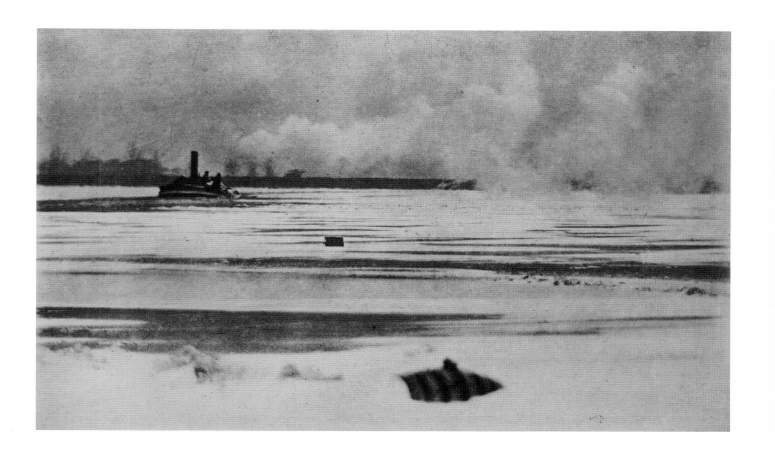

Peter Henry Emerson
Marsh Weeds, ca. 1890
Photogravure print,
10.1 x 14.2 cm
New York, George Eastman
House, museum purchase

Appendix

Glossary

Albumen

Albumen, an organic substance contained in egg-white, was first used in photography in 1847, when Abel Niépce de Saint Victor employed it as a binder, in particular for the solution of silver salts, in the preparation of negatives on glass plates. The limitations of this process lie in the difficulty of application and the poor sensitivity of the supports thus obtained. Louis-Désiré Blanquart-Évrard used the same material as early as 1850 in a procedure whereby a sheet of very thin paper brushed with a layer of salted albumin was immersed in a silver nitrate solution to become photosensitive. This "albumen paper" offers a particularly velvety surface on which the tones of the print prove rich and soft. The process reached its peak of popularity in the decade spanning the 1860s and 1870s, and was to remain in use, albeit more and more sporadically, until the beginning of the 20th century.

Ambrotype

Invented in the first half of the 1850s, the ambrotype is a photographic procedure that generates a direct positive. A glass plate sensitised with albumen is developed in a solution of iron sulphate and then presented on a dark background, often of velvet, upon which it appears as a positive. The ambrotype enjoyed great success in the United States, not least because of its cheapness.

Calotype

Patented by Henry Fox Talbot (hence the alternative name of "talbotype") in 1841, the calotype was a forerunner of the negative-positive procedures. A sheet of very thin paper, often of the type used for letters, is brushed with a solution of silver nitrate, dried, and then soaked in potassium iodide. Now sensitive to light, the sheet is immersed in a compound of silver nitrate and gallic acid, and subsequently exposed to light in a camera on a frame between two glass plates. The paper is then developed in a silver nitrate solution and fixed with potassium bromide. As the resulting image is less sharply defined than the daguerreotype, the procedure was used above all to obtain hazy, artistic effects. It was abandoned in the 1860s for simpler processes that could also be exploited commercially.

Carbon Printing

Invented by Alphonse Poitevin in 1855, the carbon printing process makes it possible to obtain particularly stable and lasting images with very deep shades of black. The paper is initially treated with a dichromate gelatin with the addition of a pigment of ground vegetable carbon. After exposure, the paper is rinsed in warm water to dissolve the lighter parts of the negative before developing. Having become insoluble to light, the dichromate gelatin forms the image by retaining the pulverised carbon. This procedure developed with a number of variants and improvements until the beginning of the 20th century.

Waxed Paper

A variation of the calotype developed by Gustave Le Gray in 1851, this procedure involves brushing hot melted wax onto a sheet of paper so as to close its pores and preserve the sensitivity of the support, which could be thus be exposed at any time within a period of approximately two weeks from its preparation. A major advantage of this method was far greater precision in the rendering of detail than the calotype, something similar to a negative on glass, but without the major disadvantage of weight that made its outdoor use particularly problematic.

Salted Paper

The first procedure of photographic printing on paper was devised around 1833 by Henry Fox Talbot and widely used in the 1840s. After the application of salt, the paper is coated with a silver nitrate solution to form a silver chloride surface. Thus prepared, the support is placed in a frame in direct contact with the negative, exposed to light, which blackens the transparent parts of the image, and finally fixed in hyposulphite solution. The tones of the resulting image are brownish, but are often tinted by means of different methods. This material gave way to albumin paper, again with direct blackening, in the mid-1850s.

Cyanotype

Invented by Sir John Herschel in 1842, the cyanotype process involves sensitisation of the paper with a solution of potassium ferricyanide and

ferric ammonium citrate, rather than silver salts. The result is characterised by the typical Prussian blue colour formed during exposure, which proves insoluble when rinsed in running water. The technique was frequently used during the 19th century, especially to produce blueprints of engineering and architectural drawings, due to its simplicity and quickness.

Wet Collodion

Developed by Frederick Scott Archer in 1851, the wet collodion process effectively took over from albumin paper, above all by virtue of the greater sensitivity obtained, and was used on a large scale for twenty years at least. The glass plate is coated with collodion (a solution of pyroxilin in alcohol and ether) to which potassium iodide has been added. After immersion in a silver nitrate sensitising bath, it is placed in a frame and exposed when still wet. Once the image has been captured, the plate is developed with ferrous sulphate or gallic acid, before the collodion dries and becomes impermeable, and then fixed with potassium cyanide. The material was used primarily for studio portraits due to the considerable

reduction of exposure time. Outdoor use proved far more complicated, above all because of the need to sensitise and develop the plate very quickly, which meant that photographers had to carry the chemicals and heavy equipment around with them. Attempts were made to remedy this drawback as from the mid-1850s with the invention of various dry collodion processes, most of which were, however, characterised by inferior sensitivity and difficulties in preparation. The collodion era ended in the 1870s with the introduction of the first silver-bromide gelatin plates.

Daguerreotype

The direct photographic process, patented by Louis-Jacques-Mandé Daguerre in 1839, involves the exposure of a copper plate, electrolytically coated with silver and carefully smoothed, to iodine vapour so as to form a layer of light-sensitive silver iodide crystals on the surface. Exposed within a few minutes of its preparation, the plate is then developed in the dark with mercury vapour, fixed with sea salt (later replaced with sodium hyposulphite), rinsed in distilled water, and dried. The

result is an extremely clear and detailed image on a mirror-like surface that can be read as a positive or negative according to the angle of observation and the colour of the background. As daguerreotypes are extremely delicate, they were mounted in protective cases, often on velvet, from the outset. The daguerreotype enjoyed extraordinary popularity, especially in France and the United States, until the 1850s, when the development of negative-positive processes enabling the production of copies revealed the daguerreotype technique's limitations as a unique image that did not allow for duplication.

Photogenic Drawing

Developed by Henry Fox Talbot between 1834 and 1838, the photogenic drawing is a negative obtained through the direct blackening of paper sensitised with a solution of salt and silver nitrate (producing silver chloride). Objects were normally placed in direct contact with the paper, and exposed to light so as to leave their imprint on the sensitive material. A strong solution of common salt was used for fixing.

Heliography

Invented by the Frenchman Nicéphore Niépce, heliography was the process used to produce the earliest known photographic images in the 1820s. A pewter plate is sensitised with bitumen of Judea, which has the property of hardening on exposure to light. The areas not exposed are rinsed in oil of lavender, and the result is a negative image subsequently inverted through exposure to vapour from iodine crystals and further rinsing in concentrated lavender essence. The technique was first used by placing the object to be reproduced directly upon the sensitive support, but then, in 1827, the prepared plate was inserted into a camera. Thus it was that Niépce obtained his celebrated *View from the Window at Le Gras* after an exposure of approximately eight hours.

Silver Bromide Gelatin

The process developed by Richard Leach Maddox in 1871 replaces collodion with gelatin of animal origin, and uses silver bromide as the photosensitive element. The substantial progress with respect to the use of collodion, wet or dry, lies in the far

greater sensitivity of the plates thus obtained, and the fact that they could be prepared long in advance, thus making it possible to sell negatives ready for use. The procedure was rapidly improved in various ways throughout the decade after its invention, and thus came to supplant all the others.

Platinotype

The platinotype print process developed by William Willis in 1873 harnesses the sensitivity of platinum salts to light. Paper is coated with a mixture of ferric salts and potassium chloroplatinate, and developed in a solution of potassium oxalate, before rinsing with hydrochloric acid. While the greatest advantage of the process lies in the extraordinary tonal depth of the images generated, the soaring cost of platinum led to its gradual abandonment before the end of the century.

Stereoscopy

The technique invented to give images the illusion of three-dimensional depth by the English scientist Sir Charles Wheatstone the year before the official announcement of the birth of photography soon found application in the photographic sphere and enjoyed extraordinary popularity all through the 19th century. A stereograph is used to take two photographs of the subject at the same time with a slight displacement corresponding to the distance between the eyes. Mounted on cardboard at a short distance from one another, and observed through a specially designed instrument known as a stereoscope, numerous types of which exist, the two images thus obtained reproduce the three-dimensionality of the original subject.

Timeline

	Culture and arts	History and society	Photography
1816			• Creation of the first photochemical images by Nicéphore Niépce
1821		• Michael Faraday demonstrates that electricity can be converted into mechanical energy	
1822			• Invention of heliography by Nicéphore Niépce
1827			• Niépce's *View from the Window at Le Gras,* regarded as the first photography ever taken
1829	• *Les Orientales* by Victor Hugo • *An Analysis of the Phenomena of the Human Mind* by James Mill • First performance of Johann W. Goethe's *Faust* staged in Weimar		• Greece wins independence from the Ottoman Empire • Niépce and Jacques-Louis–Mandé Daguerre form a partnership
1830	• *Le Rouge et le Noir* by Stendhal	• First railway line opened between Liverpool and Manchester • July Revolution in France	
1830–42	• *Cours de philosophie positive* by Auguste Comte (six volumes).		
1831	• *Notre-Dame de Paris* by Victor Hugo	• First railway line for passenger trains	
1833	• *Eugénie Grandet* by Honoré de Balzac • *The Fifty-Three Stations of the Tokaido* by Ando Hiroshige	• Abolition of slavery in the British Empire	• Death of Nicéphore Niépce
1834	• *The Last Days of Pompeii* by Edward Bulwer-Lytton	• Use of the Braille system of reading for the blind spreas throughout the world	• Creation of "photogenic drawings" by William Henry Fox Talbot

	Culture and arts	History and society	Photography
1836	• First instalments of *The Pickwick Papers* by Charles Dickens	• Texas wins independence from Mexico	
1837	• Death of Aleksandr Pushkin • Death of Giacomo Leopardi	• Coronation of Queen Victoria	• Daguerre produces the first daguerreotypes
1839	• *The Charterhouse of Parma* by Stendhal • Théodore Chasseriau paints *Susanna at Her Bath*	• Beginning of the First Opium War between the United Kingdom and the Qing Empire in China • Netherlands recognises the independence of Belgium • First Italian railway line between Naples and Portici	• Official birth of photography with the announcement by François Arago of the discovery of daguerreotype process at the Académie des Sciences in Paris • Hyppolite Bayard announces the discovery of the "direct positive" on paper • Sir John Herschel delivers his *Note on the Art of Photography* at the Royal Society in London • Samuel F.B. Morse produces the first daguerreotypes in the United States
1840	• *Tales of the Grotesque and Arabesque* by Edgar Allan Poe	• Introduction of postage stamps in Great Britain	• First daguerreotype image of the moon • Sir William Brooke O'Shaughnessy presents daguerreotypes of the city in Calcutta
1840–50			• Opening of the first daguerreotype portrait studios in the United States and Europe, and their spread throughout the world
1841	• *The Essence of Christianity* by Ludwig Feuerbach • *Murders in the Rue Morgue* by Edgar Allan Poe • First performances of Robert Schumann's first and fourth symphonies • First performances of the ballet *Giselle*, music by Adolphe Adam and *libretto* by Théophile Gautier in Paris	• First rail excursion organised by Thomas Cook on the Leicester-Loughborough line • Founding of the humorous magazine *Punch* in London • Introduction of electrical street lighting in Paris	• William Henry Fox Talbot patents the calotype or talbotype positive/negative process
1842	• First performance of *Nabucco* by Giuseppe Verdi at La Scala in Milan	• End of the First Opium War with the Treaty of Nanking, the terms of which include the cession of Hong Kong to the British crown	• Invention of the cyanotype by Sir John Herschel

	Culture and arts	History and society	Photography
1842–44			• Publication of *Excursions daguerriennes, vues et monuments les plus remarquables du globe*, a series of aquatint engravings based on daguerreotypes, by Noël-Marie Paymal Lerebours
1843	• *Fear and Trembling* and *Either/Or* by Søren Kierkegaard • Performance of *The Flying Dutchman* by Richard Wagner in Dresden • Performance of *Don Pasquale* by Gaetano Donizetti in Paris • Performance of *A Midsummer Night's Dream* by Felix Mendelssohn in Potsdam	• Founding of the periodical *L'Illustration* in Paris	• Beginning of the partnership of David Octavius Hill and Robert Adamson
1843–60	• *Modern Painters* by John Ruskin		
1844	• Joseph M.W. Turner paints *Rain, Steam, and Speed. The Great Western Railway* • *The Three Musketeers* by Alexandre Dumas • *Economic & Philosophical Manuscripts* by Karl Marx	• First telegraph message sent by Samuel Morse	• William Henry Fox Talbot publishes *The Pencil of Nature*, the first photographically illustrated book in history
1845	• *The Count of Monte Cristo* by Alexandre Dumas • *The Condition of the Working Class in England* by Friedrich Engels • Performance of *Tannhäuser* by Richard Wagner in Dresden	• Start of the First Sikh War in the Kashmir and Punjab regions of India • Start of performances by the magician Jean-Eugène Robert-Houdin at the Palais-Royal in Paris	• The first daguerreotype images of the sun captured by the physicists Léon Foucault and Hippolyte Fizeau
1845–49		• Great famine in Ireland leading to the death or emigration to the United States and Canada of a quarter of the population	

	Culture and arts	History and society	Photography
1846	• *The Philosophy of Poverty* by Pierre-Joseph Proudhon • Jean-Léon Gérôme paints *The Cockfight* and establishes himself as a leader of the Neo-Grec school	• Cardinal Giovanni Maria Mastai Ferretti becomes Pope Pius IX • First use of ether as an anaesthetic • Patenting of the Howe sewing machine • Founding of the Smithsonian Institution • Carl Zeiss opens a factory of optical instruments in Jena • Michel Knoedler opens an art gallery in New York • Adolphe Sax patents the saxophone	• First news of the spread of the daguerreotype process in China • The first-ever war photographs are taken during the Mexican-American War
1846–48		• The United States obtains vast territories in Arizona, California and New Mexico through war with Mexico	
1847			• Louis-Désiré Blanquart-Évrard introduces the Fox Talbot paper negative process into France • Abel Niépce de Saint-Victor uses albumen in the preparation of negatives on glass plates for the first time. Printing on albumen paper becomes widespread in the 1850s • Founding of the Photographic Club in London
1848	• *Vanity Fair* by William Thackeray • *The Communist Manifesto* by Karl Marx and Friedrich Engels • *Principles of Political Economy* by John Stuart Mill • Birth of the Pre-Raphaelite Brotherhood in London	• California Gold Rush • First convention on women's rights at Seneca Falls (New York) • Wave of revolutions in Europe and the First Italian War of Independence • Forced abdication of Louis Philippe and proclamation of the Second Republic in France	
1849	• *David Copperfield* by Charles Dickens • Gustave Courbet paints *The Stonebreakers* (destroyed in 1945, during the World War II) and *A Burial at Ornans*	• Suppression of the Hungarian Revolution • Abdication of Carlo Alberto, king of Savoy, in favour of his son Vittorio Emanuele II • Revolts in Dresden and the Palatinate	
1850	• *The Scarlet Letter* by Nathaniel Hawthorne	• The Second Sikh War in India • *Harper's Monthly* begins publication in New York	

	Culture and arts	History and society	Photography
1851	• *Moby Dick* by Herman Melville • Construction of the Crystal Palace, designed by Joseph Paxton, in London	• The "Great Exhibition of the Works of Industry of All Nations", the first World's Fair, is held in the Crystal Palace, London • *The New York Times* begins publication	• Invention of the wet collodion process by Frederick Scott Archer • Founding of *La Lumière*, a periodical devoted to heliography • Founding of the *Photographic Art Journal* in New York • William Bond and John Adams Whipple photograph the moon after obtaining the first daguerreotype of a star the year before • The Commission des Monuments Historiques launches the Mission Héliographique as the first state-commissioned photographic survey, carried out by Édouard Baldus, Hippolyte Bayard, Gustave Le Gray, Henri Le Secq, and Auguste Mestral • Founding of the Société Héliographique in Paris by a group of photographers including the painter Eugène Delacroix • Louis-Désiré Blanquart-Évrard opens the first photographic printing works at Loos-les-Lille • Display of photographs, especially daguerreotypes, at the Great Exhibition in London
1851–52	• John Everett Millais paints *Ophelia*		
1852	• *Uncle Tom's Cabin* by Harriet Beecher Stowe	• Louis Napoléon Bonaparte becomes Napoleon III, Emperor of the French	• The Society of Arts in London holds the first exhibition devoted entirely to photography • Publication in Paris of *Egypte, Nubie, Palestine et Syrie* by Maxime Du Camp, printed by Blanquart-Évrard, the first French book to be photographically illustrated • Invention of the ferrotype, known in the United States and also in Great Britain as the tintype, by Adolphe-Alexandre Martin • John Benjamin Dancer patents a twin-lens stereoscopic camera

	Culture and arts	History and society	Photography
1852–59	• Construction of Les Halles, the central market of Paris, designed by Victor Baltard		
1852–68	• Construction of the Bibliothèque nationale in Paris, designed by Henri Labrouste		
1853		• Commodore Perry enters the bay of Tokyo and secures the opening of Japan to trade with the West under the threat of bombardment • David Livingstone's exploration of Africa	• Founding of the Photographic Society, which also publishes its own journal, in London • Spread of photography in Japan
1853–55			• The Crimean War is documented by various photographers, including Carol Szathmari, Roger Fenton, James Robertson, Jean-Charles Langlois, and Felice Beato
1853–56		• Crimean War between Russia and the Ottoman Empire, France, Britain and the Kingdom of Sardinia	
1853–69	• Eugène Delacroix paints in the church of Saint-Sulpice, Paris		
1854	• *Walden* by Henry David Thoreau	• First safe elevator produced by Elisha Otis • Cholera epidemic in London • Invention of reinforced concrete by William Wilkinson	• Founding of the Société française de photographie in Paris • Founding of the *Photographisches Journal* in Leipzig • André-Adolphe-Eugène Disdéri patents the *carte de visite* photograph
1854–55	• Gustave Courbet paints *The Artist's Studio*		

	Culture and arts	History and society	Photography
1855	• *Leaves of Grass* by Walt Whitman	• Exposition Universelle in Paris	• Invention of the carbon printing process by Alphonse Poitevin • Exhibition of photographs held in the industrial arts section of the Exposition Universelle in Paris by the Société Française de Photographie • East India Company switches from drawing to photography for its survey of the Indian territory and monuments monumenti in India
1856		• Second Opium War between China and some of the Western powers • Steel production revolutionised by the invention of the Bessemer process • Discovery of fossils in the Neandertal Valley near Düsseldorf, in Germany	• William Thompson takes the first underwater photographs
1857	• *The Gleaners* by Jean-François Millet		• Oscar Gustave Rejlander's photograph *The Two Ways of Life* is shown in Manchester at the Art Treasures of Great Britain exhibition; Queen Victoria purchases a copy
1857–58			• Linnaeus Tripe publishes ten books of photographs on India
1858	• Creation of Central Park in New York to plans by Frederick Law Olmsted • Opening of the Covent Garden Opera House in London		• Gaspard-Félix Tournachon, known as Nadar, takes the first aerial photograph from a balloon over Paris • Carleton E. Watkins begins photographing in the Yosemite Valley • Founding of the *Stereoscopic Magazine* in London
1859	• *A Tale of Two Cities* by Charles Dickens • *On Liberty* by John Stuart Mill • *On the Origin of Species* by Charles Darwin • Francesco Hayez paints *The Kiss* • *The Angelus* by Jean-François Millet	• Second Italian War of Independence • Commencement of work on the building of the Suez Canal	• Photographic exhibition organised by the Société française de photographie in connection with the Paris Salon, albeit in a building next to the one housing the official exhibition of paintings

	Culture and arts	History and society	Photography
1859–63	• Jean Auguste-Dominique Ingres paints *The Turkish Bath*		
1859–72	• Construction of the Ring around the historic nucleus of Vienna		
1860		• The Expedition of the Thousand led by Garibaldi results in the defeat and annexation of the Kingdom of the Two Sicilies • The Second Opium War comes to an end with the Convention of Peking	• The brothers Louis-Auguste and Auguste-Rosalie Bisson take photographs on the Alps • Founding of the Zeitschrift für Photographie und Stereoskopie in Vienna
1861	• *Utilitarianism* by John Stuart Mill	• Unification of the Kingdom of Italy; Victor Emmanuel II declared king of Italy • Emancipation of the serfs in Russia • Outbreak of the American Civil War	• Nadar photographs the sewers of Paris
1861–65		• The American Civil War	• The American Civil War is documented by Mathew B. Brady and the photographers working for him, including Alexander Gardner
1861–75	• Building of the Opéra in Paris, designed by Charles Garnier		
1862	• *Les Misérables* by Victor Hugo • *Fathers and Sons* by Ivan Turgenev • *The Third-Class Carriage* by Honoré Daumier	• Otto von Bismarck becomes prime minister of Prussia	
1863	• Édouard Manet paints *Le déjeuner sur l'herbe* and *Olympia* • Alexandre Cabanel paints *Birth of Venus* • The Salon des Refusés is held in Paris	• President Abraham Lincoln delivers the Gettysburg Address and proclaims the abolition of slavery • Napoleon III sends a military expedition to Mexico and offers the Habsburg archduke Maximilian the throne of the Mexican Empire • Opening of the first section of the London underground • Founding of the International Red Cross	• Founding of La Camera Oscura in Rome • Arrival of Samuel Bourne in India

	Culture and arts	History and society	Photography
1863–67		• French occupation of Mexico	
1864		• Founding of the First International by Karl Marx and Friedrich Engels • First successful transoceanic telegraph line	• Walter Bentley Woodbury develops the Woodburytype process
1865	• *Alice in Wonderland* by Lewis Carroll • First performance of Wagner's *Tristan und Isolde*	• Abolition of slavery with the ratification of the Thirteenth Amendment • Assassination of President Abraham Lincoln	
1865–69	• *War and Peace* by Leo Tolstoy		
1866	• *Crime and Punishment* by Fyodor Dostoyevsky • *Experiments in Plant Hybridization* by Gregor Johann Mendel	• Third Italian War of Independence	
1866–69		• Meiji Restoration in Japan	
1867	• *Capital* by Karl Marx	• Franz Josef I becomes emperor of the Dual Monarchy of Austria-Hungary • Alfred Nobel invents dynamite	
1867–69			• Charles Cros and Louis Ducos du Hauron present the colour printing process to the Société Française de Photographie
1868		• The Spanish Revolution	
1868–75			• Publication of *The People of India*, in eight volumes under the editorship of Dr John Forbes Watson and John William Kaye
1869	• *Twenty Thousand Leagues Under the Sea* by Jules Verne • *The Subjection of Women* by John Stuart Mill • *Periodic Table of the Chemical Elements* by Dmitri Mendeleev • *The Idiot* by Fyodor Dostoyevsky	• Opening of the Suez Canal • First continental American railroad • John Wesley Hyatt patents celluloid	• *Pictorial Effect in Photography* by Henry Peach Robinson

	Culture and arts	History and society	Photography
1870		• Rome becomes the capital of Italy • The Franco-Prussian War ends in the defeat of France and the downfall of Napoleon III • The 1st Vatican Council proclaims the dogma of papal infallibility • Work begins on building the Brooklyn Bridge in New York	
1871		• Victor Emmanuel II make his official entry into Rome, capital of Italy • Unification of Germany with Wilhelm I as emperor and Bismarck as chancellor • The Paris Commune • The Third Republic is established in France • Trade unions are legalised in Great Britain • Heinrich Schliemann excavates the site of ancient Troy	• Richard Leach Maddox invents the gelatin silver process, which supplants all others • Founding of the Deutsche Gesellschaft zur Förderung der Photographie in Berlin • The French police use photographs taken during the Paris Commune as evidence against insurgents
1872	• *The Birth of Tragedy* by Friedrich Nietzsche • Claude Monet paints *Impression: Sunrise*		
1873	• *A Treatise on Electricity & Magnetism* by James Clerk Maxwell		• William Willis invents the platinotype
1873–74			• *Illustration of China and its People* by John Thomson
1874	• The first show of Impressionist paintings is held in Paris in Nadar's studio		
1875	• Tchaikovsky's first piano concerto		
1876	• *L'après-midi d'un faune* by Stephane Mallarmé • *Tom Sawyer* by Mark Twain • Gustave Moreau paints *The Apparition* • *Bal du Moulin de la Galette* by Pierre-Auguste Renoir	• Alexander Graham Bell patents the telephone • Nikolaus-August Otto patents the first internal combustion engine • Queen Victoria is proclaimed Empress of India	

	Culture and arts	History and society	Photography
1877	• *The Fixation of Belief* by Charles S. Peirce • The first performance of Tchaikovsky's *Swan Lake* at the Bolshoi in Moscow	• Thomas Edison invents the phonograph	
1877–78		• The Russo-Turkish War	
1879	• *A Doll's House* by Henrik Ibsen	• The Anglo- Zulu War • Thomas Edison displays an improved form of incandescent electric light to the public • Invention of the steam drill	• Birth of platinum prints
1880	• *Nanà* by Émile Zola		• Invention of the zoopraxiscope by Eadweard J. Muybridge
1880–90	• Emergence of the Neo-Impressionists in France • Emergence of Art Noveau in France and then in Europe	• Large-scale European colonisation of Africa • First use of steel in building	
1881	• *Luncheon of the Boating Party* by Pierre-Auguste Renoir	• Assassination of Tsar Alexander II and first pogrom • Assassination of the United States President James A. Garfield • Sitting Bull surrenders to US troops • End of the First Boer War with the Pretoria Convention • Completion of the Panama Canal	• George Eastman founds the Eastman Dry Plate Company in Rochester • Frederick Ives develops the halftone photoengraving process, discovered some years earlier by the Canadians George-Édouard Desbarats and William Augustus Leggo
1882	• *The Gay Science* by Friedrich Nietzsche • *A Bar at the Folies-Bergère* by Édouard Manet • First performance of Richard Wagner's *Parsifal* in Bayreuth	• The Austro-Hungarian Empire, Germany, and Italy form the Triple Alliance • The Second Anglo-Egyptian War Egypt becomes a British Protectorate • The murder of Jesse James by Robert Ford • Thomas Edison builds a dynamo-driven power station	• Étienne-Jules Marey invents the photographic and chronophotographic gun • Alphonse Bertillon's first use of photographic "mug shots"

	Culture and arts	History and society	Photography
1883	• *Thus Spake Zarathustra* by Friedrich Nietzsche • *Treasure Island* by Robert Louis Stevenson • *A Woman's Life* by Guy de Maupassant • *Introduction to the Human Sciences* by Wilhelm Dilthey	• Gottlieb Wilhelm Daimler patents the automobile engine • Otto von Bismarck introduces health insurance • The eruption of the Krakatau volcano in Indonesia causes a tsunami resulting in 36,000 deaths	
1883–86		• John Joseph Montgomery makes his first attempts at flight in California	
1884	• *The Burghers of Calais* by Auguste Rodin • Salon des Indépendants in Paris	• Berlin Conference on West Africa • Adoption of the time-zone system	• Founding of the New York Camera Club
1884–85		• The French airship *La France* makes the world's first fully controllable free flight • John Holland and Edmund Zalinski found the Nautilus Submarine Boat Company and begin work on a new submarine	
1885	• *Germinal* by Émile Zola		
1885–88		• Karl Benz introduces the Benz Patent Motorwagen, patented in 1886 and recognised as the first automobile; sales begin in 1888	
1886	• *Beyond Good and Evil* by Friedrich Nietzsche • *An Iceland Fisherman* by Pierre Loti • *Carnival Evening* by Henri Rousseau • *A Sunday Afternoon on the Island of La Grande Jatte* by Georges Seurat	• Inauguration of the Statue of Liberty in New York • Louis Pasteur develops a vaccine against rabies • The increasing pressure of the Prohibition movement in America leads to the production of a new non-alcoholic beverage called Coca Cola	• The Eastman Dry Plate Company develops celluloid roll film
1887	• *A Study in Scarlet* by Sir Arthur Conan Doyle • First performance of Giuseppe Verdi's *Othello* at La Scala in Milan		• *Animal Locomotion* by Eadweard J. Muybridge

	Culture and arts	History and society	Photography
1887–88		• Augustus Desiré Waller, a British physiologist born in Paris, creates the first practical ECG machine with surface electrodes	
1888	• Paul Gauguin paints *The Vision After the Sermon* (*Jacob Wrestling with the Angel*)	• Coronation of Kaiser Wilhelm II • Hertz discovers, transmits and receives radio waves • Founding of the Football League in England and first national soccer championship	• The Eastman Dry Plate Company markets Kodak no.1 film, leading to a revolution in photography
1889	• *The Starry Night* by Vincent van Gogh • Building of the Eiffel Tower, designed by Gustave-Alexandre Eiffel in Paris	• Opening of the Exposition Universelle in Paris • Brazil deposes the emperor and becomes a republic	• Publication of *Naturalistic Photography for Students of the Art* by Peter Henry Emerson
1890	• *The Principles of Psychology* by William James • Gaetano Previati paints *Motherhood*	• The wars against Native Americans in the United States come to an end with the Wounded Knee Massacre and the almost complete destruction of the tribes	• Publication of *How the Other Half Lives* by Jacob Riis
1893	• The Tassel House by Victor Horta		
1899	• *The Interpretation of Dreams* by Sigmund Freud and the birth of psychoanalysis		

Bibliography

Encyclopaedias and Dictionaries

• *Dictionnaire mondial de la photographie. Des origines à nos jours.* Paris: Larousse, 1994.
• Auer, Michèle; Auer, Michel. *Encyclopédie international de photographes de 1839 à nos jours / Photographers Encyclopaedia International, 1839 to the Present.* Geneva: Editions Camera Obscura, 1985.
• D'Autilia, Gabriele. *Dizionario della fotografia.* Turin: Einaudi, 2008.
• Frizot, Michel. *Une nouvelle encyclopédie de la photographie.* Paris: Hachette, 1996.
• Hannavy, John. *Encyclopedia of Nineteenth-Century Photography.* Taylor and Francis / Routledge, 2005.
• Woodbury, Walter E. *The Encyclopaedic Dictionary of Photography.* New York: The Scovill & Adams Company, 1898.

Histories of Photography

• *150 Ans de photographie, certitudes et interrogations, 1839–1989.* Charleroi: Musée de la Photographie, 1989.
• Baier, Wolfgang. *Quellendarstellungen zur Geschichte der Fotografie.* Leipzig, VEB Fotokinoverlag, 1966.
• Bajac, Quentin. *L'image révélée. L'invention de la photographie.* Paris: Gallimard, 2001.
• Bajac, Quentin, and Françoise Heilbrun. *La photographie au Musée d'Orsay.* Paris: Scala, 2000.
• Bajac, Quentin, and Agnès de Gouvion Saint-Cyr. *Dans le champ des étoiles. Les photographes et le ciel 1850–2000.* Paris: Réunion des Musées Nationaux, 2000.
• Barret, Alain, and Marianne Binet. *Les premiers reporters photographes, 1848–1914.* Paris: A. Barret, 1977.
• Bellone, Roger, and Luc Fellot. *Histoire mondiale de la photographie en couleurs.* Paris: Hachette, 1981.
• Beloili, Andrea. *Photography: Discovery and Invention.* Los Angeles: Getty Museum Publications, 1991.
• Benson, Richard. *The Printed Picture.* New York: The Museum of Modern Art, 2008.
• Clerc, Louis-Philippe. *La technique photographique.* Paris: Paul Montel, 1947.
• Coe, Brian. *Cameras, from Daguerreotypes to Instant Pictures.* Gothenburg: Nordbok, 1978.
• Coe, Brian. *Colour Photography: the First Hundred Years 1840–1940.* London: Ash and Grant, 1978.
• Coke, Van Deren F. *The Painter and the Photograph.* Albuquerque: University of New Mexico Press, 1964.
• ———. *One Hundred Years of Photographic History. Essays in Honor of Beaumont Newhall.* Albuquerque: University of New Mexico Press, 1975.
• Deval, Jean-Luc. *Photography: History of an Art.* New York: Rizzoli, 1982.
• Dewitz, Bodo von. *Daguerreotypien, Ambrotypien und Bilder anderer Verfahren aus der Frühzeit der Photographie.* Hamburg: Dokumente der Photographie, 1983.
• Eder, Joseph Maria. *History of Photography.* New York: Columbia University Press, 1945.
• ———. *The History of Photography.* New York: Dover Publications, 1978.
• Edwards, Elizabeth. *Anthropology and Photography, 1860–1920.* New Haven: Yale University Press, 1992.
• Faber, Monica, and Klaus Albrecht Schröder. *Das Auge und der Apparat. Eine Geschichte der Fotografie aus den Sammlungen der Albertina.* Paris: Éditions du Seuil, 2003.
• Font-Réaulx, Dominique de, and Joëlle Bolloch. *L'Oeuvre d'art et sa reproduction photographique.* Milan: 5 Continents Editions, 2006.
• Friedman, Joseph. *History of Color Photography.* Boston: The American Photographic Publishing Company, 1945.
• Frizot, Michel. *Nouvelle Histoire de la Photographie.* Paris: Bordas, 1994.
• Gernsheim, Helmut. *Creative Photography: Aesthetic Trends 1839–1960.* London: Faber and Faber, 1962.
• Gernsheim, Helmut, and Alison Gernsheim. *The History of Photography from the Camera Obscura to the Beginning of the Modern Era.* New York: McGraw-Hill, 1969.
• Gernsheim, Helmut. *Geschichte der Photographie. Die ersten hundert Jahre.* Frankfurt: Propyläen, 1983.
• Gervais, Thierry, and Gaelle Morel. *La Photographie.* Paris: Larousse, 2008.
• Gilardi, Ando. *Storia sociale della fotografia.* Milan: Bruno Mondadori, 2000.
• Goldberg, Vicki. *Photography in Print. Writings from 1816 to the Present.* New York: Simon and Schuster, 1981.
• Greenough, Sarah, and David Travis. *On the Art of Fixing a Shadow: 150 Years of Photography.* Washington, D.C.: National Gallery of Art, 1989.
• Gunthert, André, and Michel Poivert. *L'art de la photographie. Des origines à nos jours.* Paris: Citadelles et Mazenod, 2007.
• Hambourg, Maria Morris, Pierre Apraxine, Malcom Daniel, Jeff L. Rosenheim, and Virginia Heckert. *The Waking Dream: Photography's First Century. Selections from the Gilman Paper Company Collection.* New York: The Metropolitan Museum of Art, 1993.
• Haworth-Booth, Mark. *Photography: An Independent Art. Photographs from the Victoria and Albert Museum 1839–1996.* Princeton: Princeton University Press, 1997.
• Heilbrun, Françoise, and Philippe Néagu. *Chefs-d'oeuvre de la collection photographique du Musée d'Orsay.* Paris: Réunion des Musées Nationaux / Sers, 1986.
• ———. *A History of Photography. The Musée d'Orsay Collection 1839–1925.* Paris: Flammarion, 2009.
• Hight, Eleanor M., and Gary D. Sampson. *Colonialist Photography: Imag(in)ing Race and Place.* London: Routledge, 2002.
• Hirsch, Robert. *Seizing the Light: A History of Photography.* New York: McGraw-Hill, 1999.
• Höfel, Klaus. *Farbe im Photo: die Geschichte der Farbphotographie von 1861 bis

1981. Cologne: Josef-Haubrich / Kunsthalle, 1981.

• Holler, Wolfgang, and Claudia Schnitzer. *Weltsichten. Meisterwerke der Zeichnung, Graphik und Photographie.* Munich and Berlin: Deutscher Kunstverlag, 2004.

• Honnef, Klaus, and Jan Thorn Prikker. *Lichtbildnisse. Das Porträt in der Fotografie.* Cologne: Rheinland-Verlag, 1982.

• *Kunstphotographie um 1900. Die Sammlung Ernst Juhl,* exhib. cat. Hamburg: Museum für Kunst, 1989.

• Johnson, Geraldine A. *Sculpture and Photograph. Envisioning the Third Dimension.* Cambridge: Cambridge University Press, 1998.

• Jon, Darius. *Beyond Vision: One Hundred Historic Scientific Photographs.* New York: Oxford University Press, 1984.

• Kravets, T.P. *Documents on the History of the Invention of Photography.* New York: Arno, 1979.

• Lebeck, Robert, and Bodo von Dewitz. *Kiosk. A History of Photojournalism.* Göttingen: Steidl, 2001.

• Lecuyer, Raymond. *Histoire de la Photographie.* Paris: Baschet et Cie, 1945.

• Lemagny, Jean-Claude, and André Rouillé. *Histoire de la photographie.* Paris: Bordas, 1986.

• Lewinski, Jorge. *The Naked and the Nude: A History of the Nude in Photography.* New York: Harmony Books, 1987.

• Mathon, Catherine, and Anne-Marie Garcia. *Le chefs-d'oeuvre de la photographie dans le collections de l'Ecole des Beaux-Arts.* Paris: École Nationale Supérieure des Beaux-Arts, 1991.

• Moholy, Lucia. *A Hundred Years of Photography 1839–1939.* Harmondsworth: Penguin, 1939.

• Mora, Gilles. *PhotoSpeak. A Guide to the Ideas, Movements, and Techniques of Photography, 1839 to the Present.* New York: Abbeville Press, 1998.

• Morris Hambourg, Maria, Pierre Apraxine, and Malcom Daniel. *The Walking Dream. Photography's First Century. Selections from the Gilman Paper Company Collection.* New York: Harry N. Abrams, 1993.

• Nazarieff, Serge. *Early Erotic Photography.* Cologne: Taschen, 1993.

• Newhall, Beaumont. *Photography. A Short Critical History.* New York: The Museum of Modern Art, 1938.

• Newhall, Beaumont. *The History of Photography: From 1839 to the Present Day.* New York: The Museum of Modern Art, 1964.

• Newhall, Beaumont. *Photography: Essays & Images. Illustrated Readings in the History of Photography.* New York: The Museum of Modern Art, 1980.

• Pare, Richard. *Photographie et architecture 1839–1939.* Montreal: Callaway, 1982.

• Parr, Martin, and Gerry Badger. *The Photobook: A History.* Vol. I. London: Phaidon Press, 2004.

• Parry -Janis, Eugenia. *The Kiss of Apollo. Photography and Sculpture, 1845 to the Present.* San Francisco: Fraenkel Gallery, 1991.

• *La Photographie pictorialiste en Europe 1888–1918.* Rennes: Le point du Jour, 2005.

• *Photographies, histoires parallèles: collection du Musèe Nicephore Niépce.* Paris: Somogy, 2000.

• *Portraits d'une capital: de Daguerre à William Klein, collections photographiques du Musée Carnavalet.* Paris: Paris-Musées / Paris Audiovisuel, 1992.

• Pultz, John. *The Body and the Lens: Photography 1839 to the Present.* New York: Harry N. Abrams, 1995.

• Roosens, Laurent. *Un siècle de photographie de Niépce à Man Ray.* Paris: Musée des Arts Decoratifs, 1965.

• Rosenblum, Naomi. *A World History of Photography.* New York: Abbeville Press, 1984.

• ———. *A History of Women Photographers.* New York: Abbeville Press, 2000.

• Scaramella, Lorenzo. *Fotografia. Storia e riconoscimento dei procedimenti fotografici.* Rome: Edizioni De Luca, 1999.

• Schmidt, Marjen. *Fotografien in Museen, Archiven und Sammlungen. Konservieren. Archivieren. Präsentieren.* Munich: Weltkunst Verlag, 1994.

• Schwarz, Heinrich. *Art and Photography: Forerunners and Influences.* Chicago: The University of Chicago Press, 1987.

• Simonsen, Karin Bull. *Fotografia archeologica 1865–1914,* Rome: De Luca, 1979.

• Sobieszek, Robert. *Color as Form: A History of Color Photography.* Rochester: George Eastman House International Museum of Photography, 1982.

• Stafford, Maria Barbara, and Frances Terpak. *Devices of Wonder: From the World in a Box to Images on a Screen.* Los Angeles: Getty Research Institute, 2001.

• Szarkowski, John. *Photography Until Now.* New York: The Museum of Modern Art, 1989.

• Thomas, Ann. *Photographie et science, une beauté à découvir.* New Haven: Yale University Press, 1997.

• Westerbeck, Colin, and Joel Meyerowitz. *Bystander: A History of Street Photography.* Boston: Bulfinch, 1994.

• Willis, Deborah. *Reflections in Black: A History of Black Photographers 1840 to the Present.* New York: Norton, 2000.

• Zannier, Italo. *Storia e tecnica della fotografia.* Bari: Laterza, 1982.

History of Photography of the Nineteenth

• Adam, Hans Christian. *Die erotische daguerreotypie: eine mediengeschichliche bestandsaufnahme.* Prague: Odelfi, 1998.

• Armstrong, Carol. *Scenes in a Library: Reading the Photograph in the Book, 1843–1875.* Cambridge, Mass.: The MIT Press, 1998.

• Barger, Susan M. *The Daguerreotype: Nineteenth Century Technology and Modern Science.* Baltimore: The Johns Hopkins University Press, 2000.

• Barrett-Lowry, Isabel, and

Bates Lowry. *The Silver Canvas: Daguerreotype Masterpieces from the J. Paul Getty Museum.* London: Thames and Hudson, 1998.
• Bordini, Silvia. "Aspetti del rapporto pittura-fotografico nel secondo Ottocento". In *La pittura in Italia. L'Ottocento.* Milan: Electa 1991, 581–601.
• Bossert, Helmuth, and Heinrich Guttmann. *Aus der Frühzeit der Photographie 1840–1870.* Frankfurt: Societäts-Verlag, 1930.
• Brunet, Francois. *La Naissance de l'idée de photographie.* Paris: Presses Universitaires de France, 2000.
• Buchwald, Jed Z. *The Rise of the Wave Theory of Light: Optical Theory and Experiment in the Early Nineteenth Century.* Chicago: University of Chicago Press, 1989.
• *Catalogue des expositions organisée par la Société française de photographie, 1857–1864.* Paris: Jean Michel Place, 1985.
• Coe, Brian, and Mark Haworth-Booth. *A Guide to Early Photographic Processes.* London: Victoria and Albert Museum, 1983.
• Costantini, Paolo, and Italo Zannier. *I dagherrotipi della collezione Ruskin.* Venice: Alinari Arsenale, 1986.
• Crawford, William. *The Keepers of Light.* New York: Morgan ad Morgan, 1979.
• Darrah, William Culp. *The World of Stereography.* Gettysburg: W. C. Darrah, 1977.
• ———. *Cartes-de-Visite in Nineteenth-Century Photography.* Gettysburg: W.C. Darrah, 1981.

• Ducos du Hauron, Alcide. *La triplice photographique des couleurs et l'imprimerie.* Paris: Gauthier-Villars, 1876.
• Eder, Joseph. *La photographie instantanée.* Paris: 1888.
• Edwards, Elizabeth. *Anthropology & Photography, 1860–1920.* New Haven: Yale University Press, 1992.
• Dewitz, Bodo von, and Fritz Kempe. *Daguerreotypien, Ambrotypien und Bilder anderer Verfahren aus der Frühzeit der Photographie.* Hamburg: Dokumente der Photographie 2, Museum für Kunst und Gewerbe, 1983.
• Dewitz, Bodo von, and Roland Scotti. *Alles Wahrheit! Alles Lüge! Fotografie und Wirklichkeit im 19. Jahrhundert. Die Sammlung Lebeck.* Dresden: Verlag der Kunst, 1996.
• Faviére, Jean, and Sylvain Morand. *La mémoire oubilée: du daguerreotype au collodion.* Strasbourg: Musées de Strasbourg, 1981.
• Frizot, Michel, André Jammes, Paul Jay, and Jean-Claude Gautrand. *1839, la photographie révélée.* Paris, Centre National de la Photographie / Archives Nationales, 1989.
• Font-Réaulx, Dominique de. *Le daguerreotype.* Milan: 5 Continents, 2008.
• *From Today Painting Is Dead: The beginnings of Photography.* London: The Arts Council of Great Britain, 1972.
• Galassi, Peter. *Before Photography: Painting and the Invention of Photography.* New York: The Museum of Modern Art, 1981.
• Gastine, Louis. *La*

chronophotographie, sur plaque fixe et sur pellicule mobile. Paris: Masson and Gauthier-Villars, 1897.
• Gernsheim, Helmut. *The History of Photography: From the Earliest Use of the Camera Obscura in the Eleventh Century up to 1914.* London: Oxford University Press, 1955.
• Gernsheim, Helmut. *Le origini della fotografia.* Milan: Electa, 1981.
• ———. *The Rise of Photography 1850–1880. The Age of Collodion.* New York: Thames and Hudson, 1988.
• Goldschmidt, Lucien, and Weston J. Naef. *The Truthful Lens: A Survey of the Photographically Illustrated Book 1844–1914.* New York: Gollier Club, 1980.
• *Grand Tour: le collezioni di fotografia nei musei di Francia.* Turin: Fotodiffusione, 2000.
• Hamilton, Peter, and Roger Hargreaves. *The Beautiful and the Damned: The Creation of Identity in Nineteenth Century Photography.* London: Lund Humphries with the National Portrait Gallery, 2001.
• Haworth-Booth, Mark. *The Golden Age of British Photography 1839–1900.* New York: Aperture, 1984.
• Henisch, Heinz Z, and Bridget A. Henisch. *The Photographic Experience, 1839–1914: Images and Attitudes.* University Park: Pennsylvania State University Press, 1994.
• ———. *The Painted Photograph, 1839–1914: Origins, Tecniques, Aspirations.* University Park: Pennsylvania State University Press, 1996.

• Jacob, Michael. *Il dagherrotipo a colori. Tecniche e conservazione.* Florence: Nardini, 1992.
• Jammes, André, and Marie-Thérèse Jammes. *Niépce to Atget: The First Century of Photography from the Collection of André Jammes.* Chicago: The Art Institute of Chicago, 1977.
• Keller, Ulrich. *The Ultimate Spectacle: A Visual History of Crimean war.* London: Gordon and Breach, 2001.
• Kempe, Fritz. *Photographie zwischen Daguerreotypie und Kunstphotographie.* Hamburg: Museum für Kunst und Gewerbe, 1977.
• La Blanchére, Henri de. *L'art du photographe, comprenant les procédes complets sur papier et sur glace négatifs et positifs.* Paris: Aymot, 1860.
• Leibling, Klaus, and Hans Schellenberger. *Frühe Reise und Landschaftsphotographie.* Coburg: Steinwiesen, 1990.
• Newhall, Beaumont. *Latent Image: The Discovery of Photography.* New York: Doubleday 1967.
• Oettermann, Stephan. *Das Panorama: die Geschichte eines Massenmediums.* Frankfurt: Syndikat, 1980.
• Ostroff, Eugene. *Pioneers of Photography: Their Achievements in Science and Technology.* Springfield: SPSE, 1987.
• Perret, René. *Kunst und Magie der Daguerreotypie. Collection W. + T. Bossard.* Brugg: BEA + Poly Verlags, 2006.
• Peters, Dorothea. "Das Musée immaginaire: Fotografie und Kunstreproduktion im 19.

Jahrhundert". In *Eine neue Kunst? Eiene andere Natur! Fotografie und Malerei un 19. Jahrhundert*. Munchen: Schirmer and Mosel, 2004.

• ———. *Fotografische Kunstreproduktion im 19. Jahrhundert. Zur Metamorphose des Blicks auf die Kunst*. Cassel: Université Gesamhochschule, 2005.

• *Le photographe et son modèle: l'art du nu au XIX siècle*. Paris: Hazan, 1997.

• Plumpe, Gerhard. *Der tote Blick. Zum Diskurs der Photographie in der Zeit des Realismus*. Munich: Fink, 1990.

• Pohlmann, Urlich, and George Prinz von Hohenzollern. *Eine neue Kunst? Eiene andere Natur! Fotografie und Malerei un 19. Jahrhundert*. Munchen: Schirmer and Mosel, 2004.

• Potonniée, Georges. *Histoire de la Découverte de la Photographie*. Paris: Publications Photographiques Paul Montel, 1925.

• Pritchard, Michael. *Technology and Art. The Birth and Early Years of Photography*. Bath, Royal Photographic Society, 1990.

• Roger, Christiane. *Les miroirs qui se souviennent, daguerréotypes d'hier er d'aujourd'hui et autres procédés photographiques*. Paris: Syros / Alternatives, 1987.

• Roubert, Paul-Louis. *L'image sans qualités. Les beaux-arts et la critique à l'épreuve de la photographie, 1839–1859*. Paris: Centre des Munuments Nationaux, 2006.

• Schaaf, Larry J. *Out of the Shadows. Herschel, Talbot & the invention of photography.*

London, Yale University Press, 1992.

• Scharf, Aaron. *Pioneers of Photography: An Album of Pictures and Words*. New York: Harry N. Abrams, 1976.

• Sobieszek, Robert. *This Edifice Is Colossal: 19th Century Architectural Photography*. Rochester: The International Museum at George Eastman House, 1986.

• Trutat, Eugène. *La Photographie appliquée à l'archeologie*. Paris, Gauthiers-Villars, 1879.

• *Une invention du XIX siècle, expression et technique. La photographie: collections de la Société francaise de photographie*. Paris: Bibliothèque Nationale de France, 1976.

• Ware, Mike. *Cyanotype: The History, Science and Art of Photographic Printing in Prussian Blue*. Bradford: National Museum of Photography, Film and Television, 1999.

• Werge, John. *The Evolution of Photography*. London: Piper and Carter, 1890.
Wood, John. *The Daguerreotype: A Sesquicentennial Celebration*. Iowa City: The University of Iowa Press, 1989.

• ———. *The Scenic Daguerreotype, Romanticism and Early Photography*. Iowa City: The University of Iowa Press, 1995).

• Zannier, Italo. *Le Grand Tour dans les photographies des voyageurs au XIX siècle*. Paris: Canal Editions, 1997.

• ———. *Il sogno della fotografia*. Milan: Skira, 2006.

National and Regional Studies
• Adelman, Jeremy, and Miguel Angel Cuarterolo. *Los años del daguerreotypo, primeras fotografias argentinas, 1842–1870*. Buenos Aires: Fundación Antorchas, 1995.

• Adhémar, Jean, and Beaumont Newhall. *Daguerre et les premiers daguerréotypes français*. Paris: Bibliothèque Nationale, 1961.

• Alison, Jane. *Native Nations: Journeys in American Photography*. London: Barbican Art Gallery, 1998.

• Armstrong, Nancy. *Fiction in the Age of Photography. The Legacy of British Realism*. Cambridge, Mass.: Harvard University Press, 1989.

• Bajac, Quentin, and Dominique de Font-Reaulx. *Le daguerréotype français: un objet photographique*. Paris: Réunion des Musées Nationaux, 2003.

• Bann, Stephen. *Parallel Lines: Printmakers, Painters and Photographers in 19th Century France*. New Haven: Yale University Press, 2001.

• Bartram, Michael. *The Pre-Raphaelite Camera: Aspects of Victorian Photography*. London: Weidenfeld & and Nicolson, 1985.

• Becchetti, Piero. *Fotografi e fotografia in Italia 1839–1880*. Rome: Edizioni Quasar, 1978.

• ———. *La fotografia a Roma dalle origini al 1915*. Rome: Colombo, 1983.

• ———. *Immagini della campagna Romana 1853–1915*. Rome: Edizioni Quasar, 1983.

• Becchetti, Piero, and Carlo Pietrangeli. *Roma in dagherrotipia*. Rome: Edizioni Quasar, 1979.

• Bensusan, Arthur David. *Silver Images, History of Photography in Africa*. Cape Town: H. Timmins, 1966.

• Bertelli, Carlo, and Giulio Bollati. "L'immagine fotografica 1845–1945". In *Storia d'Italia, Annali 2*. Turin: Einaudi, 1979.

• Besson, George. *La photographie francaise*. Paris: Les Éditions Braun et Cie, 1936.

• Billeter, Erika. *A Song to Reality: Latin American Photography, 1860–1993*. Barcelona: Lunwerg Editores, 1998.

• Blom, Benjamin. *New York: Photographs, 1850–1950*. New York: Amaryllis, New York, 1982.

• Bonetti, Maria Francesca, and Monica Maffioli. *L'Italia d'argento, 1839–1859. Storia del dagherrotipo in Italia*. Florence: Alinari, 2003.

• Bouqueret, Christian, and François Livi. *Le voyage en Italie. Les photographes français en Italie, 1840–1920*. Paris: La Manufacture, 1989.

• Brizzi, Bruno. *Roma. Cento anni fa nelle fotografie della raccolta Parker*. Rome: Edizioni Quasar, 1977.

• Bruce, Chris. *Myth of the West*. Seattle: The Henry Art Gallery, 1990.

• Buerger, Janet E. *French Daguerreotypes*. Chicago: University of Chicago Press, 1989.

• Carlebach, Michael. *The Origins of Photojournalism in America*. Washington, D.C.:, Smithsonian Institution Press, 1992.

• Cartier-Bresson, Anne, and Anita Margiotta. *Rome 1850, le cercle des artistes photographes*

du Caffè Greco. Milan: Electa, 2003.
• Castleberry, May. Perpetual Mirage: Photographic Narratives of the Desert West. New York: Whitney Museum of American Art / Abrams, 1996.
• Costantini, Paolo, and Italo Zannier. Venezia nella fotografia dell'Ottocento. Venice: Arsenale, 1986.
• Costantini, Paolo, Silvio Fusco, Sandro Mescola, and Italo Zannier. L'insistenza dello sguardo. Fotografie italiane 1839–1989. Florence: Alinari, 1989.
• Current, Karen. Photography and the Old West. Fort Worth: Amon Carter Museum of Western Art, 1978.
• Davis, Keith. An American Century of Photography, from Dry Plate to Digital: The Hallmark Photographic Collection. Kansas City and New York: Hallmark Cards with Harry N. Abrams, 1999.
• Dehejia, Vidya. India: Through the Lens, Photography 1840–1911. Washington, D.C.: Smithsonian Institution, 2000.
Dewitz, Bodo von, Dietmar Siegert, Karin Schuller Procopovici. Italien Sehen und Sterben. Photographien der Zeit des Risorgimento (1845–1870). Heidelberg: Braus, 1994.
• Dewitz, Bodo von, and Reinhard Matz. Silber und Salz: zur Frühzeit der Photographie im deutschen Sprachraum 1839–1860. Cologne and Heidelberg: Brauss, 1989.
• Di Bello, Patrizia. Women's Albums and Photography in Victorian England: Ladies, Mothers and Flirts. Farnham: Ashgate Publishing, 2007.

• Elliott, David. Photography in Russia, 1840–1940. London: Thames and Hudson, 1992.
• Edwards, Steve. The Making of English Photography: Allegories. University Park, The Pennsylvania State University Press, 2006.
• Faber, Monika, and Maren Gröning. Inkunabeln einer neuen Zeit Pioniere der Daguerreotypie in Österreich 1839–1850. Vienna: Brandstätter, 2006.
• Flukinger, Roy. The Formative Decades: Photography in Great Britain, 1839–1920. Austin: University of Texas Press, 1985.
• Foresta, Merry A. and John Wood. Secrets of the Dark Chamber: The Art of the American Daguerreotype. Washington, D.C.: Smithsonian Institution Press, 1995.
• La fotografia nel secolo XIX. La veduta, il ritratto, l'archeologia. Rome: Artemide, 1991.
• Frank, Hans. Vom Zauber alter Lichtbilder. Frühe Photographien in Österreich 1840–1860. New York: Molden, 1981.
• Frassanito, William. Early Photography at Gettysburg. Gettysburg: Thomas Publications, 1995.
• Gebhardt, Heinz. Königlich bayerische Photographie 1838–1918. Munich: Laterna magica, 1978.
• ————. Incunabola of British Photographic Literature 1839–1875. London and Berkeley: Scolar Press, 1984.
• Graham-Brown, Sarah. Images of Women: The Portrayal of Women in Photography of the Middle East, 1860–1950. New York: Columbia University Press, 1988.

• Groth, Helen. Victorian Photography and Literary Nostalgia. Oxford: Oxford University Press, 2003.
Hales, Peter Bacon. Silver Cities: The Photography of American Urbanization, 1839–1915. Philadelphia: Temple University Press, 1983.
• Hoerner, Ludwig. Das photographische Gewerbe in Deutschland 1839–1914. Düsseldorf: GFW-Verlag, 1989. Honnef, Klaus, Rolf Sachsse, and Karin Thomas. German Photography 1870–1970: Power of a Medium. Cologne: DuMont Buchverlag, 1997.
• Jaeger, Jens. Gesellschaft und Photographie. Formen und Funktionen der Photograohie in Deutschland und England 1839–1860. Opladen: Leske und Budrich, 1996.
• Jammes, André, Robert Sobieszek, and Minor White. French Primitive Photography. New York: Aperture, 1969.
• Jammes, André, and Eugenia Janis Parry. The Art of French Calotype with a Critical Dictionary of Photographers, 1845–1870. Princeton: Princeton University Press, 1983.
• Jones, Kimberly, Simon Kelly, Sarah Kennel, and Helga Aurish. In the Forest of Fointanbleau: Painters and Photographers from Corot to Monet. New Haven: Yale University Press, 2008.
• Kempe, Fritz. Daguerreotypie in Deutschland. Vom Charme der frühen Fotografie. Heering: Seebruck am Chiemsee, 1979.
• Krawitz, Henry, and David J. Farmer. Picturing the Middle East: A Hundred Years of European Orientalism.

New York: Dahesh Museum, 1996.
• Linkman, Audrey. The Victorians: Photographic Portraits. New York: Tauris Parke Books, 1993.
• Lundberg, Bruce W., and John A. Pinto. Steps Off the Beaten Path. Nineteenth Century Photographs of Rome and Its Environs. Images from the Collection Delaney and Bruce Lundberg. Milan: Charta, 2007.
• Maffioli, Monica. Il Belvedere. Fotografi e architetti nell'Italia dell'Ottocento. Turin: Società Editrice Internazionale, 1996.
• Marbot, Bernard, and René Viénet. Notes sur quelques photographies de la Chine au XIX siècle. Paris: Centre de Publication Asie Orientale, 1978.
• Marbot, Bernard, and Weston Naef. Bibliothèque Nationale. Regards sur la photographie en France au XIX siècle, 180 chefs d'oeuvre du département des Estampes et de la Photographie. Paris: Berger-Levrault, 1980.
• Mayer-Wegelin, Eberhard. Frühe Photographie in Frankfurt am Main 1839–1870. Munich: Schirmer and Mosel, 1982.
• McCauley, Elisabeth Anne. Industrial Madness: Commercial Photography in Paris, 1848–1871. New Haven: Yale University Press, 1994.
• Miller, Francis, and Robert Sampson Lanier. The Photographic History of the Civil War. New York: The Review of Reviews, 1911.
• Miraglia, Marina, Daniela Palazzoli, and Italo Zannier. Fotografia italiana dell'Ottocento. Milan: Electa, 1979.
• Miraglia, Marina. "Note per

una storia della fotografia italiana (1839–1911)". In *Storia dell'arte italiana,* vol. 9. Turin: Einaudi, 1981, pp. 421–543.

• ———. "I luoghi dell'epopea garibaldina: reportage bellico e veduta nella fotografia dell'Ottocento". In *Garibaldi. Arte e Storia,* Florence: Centro Di, 1982, pp. 274–333.

• ———. "Dalla 'traduzione' incisoria alla 'documentazione' fotografica". In *La fotografia a (Rome: nel secolo XIX.*

• ———. "Die Helden zeigen, wie sie wir *Italien Sehen und Sterben. Photographien der Zeit des Risorgimento (1845–1870).* Heidelberg: Braus, 1994.

• ———. "I francesi e le prime fotografie in Italia (1839–1870)". In *I francesi e l'Italia.* Milan: Scheiwiller, 1994, pp. 208–17.

• ———. "La fotografia". In *Maestà di Roma. Da Napoleone all'Unità universale ed eterna.* Milan: Electa, 2003.

• Mondenard, Anne de. *La mission héliographique, cinq photographes parcourant la France en 1851.* Paris: Monum / Éditions du Patrimonie, 2002.

• Mormorio, Diego. *Vues et paysages italiens, photographies du XIX siècle.* Paris: Actes Sud, 2000.

• Negro, Silvio. *Mostra della fotografia a Roma, dal 1840 al 1915.* Rome: E.P.T., 1953.

• ———. *Nuovo album Romano. Fotografie di un secolo.* Vicenza: Neri Pozza, 1965.

• Newhall, Beaumont. *The Daguerreotype in America.* New York: Duell, Sloan and Pearce, 1961.

• Nir, Yeshayahu. *The Bible and the Image: The History of Photography in the Holy Land 1839–1899.* Philadelphia: University of Pennsylvania Press, 1985.

• Orvell, Miles. *American Photography.* New York: Oxford University Press, 2003.

• Palmquist, Peter E., and Thomas R. Kailbourn. *Pioneer Photographers of the Far West: A Biographical Dictionary, 1840–1865.* Palo Alto: Stanford University Press, 2001.

• Paoli, Silvia. *Scenari della memoria. Fotografia e veduta urbana a Milano nell'Ottocento.* Cologno Monzese: Silvia Editrice, 2003.

• Peters, Ursula. *Stilgeschichte der Fotografie in Deutschland 1839–1900.* Cologne: DuMont, 1979.

• Pelizzari, Maria Antonella. *Traces of India: Photography, Architecture and the Politics of Representation 1850–1900.* New Haven: Yale University Press, 2003.

• Perez, Nissan N. *Focus East: Early Photography in the Near East 1839–1885.* New York: Harry N. Abrams, 1988.

• Phillips, Sandra S. *Crossing the Frontier: Photographs of the Developing West, 1849 to the Present.* San Francisco: San Francisco Museum of Modern Art, 1996.

• *Pittori fotografi a 1845–1870. Immagini dalla raccolta fotografica comunale.* Rome: Multigrafica Editrice, 1987.

• Pohlmann. Ulrich. *Voir l'Italie et mourir. Photographie et peinture dans l'Italie du XIX siècle.* Paris: Flammarion, 2009.

• Reynaud, Françoise. *Paris et la daguerréotype.* Paris: Paris-Musées, 1989.

• Rinhart, Floyd and Marion Rinhart. *The American Daguerreotype.* Athens, Ga.: University of Georgia Press, 1981.

• Ritter, Dorothea. *Venise. Photographies anciennes. 1841–1920.* Paris: Inter livres, 1996.

• *Rom in frühen Photographien aus romischen und danischen sammlungen.* München: Schirmer Mosel, 1978.

• Romano, Serena. *L'immagine di Roma 1848-1895. La città, l'archeologia, il medioevo nei calotipi del fondo Tuminello.* Napoli: Electa, 1994.

• *Rome au XIX siècle. Photographies inédites 1852–1890.* Rome: Fratelli Palombi, 1999.

• Rouillé, André. *La photographie en France. Textes and controverses, une anthologie, 1816–1871.* Paris: Macula, 1989.

• Rudisill, Richard. *Mirror Image: The Influence of the Daguerreotype on American Society.* Albuquerque: University of New Mexico Press, 1971.

• Sandweiss, Martha A. *Photography in Nineteenth-Century America.* New York: Harry N. Abrams, 1991.

• ———. *Print the Legend. Photography and the American West.* New Haven: Yale University Press, 2002.

• Schaaf, Larry J. *Impressed By Light: British Photographs from Paper Negatives.* New Haven: Yale University Press, 2007.

• Schulte Arndt, Monika, and Dietmar Siegert. *Im Land der Sehnsucht. Mit Bleistift und Kamera durch Italien. 1820–1880.* Bremen: Fichter, 1998.

• Seiberling, Grace. *Amateurs, Photography, and the Mid-Victorian Imagination.* Chicago: University of Chicago Press, 1986.

• Settimelli, Wladimiro. *Roma e il Lazio negli archivi Alinari.* Florence: Alinari, 1982.

• Siegel, Elizabeth. *Playing With Pictures: The Art of Victorian Photocollage.* New Haven: Yale University Press, 2009.

• ———. *Galleries of Friendship and Fame: A History of Nineteenth-Century American Photograph Albums.* New Haven: Yale University Press, 2010.

• Siegert, Dietmar. *Rom vor hundert Jahren. Photographien 1846–1890.* Ebersberg: Achtenhalb Lothar Just, 1985.

• Sigurjonsdottir, Aesa. *Islande en vue: photographes français en Islande, 1845–1900.* Reykjavik: 2000.

• Stapp, W.F. *Segnali di fumo. L'avventura del West nella fotografia.* Florence: Alinari, 1993.

• Strange, Maren. *Symbols of Ideal Life: Social Documentary Photography in America, 1890–1950.* New York: Cambridge University Press, 1986.

• Taft, Robert. *Photography and the American Scene: A Social History, 1839–1889.* New York: MacMillan, 1938.

• Taylor, Roger. *Impressed by Light. British Photographs from Paper Negatives, 1840–1860.* New Haven: Yale University Press, 2007.

• Tittoni, Maria Elisa, and Anita Margiotta. *Scenari della*

memoria. *Roma nella fotografia 1850–1900*. Rome: Electa, 2002.

• Trachtenberg, Alan. *Reading American Photographs. Images As History: Mathew Brady to Walker Evans*. New York: Hill and Wang, 1989.

• Truettner, William H. *The West as America: Reinterpreting Images of the Frontier, 1820–1920*. Washington, D.C.: Smithsonian Institution Press, 1991.

• Tucker, Anne Wilkes. *The History of Japanese Photography*. New Haven: Yale University Press, 2003.

• *Une passion française: photographies de la collection Roger Thérond*. Paris: MEP / Filipacchi, 1999.

• Vitali, Lamberto. *Il Risorgimento nella fotografia*. Turin: Einaudi, 1979.

• Voignier, Jean-Marie, *Répertoire des photographes de France au XIX siècle*. Chevilly-Larue: Le Pont de Pierre, 1993.

• Watriss, Wendy, and Lois Parkinson Zamora. *Image and Memory: Photography from Latin America, 1866–1994*. Austin: University of Texas Press, 1998.

• Watson, Wendy M. *Images of Italy. Photography in the Nineteenth Century*. South Hadley, Mass.: Mount Holyoke College Art Museum, 1980.

• Weimar, Wilhelm. *Die Daguerreotypie in Hamburg 1839–1860. Ein Betrag zur Geschichte der Photographie*. Hamburg: Meissner, 1915.

• Weaver, Mike. *The Photographic Art: Pictorial Traditions in Britain and America*. London: The Herbert Press, 1986.

• ————. *British Photography in the Nineteenth Century: The Fine Art Tradition*. Cambridge: Cambridge University Press, 1989.

• Welling, William. *Photography in America. The Formative Years 1839–1900*. New York: Thomas Crowell, 1978.

• Wood, John. *America and the Daguerreotype*. Washington, D.C.: Smithsonian Institution Press, 1995.

• Wood, Rupert Derek. *The Arrival of the Daguerreotype in New York*. New York: The American Photographic Historical Society, 1994.

• Xanthakis, Alkis X. *History of Greek Photography, 1839–1960*. Athens: Hellenic Literary and Historical Archives Society, 1988.

• Zannier, Italo, and Paolo Costantini. *Cultura fotografica in Italia. Antologia di testi (1839–1949)*. Milan: Franco Angeli, 1985.

• Zannier, Italo. *Segni di luce, Vol.1, Alle origini della fotografia in Italia*. Ravenna: Longo Editore, 1991.

• ————. *Segni di luce, Vol.2, La fotografia dall'età del collodio al pittorialismo*. Ravenna: Longo Editore, 1995.

• Zeri, Federico. *Le Mythe visuel de l'Italie*. Paris: Rivages 1986.

Theory and Criticism of Photography

• Adams, Robert. *Beauty in Photography. Essays in Defense of Traditional Values*. New York: Aperture, 1981.

• ————. *Why People Photograph*. New York: Aperture, 1994.

• Barthes, Roland. *La chambre claire* (Paris: Gallimard, 1980), trans. 1980 © Farar, Straus and Giroux, *Camera Lucida: Reflections on Photography*. New York: Hill and Wang, 2010.

• Batchen, Geoffrey. *Burning with Desire: The Conception of Photography*. Cambridge, Mass.: The MIT Press, 1997.

• Batchen, Geoffrey. *Each Wild Idea: Writing, Photography, History*. Cambridge, Mass.: The MIT Press, 2002.

• Batut, Arthur. *La photographie appliqué a la production du type, d'une famille, d'une tribu ou d'une race*. Paris: Gauthuier-Villars, 1887.

• Benjamin, Walter. *Das Kunstwerk im Zeitalter seiner Technischen Reproduzierbarkeit*, in *Zeitschrift für Sozialforschung*. Paris: Félix Alcan, 1936.

• Berger, John. *Ways of seeing*. London: British Broadcasting Corporation and Penguin Books, 1972.

• Bertillon, Alphonse. *La photographie judiciaire*. Paris: Villars, 1890.

• Billeter, Erika. *L'autoportrait à l'âge de la photographie: peintres et photographes en dialogue avec leur propre image*. Berne: Benteli Verlag, 1985.

• Bolton, Richard. *The Contest of Meaning: Critical Histories of Photography*. Cambridge, Mass.: The MIT Press, 1989.

• Bourdieu, Pierre. *Un art moyen. Essai sur les usages sociaux de la photographie*. Paris: Les Éditions de Minuit, 1965.

• Braive, Michel. *The photograph: A Social History*. New York: McGraw-Hill, 1966.

• Brunet, François. *La naissance de l'idée de photographie*. Paris: PUF, 2000.

• Burgin, Victor, *Thinking Photography*. London: Macmillan, 1982.

• Clarke, Graham. *The Photograph*. New York: Oxford University Press, 1997

• Debray, Regis. *Vie et mort de l'image. Une histoire du regard en Occident*. Paris: Gallimard, 1992.

• De Paz, Alfredo. *La fotografia come simbolo del mondo*. Bologna: Clueb, 1993.

• Flusser, Vilém. *Für eine Philosophie der Fotografie*. Göttingen: European Photography, 1983.

• Freund, Gisele. *Photographie et société*. Paris: Seuil, 1974.

• Galassi, Peter. *Before photography. Painting and the invention of photography*. New York: The Museum of Modern Art, 1981.

• Grundberg, Andy. *Crisis of the Real: Writings on Photography Since 1974*. New York: Aperture, 1999.

• Howarth, Sophie. *Singular Images: Essays on Remarkable Photographs*. New York: Aperture, 2005.

• Johnson, Brooks. *Photography Speaks: 150 Photographers on Their Art*. New York: Aperture, 2005.

• Kempe, Fritz. *Theorie der Fotografie I, 1839–1912*. Munich: Schirmer Mosel, 1980.

• Koppen, Erwin. *Literatur und Photographie. Über Geschichte und Thematik einer Medienentdeckung*. Stuttgard: Metzler, 1987.

• Krauss, Rosalind. *Le

Photographique. Paris: Éditions Macula, 1990.

• Lowenthal, Anne. *The Object as Subject: Studies in the Interpretation of Still Life*. Princeton: Princeton University Press, 1996.

• Marien, Mary Warner. *Photography and Its Critics: A Cultural History, 1839–1900*. New York: Cambridge University Press, 1997.

• Moholy-Nagy, Laszlo. *Painting, Photography, Film*. Cambridge, Mass.: The MIT Press, 1969.

• Pinney, Christopher, and Nicholas Paterson. *Photography's Other Histories*. Durham, NC: Duke University Press, 2003.

• Scharf, Aaron. *Art and Photography*. London: Allen Lane, 1968.

• Schwartz, Joan, and James Ryan. *Picturing Place: Photography and Geographical Imagination*. London: I. B. Tauris, 2003.

• Schwarz, Heinrich. *Art and Photography: Forerunners and Influences. Selected Essays by Heinrich Schwarz*. Layton: Peregrine Smiths Books, 1985.

• Solomon-Godeau, Abigail. *Photography at the Dock: Essays on Photographic History, Institutions and Practices*. Minneapolis: University of Minnesota Press, 1991.

• Sontag, Susan. *On Photography*. New York: Farrar, Straus and Giroux, 1973.

• Stiegler, Bernd. *Bilder der Photographie. Ein Album photographischer Metaphern*. Frankfurt: Suhrkamp, 2006).

• Szarkowski, John. *The Photographer's Eye*. New York:

The Museum of Modern Art, 1966.

• Szarkowski, John. *Looking at Photographs: 100 Pictures from the Collection of the Museum of Modern Art*. New York: The Museum of Modern Art, 1973.

• Thomas, Alan. *Time in a Frame: Photography and the 19th Century Mind*. New York: Schocken Books, 1977.

• Trachtenberg, Alan. *Classic Essays on Photography*. New Haven: Leete's Island Books, 1980.

• Valéry, Paul. *Discorso sulla fotografia*. Naples: Filema, 2005.

• Valtorta, Roberta. *Il pensiero dei fotografi*. Milan: Bruno Mondadori, 2008.

• Wells, Liz. *Photography: A Critical Introduction*. London: Routledge, 1997.

Magazines

• Becchetti, Piero. "Una dinastia di fotografi romani: gli Anderson". *Archivio fotografico toscano* 4 (December 1986).

• Collins, Kathleen. "Photography and Politics in Rome: The Edict of 1861 and the Scandalous Montages of 1861–1862". *History of Photography*, vol. 4., 1985.

• Connes, P. "Silver Salts and Standings Waves: The History of Interference Colour Photography". *Journal of Optics* 4, vol. 18 (1987).

• Costantini, Paolo. "Una verità che l'arte non può ottenere. Gli ambienti scientifici del Veneto e le prime indagini sulla fotografia (1839–1946)". *Scienza e cultura*, vol. 1., 1987.

• Daston, Lorraine; Galison, Peter. "The image of

objectivity" *Representations* 40 (Fall 1992).

• Edwards, Elisabeth. "Photographic Types: the Pursuit of Method". *Visual Anthropology* 3 (1990).

• Fournier, Jean Marc. "La photographie en couleur de type Lippmann: Cent ans de technique et de technologie". *Journal of optics* 6, vol. 22 (1991).

• Galloway, John. "Seeing the Invisible: Photography in Science". *Impact of Science in Society* 168 (1992).

• Miraglia, Marina. "La 'veduta' fotografica come forma rappresentativa privilegiata della scena urbana e dell'architettura". *Fotografia e architettura*,1/2 (2004).

• Neagu, Philippe. "Sur la photographie d'architecture au XIX siècle". In *Monuments Historiques*, CNMHS 110 (1980).

• Pellizzari, Maria Antonella. "Paris, Bibliothèque Nationale. Obiettivo Italia". *AFT Rivista di storia e fotografia* 14 (1991).

• Schaaf, Larry J. "Sir John Herschel's 1839 Royal Society Paper on Photography". *History of Photography* 1, vol. 3 (January 1979).

• Schaaf, Larry J. "Herschel, Talbot and Photography; Spring 1831 & Spring 1839". *History of photography* 3, vol. 4 (July 1980).

• Sobieszek, Robert A. "Vedute della Camera: Nineteenth Century Views of Italy". *Image* 22 (March 1979).

• Sutton, Thomas. "On Some of the Uses and Abuses of Photography". *Photographic Notes* 163, vol. 8 (15 January 1863).

• Thompson, Stephen. "The Commercial Aspects of Photography". *British Journal of Photography* 1 (November 1862).

• Zannier, Italo. "Die Anfange der Italienischen Fotografie". *Fotogeschichte* 25 (1987).

Index of names